Art of the Soviets

Art of the Soviets

Painting, sculpture and architecture in a one-party state, 1917–1992

Matthew Cullerne Bown
Brandon Taylor *editors*

MANCHESTER UNIVERSITY PRESS
Manchester and New York

distributed exclusively in the USA and Canada by St. Martin's Press

Copyright © Manchester University Press 1993

While copyright in the volume as a whole is vested in Manchester University Press, copyright in individual chapters belongs to their respective authors, and no chapter may be reproduced wholly or in part without the express permission in writing of both author and publisher.

Published by Manchester University Press
Oxford Road, Manchester M13 9PL, UK
and Room 400, 175 Fifth Avenue, New York, NY 10010, USA

Distributed exclusively in the USA and Canada
by St. Martin's Press, Inc., 175 Fifth Avenue, New York, NY 10010, USA

British Library Cataloguing-in-Publication Data
A catalogue record for this book is available from the British Library

Library of Congress cataloging in publication data applied for
Art of the Soviets: painting, sculpture, and architecture in a one-party
 state, 1917–1992 / edited and introduced by Matthew Cullerne
 Bown and Brandon Taylor.
 p. cm.
 Includes index.
 ISBN 0-7190-3734-4 (hardback). — ISBN 0-7190-3735-2 (paperback)
 1. Art, Soviet—Themes, motives. I. Bown, Matthew Cullerne.
II. Taylor, Brandon.
N6988.A7625 1993
709'.47'0904—dc20 92-41224
 CIP

ISBN 0-7190-3734-4 *hardback*
 0-7190-3735-2 *paperback*

Typeset in Times
by Koinonia Limited, Manchester
Printed in Great Britain
by Bell and Bain Limited, Glasgow

Contents

v

List of illustrations

List of colour plates

the colour plates appear between pp. 72 and 73

Matthew Cullerne Bown and Brandon Taylor

Introduction

The history of the Soviet Union from its beginning in 1917 to its final break- up in 1991 is one of the great dramas of the twentieth century. The 1917 Revolution resounded stormily throughout Europe and the world, proclaiming a new ideology and presaging, even in its tottering infancy, a new social and economic order; today, as much as ever, arguments abound over its causes and its consequences. The gradual descent of the Soviet Union into authoritarianism in the late 1920s and early 1930s constituted a tragic social and political development, yet as historians examine that period now, it reveals multiple paradoxes. During the painful events of the later 1930s and the Second World War, followed by forty years of the Cold War, the USSR came to constitute a kind of mirror inversion of that other society – the United States and its Western allies – in which each side seemed trapped in a reciprocal and symbiotic rejection of its rival. The ultimate stakes in this conflict of ideologies – a conflict which spread to most corners of the globe and which in the 1960s and 1970s threatened war and destruction on a previously unimaginable scale – were perhaps higher than in any other struggle in the history of mankind. The Gorbachev 'compromise' of 1985 to 1991 restored some civil and cultural freedoms in the USSR, and attempted limited economic reform in harness with a new approach to foreign policy, but at the cost of the final collapse of a communist state that Gorbachev had intended, in all likelihood, to conserve. The political, economic and social fate awaiting the peoples of the former Soviet Union is still notoriously unclear.

This book considers aspects of the art and architecture of the Soviet Union during that turbulent world-historical epoch. It is, of course, a task that will require many books. The sheer size of the USSR presents problems to anyone attempting a survey of its culture. By the end of the 1920s it bound together a great conglomeration of peoples and ethnic groups, a great network of ideals and habits, impulses and prohibitions, which have only partially entered the orbit of Western scholarship and history. Such a many-faceted and complex pattern was nevertheless dominated throughout the period by Russia, the largest of the Soviet republics and the seat of power and influence right up to the present. Because the USSR was such a centralised state, we have found it necessary

to focus this book on the art produced in Moscow and Leningrad (now St Petersburg); however, one chapter deals with painting and cultural policy in the non-Russian republics.

Within this Russo-centric framework, we propose a shift of emphasis away from the work of the 'avant-garde' which has long preoccupied Western art historians, in favour of a broader, more inclusive scheme that recognises the existence of many types of art, some modernist but some deeply anti-modernist, but each to a greater or lesser extent guided by (sometimes coerced by) the apparatus of the over-arching state.

There are a number of broad areas of controversy that will be encountered by anyone attempting a survey of Soviet art. These deserve discussion in this introduction. Two of the most important challenges facing the art historian are the task of periodising Soviet art history, and the task of reconciling contrasting Soviet and Western versions of this same art history.

According to one long-standing Western orthodoxy, Soviet history – and, give or take a year or two, culture – can be divided into just two opposing periods: the 'revolutionary' period of 1917 to 1924 (the date of Lenin's death), deemed a period of classic revolutionary struggle and utopian aspirations, and the period of 'corrupted communism' which succeeded it, in which the great ideals of democracy, emancipation, and the 'withering away of the state' (Lenin's phrase from his 1924 book *State and Revolution*) became grotesquely inverted. This inversion – Stalinism – is generally held to have given birth to the cultural dogmas of Socialist Realism, and it is still the conventional view that Socialist Realism dominated Soviet art and culture right up to 1985 and the beginnings of *perestroika* (reconstruction) – despite the heroic resistance of the artistic 'underground' – and moreover that the art produced under this doctrine was stylistically monotonous and aesthetically inferior.

This book advances the idea that Soviet culture was less monolithic, more heterogeneous and, quite simply, more interesting and important than this simple stereotype suggests. This already implies, of course, a periodising scheme more sensitive than the conventional one outlined above. The traditional verdict that Soviet communism was revolutionary and somehow admirable in the years up to the death of Lenin and degenerate only in the years following is no longer accepted either in the former USSR nor in many quarters in the West today. There is a mass of incontrovertible evidence that the ossification of Soviet life under Stalin was already inscribed in the events and personalities of 1917, or even earlier. It is now acknowledged that the Bolshevik 'terror' – the policy of ruthless and at times arbitrary eradication of political dissent – loomed large before Lenin's death. Bureaucratisation, so characteristic of later

Soviet communism, can as easily be seen as part of the cultural inheritance of the Tsarist period as a devilish imposition of the Bolsheviks. Nor is it acceptable to assert that cultural freedom was characteristic only of the Lenin era; under Lenin it was clearly circumscribed. Moreover, even under the heavy weight of Stalinist politics, cultural life was animated by debate and discussion, even if many of these exchanges were marred by fear, hypocrisy and dissimulation – all characteristics of Bolshevik politics from the earliest years – and concealed as far as possible from the Soviet public and the outside world. Soviet art after the diaspora of the avant-garde in the 1920s was by no means monolithic; it partook of many of the developments within Soviet society itself. Thus the art of the first Five-Year Plan of 1928 to 1932 is distinguishable from that of the mid- and late 1930s, produced under the banner of Socialist Realism, when Stalin announced that socialism, the preliminary to communism, had been achieved; and the art of both these periods is in clear contrast to the academic realism encouraged in the grim post-war years. In considering Soviet art history we are looking not at two – or even three or four – discrete periods, but at a broad stream of events, in which the frequent breaks with the past are at least as striking as the continuities.

Indeed, art practice throughout the Soviet period was so tightly knitted into the social and political fabric that in periodising Soviet art it is often tempting to appeal to events of extra-artistic significance to provide a framework. One might even argue that the pivotal moments were either those of deepest crisis, or when measures were being taken to conceal and divert attention from crisis, often in paradoxical combination. Thus the 'Red Terror' of Lenin's administration coincided with the supremacy of the avant-garde; the emergency measures of the New Economic Policy seemed to support the re-emergence of figurative art; the collectivisation of the countryside and the cultural dystopia of 1928 to 1932 was predicated on a resurgence of 'proletarian' art; the desperate self-purification of the Party in the late 1930s marked the first phase of optimistic Socialist Realism; the trauma of the post-war years seemed to require the highly-varnished view of life provided by Stalinist academicism; and so on.

Painters, sculptors and architects were at many points in Soviet history closely directed by decisions and decrees emanating from broader Party policy, and this suggests a further way of periodising the era. From the early decrees on monumental propaganda and the *proletkults* (proletarian culture organisations) through the 1932 resolution banning autonomous artistic groupings, to the *Pravda* editorials and Zhdanov decrees of the later Stalin period, right up until the Gorbachev dispensation, it can be argued that cultural activity was nurtured, coaxed and coerced by fundamental political decisions, many of which were themselves the results of the developing relationship between the Soviet Union and the outside world.

3

This dependent relationship between artists and the state is clearly a key distinguishing feature of Soviet culture.

A further arrangement is to view political leaders as marking out a period: Lenin, Stalin, Khrushchev, Brezhnev and Gorbachev, each imposing their own cultural status quo; another contrasting, periodising model, particularly in the post-war years is to follow Russian artists and critics as they talk, for example, of *shestidesyatniki*, *semidesyatniki* and *vosemidesyatniki* – artists of the sixties, seventies and eighties. These two contrasting schemes suggest on the one hand that art was moulded by politics above all, and, on the other, that there was a significant degree of autonomous cultural development. The truth is perhaps somewhere in between.

This brings us to the second introductory question, which also requires a more open and flexible attitude than is frequently found. The construction of any history is inevitably an act of selective emphasis and exclusion; but Soviet art has suffered abnormally from the manipulations of its various historians. In particular, the growing ideological gulf between the Soviet Union and the West in the period from 1917 to the 1980s led to the emergence of two separate and frequently antagonistic evaluations of Soviet art; indeed, to two opposing histories of twentieth-century art as a whole.

In Russia in the teens and twenties the question of *which* art history should predominate (and after 1917 receive the patronage of the Party) was ferociously disputed. Avant-gardists such as Malevich and Tatlin constructed aetiologies for their own art: Malevich positioned himself 'beyond' a sequence of artistic movements leading from Impressionism through Cubism and Futurism; Tatlin saw his origins in Picasso and a 'modern' culture of materials. But avant-gardists took their standards from the future, suggesting a severance from the past, the actual destruction of museums, and so on. This was the significance of such phrases as 'tabula rasa' which entered the Futurist vocabulary in an effort to establish the radically new.

While avant-gardists refused any linkage with the past, others – including Lenin himself, who urged artists to appropriate and re-work the best of bourgeois culture – attempted to ground themselves securely in tradition. The powerful Association of Artists of Revolutionary Russia (*AKhRR*), formed in 1922, maintained that Soviet art began with the efforts of the nineteenth century Russian social realists to establish a popular yet 'revolutionary' art. All that *AKhRR* deemed necessary was to adapt stylistic and narrative techniques of the *peredvizhniki* to the problems of the present day. This idea supplied *AKhRR* with the basis for its own art history. Late nineteenth and twentieth-century departures from the relatively narrow line of Russian (and occasionally West European) social realism and, in particular, modernist movements, were held to form part of decaying bourgeois culture, and as such not to deserve a place in the true history of art.

As the 1920s progressed, the Party identified itself more and more closely with the *AKhRR* line. By the end of the 1920s it was still possible for historical collections of 'leftist' art criticism and history to appear, but they ran an increasing risk of censure or ridicule. Nevertheless, as late as 1932-3 inconsistencies in the official attitude were still apparent. Some publications appeared containing 'leftist' writings of the early revolutionary period, such as Ivan Matsa's compendious and important *Sovetskoe Iskusstvo za 15 let: Materialy i Dokumentatsiya* of 1933.But in general, what was emerging as 'modernism' in the West was written out of official versions of artistic evolution as a decadent, temporary phenomenon and castigated as 'cosmopolitanism', 'formalism' and 'subjectivism'. Following the big survey 'Artists of the Russian Federation over 15 Years', shown in Leningrad and Moscow in 1932-3, avant-garde work was not put on display at all, even in historical surveys. The makings of a clash with the aesthetic movements of the capitalist world were already in place. With hindsight, this claim seems to have been implicit in Bolshevik cultural policy from 1917-18 onwards.

By the end of the 1930s the official critical and historical definition of realism had narrowed to exclude even stylistic devices derived from French Impressionism, a movement much-loved by Russian artists, and by the late 1940s had come to signify a highly-finished academic style. In 1947 the USSR Academy of Arts was created, complete with publishing house and lavish resources, the purpose of which was to promote a narrow official version of Soviet art in which nineteenth century academic painters such as Bryullov and Ivanov were extolled as artistic exemplars. Critics at the end of the 1940s tended to describe academic artistic style as something eternal and final. The Party welcomed it as a means of providing a highly-varnished image of Soviet society: as Aleksandr Kamenski acutely suggests in his essay, the degree of naturalistic detail and verisimilitude was in inverse proportion to the truth of the pictures as a whole. Soviet art history became even more firmly entrenched in chauvinist isolation and the exclusion of the modernist protocols which held sway in the West.

An important Party aim in the 1940s and 1950s was to establish a unified cultural pattern for all the nations and ethnic groups of the Soviet Union. Official histories of the art of the Soviet republics were compiled (the most comprehensive was a sixteen-volume boxed set of albums, with two volumes devoted to Russia, published by Sovetski Khudozhnik in 1957), stressing that Soviet art could only have a limited range of expression and emphasising the supreme importance of Russian traditions for all the republics.

The Khrushchev 'thaw' led to a slight shift in perspective. Foreign movements remained critically taboo – witness N. A. Livshits' and

L. Reigardt's *Krizis bezobraziya* (The Crisis of Ugliness) published in Moscow in 1968 – but indigenous traditions were given a new airing. Icon painting, naive serf-painting, forgotten figurative artists and movements of the 1910s and 1920s, were all somewhat grudgingly admitted during the 1960s into the pantheon of Socialist Realism as honourable forebears. V. Zimenko's book *Gumanizm Iskusstva* (*The Humanism of Art*), published in Russian in 1976 and in English afterwards, was an attempt to make sense of the new broad base of influences officially permitted to Soviet artists while still retaining the slogans of Socialist Realism as a basis.

The books mentioned above are only a few examples of the anti-Western, pro-Socialist Realist art history that was produced under the watchful eye of the Party in the period up to the early 1980s. In one sense these works and others like them constitute a melancholy archive of an ideology emasculated by history. But in another sense these books are valuable insofar as they reveal the thinking of artists and critics – the mind-set of official culture – in the Soviet Union in the period of the Cold War.

The degree of emphasis and selectivity that has pervaded Western writing about Soviet art is perhaps not so obvious, and has certainly not been so remarked upon as its Soviet counterpart. Western writing has had its own ideological agenda, its own tendency to gloss over and mis-represent aspects of Soviet art. It has not cared to look seriously at those aspects of Soviet painting and sculpture which it could not accomodate within paradigms of modernism, internationalism and the avant-gardism. The American writer Louis Lozowick's *Modern Russian Art* of 1925 was based largely upon his perception of an exhibition entitled the 'Erste Russische Kunstausstellung', held in 1922 at the Van Diemen Gallery in Berlin, as well as by visits to Moscow in 1923-4. Although the Berlin show was eclectic and stylistically mixed, Lozowick's writing concentrated on its abstract and modernist content. Lozowick's preferences were echoed by Alfred H. Barr, who developed a strong interest in Russian avant-garde art and who was one of the first art historians to visit Russia and report on what he saw. In his widely read *Cubism and Abstract Art* of 1936, the title of both an exhibition at the Museum of Modern Art in New York and a book, he proposed that Cubism 'led to' Suprematism and Constructivism which in turn 'led to' geometric abstract art: thus Russian and Soviet 'move-ments' became fixed in a teleological scheme which helped generate West-ern modernist styles. Other early publications, such as René Fülöp-Miller's *The Mind and Face of Bolshevism* of 1927 and Kurt London's *The Seven Soviet Arts* of 1937 occupied a less prescriptive position, arguing that Soviet art, theatre, literature and music were undergoing fascinating changes, but that, to take the case of London's book, the state was begin-ning to impinge in dangerous and damaging ways. Although they had far greater scope than Barr's analysis, and demonstrated a greater understanding

of Soviet society, they were almost certainly less widely read. The view implicit in Barr – that Suprematism and Constructivism were the last Russian or Soviet art movements of any significance – became general currency in the West.

The relative even-handedness of Fülöp-Miller and London gave way to a frankly pro-Soviet line in a number of publications of the 1930s and 1940s. The special *Studio* number for 1935, *Art in the USSR*, though published in London, was largely written by Soviet authors and achieved a propaganda coup for an art that was, to use Stalin's words, 'national in form, socialist in content' and carefully supervised by a Party that described itself as the 'leading edge' (avant-garde) of society. Cyril Bunt's *Russian Art from the Scythes to the Soviets* and George K. Loukowski's *History of Modern Russian Painting 1840-1940*, both published in 1945, also took a positive view of cultural developments in the USSR, apparently unaware of the coercions and restrictions upon which they rested. The latter two books perhaps took their tone from the spirit of co-operation with the Soviet Union engendered by the Second World War.

The ideological realignment which took place during the Cold War put an end to any lingering thought of reconciliation between the USSR and the West. Views on art polarised. As the Soviets plumped for craft, legibility, accessibility and dogmatic adherence to 'tradition' in the form of academic realism, several critics in the West (and the artists who followed them) began to elevate abstraction and existentialism as immanent conditions of modern life and culture. Individualism and 'expression' flourished in the West; Socialist Realism remained the prerogative and tradition of the Soviets. As rhetoric and distrust accumulated, art took on the appearance of a pawn in a political and ideological struggle for supremacy. Just as the KGB chose its Stalin-prize winners and Socialist Realist artist-emissaries with care, there can be little doubt that CIA-sponsored agencies in the West took an active role in encouraging and promoting abstract and 'individualistic' art.

In reviewing the English-language literature of the Cold War, special mention must be made of the influential and widely read book by Camilla Gray, *The Great Experiment: Russian Art 1863-1922*, first published in London in 1962. Though the book did much to publicise the achievements of the Russian and Soviet avant-garde both before and after 1917, one of its important limitations was that it ended in the year 1922, as if the avant-garde represented the apogee of Russian and Soviet revolutionary culture. And yet historically 1922 was the very year in which the avant-garde or 'left' groups began to feel the winds of change, and in which Soviet painting and sculpture began to diversify into many groups, affiliations and styles. Artistic societies such as *OSt*, Four Arts, *NOZh*, *Makovets* and *Bytie*, as well as the polarised groups *LEF* and *AKhRR*, remained beyond

7

the scope of Gray's analysis. Herself taught by Alfred H. Barr, Gray was unable or unwilling to explore the artistic debates in the period leading up to Socialist Realism, even though their outcome was to determine the course of Soviet art over many years.

Guided by what might be termed the Lozowick-Barr-Gray paradigm, English-language studies of Russian and Soviet art published in the quarter century between 1960 and 1985 continued to be dominated by an almost exclusive interest in the abstract and avant-garde art of the teens and twenties. Publications such as John Bowlt's edition of documents *Russian Art of the Avant-Garde: Theory and Criticism 1902-1934* (1976), Susan Compton's *The World Backwards: Russian Futurist Books 1912-1916* (1978), and Christina Lodder's meticulous *Russian Constructivism* (1983) may be cited in this context.

In the West from the 1960s onwards a multitude of exhibitions and publications relating to October 1917, and the subsequent avant-garde hegemony, appeared. One can adduce specific reasons for this which indeed sometimes seem at odds with the *zeitgeist* of the Cold War. One was a surge of political sympathy for the Revolution of 1917 which arose out of the events leading up to the demonstrations of May 1968; it was important to many intellectuals to demonstrate the possibility of a link between art and revolutionary consciousness, however defined. Another more pragmatic concern among contemporary artists and dealers was to provide a pedigree for hard-edge abstract art, one of the main 'international' painting and sculpture styles of the 1960s and 1970s. One effect of this essentially Western style was to further discredit Soviet culture by the propagation of images of 'freedom' and 'modernity' in the home camp.

Only a minority of English-language publications, such as C. Vaughan James's *Soviet Socialist Realism: Origins and Theory* of 1973 and Elizabeth Valkenier's *Russian Realist Art: The Peredvizhniki and Their Tradition* of 1977 attempted to come to terms with the dominant aesthetic and cultural traditions of the Soviet state during most of its existence. The atmosphere of the Cold War and the discourses integral to it ensured that most of the art being produced in the Soviet Union remained comprehensively ignored. The Khrushchev 'thaw' had provided a temporary respite from the establishment Western view: a survey show of Russian and Soviet art, including some Socialist Realist paintings, was exhibited at the Royal Academy in 1959; and the London dealer, Eric Estorick, mounted shows of contemporary Soviet figurative art in New York and London in the early 1960s. But the Soviet art given most attention in the West was that which promoted a 'dissident' political stance. The travails of Ernst Neizvestny excited several Western intellectuals in the sixties; while the bulldozing of an outdoor exhibition by Soviet artists in Moscow in

1974 caused an international outcry and inspired an exhibition of Soviet underground art at the Institute of Contemporary Arts in London in 1977. However, the attempt to assert the existence of Western-style cultural values in the Soviet Union was something of a damp squib. Few Western commentators found the art itself compelling, while the vast majority of collectors and dealers, with the exception of the American Norton Dodge and the German Peter Ludwig, failed to develop any long-standing interest in contemporary developments behind the iron curtain. Western museums positively shunned them. If we add to this the long-standing political and economic isolation of the Soviet Union, it is fair to say that, by the time Mikhail Gorbachev came to power in 1985, Western audiences remained broadly ignorant of Soviet visual culture after the hey-day of the Russian avant-garde.

Gorbachev's appointment as General Secretary of the Soviet Communist Party heralded significant changes in the field of culture and the arts. In the Soviet Union, museum officials began to treat their collections with a measure of *glasnost* or openness, and no longer feared the consequences of exhibiting works by the avant-garde. The George Costakis collection of avant-garde art was rehabilitated and put on display in the Tretyakov Gallery in 1986 and Costakis himself was invited back to Russia as an honoured guest. Western scholars were admitted to much hitherto unseen material. Interestingly, both Soviet and Western interest grew not only in the once-prohibited avant-garde but also in the character of Soviet realism and figurative easel painting generally.

This juncture, the mid-1980s, coincided with another development. For a number of reasons Western artists and audiences began to grow weary of abstraction and returned once more to the figure, and to oil painting. This tendency in turn inspired a debate about 'post-modernist' art in which revivalist and appropriative aesthetics implied a more open attitude to neglected corners of the art historical past. Simultaneously, in many branches of Western culture reassessments began to be made of the social and intellectual paradigms associated with 1968.

One indirect result of this new intellectual atmosphere has been the appearance of a number of books in English looking at the art of the Soviet past, and Socialist Realism in particular, with a new interest and lack of prejudice: David Elliott's *New Worlds: Russian Art and Society 1900-1937* (1986); Margarita Tupitsyn's *Margins of Soviet Art* (1989); Igor Golomstock's *Totalitarian Art* (1990); Matthew Cullerne Bown's *Art Under Stalin*, Christine Lindey's *Art in the Cold War* and a volume of essays edited by Hans Günther, *The Culture of the Stalin Era* (all of 1991); and the two parts of Brandon Taylor's *Art and Literature Under the Bolsheviks* (1991 and 1992). The pioneering study *Stalinist Architecture* by Aleksei Tarkhanov and Sergei Kavtoradze also made its appearance in 1992.

9

Among the recent foreign-language literature it is important to mention Boris Groys's *Gesamtkunstwerk Stalin* (1988), Viktor Paperny's trend-setting study of Stalinist architecture *Kultura Dva* of 1985, and the volume of essays edited by Vladimir Berelovich and Laurent Gervereau *Russie URSS 1914-1991: Changement de Regards* (1991).

Over the same period, a number of important exhibitions have been mounted by the Tretyakov Gallery and the Russian Museum which have provided Western audiences with a glimpse of much previously unseen material from the 1920s and 1930s – and this is perhaps still only part of the story.[1]

However important the problems of its periodisation, and the evolution of its historiography, there is, in our view, one central feature of Soviet culture which requires brief discussion in this introduction. Socialist Realism was for many decades the cornerstone of art practice and debate in the Soviet Union. It represented the official line in culture from 1934 up to the late 1980s, and no artist who practised in that period could remain unaffected by its dogmas. Socialist Realism did not, however, constitute a single unvarying doctrine and as several of our chapters point out, never really constituted an exceptionless or monolithic style. The very complexity of this doctrine particularly in relation to concepts of the 'modern' deserves extensive rexamination in the West.

Two characteristics of Socialist Realism, its political tendentiousness and its subservience to the state, have parallels in Russian art and culture before the 1917 revolution. Consider the socially-committed work of the *peredvizhniki*, or, as evidence of the Russian artist's traditional subservience, the tight leash on which the Tsars kept Russian painters even in Rome. The icon-painting tradition, which preceded the development of academicism and realism in Russia and flourished there long after Renaissance humanism had revolutionised art in Europe, epitomises the Russian artist's traditional lack of freedom in contrast to his Western European counterparts. An acknowledgement and analysis of the rootedness of Socialist Realism in the traditions of Russian thought and art-practice has been notably absent from two significant recent publications on Socialist Realism by Russian emigré authors, *Totalitarian Art* by Igor Golomstock and *Gesamtkunstwerk Stalin* by Boris Groys.

It is not our intention in this introduction to provide a potted history of Socialist Realism, but we would argue that it existed in embryo from the earliest months of the Revolution. As Groys has pointed out, the utopian striving of the avant-garde was ultimately appropriated for the Socialist Realist project. But apart from a climate of radical ideas, there were plenty of concrete events which signposted the way towards it: Lenin's Plan for Monumental Propaganda (1918); the prize awarded to Brodski's portrait of Lenin (1919); the official attack on the *proletkults* (1920); the move by

avant-gardists away from fine art and into consumer-goods production and design, and the emigration of many leading avant-gardists (1920 onwards); the founding of the realists' group, *AKhRR* (1922); the Lenin Corner organised by *AKhRR* at the Agricultural Exhibition (1923); the blending of ancient, modern and traditional Russian in Lenin's mausoleum (1924 and later); the resolution 'On the Party's Policy for Imaginative Literature' (1925) and so on.

By 1928, when it received official permission to open branches country-wide and mounted the exhibition dedicated to the Red Army in the newly-built Central Telegraph Office in Moscow, *AKhRR* had established itself as the dominant force in the Soviet art world. The work of *AKhRR* artists was, more than that of any other group, the forerunner of Socialist Realism. But there was one further stormy period for Soviet art and society to negotiate before the dubious certainties of the 1930s were arrived at. This was the so-called Class War of 1928–32, when Stalin launched the collectivisation of agriculture and the First Five-Year Plan, and art-world debate achieved a new level of intolerance. The vicious polemics of the period, involving *AKhRR*, its rapid offshoot *RAPKh* and avant-garde groupings such as *Oktyabr*, had the effect (whether or not this was envisaged by Stalin and his colleagues) of breaking down any cohesion or sense of common purpose in the art world. When, in 1932, the Central Committee issued its decree 'On the Reconstruction of Literary and Artistic Organisations', which led to the formation of artists' unions to replace the variety of artists' groups, the decision was greeted with considerable relief by many artists who had been wearied by years of squabbling. The Moscow union, dominated by former *AKhRR* members, became the most influential art organisation in the USSR.

Socialist Realism itself followed soon after, proclaimed at the 1934 Writers' Congress in Moscow as the official method in all the arts. Ever since, it has generated enormous misgivings in the West. It has been decried as neither socialist nor realist; it has been identified with the worst excesses of Stalinism, characterised as repressive, philistine, servile, conservative and devoid of artistic or historical significance. But although it was a movement with depressing and sinister ramifications, it was also one of some intellectual and historical resources. It had an intellectual pedigree in the writings of Belinski, Chernyshevski and Dobrolyubov, Engels, Marx and Lenin; and it had a solid practical foundation in the tradition of Russian realist painting, a tradition which proved quite robust enough to survive the hostility it met from the avant-garde in the 1910s and 1920s. It did not develop in absolute quarantine: one could argue that it partook of the international trend towards classicism and figuration that emerged after the First World War. And if one considers the whole gamut of its development, from the prototypical works of the late 1920s through

11

the academicism of the late 1940s to the Severe Style of the late 1950s and early 1960s (Cover Plate), and also the wide range of stylistic variation in the non-Russian republics, it is clear that Socialist Realism was by no means as rigid or monolithic a method as its detractors have suggested.

This book takes seriously the idea that 'official' Soviet culture, though by no means unproblematic, deserves and requires scholarly examination on a par with that conventionally accorded to the Russian avant-garde. Christina Lodder's chapter on 'Lenin's Plan for Monumental Propaganda' examines his scheme for replacing the old Tsarist statues with those to socialist heroes – an early instance of official support for figurative art that nevertheless suffered from being poorly carried out. As Lodder points out, it is still very much an open question whether this early scheme encouraged the tendency of later Soviet sculpture in the monumental direction, or whether this would have happened anyway.

It seems no accident that much early propaganda – including Lenin's Plan – focused upon the body. As Toby Clark points out in his chapter on the 'new man' in early Soviet culture, it was precisely the body of the Soviet citizen that was a central site of ideological debate from the early years of the Revolution until the 1930s. Concepts of work, fitness, function and citizenship were all expressed through images of the body. Clark shows how in the 1920s the body was linked to ideas of science and efficiency and how in the 1930s this emphasis shifted to images of stamina, strength, and ultimately loyalty to the working class and to the Party.

Brandon Taylor's chapter 'On *AKhRR*' examines the Association of Artists of Revolutionary Russia, a grouping that became dominant in Soviet cultural politics in the 1920s, largely because it gained the support of Party ideologues who wished to denigrate the avant-garde and 'left' artists and elevate what they believed was a purely national and documentary method. The nature of this group's rhetoric, the question of its support within the Party, and its attitude to Russian traditions, to 'realism' and to photography, all foreshadowed developments in Soviet art in the 1930s and 1940s.

Catherine Cooke points out in her chapter on 'Socialist Realist Architecture: Theory and Practice' that Socialist Realism was never described by Soviet critics as a style. It was always invoked as a method, an approach, and one which postulated a far more complex relationship with tradition than is usually allowed. What we begin to appreciate in the case of the prestigious architectural competitions of the 1930s – such as that for the never-realised Palace of the Soviets in Moscow – is the close interweaving of dynamic aesthetic theory with the constraints of official cultural management: one of the dialectical bulwarks of Soviet culture.

Architecture has frequently functioned as an expression of state policy. As Sarah Wilson explains in her chapter 'The Soviet Pavilion in Paris', the critical reception accorded to this symbol of Soviet aspiration abroad was highly mixed, since it was erected at the time of the Moscow show trials, about which intellectuals in France and elsewhere were split into the two camps of the credulous and the horrified.

Wolfgang Holz's study of meaning in a number of classic works of Socialist Realism analyses the kinds of allegorical and iconographical systems employed by Soviet artists in the mid-thirties. What is remarkable is the artists' conscription of the most recent events (new buildings, cars, fashions) into a semantic system which, despite the novelty of its elements, was intended to be universally understood. The implication of such an analysis is that Socialist Realism was an art of a mythologising or folkloric bent, one requiring the widest anthropological perspective.

The culture of the Stalin period gets two contrasting analyses. In the first of Matthew Cullerne Bown's two chapters he charts the career of one of the most vilified men in Soviet art history, Aleksandr Gerasimov, from his humble country origins through his arrogant rule of the Soviet art world in the 1930s and 1940s to his relegation and decline under Khrushchev. Gerasimov's career is not only an object-lesson in the brittleness and vanity of power; it also provides a window on the internecine conflicts in the Russian and Soviet art world from the 1900s to the 1950s. Cullerne Bown's second chapter, 'Painting in the non-Russian Republics', shows how pressure to conform to the demands of Socialist Realism caused artists to strike various compromises between modernism, indigenous tradition and imposed Russian practices. Here were the makings of debilitating tensions between the republics and Moscow, whose sad legacy is apparent today.

It was at the time when Gerasimov was at the peak of his power that Aleksandr Kamenski, as a young critic, was making his mark in the Soviet art world. He was one of a number of critics hounded in Stalin's anti-cosmopolitanism campaign. His chapter 'Art in the Twilight of Totalitarianism' is both an analysis and a passionate denunciation of the decadence, iniquity and corruption which he experienced at first hand. It also demonstrates something of the rhetorical, socially-engaged style of Soviet art-writing, in a field where ethics, criticism and history can be made to merge and where facts go hand in hand with feelings.

The Khrushchev and Brezhnev eras are perhaps the most neglected in current writing about Soviet art. Susan Reid's pioneering study of the theme of memory in the art of the 1970s is one of the first Western attempts to penetrate beyond the facts and surfaces of paintings into the very psychology of the era. We learn how varied and nuanced were the positions negotiated by artists at a time when it first became possible to make

13

criticisms of the *status quo* in the art shown at official exhibitions.

A colourful figure in the grey decades of the 1960s and 1970s was the painter and self-publicist Ilya Glazunov. Aleksandr Sidorov's tale of Glazunov's career throws into focus the bad faith of an era when *apparatchiks* preached the old Party values but secretly pined for, and often enjoyed, something else entirely. Glazunov is in some ways a remarkably contemporary figure in Soviet artistic life: for many he still stands as a positive symbol of 'Russianness' in the arts; but for others he typifies the worst kind of careerism.

The Gorbachev era saw the public emergence of art that had previously been ignored, condemned or persecuted by officialdom; while simultaneously the status of 'official' art inevitably declined. Aleksandr Borofski's survey 'Non-Conformist Art in Leningrad' looks at the diversity of artistic experiment in the northern city from the 1950s to the present day, against the background of the prohibitions and restrictions inherited from Stalin.

Finally, Aleksandr Yakimovich, in his chapter on the conceptual complexities of what he calls 'independent' culture, emphasises the paradoxes and the existential confusions prevalent among artists and their audiences. The picture he draws is of a culture and a society traumatised by years of heavy-handed control; of a people stunned into perplexity and mental apathy who are yet groping their way back to reliable moral and ethical values and autonomous cultural behaviour. Now, amidst the political undertainties of the present, it is precisely freedom from politics that artists in the former Soviet Union are trying to achieve.

We would like to thank all those who have contributed illustrations, the appropriate permissions for which have been sought, and which are recorded in the picture captions where requested.

The transliteration of Russian words and names follows the convention of rendering и and й as i, and ы as y, with hard and soft signs elided. We have usually ignored the final й in names, unless they form part of a book or other title. This system has been adhered to fairly rigidly, giving us some unconvential spellings, e.g. Trotski for Trotsky and Benua for Benois.

Notes

1 Exhibitions outside the former USSR include *Kunst Und Revolution/Art and Revolution*, at the Mucsarnok in Budapest and the Austrian Museum for Applied Arts in Vienna, 1988; *Russian and Soviet Paintings, 1900-1930*, Washington 1988; *100 Years of Russian Art: 1889-1989 From Private Collections in the USSR*, London 1989; *Tradition and Revolution in Russian Art*, Manchester 1990; *Soviet Socialist Realist Painting, 1930s-1960s*, Oxford 1992.

2 For a discussion of these decrees see B. Taylor, *Art and Literature Under the Bolsheviks*, I, Pluto Press, London 1991, and II, 1992.

3 For the 1932 Decision see C. Vaughan James, *Soviet Socialist Realism: Origins and Theory*, Macmillan, Basingstoke 1973, p 120; J. Bowlt, *Russian Art of the Avant-Garde: Theory and Criticism 1902-1934*, Thames and Hudson 1988 edition, p 288, and the discussion in Taylor, *op. cit.*, II.

4 *Soviet Writers' Congress 1934: The Debate on Socialist Realism and Modernism in the Soviet Union*, London 1977, pp 156-7.

Christina Lodder

1

Lenin's Plan
for Monumental Propaganda

The relationship between a work of art and the social and political situation within which it is produced is invariably complex and difficult to reduce to a simple formula. In the conception and execution of Lenin's Plan for Monumental Propaganda, enunciated and implemented in April 1918, there apparently existed a direct relationship between Lenin's ideas and the work of the artists involved on the project. However, the assumptions usually made about the Plan leave certain aspects obscure, and further scrutiny reveals complexities which prevent the reduction of the relationship to a neat equation. The problem as it emerges is not one-dimensional but multi-dimensional.

In the writings of Soviet and Western art historians, Lenin's Plan For Monumental Propaganda has usually been depicted as immensely important for the evolution of a specifically political relationship between Soviet art and the Soviet Government, because for the first time art was directly harnessed to the service of the state and its ideology. This, it is argued, had directly artistic implications for the development of a style which could readily be adapted to the state's requirements. Consequently, the Plan for Monumental Propaganda has been interpreted as an important artistic and political step in the evolution of Socialist Realism, both as an artistic style and as a government policy.[1] John Bowlt, for instance, asserts that

> The formation and development of the so-called monumental style in Soviet sculpture, architecture and painting arose very much as a direct result of government attitudes and policies immediately after the Russian Revolution of 1917 and, in the case of sculpture, virtually owed their existence to Lenin's resonant call in April 1918 for a programme of monumental propaganda.[2]

It is also often asserted that in artistic terms the products of the Plan could generally be characterised as restrained modernism, a greater or lesser flirtation with Cubism and abstract sculpture which resulted in a muted geometricisation of a figurative content, exemplifed by Zalit's *Monument to Garibaldi* of 1919 or Matveev's *Monument to Karl Marx* of 1918 (Figure 1.1). These types of statue necessarily represented a modification of the traditional modes of monumental representation evident in Tsarist commemorative statues, such as Orlovski's *Kutuzov* in classical garb and pose, of 1837. The fusion or confusion of the two eventually produced

during the 1920s, and especially during the 1930s, a style of monumental sculpture which was recognisably Socialist Realist. The hallmark of Socialist Realism in sculpture is an essential descriptiveness which is reliant for its impact on a stark monumentality combined with a degree of simplification of the figure, and an idealisation of its facial and physical features in accordance with the 'heroic' qualities of socialist man. Typical of this style during the 1930s was Iofan and Gelfreikh's projected but never

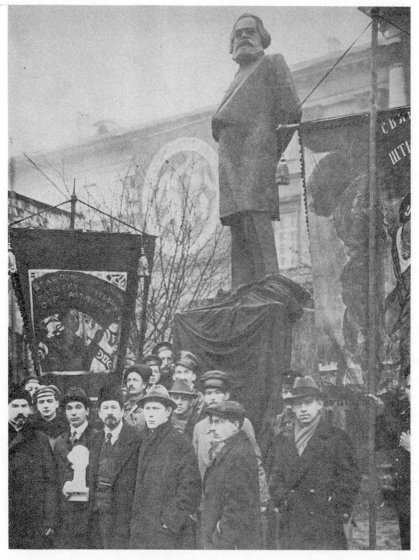

1.1 The unveiling of Aleksandr Matveev's *Monument to Karl Marx*, 7 November 1918, in front of the Smolny Institute

realised, gigantic statue of Lenin for the equally enormous Palace of the Soviets competition design. This can be clearly in Borodai's *Monument to the Chekisty* of 1967. Such images, it is argued, evidently trace their lineage back to 1918.

Nevertheless, while the general outlines of this interpretation may be acceptable, to see the Plan totally and rigidly within these parameters would be to underestimate its overall complexity, and to ignore certain of its vital features. In the first place, this interpretation imposes a greater theoretical uniformity and stylistic unity on the works of art produced than they in fact possess. The presence of a greater stylistic variety among the projects makes the line of development rather less straightforward. For instance it is not generally known that Tatlin's *Monument to the Third International* was originally conceived and produced as part of the Plan. Secondly, the traditionally accepted argument, outlined above, under-values the utopian aspects of the Plan both in its conception by Lenin (during what could be termed the initial, optimistic phase of the Revolution), and in certain of the resulting projects. Thirdly, in under-valuing the utopian nature of the Plan this traditional approach also ignores the idea that the project most illustrative of this utopian impulse was Tatlin's Tower, which was dedicated to the Third International later, in 1920. In pursuing these ideas, it seems appropriate to begin with the inauguration of the Plan itself.

The Plan for Monumental Propaganda was a component of those schemes which Lenin set in motion after the Peace of Brest-Litovsk, prior to the full-scale mobilisation of all resources to fight the Allied intervention and the Civil War. It should perhaps be viewed in conjunction with Lenin's other works which formed a part of his policy for the building of socialism in Russia.

In this context, it should be stressed that the Plan for Monumental Propaganda pre-dated rather than post-dated many of the widely proclaimed manifestations of agitational art in the mass festivals, posters, agit-trains and agit-ships which formed an essential component of the Bolshevik war effort. The planning of festivals was brought under *IZO*'s (the Department of Fine Arts) control in April 1919.[3] The first agit-train became mobile in August 1918[4] and the *Red Star* agit-ship travelled the Volga disseminating propaganda in 1919.[5] Altman's decorations for Uritski Square in Petrograd were executed for the first anniversary of the October Revolution and Lisitski's poster *Beat the Whites with the Red Wedge* was distributed in 1920. This suggests that in the Plan for Monumental Propaganda Lenin was not bringing existing phenomena under centralised control but rather that he was to a certain extent creating a basis for the development of such phenomena, their encouragement, and their harnessing to political objectives. In other words, Lenin was not pragmatically

exploiting an existing phenomenon in 1918 but making an imaginative and visionary leap by realising the potential of visual propaganda.

Lenin is traditionally acknowledged to have been the author of the Plan for Monumental Propaganda and it is usually referred to as Lenin's Plan. In 1933 Igor Grabar recalled how Lunacharski had announced to a meeting of artists and sculptors sometime during the winter of 1917-18:

> I've just come from Vladimir Ilich. Once again he has had one of those fortunate and profoundly exciting ideas with which he has so often shocked and delighted us. He intends to decorate Moscow's squares with stsatues and monuments to revolutionaries and the great fighters for socialism. This provides both agitation for socialism and a wise field for the display of our sculptural talents.[6]

According to Lunarcharski's evidence, Lenin presented the Plan to him with the words 'For a long time I have cherished the idea which I now lay before you'.[7] Certainly when Lunacharski presented the Plan to *SovNarKom*, and when he unveiled the *Monument to Radishchev* in Petrograd on 22 November 1918, he stressed Lenin's initiative in conceiving and implementing the Plan.[8] Reported in the press, such statements could have been refuted by Lenin had he wished. Lenin's ostensible acquiescence suggests that either he considered it too minor a matter to contest or that he was willing to give the Plan the power with which his name would endow it, or, of course, that he really was the author of the Plan. Lenin's constant surveillance of, and involvment in, the progress of the project, although removed from its day-to-day administration, was fairly extensive and tends to confirm Lunacharski's statements. There are records of Lenin's frequent exhortations to more activity, and demands for information. For instance, between 1 and 13 May 1918, he explored the possibility of using the unemployed to remove Tsarist monuments.[9] Lenin's impatience with the progress of the Plan by 13 May 1918 resulted in a telegram of complaint to Lunacharski: 'I am surprised and indignant at your inactivity.'[10] Moreover, on 15 June he asked for immediate information on the progress of the Plan concerning the removal of old monuments, and the replacement of citations on buildings because it was important 'from the point of view of propaganda and from the point of view of occupying the unemployed'.[11] Lenin considered the work of the Plan sufficiently urgent and important to release art workers from other schemes to concentrate on the 'state's artistic work in connection with the erection of agitational monuments, the October festivities, etc'.[12]

Trotski throws an interesting light on the political reasons and perspectives underlying the concern and urgency expressed by Lenin.

> In the squares of Soviet cities we are erecting monuments to our great men, the leaders of socialism. We are sure that these works of art will be dear to the

hearts of every worker and the entire mass of the people. Along with this, we must say to every one of them in Moscow, Petrograd and in the most out-of-the-way places: 'See, the Soviet power has put up a monument to Lassalle. Lassalle is dear to you but if the bourgeois breaks through the front and comes here, he will sweep away that monument, together with the Soviet power and all the achievements that we have now won. That means that all workers, all to whom the Soviet power is dear, must defend it in arms.'[13]

Lenin's involvement in and identification with the Plan was expressed not only at the executive but also at the practical level. Later, when the monuments were unveiled, he personally participated in the ceremonies. For instance, in Moscow on 7 November 1918 he unveiled both a memorial plaque to those fallen in the fight for peace and the brotherhood of man and a monument to Marx and Engels. On 1 May 1919 Lenin unveiled the temporary monument to Stepan Razin in Moscow and on 19 June 1920, when the Second Congress of the Comintern met in Petrograd, Lenin addressed a mass meeting and laid the foundations for monuments to Karl Liebknecht and Rosa Luxemburg on Uritski Square.[14]

The decree embodying the Plan For Monumental Propaganda was presented to *SovNarKom* on 9 April, accepted on 12 April, signed by Lenin on 13 April and printed in *Izvestiya* and *Pravda* on 14 April under the title 'The Removal of Monuments Erected in Honour of the Tsars and their Servants and the Production of Projects for Monuments to the Russian Socialist Revolution'.[15] Known also by the short title of 'Concerning the Monuments of the Republic', the decree consisted essentially of two parts: the demolition of Tsarist monuments and their replacement with 'monuments to outstanding persons in the field of revolutionary and social activity, philosophy, literature, science and art'.[16] Lenin was also anxious that some of the Plan should be achieved for 1 May and that the city should be suitably decorated for the Revolutionary festival with banners and inscriptions 'reflecting the ideas and feelings of the working class of revolutionary Russia'.[17]

By August, a list of sixty-six distinguished figures deemed worthy of sculptural attention had been drawn up and was published on 2 August 1918 in *Izvestiya VTsIK*. This list was divided into six groups, the largest of which, the 'revolutionaries and social activisits', consisted of thirty-one foreign and Russian names, including Marx, Engels, Spartacus, Lassalle, Danton, Robespierre and Robert Owen. The other groups represented writers and poets (twenty named, including Tolstoi, Dostoevski, Uspenski and Shevchenko); philosophers and scholars (three, including Lomonosov); artists (seven, including Vrubel and Rublev); composers (three – Musorgski, Skriabin and Chopin); and performers (two).[18] This list was surprisingly wide-ranging, both geographically and ideologically, yet it had been subject to Lenin's scrutiny, was signed by him, and can therefore

be assumed to have had his approval. An accompanying decree also signed by Lenin had asserted the primary importance of Marx and Engels, but had added foreign cultural figures such as Heine, and the dead heroes of October. Lenin had only exluded specifically in this decree Solovev, also popular with the Russian intelligentsia.[19] Lunacharski also declared precedence for Radishchev, Ryleev, Pestel, Belinski, Chernyshevski and Nekrasov.[20] Moreover, by the end of August other figures such as Liebknecht had been added. Yet despite these additions and subtractions, the list of names which emerged could not in any way be called restrictive, for it included figures 'who although they did not have a direct relationship to socialism, appeared to be genuine heroes of culture'.[21]

This display of cultural liberalism on the part of the emergent Bolshevik state may have been calculated to present a contrast to the repressive Tsarist regime which had forbidden, for instance, the erection of statues to Shevchenko, Tolstoi and Chopin (despite the face that the latter two statues were complete and ready to be erected.[22] Although this undoubtedly had propaganda value, especially among the wavering intelligentsia and the educated working class, the inclusion of a wide range of cultural and political figures such as Uspenski, Plekhanov and Bakunin, with ideas and philosophies antagonistic to Bolshevism, perhaps indicates rather that the Plan was not solely intended to serve narrow, specifically political objectives, but in addition, to serve wider general educational aims. In Lunacharski's words, the monuments, to be set up 'in suitable corners of the capaital', were to 'serve the aim of extensive propaganda, rather than the aim of immortalisation'.[23] They were to be made of cheap, temporary materials such as plaster and terracotta, although later it was hoped to replace them in more permanent materials. Primary consideration was to be given to 'the quantity and expressive qualities of these monuments'. In addition, it was planned to have ceremonial unveilings of the monuments. These were timed for Sundays to ensure maximum attendance, and possibly to provide a more ideologically sound alternative to traditional religious observance. They were to be accompanied by speeches, explanations and music to make the ceremonies 'an act of propaganda and a small festival'. The educational nature of the monuments by the provision of short biographies affixed to the pedestal and the publication of brochures.[24]

This direct harnessing of art to the educational needs of the masses in the construction of the new socialist society undoubtedly reflects not only a pragmatic solution to political education in 1918 but also a utopian element, present in Lenin's pre-Revolutionary thought and vision of the new society: 'there will come a time… when the liberated people will rush into science, knowledge, literature, art and architecture, and will show the world the wonder of new achievements in every kind of field'.[25] The **21**

utopian element in Lenin's conception of the Plan for Monumental Propaganda is reinforced by the evidence of Lunacharski, who recorded that Lenin cited Campanella and his utopian work *The City of the Sun*.[26] From Lunacharski's account it seems that the Italian Renaissance thinker's ideas provided the direct inspiration for Lenin's Plan for Monumental Propaganda:

> Campanella in his *City of the Sun* says that the walls of his fantastic socialist city are covered with frescoes which, serving the youth as a graphic lesson in natural science and history, arouse civil feelings and, in a word, participate in the business of raising and educating the new generation. It seems to me that this, far from being naive and with certain changes, could be adopted by us and put into operation now... I have called what I am thinking of "monumental propaganda".[27]

Although, acording to Lunacharski, Lenin recognised that 'our climate hardly allows for the frescoes of which Campanella dreamed'[28] and thus replaced frescoes with statues, the educational emphasis in Lenin's Plan and his inclusion of plaques with slogans and citations, to be displayed on the walls of the city, confirms the similarity of the ideas.[29]

The combination of statues, plaques affixed to buildings, festive unveilings and music, suggests that the Plan for Monumental Propaganda advocated and embodied an idea of a synthesis of the arts of painting, architecture, sculpture and music on the streets of the city: a synthesis which was developed further in the revolutionary festivals. This could be interpreted as a first step towards that fusion of art and life which Marx had envisaged in *The German Ideology*. This utopian element had been present in Lenin's *State and Revolution*, and the idea of fusion was current in avant-garde artistic circles at the time Lunacharski gave expression to it in his speech at the opening of the State Free Studios in October 1918: 'To link art with life – this is the task of the new art'.[30]

The conditions under which the monuments were produced equally reflected the utopian impulse. The sculptors were given 'complete freedom to express the idea of a monument in the form of a bust, a figure or a bas relief'.[31] There was no jury. The public itself was to choose which monuments should be transformed into more permanent materials.[32] To encourage 'fresh, young talent',[33] the programme and associated competition were open to all and once a project was accepted the sculptor was given an advance (half of the 7,000 roubles allocated to each monument). Completed statues were to be submitted actual size (no less than 5 arshins or 11 feet 8 inches) and they were to be placed *in situ* within three months of a sculptor receiving his advance.[34] 560,000 roubles were allocated to the project. Lunacharsky (as head of *NarKomPros* – the Commissariat of Enlightenment) and *IZO* were in charge of the Plan but in Moscow the entire practical organisation of the matter was left to the Sculptors' Union.

In Moscow 186,000 roubles as down-payments on sixty-two statues were given to the Union. Despite their promise to have all these statues ready for the first anniversary of October, only twelve had been erected by then.[35] Consequently, executive power for the Plan was returned to *IZO*. But *IZO* was no more successful because many of the delays were due to acute material shortages.[36] Indeed in Petrograd, where *IZO* retained control of the Plan, it was no more effective. Only nine monuments had been erected by the anniversary of the Revolution, including Matveev's monument to Karl Marx which was unveiled on the day itself, although 280,000 roubles had been spent on 40 statues.[37]

Thus, initially, the Plan for Monumental Propaganda was more effective in removing Tsarist monuments than in erecting revolutionary ones. In Moscow on the eve of May Day 1918 the statue of General Skobelov was removed under the supervision of the sculptors Babichev and Korolev, and on May Day itself the statue of St Romanov was demolished. Construction was much slower. Some monuments were not destroyed, but adapted. An Imperial obelisk in Petrograd was transformed into a revolutionary monument in 1918 by the addition of revolutionaries' names engraved upon it. Headed by Mark and Engels, these included in descending order Campanella, Winstanley, Thomas Moore, Saint Simon, Proudhon, Bakunin, and ended with Plekhanov.[38] To promote production *IZO* organised various competitions for specific monuments to the fighter heroes who died during the German attack on Pskov, for monuments to Karl Liebknecht and Rosa Luxemburg, and to Sverdlov.[39]

The first monument under the Plan was erected in Petrograd on 22 September 1918. Dedicated to, and depicting, Radishchev, this was followed by monuments to Lassalle (7 October) (Figure 1.2), Dobroliubov (27 October), Marx (7 November), Chernishevski and Heine (17 November), and finally Shevchenko (29 November).[40] During 1919 further monuments were erected in Petrograd, including on 9 March a monument to Garibaldi, and later one to Blanqui near the Baltic Station.[41] In Moscow thirteen monuments were erected during 1918, including statues of Marx, Engels, Robespierre, Plekhanov and Heine. More were completed in 1919, including Danton in February.[42] This is far from being an exhaustive list and there were further monuments to Marx, Byron, Herzen, Chernishevski and many others erected in Moscow, Petrograd and other major cities such as Ekaterinburg (now Sverdlovsk), Perm, Saratov, Astrakhan, Kazan, Vitebsk and Kharkov.[43]

Surviving visual documentation of the monuments is far from comprehensive and is frequently defective in quality, making it very difficult to attempt any detailed analysis of the whole range of works produced. Nevertheless, sufficient material exists to provide a basis for some general evaluations.

What emerges most strongly from an examination of this material is the wide range of styles in which the monuments were executed. Some monuments, like the statue of Marx at Tver (now Kalinin), erected in 1918, remained within a fairly traditional pattern of monumental portraiture. Other sculptors, deriving inspiration from primitive art and the innovations of Cubism and Futurism, attempted to evolve new expressive means in response to the brief of the Plan. Andreev's bust of Danton (Figure 1.3), erected on Ploshchad Revolyutsii in Moscow on 2 February 1919, sacrificed any psychological study of Danton to the expression of his revolutionary determination. In reducing the facial features to heavily textured, generalised forms (which had affinities with primitive art), Andreev emphasised the diagonal thrust of the face, accentuated the revolutionary's jaw-line and stressed the dynamism of his vision. Andreev's massing and forms remained fairly fluid. Far more geometrical and planar was Matveev's treatment of Karl Marx in the monument erected in Petrograd in 1918 (Figure 1.1). However, both of these works appeared restrained in comparison with one of the truly outrageous monuments: Korolev's statue of Bakunin, erected on Ploshchad Turgeneva in Moscow

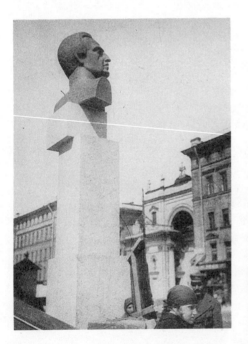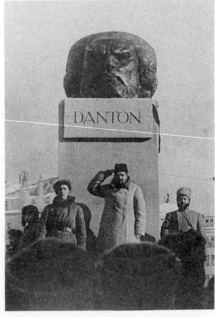

1.2 Viktor Sinaiski, *Monument to Ferdinand Lassalle*, Nevski Prospekt, Petrograd 1918

1.3 Lenin posing for a propaganda film in 1920, beneath Nikolai Andreev's monument to Danton, erected on Revolution Square, Moscow, 1919

in 1919. This monument was never graced with a formal unveiling but was demolished by the public where it stood. It was labelled a 'scarecrow'.[44] Even Punin, an apologist for the avant-garde, could find nothing to recommend it. However, it would be dangerous now to embrace opinions voiced at the time. Korolev was, of course, using Cubist vocabulary of form in this work. Exploiting Braque and Picasso's painterly experiments with the inter-penetration of planes, Korolev reduced the complexity of their multiple viewpoints to a geometrical rendition of the volumes of the human body. The figure was not fragmented in accordance with the Cubist painting but it was geometricised, its mass being rendered into simplified, acutely angular volumes. The difficulties of transposing a Cubist formal vocabulary, evolved on the two-dimensional plane of the canvas, into a three-dimensional structure were enormous and it is not surprising that the sculpture remained unresolved. Nevertheless Korolev's *Bakunin* evidently possessed presence, attracting attention and stimulating discussion, although none of it was complimentary.

Some monuments were projected but not completed and never erected. Among these were Babichev's design for a monument to Zagorsk of 1920. This employed the familiar dynamic diagonal of the Revolution but massed the figures in a far less geometrically schematic way and with more fluid volumes than Korolev's *Bakunin*. Viktor Sinaiski and Anton Lavinski in their projects of 1919 for a monument to the October Revolution also exploited the diagonal combined with a spiral form of massing, expressed particularly in the spiral of the furled flag. The use of the spiral and diagonal had been established as important motifs for specifically socialist monuments by that important precedent, Rodin's *Tower to Labour*, published in 1907. In the Vesnin brothers' design for the base of Aleshin's monument to Karl Marx, 1919-20, the spiral is rendered as a series of diagonals dynamically leading up to the figure of Marx and accompanying revolutionaries. A similar geometry was exploited by Griselli in his project for a moment to Perovskaya, especially in the schematic rendering of the podium to indicate, rather than illustrate, the forms of the human body. Perhaps one of the most effective uses of geometry, however, was by Nikolai Kolli in his project for a totally abstract monument, the *Red Wedge* of 1918. In this he used a red wedge-shape to represent the Red Army cutting into a battered white mass representing the White Army troops. This simple symbolism was later used by Lisitski in 1920 for his poster *Beat the Whites with the Red Wedge*. In both these instances the use of abstract form was powerful precisely because it was based on popularly accepted linguistic usage.

The stylistic techniques employed in the plaques were much more graphic. Because of the limited three-dimensionality of the plaques, the use of line to define and describe form was more prevalent and the descriptive **25**

and decorative content was much greater. Consequently they were less innovative and less experimental in artistic terms. This is evident in the Konenkov plaque *To Those Fallen in the Struggle for Peace and Fraternity of Peoples* of 1918, and in Sarra Lebedeva's bas relief of Robespierre.

This brief stylistic survey of selected monuments and projects produced in response to the Plan for Monumental Propaganda reveals that a wide variety of styles and artistic approaches were utilised by artists in such commissions. It also reveals that this very freedom and variety of approach produced tensions and contradictions between the purely artistic objectives of the sculptors and those visual requirements essential for the effective operation of the Plan: clarity and realism of depiction, and revolutionary description. It is not improbable that such a conclusion also struck the initiator of the Plan.

Such unfavourable conclusions were not to be amended by the fact that, firstly, many of the monuments had been produced in impermanent materials which deteriorated rapidly in the Russian climate, and secondly, that there were few experienced sculptors in Russia,[45] thus making it impossible to mobilise sculptural resources on such a scale without exposing technical and artistic inadequacies. It is therefore not difficult to adopt contemporary and present verdicts, to judge the Plan a failure, and to criticise the monuments for being ill-conceived, hastily and badly executed, and placed in positions where they were often incongruous and frequently ridiculous.[46]

Such a conclusion, however, underestimates the immensely innovative approach to, and exploitation of, visual propaganda which Lenin inaugurated with the Plan and which was developed in a more pragmatic and less utopian way during the Civil War, with the use (in addition to the press) of film, theatre, posters, agitational trains and ships as part of the Bolsheviks' multi-media propaganda machine. Perhaps Lenin's observation of the organisational difficulties encountered by the Plan for Monumental Propaganda in 1918 persuaded him to establish a more effective, centralised control and orchestration of propaganda during the Civil War. This may have been a not insignificant factor in the Bolsheviks' success. Leonid Andreev, the writer, was convinced of this. Admiring their propaganda prowess ('in the matter of world propaganda and the art of fighting with the word they [the Bolsheviks] could teach even the Germans'), Andreev was convinced that to ensure their victory in Russia the Whites needed to adopt an equally effective and centralised system of propaganda.[47]

Such perspectives make one reluctant to adopt wholeheartedly John Bowlt's conclusion that the Plan for Monumental Propaganda was a 'monumental failure'.[48] The Plan was an artistic and political experiment which opened up possibilities for future Soviet sculpture, as well as

revealing a number of inadequacies. Perhaps few if any of the monuments produced in 1918-19 were sufficiently innovative in their overall artistic conception to match Lenin's vision, and we may wish to agree with Punin's conclusion that although the monuments had a revolutionary content they lacked appropriate revolutionary form.[49] Tatlin's project for a monument, later known as the *Monument to the Third International*, was inspired by the desire to remedy such a situation, and to provide a genuinely revolutionary monument for a new revolutionary society. As Mayakovski said, 'It was the first monument without a beard.'[50]

As head of the Moscow *IZO*, Tatlin had been intimately involved with the execution of the Plan, commissioning monuments, reporting on the progress of the Plan, and participating at unveilings. In his capacity at *IZO*, Tatlin prepared and sent a report to *SovNarKom* in June 1918, concerning the organisation and execution of the Plan in Moscow.[51] In this report, Tatlin stressed the difficulty of speedily executing the project without endangering the artistic quality of the monuments produced: 'the state, as it is now, cannot and must not be the initiator of bad taste'. In a letter written probably towards the end of August 1918, Tatlin insisted that the monuments should be 'free creations in a socialist state'.[52] In this letter Tatlin referred to work on 'not only monuments to prominent figures but also monuments to the Russian Revolution, monuments to a relationship between the state and art which hasn't existed until now'.[53] It is possible that he had already conceived the idea for his own monument, although he only became a participating artist at the beginning of 1919, when he was commissioned by the Moscow *IZO* to execute a project for a monument to the Revolution.

The first information concerning Tatlin's ideas for the Monument appeared in an article by Punin on 9 March 1919.[54] This stressed Tatlin's rejection of the traditional figurative monument which could not change the face of the city in any fundamental way and his new conception that 'Contemporary monuments above all must answer that general striving for a synthesis of different types of art, such as we are observing at the moment'.[55] This, it should be noted, provides an interesting parallel to Lenin's own ideas of bringing the arts together for an educative, revolutionary purpose. It also extended experiments in the fusion of art and life which could be witnessed on the streets during the revolutionary festivals.

Punin's article stressed not the plastic forms, but the function of Tatlin's monument to express dynamism, be dynamic and perform a dynamic function as an agitational and propaganda centre:

As a principle it is necessary to stress that firstly all the elements of the monument should be modern technical apparatuses promoting agitation and

propaganda, and secondly that the monument should be a place of the most intense movement; least of all should one stand still or sit down in it; you must be mechanically taken up, down, carried away against your will; in front of you must flash the powerful laconic phrase of the orator-agitator, and further on the latest news, decrees, decisions, the latest inventions, an explosion of simple and clear thoughts, creativity, only creativity...[56]

Dynamism was to pervade the entire structure and functioning of the monument. Nothing static could be permitted. Libraries and museums were banned. Transports, projection screens, a radio station, a telegraphic and telephone exchange, a projector for throwing messages on to the clouds, art workshops and a printing shop for agitational propaganda purposes were included.

Tatlin's Monument was conceived as a revolutionary monument, performing a revolutionary function in a revolutionary stiuation. As such, it represented a reaction against the current practice of the Plan for Monumental Propaganda, although responding very positively to the utopian element in the idea of propaganda embodied in Lenin's Plan.

By December 1919 the project seemed to have been fully worked out. The model was built between March and November 1920 and exhibited in Petrograd from 8 November to 1 December 1920.[57] It was then transported to Moscow and re-erected in the Hall of the Eighth Congress of the Soviets, which was discussing Lenin's Plan for the Electrification of Russia.[58] In most respects the monument's function corresponded to Tatlin's earlier conception. The form, however, was different. Within a supporting external structure consisting of two spirals moving around a strong diagonal axis, four glass-skinned volumes were to be suspended.

According to Punin's description,

The monument consists of three great rooms of glass, erected with the help of a complicated system of vertical pillars and spirals. These rooms are placed on top of each other and have different, harmonically corresponding forms. They are to be able to move at different speeds by means of a special mechanism. The lower storey, which is in the form of a cube, rotates on its axis at the speed of one revolution per year. This is intended for legislative assemblies. The next storey, which is in the form of a pyramid, rotates on its axis at the rate of one revolution per month. Here the executive bodies are to meet (the International Executive Committee, the Secretariat and other executive administrative bodies). Finally, the uppermost cylinder which rotates at the speed of one revolution per day is reserved for information services: an information office, a newspaper, the issuing of proclamations, pamphlets and manifestos – in short, all the means for informing the international proletariat; it will also have a telegraphic office and an apparatus that can project slogans on to a large screen. These can be fitted around the axes of the hemisphere. Radio masts will rise up over the monument. It should be emphasised that Tatlin's proposal provides for walls with a vacuum (Thermos) which will help to keep the temperature in the various rooms constant.[59]

Although sources have been sought in the girder construction of the Eiffel Tower, Boccioni's *Extension of a Bottle in Space* of 1912, Bruegel's *Tower of Babel*, and Rodin's *Tower of Labour*,[60] Tatlin himself had specifically related the aesthetic bases of his Tower to his pre-Revolutionary artistic work investigating 'material, volume and construction'.[61] The whole structure was built upon an inclined truncated cone, technically known as a frustum. This was a recurrent form in Tatlin's early constructions, to be clearly seen in *Materialnyi podbor: tzink, palisandr, el* of 1917 and less prominently in the glass shape of *Materialnyi podbor: zhelezo, shtukaturka, steklo, gudron* of 1913 and in his first reliefs, like *Butylka*, also of 1913. It continued to be a prominent feature of the *Corner Reliefs* with which he moved out into three-dimensional space. With its curvilinear volumes, its juxtaposition of curved planes, and the tensile curves of the supporting spirals, recalling strongly the elegantly curving wires supporting the hanging reliefs, the integration of internal and external volumes which these define, and the very principle of the open structure embracing forms and fusing with the environment, the Tower resembles in its conception nothing so much as a gigantic *kontr-relef.*

Although Tatlin's conception of his *Monument to the Third International* extended Lenin's idea of monumental propaganda, artistically the form of the Tower derives from Tatlin's pre-Revolutionary artistic work. This would hardly seem to agree with Lenin's notoriously conservative artistic tastes. The man who wrote that 'Lunacharski... should be flogged for his futurism'[62] because he authorised the publication of 5,000 copies of Mayakovski's poem *150,000,000* would hardly have been expected to welcome the technically impractical, grandiose project of Tatlin that was to soar 300 metres into the sky and to straddle the river Neva in Petrograd. Against a background of increasing theoretical discussion concerning the nature of socialist art, the Monument acted as a practical crystallisation for Constructivism, helping to focus both pre-Revolutionary and post-Revolu-tionary artistic experiences around utilitarian objectives.[63] However, Constructivism's fusion of art and life was ultimately rejected in favour of Chernishevski's pre-Revolutionary demand for an artistic, painterly realism which could directly serve the masses as propaganda.

It is perhaps one of the great ironies that although Lenin's Plan for Monumental Propaganda contributed to the emergence of Constructivism, the Soviet state of the 1920s finally discarded its innovatory solutions in favour of the traditional static and realist concepts of painting and sculpture epitomised by the statue of Lenin on the Palace of the Soviets Building (Figure 5.1) and Isaak Brodski's painting of *Lenin at Smolny* of 1930.

The outcome of the 1920s should not, however, obscure present perspectives. The spirit of Lenin's citation of Campanella's *City of the Sun* **29**

and his utilisation of art as a propaganda medium for re-educating and re-structuring society seems to have found its most clear and spontaneous, if most impractical and utopian, reponse in Tatlin's Tower.

Notes

This paper is a slightly revised version of that which appeared in *Sbornik, nos 6-7, Papers of the Sixth and Seventh International Conference of the Study Group on the Russian Revolution*, Leeds, 1981.

1 A. Mikhailov, 'Leninskii plan monumentalnoi propagandy i tvorcheskie problemy monumentalnogo iskusstva', *Iskusstvo*, 9, 1969, pp. 11-20. This is generally the line also taken by John Bowlt, 'Russian Sculpture and Lenin's Plan of Monumental Propaganda', in H. A. Millon and L. Nochlin (eds), *Art and Architecture in the Service of Politics*, London and MIT Press, 1978, pp. 183-93.

2 J. Bowlt, op. cit, p. 182.

3 'Postanovlenie NKP o poriadke khudozhestvennogo ukrasheniya prazdnestv', *Iskusstvo kommuny*, 10, 9 April 1919.

4 R. Taylor, 'A Medium for the Masses: Agitation in the Soviet Civil War', *Soviet Studies*, 22, April 1971, p. 567.

5 G. Demosfenova, N. Nurok, N. Shantyko, *Sovetskii politicheskii plakat*, Moscow, 1962, p. 568.

6 I. Grabar, 'Aktualnye zadachi sovetskoi skulptury', *Iskusstvo*, 1/2, 1933, p. 155.

7 A. Lunacharski, 'Lenin o monumentalnoi popagande', *Literaturnaya gazeta*, 4-5, 29 January 1933. The earliest date Lunacharski gives for this conversation is the *winter* of 1917 (A. Lunacharski, 'Ob arkhitekturno-khudozhvestvennom oformlenii Moskvy', *Stroitelstvo Moskvy* , 6, 1934). Strigalev, however, dates it as occurring between 4 and 8 April 1918 (A. Strigalev, 'K istorii vozniknoveniya leninskogo plana monumentalnoi propagandy', Voprosy sovetskogo izobrazitelnogo iskusstva i architektury, Moscow, 1976, p. 221. See also H. J. Drengenberg, *Die Sowejetische Politik auf dem Gebiet der bildenden Kunst von 1917 bis 1934*, Ost-Europa Institut an der Freien Universitat, Berlin, 1972, p. 186.

8 A. Strigalev, *op. cit.*, and A. Lunacharski, 'Monumentalnaya agitatsiya', *Plamya*, 11, 14 July 1918.

9 *V. I. Lenin i A. V. Lunacharski. Perepiska, doklady, dokumenty*, Moscow, 1971, p. 62.

10 *Ibid.*, p. 61.

11 *Ibid.*, p. 69.

12 'Osvobozhdenie deyatelei iskusstva ot trudovoi povinnosti', *Teatralnyi kurer*, 29 September 1918.

13 L.Trotski, Speech at the Sixth Congress of the Soviets, Moscow, 9 November 1918, taken from *How the Revolution Armed*, London, 1979, p. 463. I am indebted to Brian Pearce for directing my attention to this quotation.

14 O. Nemiro, 'Lenin i revolyutsionnye prazdniki', *Iskusstvo*, 10, 1969, pp. 2-6.

15 *Sobranie Uzakonenii i Rasporyazhenii Rabochego i Krestianskogo Pravitelstva*, 31, p. 391.

16 *Izvestiya VTsIK*, 155, 1918, and *Iskusstvo*, 2, August 1918.

17 *Izvestiya VTsIK*, 155, 1918.

18 'Spisok lits koim predlozheno postavit monumenty v g(orode) Moskve i drugikh gorodakh RSFSR', Iskusstvo, 2, August 1918, and *Izvestiya VTsIK*, 155, 1918. An initial list of fifty worthies seems to have been drawn up by *IZO* and in particular by the historian and theoretician Pokrovski, who presented a report to SovNarKom on 17 July 1918 ('O postanovke pamyatnikov "liudyam velikim revoliutsionnoi deyatelnosti"', *Iskusstvo*, 2, 1918. Lunacharski also mentions certain names worthy of monumental

attention in 'Monumentalnaya agitatsiya', *Plamya*, 11, 14 July 1918. For a fuller discussion of the various lists see Bowlt, *op. cit.*, p. 186, and St A, 'Komu proletariat stavit pamyatniki', *Dekorativnoe Iskusstvo*, 2, 1969, p. 52.

19 'Sovet narodnykh komissarov 30 iyulya rassmotrev proekt spiska pamyatnikov velikikh deyatelei sotsializma', *Izvestiya VTsIK*, 163, 2 August 1918.

20 A. Lunacharski, 'Monumentalnaya agitatsiya', *Plamya*, 11, 1918.

21 A. Lunacharski, 'Lenin o monumentalnoi propagande', *Literaturnaya gazeta*, 4-5, 29 January 1933.

22 St A, 'Komu proletariat stavit pamyatniki', p. 52.

23 A. Lunacharski, 'Monumentalnaya agitatsiya'.

24 A series of brochures providing biographical information was also published under the general title *Komu proletariat stavit pamyatniki.*

25 V. D. Bronch-Bruevich, 'Lenin i kultura', *Literaturnaya gazeta*, 20 January 1940.

26 The first Russian translation of Campanella's Renaissance work seems to have appeared in 1906. It was republished by the Petrograd Soviet in 1918 as part of a series of utopian novels which included Sir Thomas More's *Utopia* (first published in Russian in 1903). The names of both Campanella and More appeared on an obelisk to revolutionary thinkers, produced in 1918 in Petrograd. St A, 'Komu proletariat stavit pamyatniki', p. 1.

27 A. Lunacharski, 'Lenin o monumentalnoi propaganda'; see also S. Konenkov, *Moi Vek*, Moscow, 1972, p. 214, for the text of Lenin's letter to Lunacharski, and Bowlt, *op. cit.*, p. 185.

28 *Ibid.*

29 Concerning the erection of these plaques see A. Lunacharski, 'Monumentalnaya agitatsiya', *Plamya*, 11, 1918. The Plan may also bear some relationship to French Revolutionary festivals. Russian interest in the French experience was amply attested by articles in the popular magazines and by such publications as Zh T'erso, *Pradzdnestva i pesni Frantsuzskoi Revolyutsii*, Moscow, 1918, the Russian translation of J. Tiersot's *Les fêtes et les chants de la Revolution française.*

30 *Severnaya kommuna*, 17 October 1918. For a discussion of the impact of the Revolution on the Russian avant-garde, see Christina Lodder, *Russian Constructivism*, New Haven, 1983, chapter 2.

31 'Usloviya konkursa-zakaza Moskovskomu professioinalnomu souzu skulptorov-khudozhnikov', *Izvestiia VTsIK*, 24 July 1918, reprinted in St A, 'Komu proletariat stavit pamiatniki', p. 27.

32 'Agitatsionnye pamyatniki i otnoshenie k nim soyuza skulptorov', *Izobrazitelnoe iskusstvo*, 1, 1919, p. 71. The operation of public taste was called the *sud naroda* (judgement of the masses) but became very difficult to formalise.

33 *Lenin i Lunacharski*, p. 80.

34 'Agitatsionnye pamyatniki i otnoshenie k nim soyuza skulptorov', p. 71.

35 *Ibid.*, pp. 71-2.

36 I. Grabar (ed.), *Istoriya russkogo iskusstva*, Moscow 1957, Vol. 11, p. 32.

37 'Agitatsionnye pamyatniki i otnoshenie k nim soyuza skul ptorov', p. 71.

38 This obelisk is illustrated in St A, 'Komu proletariat stavit pamyatniki', p. 1.

39 See *Iskusstvo kommuny*, 13, 1919, 15, 1919, 17, 1919.

40 These details are given in 'Otkrytie pamyatnika T. G. Shevchenko', *Iskusstvo kommuny*, 1, 1918. The Monument to Shevchenko was by the sculptor I. Talberg. The opening, attended by Lunacharski, commenced with the playing of the 'Internationale' and the distribution of explanatory leaflets.

41 'Otkrytie pamiatniki Garibaldi', *Iskusstvo kommuny*, 14, 1919.

42 I. Matsa (ed.), *Sovetskoe Iskusstvo za 15 let. Materialy i documentatsiya*, Moscow, 1933, p. 36.

43 *Ibid.* Works in Saratov are documented in *Agitatsionno-massovoe iskusstvo pervykh let oktyabrya* , Moscow, 1971. Over sixty sculptors and proposed monuments are listed as

31

participating in a competition for monuments as part of Lenin's Plan (not earlier than 1918) in *Iz istorii stroitelstvo Sovestkoi kultury 1918-1919. Moskva, Dokumenty i vospominaniya*, Moscow, l964, pp. 38-44.

44 'Uberite chuchelo!', *Vechernie izvestiya Moskovskogo Soveta Rabochikh i krasnoarmeiskikh deputatov*, 10 February 1920.

45 'It is possible to find perhaps only three or four master sculptors in the whole of Russia', 'Agitatsionnye pamyatniki i otnoshenie k nim soyuza skulptorov', p. 72.

46 Bolt, *op. cit.*, p. 189.

47 Assorted material and a letter from Leonid Andreev to Pavel Milyukov dated 26 July 1919 from the Leonid Andreev Archive, Brotherton Library, University of Leeds (F. 56). For this and all information concerning Andreev's attitudes to propaganda I am indebted to Richard Davies of the University of Leeds and to his unpublished manuscript 'Dva neopublikovannykh pisma Leonida Andreeva k P. N. Milyukovu (1919 god)'.

48 Bowlt, *op. cit.*, p. 189.

49 N. Punin, 'O pamyatnikakh', *Iskusstvo kommuny*, 9 March 1919. Lavinski's monument of Marx which was erected at Krasnoe Selo may contradict such a conclusion, but it has not proved possible to trace a photograph of it.

50 Cited in N. Kharkhiev, 'Mayakovskii i Tatlin. K 90-letiyu so dnya rozhdeniya khukozhnika', *Neue Russische Literatur Almanach*, Salzburg 1978, p. 90.

51 *Izvestiya VTsIK*, 24 July 1918, and *Iskusstvo*, 2, 1918, p. 15.

52 *Lenin i Lunacharski,* p. 80. It was one of several letters that Lunacharski forwarded to Lenin to refute the accusation that *NarKomPros* was inactive concerning the Plan for Monumental Propaganda (*ibid.*, pp. 84-94). Tatlin expressed distress at Vinogradov's complaints conerning the Plan because they discredited *IZO* (and hence the artists who ran it). The letter is reprinted in full on p. 80. It is undated, but according to Strigalev (*op. cit.*, p. 415), it was written between 18 September and 12 October 1918.

53 *Lenin i Lunacharski*, p. 80.

54 N. Punin, 'O pamyatnikakh', *Iskusstvo kommuny*, 9 March 1919.

55 *Ibid.*

56 *Ibid.*

57 *Zhizn iskusstva*, 387, 3 March 1920, 596-7, 30-31 October 1920.

58 N. Punin *Pamyatnik tretego internatsionala ,* Petersburg, 1920.

59 N. Punin, 'Tour de Tatline', *Veshch*, 1-2, 1922. Despite this description, it is clear that the largest volume was in fact a squat cylinder (see photographs in L. Zhadova, *Tatlin*, London, 1988).

60 See Troels Andersen, 'Notes on Tatlin', in *Vladimir Tatlin*, Stockholm, 1968, pp. 7-8, and John Elderfield, 'The Line of Free Men: Tatlin's "Towers" and the Age of Invention', *Studio International*, 916, 1969, pp. 162-7.

61 V. E. Tatlin, T. Shapiro, I. Meerzon, P. Vinogradov, 'Nasha predstoyashchaya rabota', *VIII sezd sovetov. Ezhednevnyi byulleten sezda VTsIK*, 13, 1 January 1921, p. 11.

62 Note from Lenin to Lunacharski written on 6 May 1921, first published in *Kommunist*, 18, 1957.

63 Following the discussion around Tatlin's Tower, the First Working Group of Constructivisits was set up in the Moscow *InKhUK* (the Institute of Artistic Culture) in March 1921. They renounced art as 'bourgeois' and as 'speculative activity', and wanted to replace it with 'intellectual production', the 'communistic expression of material structures' dedicated to specifically utilitarian aims (*Programma pervoi rabochei gruppy konstruktivistov*, MS, private archive, Moscow). For more details, see Lodder, *Russian Constructivism.*

Toby Clark

2 The 'new man's' body: a motif in early Soviet culture

In Soviet art and literature, ideas about the development of human nature have been expressed by various formulations of the *new man*, an emblematic personification of political ideals, whose purpose is to demonstrate exemplary behaviour and attitudes, and to articulate notions of the appropriate relationship between the citizen and the state. During the first twenty years of the Soviet period diverse representations of new men and women in both realist and modernist art reflected the shifting and conflicting values of a revolutionary culture. As an artistic device, its role is both prescriptive and prophetic; it seeks to inspire emulation in the present day and to reveal the improvement of humanity in the future. It derives from a conception of the function and methods of art which had been central to radical traditions in Russian aesthetics since the mid-nineteenth century, and which largely informed the rationale behind Socialist Realism after the mid-1930s.

As tireless labourers, courageous Red soldiers, or dedicated Party activists, the heroes and heroines of novels, paintings and films sought to propagate new moral codes and to provide a series of role models from which to construct revised patterns of class identity. But beyond the immediate strategies of propaganda, these formulaic personae, however rudimentary, emerged in the context of an inquiry into the properties of human nature and the methods of changing it. This inquiry was inseparable from pressing political concerns, since all questions about the future development of humanity were inevitably linked with questions about historical change, and therefore about the role of the Party and the nature of the state.

Although the anticipated transformation was generally conceived as an all-round development of mental and physical capacities, in the early Soviet period there was a particular preoccupation with the physical aspect, and the human body became a principal site for utopian speculations. In the interpretation of the body – in ideas about its proper uses and pleasures and the methods and limits of its development – Bolshevik and Stalinist culture generated myths with which to sustain conceptions of the ideal practice of citizenship. This essay will broadly trace the stages of this mythology as it changed in character during the first twenty years after the Revolution.

The new man originated as a literary device in the work of the radical democrats of the 1860s. In the absence of an arena for open political debate, literary criticism and writings on art acquired unprecedented importance as a means of covertly discussing oppositional ideas. Radical critics like Pisarev, Chernyshevski and Dobrolyubov turned their attention to the discussion and evaluation of characters in novels and figures in paintings. Chernyshevski founded a classic approach in his novel *What is to be Done?* (1864), which he wrote while imprisoned in the Peter and Paul Fortress in St Petersburg. Subtitled 'Tales of the New People', the novel idealises the milieu of the progressive intelligentsia and creates characters whose conduct, habits and relationships comprise a comprehensive value system. Chernyshevski's characterisation reflected a real social phenomenon: the emergence of a generation of young revolutionaries, who, frustrated by the false promises of the Emancipation, embraced the most radical doctrines of the day, and assumed a self-conscious role as bearers of a new critical awareness. The spirit of the 1860s was infused with the anticipation of 'a new age', an era of 'spiritual renewal' with a 'transformation of life' (*preobrazhenie vsei zhizni*) bringing with it the evolution of the new type: 'it will appear in a greater number of individuals', promised Chernyshevski, 'because goodness will then be more plentiful, and all that is now good will be better. And so history will begin a new phase'.[1] By presenting political world views in the form of the fictionalised lifestyles of individuals, Chernyshevski demonstrated the use of the concept of *type*, as formulated in Russian realist aesthetics. The concept of *type* combined the sociological category referring to a representative member of a class, or 'social type', with the Hegelian notion of the ideal. As Paperno wrote, 'for the radical critics, type is an individual fact of reality (a social fact) that, having "passed through the imagination of a poet" acquires a universal significance of mythic proportions'.[2]

The term 'new man' did not acquire a fixed definition, and was a somewhat vague label which was applied to a very broad range of sentiments arising out of various traditions. Since the nineteenth century much of the theoretical foundation for ideas about the approaching evolution of humanity had derived from the West, notably from Marx, Nietzsche, and Feuerbach, but in Russia it met with native currents of thought which were compatible with it, as well as an extreme political environment which had nurtured an intense preoccupation with the future. Under the relatively liberal climate in the cultural field during the 1920s expressions of such ideas took many different forms including some exuberant contributions from the avant-garde.

Within the Party itself, the ideal codes of behaviour for Soviet citizens were still disputed during the 1920s. A particularly controversial question was the extent to which the new way of life should transform traditional

family values. Representations of the new Soviet woman underwent specific modifications during the course of this controversy. The Party Woman's Bureau (the *ZhenOtdel*) had been responsible for enlisting and organising Soviet women, and for promoting new conceptions in order to do so. In mass agitation the portrayal of ideal revolutionary heroines took the form of biographical sketches of real and fictional women celebrating their achievements in the realms of industry, politics and the Red Army.[3] Nadezhda Krupskaya, Aleksandra Kollontai and Inessa Armand, leading figures in the *ZhenOtdel*, had initially tried to extend the agenda for emancipation, but their more far-reaching vision of a new morality had to be curtailed in the face of anti-feminist sentiments within the Party, and, in the late twenties, by the conservative outcome of the Party's debates on free love and marriage law reform.

During the early Soviet period prevailing values constantly shifted in response to rapidly altering priorities and were expressed culturally by very diverse perceptions of revolutionary ideals. There is only space here for a brief account of changing representations during the first two decades, which we will have to periodise rather crudely, although the tendency to contrast the 1920s with the 1930s raises problematic questions about continuities between Bolshevism and Stalinism. Certainly a mark of the transition between the two periods was the factional division within the Party leadership which, in the late 1920s, struggled over contesting views of the methods and pace of the movement towards socialism. The ultimate victory of the Stalinist faction, consolidated by the early 1930s, brought with it a drive to establish a united front in the field of the arts as in all other realms.

During the earlier period, science had been evoked as the primary tool for creating the new man. In 1924 Trotski had predicted:

> Even purely physiological life will become subject to collective experiments. The human species, the coagulated *homo sapiens*, will once more enter into a state of radical transformation, and, in his own hands will become an object of the most complicated methods of artificial selection and psycho-physical training. This is entirely in accord with evolution'.[4]

A feature of the high prestige of the natural sciences in the Russian radical tradition was the acceptance of the scientific models of physics and mechanics as a prototype for general scientific and philosophical theorising. Mechanistic conceptions tended to inform views of human nature in the field of early Soviet psychology in which 'objective' behaviourist schools held a prominent position. As Raymond Bauer wrote in *The New Man in Soviet Psychology*, 'viewed in the light of the psychological theories of the twenties man was a machine, an adaptive machine which did not initiate action but merely reacted to stimuli from its environment. Concepts like "consciousness" and "will" were suspect; they

smacked of subjectivism, voluntarism, idealism' .[5]

During the twenties, a crude popular interpretation of mechanistic conceptions of human behaviour combined with the intense cult of industrial technology to stimulate a recurring formula of the new man, that of the human-machine hybrid. The film maker Vertov, for example, dreamed of 'the perfect electrical man.... The new man, freed from his clumsiness and incompetence, in possession of the precise and light movements of the machine.... One has to feel ashamed in front of machines at man's inability to behave.' [6] Of course, the new man was regarded as the offspring of a general process of modernisation, and since the machine was the most readily available symbol of progress and perfectibility the machine-man *topos* was a somewhat inevitable cliché. Its prevalence was frequently satirised in novels by 'fellow-travellers' (those with mixed feelings about the Party's programme) in which 'iron' communists are portrayed as grim mechanical instruments; in a short story, Zamyatin compared a revolutionary with a revolver in a metal case.[7] As with most new man representations, the formula coincided not only with notions of ideal behaviour, but also with perceptions of the state. Mechanistic imagery became especially common in literature under the First Five Year Plan (1928-32), a high point of anti-individualistic and egalitarian sentiments, at least at a popular level. Soviet society is likened to the 'Great Conveyor Belt' (*Bolshoi konveier*, 1934), or to a locomotive with the Party its 'Drive Shaft' (*Vedushchaya os*, 1931).[8] The workers are the equal and united components of the mechanism.

Representations of the new man as a machine during the twenties were generally intended to evoke an ethos of efficiency and productiveness, and the formula resonated with the most urgent national priority following the Civil War – the development of the technological means of production. Until the end of the decade conditions did not allow for significant improvements to industrial technology, so the primary method of improving productive capacity lay in enhancing the efficiency and physical capability of the workers. In a speech to the Young Communists in 1923, Bukharin declared: 'We must direct our efforts now... towards creating in the shortest possible time a definite number of qualified, especially disciplined, living labour machines readily available to be put into general circulation.'[9] The response to this need was the national campaign for the scientific organisation of labour (*nauchnaya organizatsiya truda*, or *NOT*) under the guidance of the Central Institute of Labour (*TsIT*) authorised by Lenin in August 1921. The *NOT* movement set out to rationalise working procedures by introducing a Soviet version of the assembly line mass-production methods developed by F. W. Taylor, F. B. Gilbreth and Henry Ford. It was also a broad educational campaign for efficient habits, embracing all workers and even school children. In addition to the eight

hundred *NOT* cells in operation by the end of 1924, the Central Institute of Labour set up eight laboratories for studying 'psychotechnics', the psychological and physiological aspects of labour. In these laboratories, the simplest actions were intently scrutinised through dioptic telescopes and chrono-cyclographic cameras (Figure 2.1).

Soviet rhetoric, of course, made much of the role of factory labour as the means of forging the mentality of the new proletariat. Peasants who moved from farm to factory were often regarded as a *tabula rasa* upon which to inscribe the revolutionising effects of the industrial environment. The head of the Central Institute of Labour, the poet and scientist Aleksei Gastev, elaborated such ideas by infusing them with Pavlovian theories, creating an extreme vision of physiological education in which the actions of the factory worker's body impart to the mind the rationalising disciplines of the machine: 'The methodical, constantly growing precision of work, educating the muscles and nerves of the proletariat, imparts to proletarian psychology a special alertness, full of distrust for every kind of human feeling, trusting only the instrument, the apparatus, the machine.'[10] The instruction of the worker's body is a lesson in 'mechanised collectivism', a new approach to life which would inform every aspect of the worker's existence: 'even his intimate life, including his aesthetic, intellectual and sexual values'. And significantly, the mechanisation of labour is extended by Gastev as a model for social organisation; 'a new working-class collectivism which is manifested not only in relations between persons, but

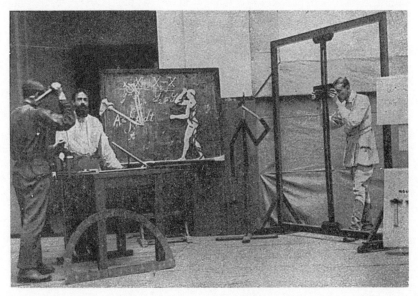

2.1 An experiment in 'psychotechnics' in a laboratory of the Central Institute of Labour

in relations between whole groups of people and whole groups of mechanisms... . Or even a machine in the literal sense of the word, will manage living people.'[11] For Gastev, the mechanised body becomes an extension of the machinery of the state.

Gastev soon became a controversial figure, and *TsIT* was attacked in *Pravda* in 1923 for its aim of 'transforming the living person into an unreasoning and stupid instrument without any general qualifications or sufficient all-round development.'[12] Against such attacks, however, Gastev cited the enthusiastic support of Lenin himself for the institute, a claim which appears to be substantiated by Lenin's personal role in securing for it generous funding. And Gastev was not a marginal crank; by 1938, according to a recent estimate, almost one million industrial workers had been trained by the methods and instructors of Gastev's institute..[13]

The motif of the mechanised body had been a regular feature of avant-garde art and rhetoric during and before the 1920s. Partly it functioned metaphorically as an icon celebrating a general modernisation of sensibility, but in Constructivist thought the formula also expressed ideas about the anticipated influence of the industrialised environment upon the Soviet mind. Constructivist design theory tended to propose a highly materialist interpretation of personality. Under the banner of 'organising the psyche of the masses', the human mind is presented as a material object amenable to a reorganisation determined by a rationally designed environment. This feature of Soviet modernism in the twenties contrasted with the earlier outlook of Cubo-Futurism, which had presented the transformation of consciousness as a metaphysical event. Before the Revolution, the exploration of forms in painting and poetry which transgressed rational constructions of space and language was related to an

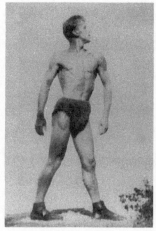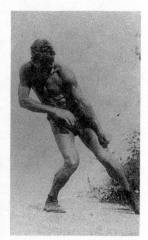

2.2 Meierhold's biomechanics

idealist search for higher modes of perception and intuition.

The later tendency to prioritise physiological experience, to attribute psychological states to physiological processes, informed Meierhold's famous theory of Biomechanics, a system for training actors, devised partly in reaction against Stanislavski's introspective stress on mood, emotion and character. Meierhold defined the human organism as 'an automotive mechanism,'[14] and like any other machine, the body, specifically the actor's body, could be made more efficient and better suited to fulfilling its function. And having defined acting as a form of labour, Meierhold turned to scientific management, particularly to American time-and-motion studies, as an inevitable model for its rationalisation. The method claimed to establish foundations for an objective study of dramatic communication by analysing relationships between states of mind and physical movements and gestures. Meierhold compiled a vocabulary consisting of twenty-two movements which were recorded on film (Figure 2.2). Once the actor had assimilated these motions with their corresponding 'content', they could be deployed in the play, and after extensive training in the Biomechanical method, the actor would be able to internalise the standard movements and reproduce them with an automatic rapidity which Meierhold, inspired by Pavlovian ideas, called 'reflex sensitivity'.

The method was introduced to the curriculum of the Higher State Theatre Workshops in 1922. Its aim was not to make the performer act in a mechanical fashion, indeed Meierhold's productions were boisterous affairs combining gymnastics with circus and *commedia dell' arte*. But the apparent spontaneity was premeditated, and supposedly planned with scientific accuracy. The assistant directors, among them the young Sergei Eisenstein, were known as 'laboratory assistants'.

Meierhold's idea that the artist should be a physically perfected instrument was shared by others in the avant-garde. Naum Gabo describes the artist specifically as a precision tool: 'The plumb-line in our hand, eyes as precise as a ruler, in a spirit as taut as a compass...we construct our work'.[15] 'We distrust the eye', wrote Tatlin, 'and place our sensual impressions under control.'[16] In his work for the architectural laboratory in the VKhuTeMas, Ladovski designed special equipment for monitoring the senses. As well as inventing a device he called the *prostrometer* (space-meter) for examining the spatial properties of forms, he devised the *oglasometer* (volume-meter) for checking the accuracy of an individual's judgement by eye of the properties of volumes, and the *ploglasometer* (surface-meter) for testing the individual's faculty for perceiving the qualities of surfaces. The latter two instruments were also used in the laboratory's Pedagogical Division for measuring what Ladovski called the 'psycho-technical abilities' of practising architects, and for assessing the

39

aptitude and suitability of students for the profession.[17]

The representation of revolutionary development as a programme of physical education had been immortalised by Chernyshevski in his prototypical new man, Rakhmetov, the most striking character in *What is to be Done?* Rakhmetov, 'the best of the best', is clearly a professional revolutionary, but the novelist could not say so openly. Instead he is presented as an athlete preparing for a crucial contest: 'He adopted the diet of pugilists; he ate food known exclusively as strengthening, especially almost raw beef-steak'; 'Gymnastics, labour for the development of his strength, and reading were Rakhmetov's personal occupations', and 'with each new task, with each change, new muscles were developed'.[18] 'If we place him in an environment in which gymnastics and all forms of sport are both available and compulsory,' Meierhold wrote, some sixty years later, 'we shall achieve the new man who is capable of any form of labour.'[19] The image of the ideal body is combined with the ideal of collective activity in the Soviet cult of sport. Sport has always been a very dominant feature of Soviet life, and takes a central place in official ideas about human development and education. The image of the new man as a sportsman is a natural analogue to that of the hero-worker, and a much favoured subject in Soviet art. During the early Soviet period sport was regarded as a component of a more broadly termed 'physical culture', which included physical education, gymnastics and various outdoor pursuits. The management of physical culture sought to organise and politicise leisure activities and to unite them with the priorities of labour.[20]

One of the functions of sport which has remained largely unchanged since the early Soviet period is the ceremonial role of sports displays in political parades. The inclusion of gymnastic pageants in mass festivals began during the Civil War. By 1933 the now traditional May Day sports parade in Red Square involved 105,000 participants. As a pacific equivalent of the military march-past, such displays were, of course, a feature of both a communist and fascist 'national liturgy' which originated in the German gymnastics movement of the nineteenth century. Their function is clear; as Susan Sontag put it, 'such choreography rehearses the very unity of the polity'.[21] Another persisting feature has been the integration of sport with labour, which takes both utilitarian and utopian forms.[22] Its utilitarian form is most evident in the 'production gymnastics' which became a part of factory life after the late twenties. The utopian form is seen most clearly in the sports pageant, in which labour and sport images are merged in allusion to the Marxist prophesy of a future elevation of work to the plane of recreation or play. The sportsman is thus an inevitable new man type because of this characteristic combination of present and future. The sporting worker is fit for the everyday tasks of building socialism, and also foreshadows his unalienated descendants.

40

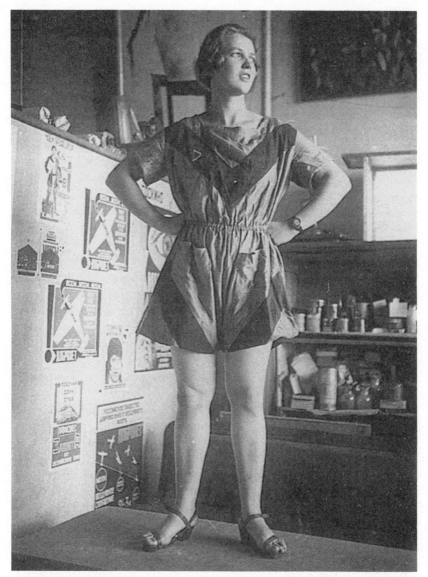

2.3 Sports costume designed by Varvara Stepanova, 1924. Photo by Rodchenko

The motif of *homo ludens* was elaborated most fully in the avant-garde and *proletkult* vision of the 'theatricalisation of life'. In a mass performance planned to celebrate the Third Congress of the Communist International 'the gymnastic associations on motor vans were to have shown the people of the future engaged in throwing the discus and gathering the hay into sheaves.... Rhythmic movements performed by the pupils of the public training schools were to have symbolised the phrase, **41**

Joy and Strength – the Victory of the Creators'.[23] Behind the vision of the integration of work and leisure was an aestheticising drive to eliminate private and unorganised activity. In a striking example, Varvara Stepanova, famous for her theatrical and textile designs, classified her clothes according to two basic categories – production clothing (*prozodezhda*) and sports clothing (*sportodezhda*)[24] (Figure 2.3).

Despite the persistence of some of its elements, the underlying ideology of Soviet sport culture was transformed under Stalin. The most significant feature of this transformation was the new attitude towards competition. During the twenties, a strong disapproval of competition in sport was articulated by two influential groups. One was a health movement comprised of scientists and medical personnel, known as the 'hygienists', who exerted a strong influence on the Supreme Council of Physical Culture, and the other group was the *proletkult*. Both denounced competition as an unhealthy bourgeois relic. In this period, ideal representations of sportsmen in art and literature tended to portray them in non-competitive but disciplined pursuits, like gymnastics, or in festively amateurish team games. However, these sentiments did not survive the introduction of the social and economic policy of 'socialist competition'. In 1936 the Party ratified a shift in emphasis towards competitive sport, and endorsed the creation of a professional elite of top athletes. Socialist competition had also replaced Soviet Taylorism as the leading ideal of work culture. By the mid-thirties, the *NOT* movement had been overtaken

2.4 Aleksei Stakhanov, 1938

by a new spirit in work values, in which less emphasis was placed on over-all efficiency and more on creating specialised cadres. Gastev's institution was disbanded, and he was murdered during the Great Purges.

Studies of Stalinist culture in the past have often adopted a 'totalitarian' model, focusing on the imposition of orthodoxy from above and presenting the arts as an instrument of 'official' propaganda. But recently a more dialectical appreciation of the relationship between Soviet art and the state has produced alternative models. One of the most interesting is Katerina Clark's proposal of adopting an anthropological approach to Stalinist culture as a system of mythology which provided affirming myths through which to maintain the status quo.[25] By appropriating the capacity of myths to organise and synthesise culture, a more homogeneous expression of political culture took the form of a 'synthetic folklore'.

Images of ideal heroes and heroines took a central place in this folklore, and the key hero-type of the second half of the 1930s was the Stakhanovite, the Herculean athlete of labour (Figure 2.4). On the night of 30-31 August 1935, Aleksei Stakhanov, a coalminer from the Orel province, hewed 102 tons of coal, or fourteen times his quota, breaking all previous records. The cult which was constructed around his feat and the ensuing Stakhanovite movement contrasted with earlier representations in the rhetoric of the new man not only in its extravagance, but also in the extent to which it crystallised an ethos of individual behaviour into a full pattern of values to sustain the leadership and its notion of the social order. The cult of Stakhanovism was partly a campaign to stimulate production levels in industry by encouraging workers to emulate Stakhanov's achievement. It was also a new system of production, which redefined the relationship between workers and management and introduced a new hierarchy of labour. Stakhanovites were paid more than other workers and gained various privileges. In this they resembled their precursors, the 'shock workers', but exceeded them in the level of their rewards and authority. Trotski, in exile, condemned Stakhanovism for creating a labour aristocracy which signalled the decisive abandonment of egalitarian ideals.[26] As Lewis Siegelbaum has described, part of the Stakhanovites' symbolic role was that of personifying the ideal consumer, whose comparatively more comfortable lifestyle evoked the promise of a communist cornucopia.[27] The Stakhanovites' domestic life was widely represented in the media and in the journal *Stakhanovets*. Despite the large proportion of women among industrial workers, most Stakhanovites were men, and the representations reinforced the subordinate role of their wives, who were urged to be 'housewife-activists'.[28]

In the Stakhanovites' hagiography, their mythic stature was coloured by

comparisons with Prometheus and with the *bogatyr*, the epic hero of Russian folklore who performs superhuman feats. During this period, art and literature turned increasingly to folk traditions in search of terms with which to describe the increasing miracles of socialism. Alongside the Stakhanovites, another special group was created as suitable subjects for such fabulous epithets: the brigade of record-breaking aviators. During the 1930s the Soviet aviation industry made extraordinary efforts to challenge the limits of flight; by 1938, Soviet aviation claimed to have set some sixty-two world records, including the longest, highest and fastest flights, and the first landing on the North Pole.[29] Among their various propaganda uses, the extensive publicity given to the flights in the media served to distract attention from the Great Purges. In 1937, a year of unprecedented mass arrests, a crew member on the polar flight told foreign journalists, 'Don't believe all the fairy tales you hear about our country, but instead believe such feats as these.'[30] But the flights themselves were represented specifically as fairy tales and were constructed around the iconography of the cult of Stalin. The pilots were titled 'Stalin's falcons', the falcon being rich in connotations in Russian folklore. Falconry had been a royal privilege and falcons were closely associated with princely powers. Sometimes monarchs were themselves portrayed as falcons.[31] In public Stalin associated closely with the pilots and Stakhanovites, taking a fatherly role as protector and advisor.

One of the features of representations of the new man is a collapsing of conventional notions of time and history. In the transformation of aviators and champion workers into mythic heroes of the past and the future, present-day reality tends to disappear. Katerina Clark has argued that Stalinist culture after the mid-1930s proposed two orders of reality, ordinary and extraordinary, and correspondingly, two orders of human being, of time and place, and so on: 'Ordinary reality was considered valuable only as it could be seen to reflect some form or essence found in higher-order reality'.[32] Within this structure, individuals are differentiated across a new hierarchy of knowledge. The Stakhanovites were uneducated and politically unsophisticated – few of them were Party office-holders – yet they did not achieve their feats through mere physical strength, but through will-power, by daring to transcend established empirical norms and by disdaining 'scientifically' determined limits of technology. The construct ensured Stalin's position above them, as a higher source of guiding consciousness. It also served to mythologise the Party's efforts in a truly miraculous task which was contrary to its own 'scientific' laws of society. Instead of socialism arising out of the achievement of political power by a Party representing a large proletarian majority in a country already thoroughly industrialised, the Communist Party in the Soviet Union was attempting to create by force of will the organisation, the

industry and the proletariat which should, in theory, have preceded it. In art and architecture the evocation of super-human accomplishments motivated a general trend towards gigantism and monumentality.

Lenin himself was apparently something of a fitness fanatic. He claimed to have been an enthusiastic sports player in his youth, and, like Rakhmetov, pursued a daily regime of physical exercise and callisthenics.[33] But representations of him seldom stress athleticism. His chief iconic attribute is the book, which he writes or holds under his arm. Of course, the image of the bookish Lenin reiterates his role as the keeper and distributer of the law. Stalin's representation is somewhat different. As the 'practical man', his awareness of pragmatic necessity enables him to scorn the intellectuals' respect for doctrine, but his role as the source of consciousness requires him to be equally unathletic. In the construction of his cult he is only vicariously associated with the achievers of high physical performance.

The new epistemology marked a philosophical change which turned away from the fervent positivism of the twenties, one expression of which had been the machine-like new man. The vision of machine-like perfectibility had been supported by mechanistic trends in psychology, which reduced the psyche to a specific organisation of matter governed by physical laws, determined by the environment and amenable to improvement by 'psycho-physical training'. And clearly this view of human development coincided with a mechanistic, materialist view of historical development. By the end of the 1920s, however, the rationale for such constructs was no longer compatible with the new mode of leadership and economic policy introduced with the First Five Year Plan. In the context of a 'revolution from above' the new leadership was not content to be a drive shaft which cannot determine the direction of the train. Stalin's rise to power occurred as a victory for the faction insisting on drastic intervention, and a defeat of those who urged a more restrained and gradual approach. The defeat of the 'left' was prepared at a philosophical level by the outcome of the debate between the relative value of mechanistic and dialectical materialism. Mechanistic materialism fell from its dominant position, along with the faction of Bukharin, one of its most prominent exponents. The mechanistic model of development was regarded by the Stalinist faction as an excessively passive and fatalistic form of determinism. While it reinforced the prophesy of the inevitable rise of communism, it allowed insufficient scope for the Party's role in that process. Under the rise of Stalin, Lenin's conception of the active agency of the Party and of consciousness in historical change was expanded to present an organic model of the state capable of generating its own forces and of determining its own destiny and direction through its immanent will.

After 1931, the Party leadership enforced an orthodoxy in Soviet Marxist

45

psychology in which the concept of 'will' lost its negative connotations and was elevated as the main resource for outstanding achievements such as those of the Stakhanovite and record-breaking athlete. The transition from the 'perfect electrical man' to the *bogatyr* hero of labour marked a change in what might be called a political physiology. The individual, like the state, is no longer a responsive mechanism adapting to external forces, but a self-motivated entity internally initiating its own actions and development. This change brought with it a revision of the status of the individual before the law, as Bauer has noted.[34] The first Soviet criminal code (1919) states that crime in a class society is the result of the social structure and not the 'guilt' of the criminal. The very terms 'crime' and 'punishment' were regarded as concepts tainted with bourgeois morality and incompatible with determinist philosophy, and in the code of 1924 they were replaced with 'socially dangerous act' and 'means of social defence'. But after 1937 Soviet criminal law reinstated the responsibility of the offender. Criminals 'deserved' their punishments, and Stakhanovites their rewards.

The picture of the fit, lean and muscular socialist overpowering the sated, flabby and enervated capitalist has been one of the most enduring themes in Soviet propaganda. In the past, the hopeful image has starkly contrasted with the sad reality of the appalling physical condition of the Soviet people, debilitated by disease, famine and warfare. Those who sustained the revolution in its early years, in the face of almost intolerable conditions, fostered a yearning for perfection which was the product of an acute awareness of imperfection. The vision of the new man, perhaps like all utopian ideas, concealed a set of profound anxieties. Behind the dream of the regeneration of humanity, there were, apparently, ominous forebodings of its degeneration.

Some of these anxieties converged around the problem of fatigue, and had several sources. In the face of immediate evidence it was clear that the Revolution had had a disastrous effect on Soviet health, as David Joravski has described:

> Eight years of war, social upheaval, economic collapse and famine, 1914-22, had done enormous damage to mental health. Psychiatrists used various terms to describe what they saw.... Some spoke of mass neurasthenia, others of mass schizoidisation, or the widespread appearance of autistic symptoms, or simply of "Soviet *iznoshennost*" (exhaustion or premature aging).... Whatever terms were used, there was a general agreement on a great increase in the number of psychically bruised and worn-out people, tending to shrink into themselves, to become apathetic, or to lose the capacity for work....'[35]

This evidence resonated with the long-standing feeling that 'Oblomovism', an irredeemable laziness and absence of will-power was the overwhelming

national disease. It also must have aggravated fears that the revolution itself was generally running out of steam. A disturbing problem for the Party, by the late twenties, was the very poor health of the Party itself; repeated studies of the over-worked Party activists throughout the country indicated that those suffering from nervous illnesses numbered between 41.5 and 88.7 %.[36]

These anxieties joined with a general preoccupation with fatigue that had arisen throughout the industrialised world since the late nineteenth century, when there was a widely held belief that rapid modernisation would be accompanied by a corresponding depletion of human energies. The discovery of the second law of thermo-dynamics, concerning the dissipation of energy, provoked a conception of an international economy of energy, in which nations which best used and conserved their energy reserves, residing in natural resources and in the muscles of the labour force, would also outstrip rival nations in the race for progress. Such ideas informed the general cult of efficiency, particularly fervent during the twenties, and provoked some unusual schemes of energy conservation. During the First Five Year Plan, the architect Melnikov designed his 'Sleep Laboratory', a scientifically planned dormitory for reconditioning the exhausted workers. A more general approach to energy conservation lay at the heart of the programme of Russian Rationalist architecture. The principal theories of *AsNovA*, the Association of New Architects, were founded on the premise that the perception of form involved an expenditure of energy which should be kept to a minimum by the correct employment of rational forms. Ladovski, the group's leading theorist, described the relationship between architecture and the individual in terms of 'an economy of psychic energy in the process of observing a building'.[37]

The problem of fatigue became a central concern of Soviet psychiatric and neurological research, much of which was directed at the 'psychotechnical' study of work. However by the end of the twenties, during the intense drive for industrialisation, a preoccupation with the negative effects of labour, and with 'Soviet exhaustion', were denounced as a subversion of shock-brigade tempos,[38] and the leadership enforced renewed stress on the vitalising effects of labour. The official line in the thirties was the assertion that 'socialist inspiration reduces the worker's ... fatigue'.[39] The mythic, *bogatyr* Stakhanovite, by internally generating will-power, spurns the empirical limitations of his body.

The mythology of the new man's body prophesied a spectacular release of physical forces, and posited the means through which this might occur. But it also invariably provided structures through which the forces were to be contained and channelled in appropriate directions. In mechanistic formulations of the twenties, such structures lay in the limits of science, technology and the disciplines of industrial labour, while the more

47

spontaneous energy of the later Stakhanovite-type ensured his subordination to the guiding consciousness of Stalin. In contrast with fascist appeals to the pleasures of physical immediacy, prevailing Soviet interpretations of the body have been ascetic. A conservative ethos of the family further underscored the body's proper uses, and the woman's body was more or less written out of the fantasy. Perhaps it had always been a fantasy of extravagant virility, but one related, of course, to the larger dream of 'mastering' nature.

That the movement towards communism would bring with it physical development was promised by Marx. Freedom from the crippling and stunting effects of an unnatural organisation of society would bring the unalienated creature full development of physical and spiritual capacities. But Marx does not stress the aspect of physical strength; instead, human development is presented as a cultivation of the senses leading towards a true consciousness of reality. The institution of the Party as the vanguard of revolutionary consciousness was the special twist to Marx's conception of historical change which Lenin introduced in his *What is to be Done?* (1902), titled in tribute to Lenin's favourite novel. Lenin makes a distinction between two manifestations of revolution: the 'spontaneous' uprisings among workers and the 'conscious' activities of the Social-Democratic Party. The Party's possession of consciousness justifies its position of leadership: 'there could not have been social-democratic consciousness among the workers. It could only have been brought to them from without.'[40] The metaphorical comparison between the body and the state is not an overt feature of Marxist conceptions of society. Marx's emphasis on struggle and conflict precludes an image of organicist unity, and in his vision of the future the state is not fit and healthy, but withered away. But in Lenin's distinction between the Party's consciousness and the peoples' spontaneity it is difficult to ignore the shadow of that classical construct of the government as head and the people as body, which draws attention to the related anthropomorphic ghost lurking in Marx's base-superstructure model. Organicist images are rare in Lenin's writings, and when they occur it is often in negative forms. There is, for example, a tendency to describe subversion and deviance as degenerate or sick, as in his famous attack on 'The Infantile Sickness of Leftism'. Another revealing example slipped out in a letter to Gorki in 1919, when Lenin remarked that the intelligentsia 'fancy themselves the nation's brain. In fact they are not the brain but the shit'.[41] Through the hindsight of the Purges, the analogy seems particularly unfortunate. It is under Stalin that the image of a purged and purified body politic fully emerges.

Notes

1 Nikolai Chernyshevski, *What is to be Done?* (first published 1864), London, 1982, p.175.
2 I. Paperno, *Chernyshevski and the Age of Realism*, Stanford, 1988, p.9.
3 See Barabara Evans Clements, 'The Birth of the New Soviet Woman', in A. Gleason, P. Kenez and R. Stites (eds), *Bolshevik Culture: Experiments and Order in the Russian Revolution*, Bloomington, 1985.
4 Leon Trotski, *Literature and Revolution* Ann Arbor, 1960, pp.254-5.
5 Raymond Bauer, *The New Man in Soviet Psychology*, Cambridge, Mass, 1959, p.5.
6 D. Vertov, 'We – Manifesto on the Disarmament of the Theatrical Cinematography', first published in *Kinofot*, 1, 1922, translated in *Art in Revolution*, London, 1971, p.96.
7 The short story is 'Rasskaz o samom glavnom' (1924) cited in A. M. Van der Eng-Liedmeier, *Soviet Literary Characters*, Amsterdam, 1959, p.20.
8 See Katerina Clark, 'Little Heroes and Big Deeds: Literature Responds to the First Five-Year Plan', in Sheila Fitzpatrick (ed.), *Cultural Revolution in Russia, 1928-1931*, Bloomington, 1984, pp.189-206.
9 Quoted in Kendall Bailes, 'Alexei Gastev and the Soviet Controversy Over Taylorism, 1919-24', *Soviet Studies*, XXXIX, July 1977, p. 387.
10 Quoted in *ibid.*, p.377.
11 *Ibid.*, see also Samuel Lieberstein, 'Technology, Work and Sociology in the USSR: The NOT Movement', *Technology and Culture*, 16, January 1977, pp.48-64.
12 *Pravda*, 11 January, 1923, quoted in Bailes 'Alexei Gastev', p. 137.
13 Bailes, p.137.
14 Vsevolod Meierhold, 'Programme of Biomechanics', 1922, translated in Marjorie Hoover, *Meierhold: The Art of Conscious Theatre*, Amhers, 1974, Appendix 3, pp.311-16.
15 N. Gabo and A. Pevsner, 'The Realistic Manifesto' (Moscow, 1920) translated in Herbert Read (ed.),*Gabo: Constructions, Paintings, Drawings, Engravings,* London, 1957, and in John Bowlt (ed.), *Russian Art of the Avant-Garde: Theory and Criticism, 1902-1934*, New York, 1976, 241-2; and in Stephen Bann (ed.), *The Tradition of Constructivism,* London, 1974.
16 Vladimir Tatlin, 'The Work Ahead of Us', 1920, translated in Bann, p. 12.
17 S. Bann and J. Bowlt, *Russian Formalism: A Collection of Articles and Texts in Translation,* Edinburgh, 1973, p. 161. The instruments were illustrated in *Stroitelstvo Moskvy*, 10, 1928, pp. 14-18.
18 Chernyshevski, *op. cit*, p. 233.
19 Vsevolod Meierhold, 'The Actor of the Future and Biomechanics', 1922, translated in Edward Braun (ed.), *Meierhold on Theatre,* Chatham, 1969, p. 200.
20 For a history of Soviet sport see James Riordan, *Sport in Soviet Society,* Cambridge, 1977.
21 Susan Sontag, 'Fascinating Fascism', *New York Review of Books*, 6 February 1975, p.26. The essay is reprinted in Brandon Taylor and Wilfried van der Will (eds and intr), *The Nazification of Art: Art, Design, Music, Architecture and Film in The Third Reich*, Winchester, 1990, pp. 204-18.
22 See John Hoberman, *Sport and Political Ideology*, London, 1984, pp.170-7, 190-8. Hoberman's interesting study compares Marxist and fascist sport ideologies – his account of the early Soviet period is similar to my own, and I am very much indebted to it.
23 Rene Füllöp-Miller, *The Mind and Face of Bolshevism*, London and New York, 1927, p.149.
24 See Christina Lodder, *Russian Constructivism*, London, 1983, p. 149.
25 Katerina Clark, 'Utopian Anthropology as a Context for Stalinist Literature', *Stalinism: Essays in Historical Interpretatio*n, New York, 1977. See also Katerina Clark, *The Soviet Novel: History as Ritual*, Chicago, 1981 and Christel Lane, *The Rites of Rulers: Ritual in*

Industrial Society – The Soviet Case, Cambridg, 1981.

26 Leon Trotski, *The Revolution Betrayed*, New York, 1972, pp. 79-85.

27 Lewis H. Siegelbaum, *Stakhanovism and the Politics of Productivity in the USSR, 1935-1941*, Cambridge, 1988), pp. 210-14.

28 *Ibid.*, p. 241.

29 Kendall Bailes, *Technology and Society Under Lenin and Stalin,* New Jersey, 1978, p. 386.

30 *New York Times*, 29 June 1937, quoted in *ibid.*, p. 389.

31 Bailes, *Technology and Society*, p. 386.

32 Clark, *The Soviet Novel*, pp. 146-147.

33 Nikolai Valentinov, *Encounters with Lenin*, Oxford, 1968, pp. 79-81, cited in Hoberman, p. 174.

34 Bauer, *The New Man*, p. 40.

35 David Joravski, 'The Construction of the Stalinist Psyche' in *Cultural Revolution in Russia*, p. 113.

36 *Ibid.*, p.271.

37 N. Ladovski, 'Experiments for the Establishment of an Architectural Theory', *Izvestiya ASNOVA*, 1926, quoted in A. Kopp, *Constructivist Architecture in the USSR*, London, 1985, p. 126.

38 Joravski, p. 118.

39 *Ibid.*, p. 116.

40 V. I. Lenin, *What is to be Done?*, Moscow, 1947, p.31.

41 V .I. Lenin, *Sochineniya* (4th edition) XLIV, p. 227, quoted by Joravski, p. 105.

Brandon Taylor

3 On *AKhRR*

The Association of Artists of Revolutionary Russia (*AKhRR*) was arguably the most important art organisation in Soviet Russia between 1922 and 1932. It was so, quite simply, because *AKhRR* embraced more artists, produced more art and held more exhibitions than any other group in what by any standards was a turbulent and historically pivotal period. Moreover during the decade after 1922 *AKhRR* came nearer than any other visual art organisation to becoming an 'official' or 'state' organisation – an important position in a single-party state, but an even more important when one takes into account the fact that *AKhRR* was increasingly favoured by the leading faction of the Soviet Communist Party after about 1925-6.

And this gives us a hint of why *AKhRR* is also problematic, particularly in the ethos of contemporary art history in the West, which looks to the past not only for dispassionate reconstructions of 'forgotten' periods and works, but which also 'remembers' these forgotten periods in line with contemporary preoccupations.

To take the 'forgetting' first. In Western Europe, the 'modernist' orientation of the Cold War period (say 1955 to 1990) effectively ignored the work of the *AKhRR* artists and represented 'Russian' art since 1917 (less usually 'Soviet' art) as an affair of early modernist brilliance corrupted by a steady decline, down to a nadir around 1945-50. For similar Cold-War-ish reasons, *AKhRR*'s works either were not sought or did not become available to Western collectors and museums; and hence by a self-confirming logic of exclusion the names of *AKhRR* painters and sculptors were erased from the 'true wood' of twentieth century art.

There have been, however, a number of publications which have attempted to look at *AKhRR*'s considerable and undoubtedly significant legacy. The first steps in this reassessment have been important, but simple: to recognise the central facts of *AKhRR*'s existence and to chronicle some of its more celebrated and perhaps typical works; secondly, to make clear the links between *AKhRR*'s approach to art and the cultural preferences of Lenin, Trotski, Bukharin (at times), Lunacharski (also at times), and Stalin (ambiguously but increasingly after the middle 1920s).[1]

I venture to propose here that the next steps in this process of cultural excavation might be as follows: first, to examine some of the debates surrounding the exhibiting history of *AKhRR* in the middle and later 1920s, particularly the urgent rhetoric of 'realism', 'revolutionary art' and **51**

*massovos*t or mass-ness; secondly to look again at the qualities of some *AKhRR* paintings in terms of a prelude to what later (after the demise of *AKhRR*) became known as 'Socialist Realism'; and thirdly (perhaps most problematic of all) to look at the dynamics of 're-memorising' the *AKhRR* phenomenon from the standpoint of contemporary changes in taste and a landscape of rapidly changing cultural expectations in the West.

The initial stimulus for the foundation of *AKhRR* was the 47th exhibition of the *Peredvizhniki* or Association for Travelling Art Exhibitions (the 'realist' art group that had broken away from the Imperial Academy in 1863 around artists such as Kramskoy, Ge, Makovski, and later Savitski, Viktor Vasnetsov, Surikov and Repin) which opened on 20 February 1922. By this date, what in Western art history is called the 'avant-garde' (though it was seldom referred to in this way at the time) – that is, the Suprematists, Constructivists and Productivists, as well as many unaffiliated 'experimental' artists, mostly based in Moscow and Leningrad – had benefited from the patronage of Lunacharski's administration at *NarKomPros* (the People's Commissariat of Enlightenment) but had entered upon a period of uneasy reassessment. This pivotal moment around 1921-22 is itself worthy of detailed analysis, but among its determining factors were: a campaign by Lenin to quash independent cultural organisations that sought to operate autonomously, beyond the bounds of the Party, such as *proletkult*; an atmosphere of increasingly strict discipline within the Party itself, born partly of fears that factional differences could split the Party asunder; all this combined with Lenin's own growing impatience with 'Futurist' art; yet at the same time a more relaxed cultural dispensation ushered in after the birth of the New Economic Policy at the Tenth Party Congress in March 1921, which opened up opportunities for private trade and hence made art dealing and the supply of easels, canvas and paints more regular.

Specifically, a debate about the renewed possibilities for easel painting was now very much 'in the air'.[2] Members of the *Peredvizhniki* had by and large opposed the Revolution in 1917, and in many cases had gone into hiding. Certainly they resented the favours granted to the so-called 'left' and 'Futurist' groups by *NarKomPros*; and yet at the same time they had continued to work and to look for patronage throughout the years of the Civil War. They exhibited in a few mixed exhibitions organised by *NarKomPros*, and despite their official disfavour managed to retain enough organising ability to plan a few of their own exhibitions. Their 47th was the first since 1917.

Its paintings were predominantly attempts to reflect revolutionary and pre-revolutionary events in a 'realist' style, while the exhibition attempted through its catalogue to present less a revolutionary than a populist platform that would rally easel painters who had 'gone underground'

during the period of the domination of art by the 'left'. The catalogue of the 47th exhibition reminded its readers that the Association of Travelling Art Exhibitions had begun its work 'under the spontaneous influence of the ideas of the populist movement [and that] the first task of the Association was to give the people a living, intelligible art which faithfully reflected their life'. It also claimed (what was true in the Association's early days, but hardly at all after about 1890) that 'in this work, the Association not infrequently suffered persecution at hands of the old power'. It now claimed that this, its 47th exhibition, 'coincides with the final consolidation of worker-peasant power', and that the Association considered it necessary 'to reflect, with documentary accuracy, in genre, portrait and landscape, the life of contemporary Russia, and to depict its entire working life in its multi-faceted national character'. It remained confident that it would continue to have its exhibitions circulated 'to the deepest corners of Russia'; and ended by appealing to 'all the forces of youth who are sympathetic ... to realism' to come and lend support to its programme.[3]

What was here called 'documentary realism', it should be noted, was by no means necessarily the preserve of the old or the conservative. It was still the style practised by countless art teachers up and down the country, and was the kind popular among younger artists entering training, the vast majority of them unaware of 'modernist' developments in the rest of Europe. Even an ardent Futurist like Nikolai Punin admitted that *Peredvizhniki*-style painting had enormous popular appeal.[4]

And yet by all accounts the 47th exhibition suffered critically from its backward-looking appearance: here were merely anecdotal accounts of striking workers, hungry families and revolutionary deeds, many critics compained. 'This is not the realism we were waiting for after the liquidation of Futurism', wrote D. Melnikov in *Tvorchestvo*.[5] The poet Sergei Gorodetski, formerly an Acmeist,[6] writing in *Izvestiya*, confessed that the *Peredvizhniki* had undergone a massive decline since the 1890s. Its best artists such as Repin had 'suffered from a tendency to mysticism'. The majority had even succumbed to feelings of sympathy for the disappearing landed class, Gorodetski felt. Thus he thought that the present-day *Peredvizhniki* – artists such as Baksheev, Bakhtin, Kelin, Korin, Korytin, Maksench, Milaradovich, Makovski and Savitski – remained rooted in a previous epoch. 'It's all 1890s', moaned Gorodetski, 'and in Makovski's case the 1880s. It's all Turgenevism, the weeping of the ruined estates.' The exceptions were 'a few artists such as Kasatkin, who continued to depict working life, and the young Pavel Radimov'. 'The painter of the miners and of the 1905 Revolution, Kasatkin, in his severe spartan manner, gives us truthful pictures of working life', Gorodetski continued;

Radimov ... in several studies of hunger and of the Kazan tartars, achieves even greater power. This method of realism, at a time of a rising tide in the forces of

youth, and on condition of technical improvement, may lead the Association of Travelling Art Exhibtions to great and useful work... but a condition of this [Gorodetski concluded] is a persistent study of the life and existence of the working and peasant class'.[7]

Gorodetski's position was that the best of the *Peredvizhniki* would 'perhaps be the intitiators of an authentic revival of the Travelling Art Exhibition idea, no longer on the soil of populism, but based on the scientific world-view of the working class'.[8]

His words, in fact, were already coming true. The week before his article was published, on 4 March 1922, a critical discussion of the *Peredvizhniki* exhibition had resulted in the formation of a new society, led by Radimov, called the Association of Artists Studying Revolutionary Life, whose declared intention it was to distance itself from the style of the older *Peredvizhniki*. The new Association contained, besides Radimov, Kasatkin, Arkhipov, Malyutin and Yuon from the older generation, Grigorev, Katsman and a group of younger artists such as Nikolai Kotov, Vasili Zhuralev, Petr Shukhmin, Boris Yakovlev and Petr Kiselis, totalling twenty-five. The group then changed its name to the Society of Artists of Revolutionary Russia, and changed it again (on 13 May 1922) to the Association of Artists of Revolutionary Russia, or *AKhRR*.

Following the group's exhibition in May 1922 entitled 'Exhibition of Pictures by Artists of the Realist Direction in Aid of the Starving' – a title clearly designed to signal the group's sympathy with the post-Civil War drive for social reconstruction – the aims of *AKhRR* in its early period were summarised in the catalogue to its second Moscow exhibition of June-July 1922, 'Exhibition of Studies, Sketches, Drawings and Graphics from the Life and Customs of the Workers and Peasants' Red Army'. This exhibition contained 166 works by some forty artists, and as such was small in comparison with the majority of *AKhRR*'s later exhibitions. Its brief 'Declaration' contained what looks like a revised agenda for 'realist' art. It first of all situates *AKhRR* as the group that will set down 'artistically and documentarily' the 'revolutionary impulse of this great moment of history', that is, the October Revolution and its aftermath.[9] The Revolution, it said, 'in liberating the forces of the people, has aroused the consciousness of the masses and of artists – the spokesmen of the people's spiritual life.' The old art groups from before the Revolution 'have lost their meaning... and continue to exist merely as circles of people linked together by personal connections, devoid of any ideological basis or content' – a negative reference to the *Peredvizhniki*, as well as a proposal for a link between *AKhRR* and the Party.

Nevertheless, *AKhRR*'s Declaration took over one aspect of the *Peredvizhniki*'s original programme when it described the task ahead as 'not merely an artistic one, nor necessarily a revolutionary one, but a civic

duty'. In other respects its constituency and its message were claimed to be contemporary: its first commitment was to 'the life of the Red Army, the workers, the peasants, the revolutionaries, the heroes of labour' whose deeds it would now represent. The Declaration also introduced the concept of 'heroism' in both art and life. It proclaimed the Revolution to be 'a day, a moment', of heroism; 'and now we must reveal our artistic experiences in the monumental forms of the style of heroic realism', it said. This style was to be the foundation of 'the universal building of the art of the future, the art of a classless society', and would go far beyond those 'abstract concoctions which discredit our Revolution in the eyes of the international proletariat'.[10] It was clear that the language of *AKhRR*'s self-promotion was to be through and through rhetorical, just as, in different terms, the language of 'left art' still undoubtedly was.

On the one hand it is clear that *AKhRR*'s programme (as well as its style) endeared it to military leaders who had close connections with centers of power within the Party and the government. Yet it is also true that in 1922 there was by no means an enforced 'line' on the arts, and indeed it cannot be said that either the Party or the government had fixed views on artistic method, even though *AKhRR*'s references to 'documentation' and to 'contemporary life' look like reflections of Lenin's preferences for an accessible, popular yet political style.

Supportive voices from N. Shcheketov, V.Lobanov and F.Roginskaya were drowned out by the complaints of the 'centre' and the 'left' to the effect that *AKhRR* had revived a merely passive naturalism which had little or no 'heroism' in it; certainly not of the monumental sort. 'Belated *Narodniki*' was a charge levelled at them by some: a term designed to associate them with 'populist' intellectual altruism of the nineteenth century.

Other critics were torn between the laudable aims of *AKhRR* and what they saw as the inferior quality of its work. 'We are surely agreed', wrote Amshei Nyurenberg in *Pravda*, that a 'style of heroic realism in monumental forms' must be created now: but he admitted that the exhibition did not achieve its goal. 'The difficult and heroic life of the Red Army is occasionally captured by the *AKhRR* painters – in Malyavin's portrait of Lunacharski,[11] in Yakovlev's and Katsman's drawings – but is otherwise absent. The canvases of Bashilov and Radimov', he contended, 'are utterly undeveloped; this is raw material'.[12]

At *AKhRR*'s third exhibition in Moscow, entitled 'Life of the Workers' in late 1922, similar complaints were made about the excess of good intentions over art. One Yuri Topolev, writing in *Trud* (Labour), quoted approvingly from the catalogue's stirring prose, yet wished to say that 'the authors of those intentions produce very slight and disappointingly paltry works'. Instead of heroic realism we in fact see a 'very humble naturalism, sometimes amounting to little more than conscientious sketching from

nature. The portraits of the leading figures of VTsSPS [All-Union Central Council of Trade Unions] are commendable in their way; yet where is the working life of the proletariat in its refashioned form?' *AKhRR* have

> sketched a row of workers at work, factory workshops, and labour in its various manifestations. But they have failed to show a single characteristic of the new revolutionary life of the workers; not a single workers' meeting or factory committee, not a single workers' school or revolutionary holiday, etc. There is not a single work on which it would be possible to put the date 1922...'.[13]

On the other hand a approving report appeared by Baratov in the journal *Bednota* which took pains to lambast 'left' artists with their distortions and inaccuracies. Such artists 'show a Red Army man with squinting eyes and a triangular nose, while a peasant is shown as almost a kind of monster... In a word it is an absurdity; the beauty, the grandeur of the worker-peasant cause, its newness in the history of mankind, goes completely unreflected in the concoctions of these scribblers and daubers'.[14] For Baratov, the matter seemed to come to this: 'if occasionally real life has been depicted unskilfully, then this is just a matter of time, for the comrades are working on it ...'. And in any case the lesser works were 'outweighed by the fine examples from Arzhennikov, Bashilov, Bogatov, Vladimirski, Kostyanitsin, Lvov, Malyutin, Malyshko, Perelman, Pokarzhevski, Freshkov and others'. Even Kozlov, the typesetter of *Bednota*, was pictured at his machine. Portraits of figures in the Trade Union movement were also finely executed. 'Here', says Baratov, 'you see your real self and your life... we must wish the comrades of the Association every success'.[15] Indeed, they had it. The entire exhibition, which had been planned to coincide with the Fifth Congress of Trade Unions in Moscow, was purchased by the Trade Union administration and formed into a new Museum of Labour, with many commissions for comparable works coming in its wake.

As the events surrounding these early exhibitions show, *AKhRR*'s immediate popularity with Trade Union and Red Army officials placed it in both an enviable but at the same time a highly problematic conjuncture. Aleksei Volter tells us in his reminiscences how the organisational base of *AKhRR* was expanded rapidly after its formation. It soon contained (like most state organisations) a Party cell of which he, Volter, was the leader.[16] This would be required to transmit Party policy and oversee discipline – even if a Party 'line' on the arts was by no means yet formulated. A publishing group was formed under Perelman, a Production Bureau for manufacturing prints of works of art was formed, also under Volter, and an Exhibition Bureau and an Information Bureau quickly followed (1923 and 1925 respectively). No other artistic organisation of the time had such an extensive and powerful infrastructure.

Nor did any other group have such influential friends. *AKhRR* artists were beholden to the charisma and power of senior state and Party personnel, several of whom, for better or worse, were either amateur artists themselves or had strong views on the arts. In practice there was a price to be paid for these friendships: an inevitable loss of independence and an intensification of stylistic resources within relatively narrow boundaries. This notoriously extended to Red Army stalwarts such as Kliment Voroshilov, a close ally of Stalin who appears in many *AKhRR* canvases, both of this period and later. Pavel Radimov tells us in his memoirs how he visited Voroshilov on the occasion of the Fourth Comintern Congress, late in 1922:

> I went to see him in his small room at the National Hotel [in Moscow] to talk about the proposed Red Army Exhibition [that of 1923]. I did a sketch painting of Voroshilov, and also of Budenny, who was there at the same time. Comrade Budenny jokingly commented that it was much easier to take part in a battle than to pose for a painting. On looking at the study I had done he became carried away, and, seizing the brush, corrected his portrait a little. I left the hotel inspired by the comradely conversation I had had'.[17]

The question of Trotski's views on the visual arts is particularly fascinating in such a context, since as People's Commissar for Military and Naval Affairs and as Lenin's closest ally in the leadership he was clearly a key figure. It is of course all the more interesting in that Trotski was a gifted literary critic and a brilliant writer and debater. His major statement of the early 1920s, *Literature and Revolution*, was published late in 1923 and indeed contains penetrating analyses of Futurism, Tatlin's Tower, and avant-garde writing (such as that of Mayakovski), but little on painting or sculpture – except for the following comment. It comes in a passage on what Trotski calls the *ralliés*, meaning those who have 'accepted the reality of October but without assuming any responsibility'. They are silent when it suits them, says Trotski, but take part sometimes, when they are able. They are

> pacified philistines of art, its ordinary civil servants. They are not ungifted, and indeed we find them everywhere … [they] paint 'Soviet' portraits and sometimes great artists do the painting. They have experience, technique, everything …. Yet somehow the portraits are not good likenesses. Why? Because the artist has no inner interest in his subjects, no spiritual kinship, and he paints a Russian or a German Bolshevik as he used to paint a carafe or a turnip for the Academy, and even more neutrally, perhaps. I do not name names, because they form a whole class… Although these *ralliés* will not snatch the Polar Star from the heavens, nor invent smokeless powder, nevertheless they are useful and necessary, and will be the manure for the new culture. And that is not so little.[18]

If this double-edged passage is about the *AKhRR* painters – as it must

surely be – then the fact that neither the group nor its individuals are named may well be significant. Trotski may have wanted to appease his military colleagues. On the other hand, the book was written during the summer of 1922, when Trotski had taken time off from politics at what was a crucial moment in his political career. He had already reacted in a lukewarm manner to Lenin's efforts to move against Stalin for his rudeness, and he had also rejected Lenin's offer to make him, Trotski, Vice-Premier: two errors of judgement that history does not easily forgive him. He had also conciliated with the 'triumvirate' of Zinovev, Kamenev and Stalin in ways that showed little awareness of their barely concealed hostility towards him. Trotski's verdicts on the *AKhRR* painters – if that is what they are – may also rate as examples of the kind of statements about culture for which he was so mercilessly attacked later by the Stalin group. In effect he had both condemned and approved the *AKhRR* formation in one and the same breath. The subtly 'dialectical' tone of *Literature and Revolution* was to stand him in poor stead in the treacherous political climate then developing.

It is also very instructive to look at the views of Lunacharski on the *AKhRR* artists and exhibitions in the early and middle 1920s – for his critical voice too was capable of many a subtle inflection. As Commissar for Enlightenment after 1917 he is popularly supposed to have supported the avant-garde to the exclusion of all others. Yet like Lenin he was instinctively conservative in matters of taste (his plays are written in a thoroughly retrograde style), and he was by no means opposed to the *AKhRR* – indeed, he spoke very frequently in their support. An example is the ceremony on 9 May 1923 to honour Nikolai Kasatkin as a People's

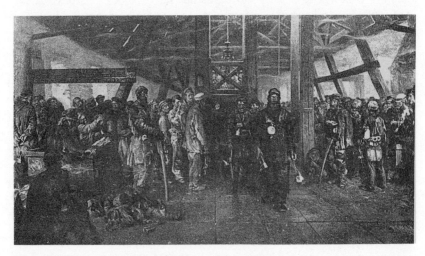

3.1 Nikolai Kasatkin, *Miners Changing Shift*, 1923

Artist of the Republic (at sixty-four he was a senior figure in that milieu), at which Lunacharski proceeded to play off the claims of the 'modernists' against their 'realist' detractors. The basic idea of the Cubists is 'to construct the data of nature in the manner of a crystal, to give it logicality, order and principle – hence the leaning towards geometricisation. Here, human orderliness is set over against the order of nature'. And in this, says Lunacharski, 'there is only a sign of the recently intensified instinct of the bourgeoisie to plan and to organise its preconceptions. Yet such a metaphysical art cannot alter the appearance of the world.' Cubism he describes as a 'fricassee of actuality and metaphor which cannot change nature'; in any case it is handled in a 'chancy, arbitrary manner' by the Cubists themselves. Bourgeois art, he says, having lost its way, 'now takes a stone for bread'.[19]

And yet Lunacharski's defence of *AKhRR* is by no means a simple one. He makes it clear that merely providing a mirror of reality is not enough – no more so than the modernist idea of painting as 'a world in itself'. And yet the most powerfully tendentious art will rise above tendentiousness, he says. Firstly, in overcoming 'the revulsion to themes and content in art, the importance of the *idea* was paramount'. The idea 'must organise a whole series of previously determined moments of the spectator's experience... and thus ignite the soul of every person who sees it.' And Kasatkin, in this context, 'knows what to say to the worker, to the peasant, to the Red Army soldier... this artist is close to the working class' (Figure 3.1). Lunacharski believed that Marxist ideas would operate as it were subconsciously. And

> what grandeur there is here, what oportunities to influence the flow of events by means of the elements of art... acting specifically upon the emotions and will of the people. *This* is the sort of art that I call agitational. And I would like artists coming up from the working class to have an effect upon present and future society... such an artist must be a realist.

Moreover other artists must learn the three things that Kasatkin knew: 'a maximally intelligible language, the presence of deep, lived experience, and an attempt to penetrate the inner world of the people, not in its backward layers, but in its front ranks, in its Communist Party.'[20]

Of course this was an official speech; and yet it shows that Lunacharski was prepared to nourish the debate about 'realism' and 'modernism' with a philosophical position in which 'form' was not placed over against 'content', but was integral to it; where the 'idea' was imperative, and could organise perceptions and experience in a genuinely Marxist way. One of the perplexing aspects of *AKhRR* painting and sculpture in the mid-1920s was precisely that it lent itself to *both* the relatively simple tastes of the likes of Voroshilov and his ilk, *and* to several (and not always consistent) theorisations based on Marx and Lenin viewed through the prism of contemporary ideology.

In fact, contrary to what is regularly written and said, the progress of *AKhRR* in the years between the mid-1920s and 1932 is extremely complex. Not only did the Party find cause to agonise internally over the definition of an artistic policy in 1924-5; the middle 1920s were also the years in which other visual arts groups flourished, many of them wrestling with similar problems of defining a theory and a practice of art that were consonant with an evolving Soviet reality, one that was itself fissured along the lines of strict proletarian consciousness and the struggle for a 'classless' society, contrasted with a modicum of market competition and relative cultural tolerance. The space of this extraordinarily acute dilemma contained some of the most interesting formations of the period: among them *Chetyre iskusstv* (Four Arts), the Society of Easel Painters (*Obshchestvo stankovistov*, acronymically *OSt*), *Makovets*, *Bytie*, the New Society of Painters (*NOZh*), and many others. All of them were to some degree figurative; most made claims for 'realism'; most defined their own 'path' in art as contemporary, engaged and relevant; and all of them to some degree depended upon the state – in spite of the market – not only for recognition but for financial and material support.

This is not the place to examine the varied and often impressive work of artists of the quality of Adlivankin, Petrov-Vodkin, Istomin, Kuznetsov, Saryan, Deineka, Labas, Luchishkin, Shterenberg, Pimenov, Vilyams and literally dozens of others – artists even today virtually unknown in the West.[21] The issue is how the state (and indirectly the Party) could respond to the many claims made upon its attention without compromising its evident sympathy for *AKhRR* as a truly popular, Bolshevik organisation and style.

The debate on aesthetics within the Party in the early part of 1925 issued in a Resolution entitled 'On the Party's Policy in the Field of Imaginative Literature', which was almost certainly intended as a directive to workers in the other arts. Largely orchestrated by the still moderate Bukharin (one of Lenin's favourite younger Bolsheviks and himself an amateur painter), the Resolution was careful not to concede hegemony to the zealous proletarian groups, *nor* to grant complete freedom to the so-called 'fellow-traveller' writers who were wavering in their support for a communist line and wished to proceed within the limits of their own definition of 'art'. Instead, the policy was that all groups should compete for credibility in the eyes of the Party within a framework of broad support for a communist world-view – but *not* that manner or style should be prescribed.

The Resolution on literature is widely regarded as a subtle compromise between extremes, promulgated in at a time when the younger communist cadres brought into the Party after the death of Lenin were agitating for a much 'purer' line in literary (and artistic) affairs than was compatible with the sort of relatively relaxed civil life established under *NEP*. It is at least

3.2 Opening day of the *AKhRR* exhibition 'Life and being of the peoples of the USSR', Gorki Park Moscow, 1926

arguable therefore that the delicate balance achieved by the Resolution was shattered by the dramatic turn of events within the Party after 1925. Trotski was now openly in disfavour, and was pushed out of the Commissariat for Military Affairs (even Mikhail Frunze, Trotski's successor and a friend of *AKhRR*, was quickly removed in favour of Voroshilov[22]). *NEP* itself was now increasingly under pressure from those who believed it to be a form of 'backsliding' into capitalism. The result, eventually, was the overthrow of *NEP* and the assertion of doctrinaire rules of culture which in their worst manifestation were repressive and ineptly administered.

What we are concerned with here however is a moment before that final destination, in 1926, when the fate of Soviet culture was still – if we do not read later events back into the period – in the balance. A significant occasion in 1926 was *AKhRR*'s massive eighth Moscow exhibition entitled 'Life and Being of the Peoples of the USSR'. At well over four times the size of the previous largest *AKhRR* show, it featured some 298 artists from all corners of the Union and displayed over 1,700 works. The opening day was declared a public holiday (Figure 3.2) and the main speech was once again by Lunacharski.

In terms of affiliation the eighth exhibition was diverse, and as some critics pointed out, the exhibitors included members of previously disparate groups, such as the Jack of Diamonds, the Union of Russian Artists and the World of Art. Struchkov, for example, emphasised that while some artists from these groups brought to *AKhRR* refinement and

craftsmanship, it was from *AKhRR* that they 'received their political school-ing'.[23] Generally, the number of submissions per artist was far greater than before. Older masters such as Arkhipov as well as younger painters like Nikolai Belyanin, Fedor Bogorodski, Boris Vladimirski and Aleksandr Grigorev submitted two or three times their previous quota. Several submitted works for the first time: the sculptors Mikhail Babinski and Aleksei Babichev (the latter from *InKhUK*), the painters Aleksandr Gerasimov, Pavel Istomin, Boris Komarov, Aristarkh Lentulov, Matvei Manizer, Robert Falk, Nikolai Shestakov, and many others whose names are hardly known.[24] Considerable numbers of paintings were submitted by the mainstays of the Association: fifteen by Volter, forty-three by Deikin, twenty-nine by Karev, eighteen by Katsman, twenty-six by Kiselis, forty-five by Korygin, twenty-one by Kotov, twenty-nine by Kustodiev, twenty-eight by V. Kuznetsov, thirty-four by Lekht, forty-four by Ilya Mashkov, forty five by V. V. Meshkov, seventeen by Radimov, sixteen by Serafima Ryangina, fifteen by Georgi Ryazhski, fourteen by Yuon, and so on. Viktor Perelman showed his *Blue Blouses* (Figure 3.3), and Isaak Brodski his *Shooting of the Twenty-Six Baku Commissars*.

3.3 Viktor Perelman, *Blue Blouses*, 1926

Lunacharski's address clearly echoed the dominant Party line in 1926 in stressing national unity and self-consciousness.

The artists of the AKhRR have travelled throughout the boundless expanses of our Union; the exhibition reflects both Murmansk and the Crimea, the Donbass and the Causasus, Riga and Siberia with their totally distinctive and unforgettable characteristics of countryside, atmosphere, sunset illumination and conditions of life. It is a kind of vast and highly artistic report of what sorts of surroundings the numerous peoples of our Union live in.... the exhibition has not only an artistic but a geographical and ethnographical character; and this is precisely because these disciplines fall within the general task of 'knowing thyself'.

The portraits, he believed, represented 'the organisers of a completely renewed social being, hitherto unknown in human history ...' The landscapes represented not merely a genre, but 'a vast stratum of an old type of existence, through which the sprouts of a new life are struggling'. Varied working habits were depicted, and not just the furnaces and workshops of the city. The exhibition would appeal to all tastes, to formalists and the masses alike, because it provided 'such an imposing, heartfelt lesson in what our Union is'.[25]

Lunacharski's encomiums were supported by the critic and literary historian P. S. Kogan, a one-time supporter of *Proletkult* leader Aleksandr Bogdanov and by then an establishment figure and President of the Academy of Artistic Sciences. The new patron for art, the state, could now be viewed as benevolent, supportive and vivifying – this was the substance of Kogan's address. 'Comrades, there are only two methods for the creation and execution of works of art', he said;

One method arose in the era of chamber art, when there were rich, closed salons where those of refined interests and a highly tuned sensibility, both rich and titled, admired works of art alone, in his own room... and then there are other eras, of monumental art, when the artist... feels his heart beating in unison with the hearts of the creative classes, of the people themselves, when he feels that the place for his work is on public squares, in front of the masses, or in grandiose surroundings which attract people by the thousand.

AKhRR, he said, was forging a monumental style in similar fashion, 'not from inside studios and workshops, but from the depths of people's lives. Above all, because it passes from content to form and not the other way round, *AKhRR* is creating great possibilities for art.'[26]

But these official statements were only the beginning of a hard-fought and protracted critical debate. After the pyrotechnics of the opening ceremonies, the first salvo was fired by Pavel Novitski, rector of the *VKhuTeMas* (Higher Artistic and Technical Studies) from 1923 to 1926 and clearly something of a friend of 'formal' art. 'We cannot and will not join in the official songs of praise of *AKhRR*, which are touched off by the

mere mention of the revolutionary themes and subjects that are in the eighth exhibition', Novitski wrote in *Sovestkoe iskusstvo* in June. 'It is not enough to write under an ordinary portrait of a passive portrait the words 'Active Komsomolka', or under the portrait of an old farmer 'Chairman of the *VolIspolKom*'... this is nonsense.' Novitski then asks what difference there really was between the 'sickly, tasteless and dull portraits of Revolutionary and Party officials painted by Katsman, and the drawing-room portraits of generals painted in Tsarist times'. He lamented the 'endless pile of indifferent material from ethnographic museums'. This is the kind of 'rough, amateurish style that provincial drawing masters taught to the workers and working youth in countless art circles... Where is the pathos of struggle and construction, the powerful surge of art into our lives that will help to mould it creatively?' For most of the artists Novitski had only relentless abuse; the majority were 'archaic people from the past', whose fate it was 'to fill the dusty rooms of provincial museums and to decorate the foyers of state theatres...'. The Cézannists Mashkov and Lentulov, who Novitski conceded were 'great masters', had no affinity for the Revolution anyway, whereas Arkhipov was the only artist who had managed to keep his mastery and intelligence. 'But what does he add to the past?' Novitski asked. 'What will he give to the future? In a word: a decisive methodological retreat; revolutionary slogans and reactionary practice; dictatorship of the bourgeoisie in a monumental form...'.[27]

Novitski's article sparked off a host of reactions from friend and foe alike. No less a person than Robert Pelshe, director of art for *GlavPolitProsVet* and editor of *Sovetskoe iskusstvo* issued the first reply. Agreeing with Novitski that the exhibition contained much that was amateurish and incomplete, Pelshe commented that

> Comrade Novitski is not making a judgement as a Marxist dialectician, but as an idealistic and entirely subjective metaphysician... if he demands the immediate creation of a completely revolutionary form in painting... He overlooks the fact that new monumental forms don't jump suddenly out of an artist's head... but can only be produced through a programme of development, hard work and tenacity, sometimes even taking whole generations.

He then makes an argument that seems to have been common among the supporters of AKhRR: that acheiving what he described as a 'scientific Marxist understanding of the world' implied a materialist approach to art; which in turn implied 'realism' as the true and proper method for art.

But unlike those who might have made a vulgar identification of materialism with naturalism, and of naturalism with 'realism', Pelshe seems to be committed to the view that 'realism' is more than mere pictorial naturalism; his frequent reference to 'revolutionary form' is some kind of evidence for that. His case against the modernists amplifies his view. Broadly, he was hostile to the European art movements of the

'bourgeois' period which 'distorted' appearances, because they seemed to do so arbitrarily, quite aside from being alien to the masses (which in an obvious sense they were). Pelshe described his 'realism' as being contingent upon the 'extremely complex conditions' of art in the revolutionary epoch: but much more than that he does not say. In fact it comes as something of a disappointment that his arguments degenerated into mud-slinging and abuse. The *AKhRR*, he said, had

> gained the respect of all those who are not suffering from the mental disease of the 'left' radicals, and for having fought against Futurism, Cubism, Expressionism, Verism, Dadaism, Suprematism, against foolishness and laziness, against careless indifference and doubt; for all of which AKhRR substitutes quality, responsibility and craft.[28]

The tone of an opening announcement in *Zhizn iskusstva* (Life of Art) suggested that its debate was also to be far from dispassionate. 'The Editors want to open a discussion on the ideological and artistic principles of *AKhRR*, the most important association in the field of representational art, with an article by Secretary General of *AKhRR*, Comrade Katsman...', it said. Katsman's piece, entitled 'Let Them Answer!', erected some stark contrasts between *AKhRR* artists and the 'left'. Previously, says Katsman, the 'left' were able to

> guide the artistic development of the whole of the USSR. "Left" artists ran the art schools and appointed each other as professors and lecturers. They had their own teaching methods. "Left" artists decided how celebrations were to be organised. "Left" artists ran museums... [they] controlled the book market for eight years with their "left" literature... they had their own studios, the best paints, the best brushes, the best canvases...

Yet what did they do with all this, Katsman asked? 'Nothing, or almost nothing.' He believed that 'nothing could save those who had learnt from 'left' artists such as Picasso, Cézanne, Matisse or Marinetti; that their 'intellectualism and their individualism did not fit anymore into the epoch of the workers' and peasants' Revolution'. In fact he felt that the very terminology of 'left' and 'right' was apt to mislead; that there were artists of other groups, whose contribution was not at all insignificant. Clearly Katsman believed that the so-called 'fellow-travellers' had a legitimate role to play.

In the week following Katsman's challenge there appeared in *Zhizn iskusstva* an important short article by an author who identifies himself only as 'V.B.', demonstrating a prescient grasp of arguments that only became current much later. Under the heading 'About the Realism of the "Lefts" and of *AKhRR*', V.B. points out that 'For a long time no art concept has caused so many confusions as [realism]... the idea became elusive, had many meanings, and in the end explained nothing. The word 'realism' is

now as empty as heaven...'. V.B. goes on to argue that although *AKhRR* appealed to 'truth', to 'truthfulness' and to 'impressions of life, which stand above talent and mastery', it is nevertheless 'difficult to imagine anything more unspecific in its relationship to class, anything more historically colourless or theoretically obscure than this absolute 'apprehension of truth' which the *AKhRR* speak of'. In fact – and here is the centre of V.B.'s productivist-like argument – the very concept of 'realism', or 'truth', is now only a historical relic; 'we are dealing not with an absolute norm, but with a quantity which changes with history'. For us, says V.B., the realistic approach of greatest value is one which 'reforms material reality and thus follows the efforts of the revolutionary class. This way lies not reflections, as in a mirror, but the creation of real things'.[30]

But this was not the line most frequently taken with *AKhRR*. M. Brodski (no relation of the painter) wrote to *Zhizn iskusstva* late in July offering the view that 'things are looking bad for *AKhRR*... they take the path of least resistance where technique and ideology are concerned'. They have descended to 'landscapes, bourgeois cosiness, geraniums and guitars'. Kustodev, Katsman and Grigorev were 'good-for-nothings... wouldn't it have been better to send 5 or 10 good cinema people to record the life of our country, rather than 100 artists?' Brodski asked. *AKhRR*'s show was 'not a triumph in art; only of the transitional political-economic and social phase which we are leaving slowly but gradually behind us'.[31]

Katsman's previous challenge to the 'left followers of Picasso and Cézanne' also produced some responses. I. Rabichev pointed out (*contra* Katsman) that Cézannism had already entered *AKhRR* in the persons of Falk, Mashkov and Lentulov – in a sense it certainly had. In any case, argued Rabichev, *AKhRR* was not mass art, nor was it knowledgeable about the life of the workers and peasant masses. 'Workers know their factories and the farmers their villages far better than the *AKhRR* artists... any photograph can record these things far better than the simple-minded incompetents of *AKhRR*'.[32]

Boris Arvatov, theorist of production art and already familiar from his contributions to the Moscow *InKhuK* (Institute of Artistic Culture) and to *LEF*, also attempted to rally *AKhRR*'s opponents. Futurism, Suprematism and Cézannism are not necessarily 'left', he said, but rather a product of a particular post-revolutionary period. And many useful devices had been created in that period, witness montage (as he pointed out, the very style in which Katsman's article had been printed). Arvatov, too believed that *AKhRR*'s efforts would be rendered redundant by the development of widespread colour photography, and by the final overcoming of the 'lack of culture' typical of old Russia.[33] Nikolai Chuzhak, finally, also of *LEF*, weighed in with a series of points of his own. *AKhRR* tried to avoid abstraction in order to 'not insult the Revolution in the eyes of the

international proletariat', to use *AKhRR*'s own words. But in that case what are Radimov's *Bridal Gathering in the Volga Region* and Lentulov's *Dutch Feastday*, if not such insults? More heroic servility than heroic realism, *AKhRR* artists had now taken to the habit of 'crawling around the stables of their patrons' in an unseemly craving for favours, said Chuzhak – a charge that was in large measure true.[34] But by November 1926 the debate in *Zhizn iskusstva* was pronounced 'over' by the Praesidium of *AKhRR* – in itself a sign of the control which *AKhRR* now had over its critics. In a final article, the Praesidium insisted that the notion put about by *LEF* and other groups that easel painting was obsolete had proved mistaken. 'Easel art did not want to die, and *AKhRR* proved that it still had a long and glorious life in front of it.' *AKhRR*'s aim was to find 'a balance between form and content', a balance which it would eventually achieve 'in a more devloped epoch'. A single word characterised its ideology now, according to the Praesidium, that of *massovost* (mass-ness). *AKhRR* wished to include 'literally millions of spectators' in the sphere of fine art; 'One has to understand this word [*massovost*], feel it deeply inside of you, comprehend it completely, and then look at the achievements together with the faults of *AKhRR* with a new eye.' 'Whatever else may be said, does not the intense controversy aroused by the eighth exhibition show how strongly the Soviet public is reacting to the movement known as *AKhRR*?'[35] Such was the characteristic language deployed by *AKhRR*'s critics and supporters in 1926. It suggests the existence of a powerful lobby, indeed of persons in high places who felt it their business to expound a popular, national and in some sense 'realist' art.

But we must remember that *AKhRR* was at no time a fixed or inexorable phenomenon. In assessing the artistic claims of *AKhRR* to represent a broad communist consensus it is of no little importance to agree upon which phase of the Associations's work one is discussing. The formation of *AKhRR* in early months of 1922 suggests a historical role for the Association very different from that which is usually imputed. Lenin's insistence on 'assimilating and using' the culture of the pre-revolutionary period, rather than 'throwing overboard' the giants of previous art and burning the museums (as the 'avant-garde' and 'left' were advocating) is only one of the factors which attended the birth of this style.

Equally, it must be true that no amount of persuasion by the Party leader could have determined the nature of *AKhRR*'s characteristic approaches: its naturalism, its 'documentary' aspirations, its forbearance in the face of modernist self-reflection, its attempt to unite something it saw as a 'tradition' with the cultural needs of a notional 'proletarian class'. It is undeniable that the relatively low educational attainments of this class – a high percentage of whom could barely read or write – was another factor which militated against desires for hegemony on the part of the 'left'. **67**

3.4 Aleksandr Deineka, *The Defence of Petrograd,* 1927

Certainly it is impossible to assert, given the Party's own uncertainties and dilemmas in 1922, that *AKhRR*'s manner was somehow 'imposed' from above, even if, as is now evident, it quickly added the support of military and trades union bosses to the already powerful opinions of Lunacharski, Lenin and Trotski and against those of 'leftists' like Bukharin and Kerzhenstev.

By mid-decade, say 1926, it still seems to me far too early to say that *AKhRR* was *nothing more* than a reflection of official Party policy in the arts. By that time very powerful in organisational terms, its aesthetic position can best be described as a re-working and extension of certain aspects of Russian nineteenth century painting within the framework of a class-conscious engagement with contemporary Soviet reality. At the same time it can be argued that the work of the *AKhRR* painters and sculptors achieved little if not a re-appraisal of the very idea of 'tradition' in the wider context of 1920s art. If 'tradition' means 'that which is handed down from one generation to another',[36] then assuredly *AKhRR* was not 'traditional', since its connections with the *Peredvizhniki* and other 'social realisms' of the later nineteenth century were constructed and selective: actively adopted rather than passively received, they were novel modifications of, and variations on, those nineteenth century practices

rather than exemplifications of a 'generally accepted custom or method of procedure'.[37] Indeed, in common with other European 'returns' of the early and mid-1920s such as *Neue Sachlichkeit*, *Pittura Metafisica* and Cubist classicism, *AKhRR* painting and sculpture can just as plausibly be referred to as an alternative modernism to the one we know and worry about – no less dynamic and future-orientated than the more familiar one (conceivably on occasion even more so), but whose face-off with the art of the past was conceived as assimilation rather than overthrow.

For the historian of the present, the dilemmas of interpreting *AKhRR* between the time of the 1926 exhibition and the 1932 Decree 'On the Reconstruction [*perestroika*] of Artistic and Literary Organisations' are very different in kind.[38] The salient development of 1926 and 1927 was the crisis of the New Economic Policy and the manoeuvering of the top echelon of the Party against Trotski's rapid industrialisation programme, which in concert with a paranoia of national isolation led to desperate moves in the countryside by the beginning of 1928.

Until the beginning of that year official state and Party ceremonials remained near the centre of *AKhRR*'s work. A major exhibition of February 1928 entitled 'For the Anniversary of the Workers' and Peasants' Red Army' (in fact its tenth anniversary) provided a display of 'documentary' easel painting that celebrated a host of earlier military achievements. Commissioned the year before, the show contained such works as Mitrofan Grekov's *The Batle of Egorlinski*, Aleksandr Gerasimov's *The German Invaders in the Ukraine in 1918*, Aleksandr Deineka's famous *The Defence of Petrograd against Yudenich in 1919* (Figure 3.4), Konstantin Savitski's *The Spontaneous Demobilisation of the Old Army in 1917*, Isaak Brodski's *The Conference of the Revolutionary War Council in 1926*, and many more.

The path furrowed by *AKhRR* in the last years of its life was not in the event a smooth one. Tensions within the organisation grew, the most damaging of which was the disagreement between the younger 'proletarianising' cadres who tended in the direction of mural art, agitational work in factories and 'team-work', and the older members who still favoured the epic oil-painting genre (Plate I). Plagued by criticism from 'left' groups such as the brave and very talented *Oktyabr* as well as from youthful proletarian zealots within its own ranks, it became, like other cultural organisations of the First Five Year Plan period, a testing-ground of ideological position in which the actual production of art sometimes took second place to frenetic, almost rabid proselytising on every side. The immediate outcome was the 1932 closure of all the contending groups and the start of active command of culture by the organs of the Party, in which the theory and practice of 'Socialist Realism' – never fully or finally defined as a style in the visual arts – began to be elaborated.

A final word is in order about contemporary persepctives on the work of *AKhRR* and the problems of its increasingly complex legacy. An important question that has not yet been addressed concerns relations between this 'forgotten' manner and recent debates about, and the practices of, 'realism'. On the one hand it must be acknowledged that the term 'realism' is today a highly contested one; that its associated practices have leant heavily upon the writings of mid-century theorists of the stature of Brecht and Benjamin, concepts of irony and displacement, and debates around the nature of photographic work. While some critics elevate notions of fragmentation and aesthetic displacement as essential to contemporary definitions of 'the real' – hence drawing upon Brechtian concepts and refusing the possibilities still inherent in the 'naturalist' legacy – some see all 'realisms' as equally out-moded, given the current context of information expansion and overload. Jean-François Lyotard, for example, has famously claimed that 'the so-called realistic representations can no longer evoke reality except as nostalgia or mockery, as an occasion for suffering rather than for satisfaction'.[39] Lyotard mentioned that this was the result of a process of increasing 'derealisation' of all familiar objects, social roles and institutions.

So far as *AKhRR* is concerned, Lyotard's thesis – in many respects a plausible (if pessimisitic) prognosis for our time – will have to take account not of the familiarity of *AKhRR*'s manner to Western audiences, but of its very unfamiliarity. The details of *AKhRR*'s determining influence upon subsequent Soviet art are only just beginning to emerge. But equally, the end of the Cold War is now making it easier for us to see that 'modernisation' comes in a variety of guises, some of them apparently traditional while still being simultaneously utopian and functional *vis-à-vis* a notional group or class – this is something which *AKhRR* shared with the so-called avant-garde.

More importantly, political changes in Eastern Europe in the past few years have opened Western curiosity to a kind of art whose afilliations with early Soviet socialism are (at the least) curious and absorbing.

Yet, since Western socialism has long since departed from the revolutionary traditions of 1917, it is no longer entirely a question of whose socialism and whose revolutionary art one is espousing. In the case of *AKhRR* and most of early Soviet painting outside the reaches of the avant-garde, it is certainly no longer mandatory to villify and anathematise the art of groups whose politics we may not share. Above all else, now is a time for revisions and reconciliations, as well as new explorations. And that surely is to be welcomed – if the Iron Curtains of twentieth century culture are finally to fall.

Notes

1 Among the pioneering publications are E. Valkenier, *Russian Realist Art: The State and Society: The Peredvizhniki and their Tradition*, Ann Arbor, 1977; H. Gassner and E. Gillen, *Zwischen Revolutionskunst und Sozialistischem Realismus, Dokumente und Kommentare: Kunstsdebatten in der Sowjetunion von 1917 bis 1934*, Cologne, 1979; among the more recent, M. Cullerne Bown, *Art Under Stalin*, Oxford, 1991, and my own *Art and Literature Under the Bolsheviks*, 2 volumes, London, 1991 and 1992, from which some parts of this account are adapted.

2 See the section 'The Debate Around Easel Painting 1922-24', in my *Art and Literature under the Bolsheviks*, 1.

3 *Katalog 47-oi vystavki kartin v tsentralnom dome prosveshcheniya i isskustva*, Moscow, 1922, reprinted in 'Deklaratsiya t-va peredvizhnikh vystavok, 20 Fevralya 1922', in V. N. Perelman (ed.), *Borba za realizm v izobrazitelnom iskusstve 20kh godov: materialy, dokumenty, vospominaniya*, (hereafter *Borba za realizm*), Moscow, 1962, p. 103.

4 N. Punin, 'Proletarskoe iskusstvo', *Iskusstvo kommuny*, 19, 13 April 1919, p. l; cited in E. Valkenier, *op. cit.*, p. 149.

5 J. Melnikov, '47-ya Peredvizhnaya vystavka', *Tvorchestvo*, 1-4, 1922, pp. 70-72.

6 Acmeism flourished as a literary method before 1914, and its main exponents were Nikolai Gumilev and Sergei Gorodestski and, later, Akhmatova and Mandlestam. For a brief account see V. Zavalishin, *Early Soviet Writers*, New York, 1958, pp. 41-60.

7 S. Gorodetski, '47-ya Peredvizhnaya vystavka', *Izvestiya*, 12 March 1922; *Borba za realizm*, p. 104.

8 *Ibidem*.

9 'Deklaratsiya Assotsiatsiya khudozhnikov revolyutsionnoi Rossii', June 1922; reprinted in J. Bowlt, *Russian Art of the Art-Garde: Theory and Criticism 1902-1934*, New York, 1976, p. 266.

10 'Deklaratsiya', Bowlt, pp. 266, 267.

11 This was the only work shown by Malyavin; and apart form a single work shown in the third exhibition he does not figure in the AKhRR listings at all.

12 A. Nyurenberg, 'Vystavka 'Zhizn i byt Krasnoi Armii', *Pravda*, 2 July 1922; *Borba za realizm*, pp. 123-4.

13 I. Topolev, 'Vystavka blagikh namerenii', *Trud*, 21 October 1922; in I. Gronski and V. Perelman (eds), *Assotsiatsiya khudozhnikov revolyutsionnoi Rossii: sbornik vospominanii, statei, dokumentov* (hereafter *Assotsiatsiya khudozhnikov*), Moscow, 1973 pp. 196-8.

14 Baratov, 'Iskusstvo revolyutsii', *Bednota*, 1 October 1922; in *Assotsiatsiya khudozhnikov*, p. 195. I have been unable to identify precisely what Baratov is referring to here, or whether, as may be the case, he is creating merely imaginary descriptions of 'typical' Futurist works.

15 Baratov, *ibidem*.

16 Other members were Grigorev, Fridrikh Lekht, Evgeny Lvov, N. N. Maslennikov, Georgi Ryazhski and Y. Malotsislennost.

17 P. A. Radimov, 'Pervyi god AKhRR' (1964), in *Assotsiatsiya khuzhnikov*, p. 101.

18 L. Trotski, *Literature and Revolution*, 1923, p. 37.

19 A. V. Lunacharski, 'Iskusstvo i rabochii klass', 3 May 1923, in *Assotsiatsiya khudozhnikov*, p. 258.

20 Lunacharski, *op. cit.*, pp. 257, 259..

21 These artists are covered in my *Art and Literature under the Bolsheviks, passim*.

22 Frunze met his death in an operation on his stomach, apparently at Stalin's command.

23 G. Struchkov, 'Vystavka *AKhRR*', *Krasnoyarskii rabochii*, 18 May 1926, in *Assotsiatsiya khudozhnikov*, pp. 241-2.

24 These include Barmachev, Belyaev, Brukman, Vasilev, Gubina, Dyubor, Kelinov,

Kolobov, Pervov, Sapozhnitov, Sichkov, Fradkin and the sculptor Yakerson. Lists of the artists and their works in the Eighth Exhibition are available in *Assotsiatsiya khudozhnikov*, pp 334-419.

25 A. V. Lunacharski, 'VIII vystavka AKhRR', in *Borba za realizm*, pp. 225, 226-7.

26 P. S. Kogan, 'Novaya systema tvorchestva', 3 May 1926; in *Assotsiatsiya khudozhnikov*, pp. 227.

27 P. I. Novitski, 'On the AKhRR: A Big Question', *Sovetskoe iskusstvo*, 6, June 1926; in H. Gassner and E. Gillen, *Zwischen Revolutionskunst und Sozialistischem Realismus: Dokumente und Kommentare: Kunstdebatten in der Sowjetunion von 1917 bis 1934*, p. 272 ff, from which all references are taken.

28 R. Pelshe, 'One Must Be Able to Cope'; Gassner and Gillen, *Zwischen Revolutionskunst*, pp. 274, 275.

29 E. Katsman, 'Let Them Answer!', *Zhizn isskustva*, 27, 6 July 1926; in Gassner and Gillen, *Zwischen Revolutionskunst*, p. 278.

30 'V.B.', 'About the Realism of the 'lefts' and of *AKhRR*', *Zhizn iskusstva*, 28, 13 July 1926, pp. 11-12; in Gassner and Gillen, *Zwischen Revolutionskunst*, p. 279. The identity of 'V.B.' remains uncertain. Although conceptually the writing has the tone and even the sophistication of Walter Benjamin, Benjamin's arrival in Moscow did not take place until later in the year. He did, however, take a critical view of *AKhRR*. See for example his *Moscow Diary*. ed. G. Smith, Cambridge, Mass. & London, 1986, p. 39.

31 M. Brodski, 'Tvorchestvo li?', *Zhizn iskusstva*, 3, 27 July 1926 pp. 8-9; in Gassner and Gillen, *Zwischen Revoltionskunst*, p. 281.

32 I. Rabichev, 'Ya otvechayu', *Zhizn isskusstva*, 31, 3 August 1926, pp. 8-9; in Gassner and Gillen, *Zwischen Revolutionskunst*, p. 282.

33 B. Arvatov, 'Otvet T. Katsman', *Zhizn isskusstva*, 34, 24 August 1926, p. 7; in Gassner and Gillen, *Zwischen Revoltuionskunst*, p. 283.

34 N. Chuzhak, 'Vokrug geroicheskogo realizma', *Zhizn iskusstva*, 36, 7 September 1926, pp. 5-6; in Gassner and Gillen, *Zwischen Revolutionskunst*, pp. 276-7.

35 Praesidium of the *AKhRR*, 'Otvet nashim protivnikam', *Zhizn iskusstva*, 43L45, November 1926, pp. 4-5; in Gassner and Gillen, *Zwischen Revolutionskunst*, pp. 286.

36 *Shorter Oxford English Dictionary*, p. 2225.

37 *Shorter Oxford English Dictionary, loc. cit.*.

38 A fuller account than is possible here is given in my *Art and Literature under the Bolsheviks*, 2.

39 J-F. Lyotard, *The Postmodern Condition: A Report on Knowledge*, Manchester, 1984, p. 74.

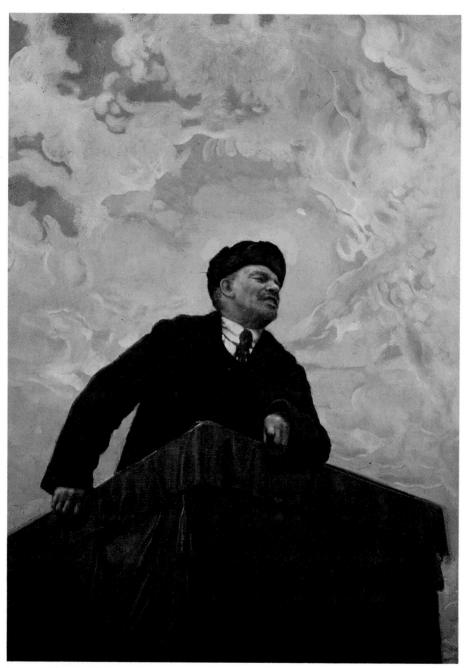

I Isaak Brodski, *V. I. Lenin on the Tribune*, 1927.

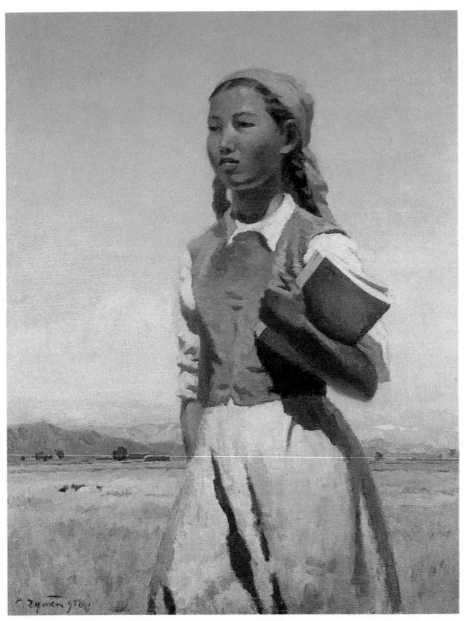
II Semyon Chuikov, *A Daughter of Soviet Kirgizia*, 1950.

III Aleksei Vasilev, *They Are Writing About Us In 'Pravda'*, 1951.

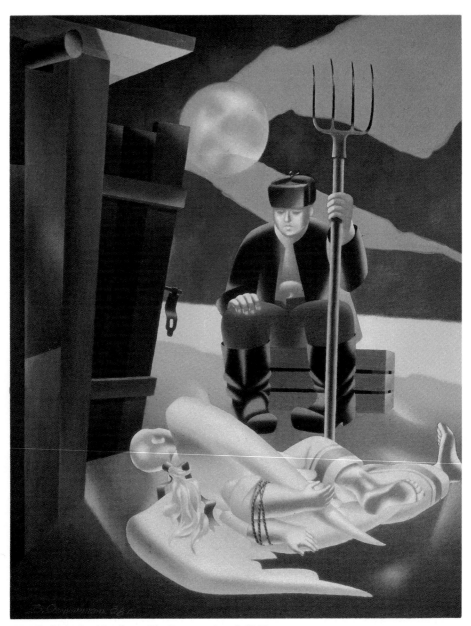

IV Vladimir Ovchinnikov, *The Russian Angel*, 1988.

Wolfgang Holz

4 Allegory and iconography in Socialist Realist painting

The function of art as a system of mediation between state and society has a long tradition in Russian culture, the most familiar example of which is the *Peredvizhniki* movement of the second half of the nineteenth century. Later, Tolstoi and Gorki in literature exerted an enormous influence on discussion of what was to be done, and how. Art has seldom been used less directly for political purposes, however, than in some aspects of Socialist Realism. Here, art was allocated a role close to that of mass propaganda on behalf of the programmes of the Five Year Plans. But the sign systems that were used to articulate this propaganda have rarely been analysed. Here, I concentrate on some general principles and a small number of examples from the 1930s.

It can be argued that the most striking semiotic strategy in Socialist Realist art is the principle of allegory – a cultural category that originates in antiquity. One critic has suggested that allegory again became dominant in Socialist Realism because of the traditional affinity of allegories with ideology in general, and more particularly because of the role of Soviet art in social planning, which tended to move art away from the hallowed ideas of individual 'insight' and 'expression'.[1]

The social and political implications of this aspect of Socialist Realism are well known in outline. According to Zhdanov's speech at the First All-Union Congress of Soviet Writers in 1934, the key concepts of *narodnost*, *tipichnost* and *partiinost* meant that art had to be socially relevant to the mass viewer from the Party's point of view, as well as understandable and instructive ideologically. In such a context, allegory became a natural first resort.

The common use of allegory by Socialist Realist painters might also be explained by reference to Stephen Greenblatt's observation that 'allegories arise in periods of loss, periods in which a once powerful, theological, political or familial authority is threatened with effacement'.[2] The immediate difficulty with such a hypothesis in the Soviet case is that it requires us to see the Stalin period of Soviet society as one of decline, which is very much the reverse of how it tried to represent itself externally. One is tempted to add to Greenblatt's hypothesis that the Soviet regime of the 1930s and onwards was indeed one of decline and possible effacement, and that it needed by a second strategy to make that possibility to all intents

and purposes publicly invisible.

This suggests that the category of allegory in Socialist Realist painting should be seen as part of a far wider aesthetic effort to find public approval for a type of society that was verging upon the totalitarian, in effect as an advertising agency for a societal form that had been deprived of its many national roots, and that this aesthetic was an aspect of the search for a cultural and political identity in which the nation collectively could believe. The main strategies through which allegory in Socialist Realist painting sought to underpin this propagandistic goal of reunification can be summarised under five headings.

The first I shall call the 'illusion of instantaneous progress' or 'the immediate equation of 'is' and 'will be''. The inner logic of the Five Year Plans as organisational models for Stalinist society required life, work and production to be perceived as a continuous and inexorable movement from one target to the next, according to pre-ordained norms. Thus life under the Five Year Plans conceived of contemporary existence – the 'is' – as a permanent progress towards future socialist happiness – the 'will be'. These kinds of utopian visions (which nevertheless differed from real utopias in the sense that they really were intended to come about) were expressed iconographically in various forms of allegory, which represented precisely this movement from 'is' to 'will be'.

Among the most common is that which plays upon the idea of 'marching forwards', in which the Socialist Realist painter portrays people making steps or marching towards a point outside the picture, where the viewer is located. Vivid examples of this semiotic practice are Boris Ioganson's *Students: the Workers' Faculty is Marching On* (1928), D. Shavygin's *At the Seaside* (1934), Aleksandr Deineka's *Donbass* pictures from 1932 to 1935, or S. Adlivankin's *Award* (1937), which actually has a young family speeding on a motorcycle with sidecar right into the viewer's space – an extreme example of motorised progress standing both for the over-fulfillment of the Plan and for the exultation resulting from it. Other iconographic forms of visualising this progress are such devices as widening and contracting perspective, citizens gazing towards distant points outside the frame of the picture, or diagonally dynamic structures which imply movement upwards and forwards.

A second strategy is the use of the 'carnival' of 'red' (i.e. communist) workers and peasants in stereotypical form. A simple illusion of 'socialism in one country' could be achieved by systematically colouring red everything that was to be semantically connected with socialist ideology in one way or another. It was not only the brashly coloured red banners that carried the insinuation of progress in Stalinist society; there were those fairy-tale-like 'colour allegories' – red blouses, headscarves, shorts and even practical equipment – that attempted to create the illusion of

ideologically transformed workers and peasants in all aspects of their every-day life and being. It is obvious that most of these motifs were simply disguises or 'models', not due to an overabundance of red in reality, but to a concerted effort to structure *represented* reality in 'attractive' ways. The colour itself, in the end, becomes an allegorical device and is recognised as such.

The manipulative mix-up of various reds – not all of them 'pure' communist colourations – then functions to connote socialist 'essence' as pervasive and almost 'natural'. It also made ideology accessible to the sense of sight and firmly associated with objects which could be known and understood. Plastov's red peasant women are as utopian as Deineka's *Collective-Farm Woman* (1935), who wears a totally red dress while cycling on a racing bicycle through the countryside. They are both ideo-logical allegories, present-day symptoms of a future socialist paradise. They helped, moreover, to make socialism as an abstract theory palpable to the mass viewer. They also revived a popular linguistic convention whereby red as colour (*krasnyi*) became identifiable weith the moral level of the beautiful (*krasivyi*) and thereby the good. Socialist Realism at-tempted allegorically to transform socialist ideology or 'redness' directly into objects of moral beauty or worth.

A third device was that of the New Soviet Man: the social body with a communist soul. In order to idealise Soviet man as a physical image and to categorise him (depending upon the number and quality of his abilities) into the production castes of the Five Year Plan society, Socialist Realist artists miraculously gave birth to living allegorical types. The properties of model workers and peasants shown in portraits of the 1930s were not meant to be actual individual traits, but physical signifiers of their social identification and importance. Persons in Socialist Realism were thus carefully defined social bodies whose physical properties were to be typical ideals for one production-sector of Stalinist society or another.

All those 'portraits' of tractor-drivers, factory workers, sportsmen and women by Samokhvalov, Ryazhski, Deineka, Gerasimov and others were not supposed to carry individual values or personal traits of character because their soul only exists – at least in representation – in the material emblems of their production-class, such as hammer, pick-axe, headscarf or worker's cap. So-called portraits of Soviet men and women thus effectively created a 'body culture' that sought to develop standardised heroic bodies for each particular production-class. In cases like Ryazhski's *Party Delegate* (1927) and *Chairwoman* (1928) (Plate I), the conditioning of the individual as socialist production-hero is underlined by the fact that the same women fulfills two different social roles, each of them defined only by the material role insignia: a man's heavy fur-coat and a red headscarf.

Stalin himself is seldom depicted in Socialist Realist portraiture without

75

emblems of leadership. This would seem to point to the fact that both his pictorial value as image and his personal value as individual were to be reduced to his social function as leader. This may be why, for instance, Stalin was frequently portrayed by Gerasimov (among others) in close physical 'body-relationship' to Lenin, in order to prove both his ability as leader as well as the legitimacy of his power.

And again, apart from their allegorical function of providing ideal production-types, Socialist Realist portraits often wear a kind of pretended spiritual pathos which is evoked by mysteriously blurred backgrounds – landscapes, skies or townscapes – which bear some resemblance to similar formal exercises in Russian icon art.

The fourth technique stems directly from this last observation and concerns the creation of 'socialist' and 'realist' icons. Apart from the obvious religious signification of the many Stalin and Lenin portraits, especially in the 1940s when the Stalin cult was at its peak, Socialist Realist art was generally rich in religious symbols and allegories. For example, both light and movement, as well as various socialist 'key symbols'[3] became prominent methods of allegorising a quasi-religious meaning. We find that many characters depicted on the canvas are illuminated by a mysterious sunny light. Art-historically this may be either an imitative technique, or a quotation from French Impressionism. In terms of the political meaning of Socialist Realism, this overabundant 'heavenly light' which falls on to the faces of the figures has to be brought into semantic alignment with the projected utopia of the Five Year Plans. Light then symbolises both the final state of socialist ecstasy, or the progress of socialist man towards this condition, an image of 'progress' associated with the very goals of the Five Year Plan. They should also be related to those classical utopias of European cultural history such as Campanella's *City of the Sun*, written in Italy in the sixteenth century. In such terms, Socialist Realist characters like Ryangina's young couple on the pylon (Figure 4.2) are ideal images of those 'chosen' by Stalin to live with him in socialist paradise.

A further pictorial method of advertising socialist creed in the 1930s was that of copying Aby Warburg's 'pathos formula'[4] – that is, the common practice in art reaching back to antiquity of portraying emotions or religious beliefs in external visual symbols. Garments of saints ruffled by movement or the flying hair of a Greek beauty on vases became formal translations of their inner states. Many examples of the 'pathos formula' can be found in Socialist Realism, where symbols are used to signify movement in space or time (according to the 'progress' ideal) as well as suggesting ideological zeal. Again, Ryangina's 'builders of socialism', with their hair blown by strong winds are perfect allegories of socialist saints moved by Stalinist 'spirit'.

In any comparison with Russian icon art, Socialist Realist paintings would have to be called 'socialist icons' as there is frequently a ready-made translation from the purely sign-culture of socialism into spiritual culture. The iconic symbol of cross corresponds to the socialist device of the hammer and sickle; Lenin's hands can often be formally equated with God's; Stalin thrusting his arms invitingly towards the socialist viewer outside the picture might be compared to the figure of Jesus Christ sanctifying religious viewers in real space. Members of the Politbureau turn into archangels, and tractors on the collective farm develop into the mechanised steeds of saints. Taken collectively, such socialist symbols form a coherent, hierarchical text of pseudo-religious allegory. This text then formed a kind of mass media for spiritual indoctrination and contemplation of the virtues of Soviet socialism.

The fifth main set of devices may be termed those of the 'dream theatre'. Art under centralised communism not only acted as a set of pseudo-religious allegories but also fulfilled ritual functions by integrating the viewer (and the mass to which he or she belonged) into the painting. In order to explain this theatrical 'communication strategy' between viewer and painting, Thürlemann has used the term *mise en abîme* (originally concieved by the literary theorist L. Dallenbach), which denotes the effect of 'mirroring' the viewer inside the picture both in order to manipulate the viewer's processes of perception and to represent the viewer as a fictional 'actor' inside a particular scene.[5] This aesthetic method – enlarging the viewer's psyche by inducing him into different realities of consciousness while simultaneously turning the act of viewing itself into a visual 'ritual' – is found in almost all Socialist Realist pictures.

One common method of integrating the viewer was to provide side characters who observe the main action as spectators. The viewer is then supposed to react according to his 'double's' reaction in the picture: with wonder, pride, happiness, sympathy, acclamation or awe. Other visual devices for the facilitation of the viewer's mental and psychological transgression into the paintings were *group confrontation*, i.e. groups painted *en face* which invite the viewer to become part of the collective; *discovering the unknown woman*, i.e. trying to attract the (male) viewer's curiosity through erotically presented back-portraits of women (for example Plastov's collective-farm festival); and *shop window illusions*, such as presenting cornucopian displays of food as in Ilya Mashkov's *Soviet Loaves* (1936), in which the viewer is encouraged to reach out and lift food from the canvas, but in the absence of the real thing.

Aesthetically manipulated, the viewer thus becomes physically and psychologially part of the 'ideological dream reality', a phenomenon Paperny refers to as a 'doubling of the world'.[6] Not only is the viewer left in doubt as to which world he belongs to, but he experiences himself as

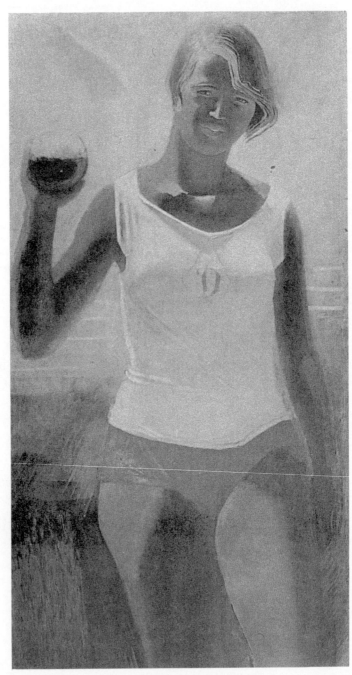

4.1 Aleksandr Samokhvalov, *The Shot-Putter*, 1933

simultaneously 'real' yet participating in a work of art. In this sense, Socialist Realism was created in the 1930s as a complex allegorical device, helping to transform communist society under the Five Year Plans into a unified ideological and psychological space, a *Gesamtkunstwerk*,[7] in which state and art could mix indissolubly.

Let us look at four particular Socialist Realist paintings in order to see some of these devices at work. The first is Aleksandr Samokhvalov's *The Shot-Putter* (1933) (Figure 4.1). Samokhvalov (1894-1971) specialised in portraying the New Socialist Woman whom he observed at sporting events or in physical labour on building sites. His *Shot-Putter* shows a sportswoman dressed in a white jersey, bearing the letter 'D', an abbreviation and symbol for the Moscow sports club *Dinamo* (although *Dinamo* was also the name of an electric factory that produced parts for the Moscow metro). She also wears red shorts. In her right hand she holds the metal ball. In the left corner of the background a zeppelin hovers almost casually in an illuminated sky. The sports fields and the race track are depicted in an abstract manner.

An element of the semantic structure of Samokhvalov's portrait is the use and the effect of light in relation to the girl's physique. On the one hand, the bright sunlight stresses her soft and delicate features (short, blonde hair that romantically covers parts of her face), and on the other hand places an enormous emphasis on her female attributes such as broad hips, thick thighs and full breasts. Two different roles of the New Socialist Woman are semiotically promoted by this strategy of light. First, romanticism as an obligatory trait of socialist woman; second, the ideal of the proletarian 'physical' woman full of masculine power as well as of femininity. Moreover the two ideals seem to be dynamically fused in a single complex body-portrait. What is on the surface a female shot-putter is in practice an allegory, whose sign language is that of the physical and which seeks in part to define socialist women exclusively as 'body beings'.

Simultaneously, the Russian title of the picture, *Devushka s yadrom*, mobilises another dimension in the portrayal of the New Soviet Person. Samokhvalov puts forward a general ideal of socialist humanity, culminating in the understanding of human physique as parallel to industrial machinery – the real ruling 'subjects' in the Five Year Plan society. By combining the alliteration of *devushka* (girl), *dirizhabl* (zeppelin) and *dinamo* into a semantic pictorial structure – condensed into the letter '*D*' – the New Socialist Person is assimilated to 'machine physique', and the concept of 'dynamic machine' is used to determine their function, movement and rhythm. Thus the *dinamo*-woman becomes totally identifiable with her 'dynamic' physicality. She succeeds in incarnating the ideal of the 'machine-body', inside which soul and physical body bear the dynamic tempo of the organised society.

My second example is painted by a woman, namely Serafima Ryangina's *Higher and Higher*, of 1934 (Figure 4.2). Ryangina's poster-like canvas shows a young socialist couple at work, climbing up an electric pylon. Judging by the minute houses and the train far beneath, they are at a height of five hundred metres feet or more above the ground. Both figures are dressed in work clothes, carrying a metal rope and a pair of pincers. If

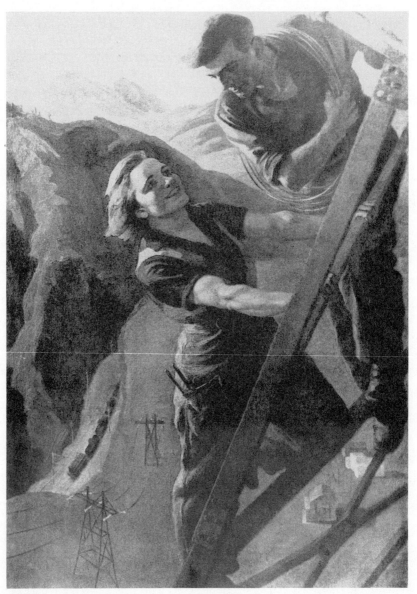

4.2 Serafima Ryangina, *Higher and Higher*, 1934

they were not standing on a pylon, it might be assumed that they were on a mountain tour, as the backdrop of mountain ranges seem to suggest. The man is looking intensely into the woman's face, and she herself is staring towards some invisible point near the top of the pylon. Both faces are brightly illuminated by the sun, and their hair is blown by the wind in order to indicate the movement of their actions as well as the pathos of their deeds. The couple's movement upwards is encouraged pictorially by the dynamic diagonal of the electric pylon that cuts right through the image. Neither beginning or end of the pylon can be seen by the viewer.

Ryangina's *Higher and Higher* represents an obvious panegyric to the idea of progress under the Second Five Year Plan. Read purely on the level of 'realism' alone, Ryangina's picture might be seen as advertising the State Electrification Campaign (GoElRo) that had been started by Lenin after the Revolution and was finished in 1930. Taking into account both the date of Ryangina's picture – 1934 – and the strategy of the Plan as a psychological impetus for pushing society to ever more ambitious production levels, the painting can be interpreted as semiotically imitating the oscillation between the 'being' of present reality and the 'will be' of collective production targets. The 'gaze of progress' is written upon the woman's face – she seems to be looking from the moment of the Plan defined into the realm of future happiness represented by the Plan fulfilled. The electric pylon is both sign of and means towards these goals.

Equally, Ryangina's image can be read back into the timeless age of Adam and Eve, an interpretation encouraged by the archetypal landscape and the 'couple constellation' at the centre. From this vantage-point, the viewer is asked to believe (or go on believing) that Soviet society is about to reconstruct paradise on earth, a socialist 'utopia' in which Adam and Eve walk around in overalls and carry screwdrivers.

My third example is Yuri Pimenov's *New Moscow* of 1937. The painting shows a street scene in the centre of Moscow, near the Bolshoi Theatre and Sverdlov Square. In the foreground, a young woman is steering a convertible along a boulevard-like prospect towards the House of Trade Unions (*Dom Soyuzov*), depicted in bright red colours. Pimenov's perspective is that of the viewer seated in the rear of the car, watching busy street life – black limousines, pedestrians and red trolley-buses. Next to the House of Trade Unions, and of the same height, are two neo-classical buildings, and behind these, in the distance (marked by the watered-down blue), the monumental architecture of the new Moscow. To make their skyscraper appearances more impressive – as if their tops were vanishing into the skies – Pimenov painted them only half-size.

The idea for this new type of socialist city, put into practice in Moscow at the end of the Second Five Year Plan (1932-7), very much conforms to a certain image of the Western metropolis such as Paris or New York. It was

intended to demonstrate social progress under Stalin's rule, with cars as symbols of technical achievements and women drivers as symbols of equal rights and opportunities. The dominant idea of movement, of a new rhythm of life achieved by socio-political progress, is intensified by Pimenov on a secondary level of meaning, which is both highly poetical as well as indicative of the architectural history of Moscow. In Stalin's 'General Reconstruction of Moscow' which began in 1934, the Okhotnyi Ryad, one of the traditional, pre-revolutionary shopping and trade sites, was completely destroyed. The resulting open space between the Manezh building and the Hotel 'Moskva' as well as the area flattened near the Bolshoi Theatre, were to function as parade thoroughfares and gathering points for socialist *prazdniks* taking place in nearby Red Square.[8] In conjunction with the construction of the metro, Stalin intended to shape Moscow into the world's leading 'metro-polis', overtaking Paris, London and New York in size, beauty and speed. It is in this sense that the lyrical figure of the young woman in the car allegorically glorifies the progress of society by her journey through time and space. At the same time she tries to reconcile the old and eradicated Muscovite world with Stalin's 'new' world by charming the viewer into a romantic tale.

First, her journey through the space of the picture from classical and neo-classical buildings (the House of Trade Unions was built by the famous architect Kazakov and was used as an assembly for the Moscow nobility after its restoration in 1812)[9] to the Stalinist architecture in the distance signifies symbolically the progression from feudal and bourgeois times to socialism under Stalin. Thus the painting constructs both life and architecture under Stalin as signs of a new classical era that has 'overtaken' history and created a new present.

Second, the kind of romantic relationship suggested between the young woman and the viewer as well as between the girl and socialist ideology are suggested by the intermingling of different reds and by the visual communication line through the rear-mirror of the girl's car. On the one hand, the red of ideology (red banners in front of the *Dom Soyuzov*) is echoed by the romantic reds of the young woman (red carnation, red spots on her white dress), and connected with each other by the red of the trolleybuses. On the other hand, a 'romantic affair' arises out of the confrontation between the viewer and the girl's face in the mirror, a romantic illusion that creates a continuous tension out of the viewer's curiosity to know the girl's face, which is never satisfied except in imagination. The political and cultural message of Pimenov's painting is thus condensed in a new classsical allegory of woman that works as representation of the new social *zeitgeist*. *Zhenshchina* (woman) in this understanding functions as a semantic and grammatical equivalent to

Novaya Moskva (New Moscow), thus effectively reiterating politics once

more at the level of allegorical femininity.

The fourth and final example is Arkadi Plastov's *Collective Farm Festival of 1937* (Figure 4.3). Plastov painted this picture in the heyday of Stalinist collectivisation, when up to 90 per cent of the peasant farms had been transformed into *kolkhozi* (collective farms) after a tremendous battle between kulaks, Party officials and poor peasants. Given the fact that at least two to three million kulaks died or were deported during this period, and considering the severe famines of 1932-33 during the early phase of collectivisation, Plastov's genre painting in the *Peredvizhniki* style seems to figure as a triumphant pictorial myth (*kartina-mif*). As German puts it, 'Borderlines between tough reality and fairy-tale have dissolved… Nevertheless, Plastov's picture may claim authenticity, because many people at that time believed in miracles that in the end became reality .'[10]

In the foreground, Plastov depicts cheerful peasants who are eating from tables full of food, dancing, playing the balalaika and talking. The peasant crowd is full of movement, and it harmoniously unites children, youths, young men and women as well as a group of *stariki* or older men, seated next to the samovar. To the left, near a brightly-lit *kolkhoz* building, Plastov has placed a makeshift wooden podium backed up by a combine, with a portrait of Stalin on top of it: its frames mysteriously mix with the colours of the sky, and it carries sheaves of wheat ornamenting it pseudo-religiously. The red star and banners situate the festival officially: the paradisal atmosphere of the scenery is summed up by Stalin's slogan

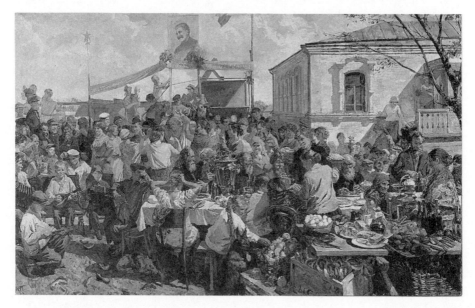

4.3 Arkadi Plastov, *Collective Farm Festival*, 1937

'Living has got better, living has got jollier', which had become a Party watch-word at the First Union Conference of Stakhanovites in November 1935.

If one follows 'visual directions' inside Plastov's painting – colour structures and general composition – it becomes obvious that there is a top-bottom structure dominated by the position of the God-like portrait of Stalin 'in heaven' and extending down to the peasants' tables (where there is a separate structure of relationships between the silver samovar, the *stariki* and the Stalin podium). There is also a diagonal structure of reds starting from the red banners, then switching over to the 'red woman' in the middle and ending in the red tomatoes on one of the tables in the right-hand corner.

The 'top-bottom' relation which is articulated as a pyramidally shaped peasant community can also be understood as symbol for the quasi-feudal type of socialist society which Stalin proposed after 1931, with himself as absolute leader and as the Soviet masses as happy, subservient followers. The secondary or contained structure involving the samovar, the *stariki* around it and Stalin's portrait, would seem to aim at a reunification of the Russian *mir* tradition of a closely bonded village community and socialist *kolkhoz* life, of Russian and socialist culture – something that was highly desirable after the harsh conditions which accompanied the introduction of collectivisation on the farms. Finally, the diagonal structure which connects the red of Soviet ideology (red star, banners) with the sensual reds of food and vibrant femininity, again mixes up political meanings with popular ones, rendering an elitist ideology attractive and familiar to the mass viewer. It is an instance of how ideology in Socialist Realism is converted into a symbology of bodies, tastes and appetites rather than offering cognitive explanations.

Notes

1 M. Warnke, in *Lexikon der Kunst*, 1, Leipzig, 1987, p. 10.
2 S. Greenblatt, 'Allegory and Representation', in *Selected Papers from the English Institute*, Baltimore and London, 1981, p. viii.
3 C. Lane, 'The Rites of Rulers', in *Ritual in Industrial Society: the Soviet Case*, Cambridge, 1981, p. 195.
4 H. Gassner and E. Gillen, 'Vom utopischen Ordnungsentwurf zur Versöhnungsideologie im aesthetischen Schein. Beispiele sowjetischer Kunst zwischen 1 Fünfyahrplan und der Verfassungskampagne 1936/37', in W. Süss and G. Erler (eds), *Stalinismus. Probleme der Sowjetgesellschaft zwischen Kollektivierung und Weltkrieg*, Frankfurt a.M. and New York, 1982, pp, 272-341; this quotation p. 275.
5 F. Thurlemann, *Vom Bild zum Raum. Beiträge zu einer semiotischen Kunstwissenschaft*, Cologne, 1990, p. 188.
6 V. Papernyi, *Kultura Dva*, Ann Arbor, 1985, p. 212.
7 B. Groys, *Gesamtkunstwerk Stalin. Die Gespaltene Kultur in der Sowjetunion* (Munich, 1988, p. 42), says about the political implications of Socialist Realism in general that 'They [the Party] in reality created the only piece of art officially permitted – socialism –

and at the same time they were the only critics of their work; they were experts in the only indispensable poetics – the poetics of building up the new world.... . this entitled them to command the production of novels and sculptures in the same way as they commanded steelworks and the planting of turnips.'

8 V. Papernyi, 'The Emergence of a New City', in H. Günther (ed.), *The Culture of the Stalin Period*, London, 1990, pp. 229-40; this quotation, p. 230.

9 K. Schlögel, *Moskau Lesen*, Berlin, 1984, pp. 68-9.

10 M. German, in *1920-1930 Zhivopis*, Leningrad, 1988, p. 14.

Catherine Cooke

5 Socialist Realist architecture: theory and practice

Socialist Realism is usually characterised as the aesthetic principle of Stalinism, and its specific formulation, like its first works, did indeed emerge as weapons of Soviet cultural policy at the height of his rule. But its roots go back much further, in architecture as in other arts, both within Russia and in Marxist thought in Europe.[1] Moreover, being inherently 'a method not a style', it is only with the advent of a genuine option for pluralism that Socialist Realism has finally ceased to be the official basis of the critical criteria applied to Soviet buildings by establishment critics and historians. Younger, less academic writers in the Soviet Union today dismiss Socialist Realism as a phenomenon entirely confined to the Stalin period, and, equally inaccurately, as a 'style' originating in the dictator's own untutored and megalomaniac tastes. Older critics, on the other hand, have better understood its true nature. Thus in 1980 a leading architectural critic of the older school, Yuri Yaralov, was presuming its continuing authority in Soviet practice when he wrote that post-modernism, with its historicism, popular codings and anti-elite orientation, showed Western architecture 'to be aspiring to enter organically into an environment of similar aims to our own'.[2]

What then are the identifying characteristics of Socialist Realism in general, and in architecture particularly? Four principles essentially define it. Before tracing the development and embodiment of these ideas in Soviet architecture under Lenin, Stalin, and briefly in the revisions undertaken by Khrushchev, the central tenets can be most resonantly conveyed in the words of the time.

The first principle was still being clearly expounded in an authorised Leningrad University textbook on aesthetics of 1980:

> From the early 1930s and the first serious discussions of Socialist Realism it is treated as a *method of artistic reflection* (*otrazheniya*) *and creative work*, and not as a *style*. As Lunacharski said: "Although the word 'style' does not have a fully exact, established definition, one must object strongly against any identi-fication of the term 'socialist realist' with any specific style, since Socialist Realism presumes a diversity of styles – indeed it requires a diversity of styles."[3]

The second principle specified that the 'method' involved constant pursuit of new syntheses between those elements of tradition, on the one hand, and

of its own period on the other, which are considered ideologically progressive within that culture at its current state of socialist development. In the words of a leading architectural theorist and critic, Ivan Matsa, writing in 1943:

> Can one see Socialist Realism as anything but a completely new historical phase in the development of world art? But at the same time, can one imagine its birth and development as something apart from, separated from, tradition? ...
>
> Innovation must draw... not just on discoveries of the front-line of science and technology, but also on the positive traditions of its own people.... . The bold and persistent development of the best progressive traditions, of those traditions which have some objective relation to the evolution of our architecture, represents one of the indispensible links if our Soviet architecture is to make progress.
>
> The innovator will create a work that is original, but that originality will have nothing in common with the pursuit of a difference "at all costs" from everything already existing, or with the total liberty of being left to express merely personal tastes.[4]

This rejection of the avant-garde and libertarian position leads to the third principle, which defines the artist's function in relation to society and his so-called 'leading' (*vedushchii*) role in development of its collective psychology and its self-understanding. This quotation is again from Lunacharski , who more than any other individual was the formulater of Socialist Realism from the 1917 Revolution to his death in 1933.

> It is not just that the creative artist should show the whole of his class what the world is like at the time, but also that he should help his contemporaries to gain an understanding of the reality around them, to help in the creation of the new man. Thus he seeks to speed up the pace of development of that reality, and through his artistic work he can create such an ideological centre as will stand above this reality, which will pull upwards, which will make it possible to look into the future.[5]

Thus the artist under Socialist Realism is not located out on some dewline of aesthetic research which the masses, by definition, can never attain. His proper position is at the leading edge of that mass itself, drawing its members forward, or in socialist terms 'upward', step by step. From this position his chief tool of communication is one with its own long tradition in pre-modern aesthetic systems: the 'image', or form-with-a-meaning, in Russian the *obraz*. In Matsa's words of 1942:

> The essential characteristic of each artistic image resides in its capacity to transmit sentiments which are concrete and specific. Any artistic idea taken on its own remains an abstraction if it has not been realised in a concrete form as an image, and can lead only to a spiritless symbolism or to a formal game played merely with the means of artistic expression.[6]

This package of principles was cryptically summed up in the central **87**

dictum of Socialist Realism, that art should be 'National in form and socialist in content'.

Here we see the basis of the conflict between Socialist Realism and avant-garde modernism. The modernists' work was internationalist, seeking aesthetic principles and languages that made no appeal to particularities of a given national culture. Worse still, they were investigating the nature of formal systems as such, in order to build languages for this supra-national modernity from first principles, out of freshly researched fundamentals. The threat which this abstract avant-garde direction represented, however, was not merely that of a 'bourgeois' concept against the socialist. That would have been easy to dismiss as an ideological deviation. The problem was more subtle and the threat deeper, because in the crucial formative years after the 1917 Revolution, both sides were represented within the Bolshevik Party's own internal debate about the proper nature of a proletarian culture.

The proper source of a socialist aesthetic

Aesthetics are not characteristically at the centre of revolutionary debate whilst the political overthrow is being achieved. But when the activists have to disseminate their inspiration more widely, to build rather than destroy, to manifest the new structures and values in life's everyday details, then aesthetics become central as they shape the entire process of communication. The centrality of that educational and communicative function was recognised in the very first days of the Russian Revolution when Lenin brought such a sophisticated figure as Anatoli Lunacharski into the first Soviet government as so-called Commissar for Enlightenment, meaning the arts, education and culture. Lunacharski was an interesting and complex figure, known and respected amongst art collectors and patrons of the old social upper crust, but an active observer of the youthful new movements which Lenin, like most others, refered to collectively as 'futurist'. A man who could immediately harness to his campaigns such socially and artistically opposite figures as Aleksandr Benua (Benois) and Vladimir Tatlin was very well equipped for resolving the internal dispute.

This dispute was essentially between Lenin and his reading of Marx's aesthetics, and the leader of the newly formed Proletarian Culture organisation, *Proletkult*, Aleksandr Bogdanov. The Bogdanov faction insisted that the past must be treated as a *tabula rasa*, from which proletarian art and culture would be built on entirely new principles. To Lenin the underlying principle was that of Marx, that 'Everything which was created by humanity before us' must be critically assessed, and 'the treasures of art and science must be made accessible to the whole popular mass.' In Lenin's words of 1920,

> Proletarian culture is not something dreamed up out of nowhere; nor is it the
> invention of people who call themselves specialists in proletarian culture. That
> is all complete nonsense. Proletarian culture must emerge from the steady
> development of those reserves of experience which humanity has built up under
> the yoke of capitalism.[7]

Lunacharski faced the task of turning this general philosophy of cultural
development in the broadest sense into a policy for culture in the narrower
sense, of an aesthetic for the arts under Bolshevism. His knowledge base
was solid enough to enable him to do so early, and without equivocation.
Thus in 1920 he was already explicit about the irrelevance of modernist
aesthetics and artistic movements to the mass population of Russia.

> Within the line of development of European art, Impressionism, all forms of Neo-
> Impressionism, Cubism, Futurism and Suprematism are natural phenomena... .
> All this work, entirely conscientious and important as it is, has the character of
> laboratory research [a phrase from Tatlin]... But the proletariat and the more
> cultivated sections of the peasantry did not live through any of the stages of
> European or Russian art, and they are at an entirely different stage of develop-
> ment.[8]

In the following year, addressing the Communist International, he was
explicit about what the source of their art, in the broadest sense, would be:

> The proletariat will also continue the art of the past, but will begin from some
> healthy stage, like the Renaissance ... If we are talking of the masses, the natural
> form of their art will be the traditional and classical one [i.e. rooted in the
> classics, not necessarily in Antique Classicism], clear to the point of transparency,
> resting ... on healthy convincing realism and on eloquent, transparent symbol-
> ism in decorative and monumental forms'[9]

The early date of these categorical statements is important for the fate of
the avant-garde in the arts in general, but even more significant for the fate
of architecture. Within painting, literature and the plastic arts, the main
leaps into modernism had pre-dated the 1917 Revolution. Both Malevich
and Tatlin, for example, had fully developed their new languages by 1914-
15. The Revolution of 1917 enabled them to jump quickly up professional
ladders to public positions hitherto blocked by a traditional establishment.
The new ideology offered a mission to which to respond. But the main
aesthetic and theoretical positions were already achieved, if not before the
Revolution, very quickly afterwards. Architecture on the other hand, was
as ever slower to change. Its social and material dimensions are far more
substantial, and the subtleties of their formal implications thus more
difficult to resolve. With the previously booming economy reduced to
stand-still by World War I and the Revolution, and much of the building
materials industry destroyed in the Civil War, there was no timber, no
bricks, no cement in the early twenties. Not until the building season of

1924 did building activity even start to stir, as one state economist put it, 'after ten years asleep'.[10] The first group of programmatically modernist architects formed itself in Moscow just as this process started in 1923, as the Association of New Architects, *AsNovA*. They were concerned with building a 'Rationalist' science of architectural and urban form on the basis of perceptual psychology, and theirs was the dominant position in modernist teaching in the integrated art and architecture school in Moscow, the *VKhuTeMas*.

With nothing serious being built during the Civil War or just after, ideas for competitions and exhibition pavilions were the only real media for architectural development. Most interesting for the early development of what became the Socialist Realist approach was Fomin's competition project of 1924 for the Soviet Pavilion in Paris of the following year. Melnikov's winning scheme, built under the influence of Rodchenko and French carpenters, was the famous dramatic, dynamic and highly modular scheme which established Western expectations of a Russian modernism. Equally seminal for the contrary direction, though never hailed as such, was the entry by the very experienced and talented young architect, Ivan Fomin, famous as a neo-classicist and in art nouveau before the Revolution.

Here was precisely that direct and popularly comprehensible imagery that would be the hall-mark of Socialist Realism. Nineteenth century Russian realist debates had been acutely conscious that, in the famous critic Stasov's words, 'architecture can only affirm, it cannot depict', and here in precisely the approved manner *avant la lettre* was a building form that did both, affirming with its form and depicting with its sculpture. At the same time it addressed both industrial and heroic dimensions of the new ideology simultaneously, where for most of the twenties these would remain polarised into different architectures. In Fomin's words:

> I have been concerned above all that the style of the pavilion should reflect the character of the workers' and peasants' government of this country. Therefore my architecture has a somewhat utilitarian character and combines decorative elements appropriate to exhibitions with elements of industrial and factory building, as is clear from the perspective drawing. The central figure is a worker, calling others, and on all sides the architectural forms gravitate toward him, as a symbol of how all nationalities are aspiring to unite in response to the call of the worker and have come together into the USSR.[11]

The project attracted no particular attention, and with other successful young leaders of the pre-revolutionary profession in the former capital like Vladimir Shchuko, who sought to continue something of the old disciplines into a socialist architecture, Fomin spent the twenties firmly in the profession's second rank behind the uncompromising modernists, only to be called forward when the tide finally turned towards a new synthesis of

old and new in the early thirties. Before that, in the brief six-year peri
1924/5-29/30, modernism would emerge, develop theories and extensive
building practice, and be cut down in the prime of its professional authority
at home and abroad. But the writing on the wall was already clear even
before the leading group, the Constructivists, had started.

Only in 1924 did the manifesto of architectural Constructivism appear,
in the form of a scholarly book *Style and Epoch* by the young architect
Moisei Ginzburg. Its central theme was the role of the machine in forming
the *zeitgeist* of the new epoch, as the proper model for spatial and human
organisation in architecture and as the basis of a new aesthetic of dynamic,
functionally generated assymetries. In late 1925 he formed the Union of
Contemporary Architects, *OSA*, with the Vesnin brothers and colleagues
from the Constructivist art and literary group *LEF*, to develop these ideas.
The architectural group's work was centred around their 'functional
working method', whose inner logic and specific techniques for generating
the spatial organisation of buildings were explicitly modelled upon
engineering, the machine and the modern flow-line organisation of
factories advanced by Ford, and by the Russian Taylorist (and poet)
Aleksei Gastev.[12] In 1926 they were just getting going, preparing the first
issue of their journal, *Sovremmenaya arkhitektura*, when a speech by
Lunacharski to the State Academy of Artistic Sciences, *GAKhN*, demol-
ished all claims of their machine-inspired approach to socialist legitimacy.
I quote it at some length as it is little known, but vitally important for
showing how early in relation to architectural modernism was the fate of
the machine approach sealed and the essentials of a populist historicism
established as the politically correct direction for Soviet art.

It is being said that this is a new stage in human history; that the proletariat is
entering into the stage of urbanisation; that the machine is poetic; that the
factory is the most powerful thing that can be seen on earth; that any form of
literary tale is a mere mirage compared to the poetic situation in which science
brings about a new factory. I do not in any way deny that the proletariat may
find original and attractive colouration for its life in poems of productivity...
But it has to be said that ... only futurism and the artists of *LEF*, that seedbed of
Constructivism, who are the avant-garde of a leftist Euro-American urban
culture, can become wholly immersed in this element... .

We [Bolsheviks] have not entered the world in order to finally make the
machine the mistress of our lives, as advocates of time-and-motion study like
Gastev are advocating through their socio-political literature. We came in order
to liberate the individual from under the power of the machine... . Let the
rhythm of the machine certainly become an important element in our culture, ...
but the machine cannot be the centre of our art.

There exists with us in Russia a vast Euro-American conception of the
culture of individual creative work, of that high art which was created by the
geniuses, the great talents of Euro-American culture. Certainly there is a very

91

great deal that can be absorbed from the products of this individual art.... but as a whole it is alien to us... .

Much more nourishing an environment for proletarian art is that mass of vernacular, peasant art, that art which developed in the primal period of our ancestors... .

It is precisely from here that we should draw models, from this art evolved over the course of centuries, which devised a "style" that is almost irreproachable in the inner rigour and order of its crystalisation of form. Despite the fact that it developed while civilisation itself was still beginning to emerge, it is precisely this vast body of creativity which can now provide that nutritious environment for proletarian artistic labour – because of its multi-valued character, and because of the collective nature of the basic principles underlying its products.[13]

Over the next four years, through the force of their design work, the clear-headed public campaigns on technical issues, and their self-publicity through a highly professional journal, the Constructivists came to dominate modernist architecture in both practice and schools across the whole Soviet Union. Many ambitious students of non-metropolitan and non-Russian backgrounds found the Euro-American flavour of debate and design distasteful. They had learned to design modern buildings, and their work differed little from that of their teachers except in quality and rigour. Many, being loyal party members of working class or peasant origin, also despised the leaders of *AsNovA* and *OSA* for their social origins and suspected their political loyalties. 'Specialists' in all fields were undergoing such attack including in the later twenties, and the more intellectual figures in architecture were typical targets. Thus in mid-1929 a group of young architects containing many from Armenia and other republics formed an aggressively and explicitly 'proletarian' architectural group, *VOPrA*. Leading members were Alabyan, Mazmanyan, Kochar, Mordvyshev (who Russianised himself to Mordvinov), under the chairmanship of the critic and ideologist Ivan Matsa whom I quoted earlier.

Their founding declaration was effectively a first draft of a manifesto for a Socialist Realist architecture. In the manner which was becoming politically obligatory, it opened by 'rejections', in this case effectively rejections of their teachers. They rejected 'eclectics who mechanically copy the old architecture and blindly subject themselves to Classical canons and schemas'. They were carrying forward the ethos of 'mercantile industrial capital'. The Rationalism of *AsNovA* was a result of this trend colliding with 'the psycho-ideology and habits of the petit-bourgeios intelligentsia'. Constructivism had been 'useful in the process of overcoming eclecticism ... and promotion of questions of technical rationalisation, mechanisation and standardisation in construction', but in the end it was 'mere leftist mouthings and "revolutionary" clichés.' To defeat all these, 'proletarian architecture must develop its theory and practice through applying the

92

method of dialectical materialism'. Its purpose was 'to organise the will of the masses for struggle and labour'.

The means were a new synthesis of selected elements of the historic cultural legacy with contemporary technique. In place of the electicist's 'mechanical copying' they were 'in favour of assimilation of the culture of the past on the basis of Marxist analysis and the critical use of historical experience', but were equally committed to 'dialectical use and application to architectural work of all achievements of modern science in relation to form, colour etc.' Their 'method in architecture' would somehow 'take into account the largest possible number of elements which make up architecture'. Objectively that did not sound very different from the aims of the Constructivists' functional method. But they meant it to sound very different when they declared 'For us, form… is not an aim in itself, but the means for expressing a concrete meaning'. This was a meaning whose 'emotional-ideological' component would predominate.[14]

The more Germans arrived as refugees from Frankfurt and the Bauhaus during 1930, planting 'boxes' in parallel lines across the steppe or Moscow suburbs, the more the chauvinism in *VOPrA* evoked a genuine sympathy. But what should this new architecture look like?

Getting a style from the method

Popular discontent with bad modern buildings and a desire for something that speaks the language of mass aspiration is a phenomenon easier to understand in the West after the bubbling up of post-modernism and in Britain, specifically, after the interventions of royalty on behalf of 'the people'. Illiterate peasant or visually illiterate consumer, the 'meaning' being pursued may be different but the phenomena are structurally similar. The ideal medium for the first show trial, then as now, was the architectural competition.

In February 1931 the Soviet government launched a competition process that was to run through four stages over two years. It produced a vast, virtually unbuildable project, but more importantly, a clearer definition of the Party's conception of a socialist architecture.[15]

The brief was for a so-called Palace of Soviets, a vast complex for congresses and mass assemblies of popular representatives, to stand near the Moscow River just beside the Kremlin. Its scale was set by the two main auditoria for fifteen and six thousand people. The aesthetic brief went no further than a general injunction for the building to 'be a monumental structure, outstanding in its architectural features and fitting in artistically with the general architectural scheme of Moscow', preferably 'capable of being seen from the city's outskirts.' Lying behind the brief, however, was the challenge of Sergei Kirov to the competition seen as its precursor, the **93**

Palace of Labour of 1922-3, to produce 'such works of great architecture as our enemies never dreamed of'.[16] By June, with first projects coming in, a major speech to a Plenum of the Party Central Committee by Moscow Party Secretary Kaganovich deplored the lack of 'serious Marxist-theoretical bases for our practice' in the areas of city planning and architecture, and challenged the profession 'to devise an architectural formulation of the [Soviet] city that will give it the necessary beauty'.[17]

The first invited schemes from Soviet architects of various persuasions were published that summer with an official 'critique' from a special committee under Lunacharski.[18] Much of the criticism at this stage was still functional: 'how will Ladovski' – leader of the Rationalists – 'tackle the accoustic problems in his hemispherical auditorium?' Subtler themes with a familiar ring emerged repeatedly. One scheme by other Rationalists 'looks like a factory with hangars, chimneys etc, even though they have no functional significance here'. Even in the 'realistic project' of eclectic establishment figure Aleksei Shchusev 'the simplicity of aesthetic treament gives the building an industrial character inappropriate to the Palace of Soviets.' At the next stage, Corbusier's scheme was dismissed for 'cultivating the aesthetic of a complicated machine that is to "turn over" huge masses of humanity'.[19] The other underlying disatisfaction which constantly recurs is with any assemblage of parts or stylistic devices that is 'purely mechanical', either because it 'follows only the functional purpose of the separate parts', or because it fails in the aesthetic purpose of creating a 'unity of ideological expression'. Even the eventual winner, Boris Iofan, failed on both these counts with his first project. The fear that one can detect here is the classic Russian fear of a lack of clearly apparent order, of *bezobraziye* – the chaos of formlessness, literally of image-lessness. In their canon, assymetrical planning 'which gives the impression of being an accidental conglomeration', 'deprives the building of ideological purpose' because it fails to communicate that fundamental principle of the Soviet programme, 'plannedness'.

In the architecture of society's symbols, said Lunacharski's committee, it is the purpose of such a building 'to characterise the epoch and embody the urge of workers towards the building of communism.' Here the principle 'of form being determined by the functions of internal accomodation' was a 'necessary but not sufficient principle'. Consciously or not using Constructivist jargon as a shorthand, they provided a first positive specification of how the full 'embodiment of values' might be achieved.

> The functional method of design must be supplemented by a corrective: an artistic treatment of the form. All the spatial arts must be employed: architecture, which gives proportionality of the parts; painting, which uses colour; sculpture, for richness of light and dark, in combination with lighting technology and the art of the theatrical producer.[20]

As the committee later spelt it out, architecture, like all other arts under socialism, must be ideologically 'active'. 'Unadorned construction without further architectural design' was therefore an abnegation of political obligation.

Some stages later, having responded to the injunctions, Boris Iofan produced a scheme declared by Lunacharski to be 'grandiose, hospitable, simple and light' in accordance with 'what we should demand from our first great architectural monument'. It did not 'avoid classical motifs, but attempted to surpass classical architecture'. It was 'expressive and monumental'. It 'conformed to the highest technical achievements of today' – presumably in the demands it made on concrete engineers – 'to create a distinctive architectural work of the socialist age' by means of 'critical assimilation of the heritage'. Soviet architects 'should be learning from the masters of the past: their techniques, methods and forms of aesthetic and architectural expression'.[21] As *Izvestiya* pointed out in true Leninist spirit, 'assimilation does not mean copying: it is a creative activity of upward march from the peaks of former culture towards new

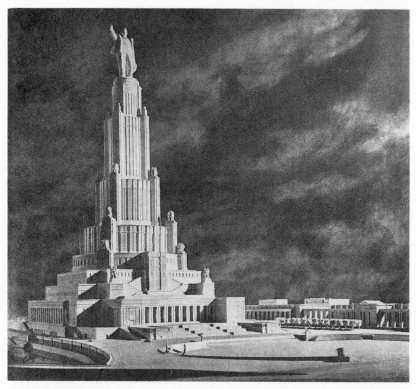

5.1 Boris Iofan with Vladimir Shchuko, final project for the Palace of the Soviets, Moscow, 1933

achievements'.[22] Shchuko was brought in to help young Iofan build it (Figure 5.1).

Western modernists were outraged. After the final announcement in spring 1932, officers of CIAM wrote twice to Stalin. In 'signalling their dissatisfaction', Van Esteren, Bourgeois and Giedion informed the great dictator and heir of Lenin that his chosen project was 'a direct insult to the spirit of the Russian Revolution'.

> Turning its back on the inspiration of modern society which found its first expression in Soviet Russia, this verdict sanctifies the establishment architecture of the monarchic *anciens régimes*.
> The world which has its eyes fixed on the development of the great Soviet construction effort will be stupefied by it.[23]

Stupefaction was entirely in the spirit of Kirov's defiant challenge 'to our enemies'; if the letter ever reached the Kremlin, a toast to capitalism doubtless ensued.

Meanwhile Soviet modernists made various attempts to grapple with this new demand for expression and contextualism. The most sophisticated was certainly Leonidov's competition scheme for the Heavy Industry Commissariat on Red Square in 1934, and Melnikov's could be seen as the most hypertrophied. In that competition and elsewhere, the Vesnins and Ginzburg, like Fomin with his new syntheses, showed themselves less able to handle the scalar problems of such vast volumes than the purer traditionalists.[24] When the scale came down however, as in the new focal buildings for the restructured Moscow, other modernists like Ilya Golosov, always more concerned with formal dynamics than functional detail, produced some convincing essays in the new genre. Uncomfortable as it may have been for Ladovski or Ginzburg to sit with *VOPrA*'s Alabyan, the main trends of the twenties were represented by their leaders on the catholic Board of the new official Union of Soviet Architects when the independent architectural groups were closed down in July 1932.

Developing the practice

Disbandment of the old literary groups preceded the architectural reorganisation by three months, and the writers were much quicker to assemble in a Congress that would define more closely their new aesthetic and its techniques. Indeed, when the architects finally met in June 1937 they did little but consolidate their witch-hunt and refine their personal apologias. It was the Writers Congress of August 1934, and in particular Maxim Gorki's keynote speech, which established the nature and tools of a Socialist Realist aesthetic.

Gorki's personal history made it natural for him to use pre-revolutionary

bourgeois realism as a point of contrast. As Zhdanov's opening speech had said, the socialist version was also 'romantic', but revolutionary. It would depict reality not in a 'scholastic way, as objectivity, but in its revolutionary development'.[25] It did so for the whole of humanity, said Gorki, not for indulgence of the individual bourgeois conscience or 'personality'. He made a clear distinction between old and new concepts of the artist's role. Gone was what he termed 'leaderism': the old notion of the avant-garde position, 'fruit of effete, impotent and impoverished individualism'. The new role was 'leadership', that leading (*vedushchii*) role I defined earlier.[26]

Folklore – Lunacharski's 'art from the primal period of our ancestors' – should be drawn upon for the traditional definition of the archetype. Perfect heroes in Socialist Realism, as in folklore, will be human or social types, not individual personalities. Crucially their contribution, like the aim of the literature as a whole, must always be optimistic – in contrast to the 'pessimism which has been spread by the Christian church for two thousand years'.[27]

The transposition to architecture becomes easier to conceive when he rises to a higher level of generality in discussing the creation of image systems and myth.

> To invent means to extract from the sum of a given reality its cardinal idea and to embody it in imagery – that is how we got realism. But now this is supplemented with the logic of hypothesis, the desired, the possible, to obtain the romanticism which is the basis of myth and is highly beneficial in tending to provoke a revolutionary attitude to reality, that changes the world in a practical way.[28]

Equally crucial to architecture, and indeed he mentions it, is the insistence on the multi-national nature of the new Soviet culture.

> I deem it necessary to point out that Soviet literature is not merely a literature of the Russian language, it is an all-Union literature…. . We obviously have no right to ignore the literary creation of the national minorities simply because they are less in number. Artistic value is guaged by quality not quantity. If we Russians can point to Pushkin, does it not follow that the Armenians, Georgians, Tatars, Ukrainians and other peoples are capable of producing equally great masters of literature, music, painting and architecture?[29]

Yet they must have the larger aims in common. Thus we have the key slogan of all Socialist Realist art, which was the challenge to architecture too, that it must be 'National in form and socialist in content'.

Critical assimilation meant sifting one through the filter of the other. It meant examining the local traditions to establish what remained valid, in the sense of having a positive meaning or representing a socially 'optimistic' trait in the context of that community's state of development

97

towards socialism. In the final stages of the Palace of Soviets discussions, in mid-1932, a useful formulation had been presented of the ways by which architecture could carry forward 'positive' elements of a given tradition. Four were identified: the use of individual compositional and spatial elements from the old to build up new forms for the new context; to employ the spaces and volumes of the past as a whole but to modernise them as appropriate to new functions and materials; to make a mechanical application of archaeologically accurate decorative motifs and formal details; to deliberately revive archaic forms in their entirety, without significant modification.[30] Examples of all these approaches can be found in late nineteenth century 'Russianist' architecture. These were the means, as Stasov would have said, whereby architecture might 'affirm' its support for the values they represented. As the Palace of Soviets committee also insisted, the building of an effective popular narrative demanded the supplementing and reinforcing of this architectural dimension by the depictive media of sculpture and painting.

During the First Five Year Plan, from 1928-32, there was as heated a debate about the overall form of the Soviet socialist city as there was about the architectural language of its buildings. As the capital, Moscow was both showpiece and laboratory. Bold restructuring proposals from Soviet modernists like Ladovski and Ginzburg had been rejected, as had those from foreigners like Le Corbusier or Ernst May. Kaganovich's speech to the Central Committee Plenum in June 1931 had laid out the brief in terms of roadworks, utilities modernisation, improvement of public facilities, and had officially launched the Metro project. His challenge to planners to produce 'serious Marxist-theoretical bases' for Soviet town planning fell to the city's chief planner, Vladimir Semenov, to implement. A keen and widely travelled student of European planning developments in the 1900s, Semenov was the man who even then recognised Russia's cultural differences from Europe and charged his own profession with 'finding the natural form for the Russian town in the mists of our own history'.[31] His own professional approach therefore coincided with that now advanced, more ideologically, as Socialist Realism. The central tenet of his 1935 Plan for Moscow was retention of the city's historically developed radial-concentric plan centred on the Kremlin. More than ever it seemed symbolically correct that all roads led to the Kremlin, and the main arteries were to be widened precisely to reinforce the power and clarity of this form. 'In contrast to the capitalist cities', there must be 'no overcrowding of people onto sites'.[32]

The city was planned as a single physical, sculptural 'ensemble'. Marking its key points and lining its main arteries would be 'monumental buildings which will determine the look of the city as the capital of the proletarian revolution'. One was the Palace of Soviets. In accordance with

the Socialist Realist canon established in that competition, the rest too would 'combine the best models of traditional (*klassicheskaya*) and new architecture, with all the achievements of contemporary architectural and constructional technology'. Leading architects of all earlier persuasions developed these nodes. Thus Mordvinov, for example, proposed doubling the widths of Tverskaya Street and of Red Square (the former realised, the latter mercifully not). Shchusev and the Vesnins did vast schemes for the Moscow River Embankments. Ilya Golosov designed a *TASS* headquarters for Pushkin Square, and so on. On plan and three-dimensionally, the traditional form of Moscow, as a typical Russian town of *kreml'*, housing matrix and orientational landmarks on public 'squares', was redrawn on a scale commensurate with Soviet aspirations, and served as the model for Socialist Realism in city planning. The city-as-machine was an appropriate model for the new industrial towns, and was used there. For a centre of political power and aspiration, the focus was to be on the user's perception of the city as a three-dimensional form communicating an 'optimistic' ideological message.

In 1935 the first line was opened on the city's biggest prestige project, the Metro. Here, too, the list of architects was still catholic. Amidst many lesser names were Ladovski and his pupil Krutikov, Corbusier's Constructivist collaborator Kolli, as well as Fomin. The interest of the first stations lies in their perceived failing in relation to the Socialist Realist canon. They were purely architectural, and did not use the depictive arts of painting or sculpture to reinforce their message. It was only in the second and subsequent stages that the vigorous mosaics of Alexander Deineka and the sculpture of Matvei Manizer (see back cover plate) became integrated with structure to produce the famous thematic interiors celebrating revolution and labour.

The First Congress of Soviet Architects in 1937 confirmed Socialist Realism as 'the method of Soviet architecture', without doing much to illuminate further its professional implications. Kaganovich set them a challenge to which the Metro had already responded handsomely: 'The proletariat does not just want buildings. It does not simply want to live comfortably. It was its buildings to be *beautiful*. And it wants its housing, its architecture, its towns, to be *more beautiful* than in any other countries of America or Europe.'[33]

The middle and later thirties were a period of megalomaniac projects for public buildings that would reshape the image of cities right across the USSR. Given real priorities in industrial development, and later, in military preparation, very few of them were built. The injunction to convey the content through 'national' forms was pursued with less subtlety than after the war, when experience in these new modes was greater. There were important and effective examples, however, such as the Government

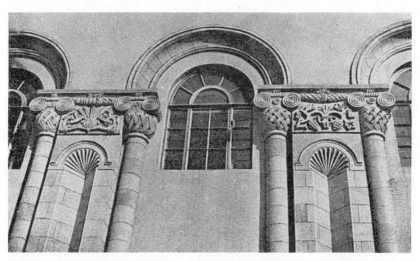

5.2 Aleksandr Tamanyan, Armenian Agriculture Commissariat, Lenin Square, Erevan, 1929-41 (detail of main elevation)

House of the Georgian Republic in Tbilisi by Kokorin and Lezhava, or the Agriculture Commissariat of Armenia in Erevan, by Tamanyan (Figure 5.2). In both these cases, a generally classical *parti*, which speaks of centrality and authority, is typically reworked at the level of spatial and decorative detail through indigenous traditions; in the Georgian case, of deeply shaded courtyards and clean-cut non-trabeated treatment of masonry, and in the Armenian, of rhythmic and linear bas-relief decoration.

Post-war reconstruction of cities destroyed by the Germans was conducted in an atmosphere of yet more heightened popular chauvinism. Much replanning was done before hostilities finally ceased, as planners went into cities with the liberating troops. The essential basis of the Socialist Realist approach to city planning, rooted in the real viewer's three-dimensional perception of mass and ensemble, was given firmer theoretical basis and clearer recipes in the work of Andrei Bunin, whose *Architectural Composition of Towns* was published by the Academy of Architecture in 1940. Bunin's principle inspiration was Camillo Sitte, though as ever in Soviet literature of that time (and later), the ideas are presented as purely and logically Soviet.

The first project conducted explicitly as a model was Shchusev's for reconstructing the small Moscow-region town of Istra, destroyed and soon liberated in 1941. The proposals were neither a reconstruction of the old, with its historic disadvantages, nor, as was very explicitly explained, a 'modernisation' through the 'dry, geometrical planning' he characterised as 'capitalist'.[34] It was a spacious new civic architecture created by reinterpretation of a uniquely Moscovite style from a high period of self-

confidence and prosperity: the late seventeenth century Moscow Baroque. Traditional building types were reworked for Soviet functions. The reference points here were clear, and the synthesis of old and new logical. These were urban and architectural images which fully conformed to Matsa's specification quoted earlier, written in the following year, that they 'transmit sentiments which are concrete and specific'.

A different problem arose with the new industrial cities whose history went back only to the First Five Year Plan. The replanning of Stalingrad typified the shift in priorities which had taken place. Its original plan of 1928-9 was based on the 'machine' principle, with the whole river area treated as part of the production equipment. In the replanning this was programmatically replaced by an opening up of the riverside land to public recreation and commemorative parks, celebrating an ideological vision of the good life given by the state to its citizens.

More interesting than the megalomaniac civic statements of immediate post-war planning, largely unbuilt, was the scale and subtlety of the extensive developments of housing and community facilities. In the late forties and very early fifties, these were typically low-rise, and showed serious attempts to reinterpret local building traditions in form as well as decoration, in many cases most successfully. Unfortunately much of this work was swept away in later redevelopments and is little known, since it might now offer some useful models.

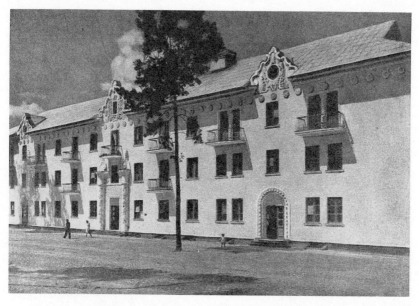

5.3 A. V. Dobrovolski, Standard Block of Twenty Workers' Apartments, Darnitsa near Kiev, published 1952

Thus low-rise apartment developments in and around Moscow took the courtyard form of the old urban estates which were the characteristic matrix of the old city. In Kiev, characterised by a more properly street architecture, terraced housing had its entrances celebrated in typically florid Ukrainian sculpted decoration (Figure 5.3). In Central Asia, the equivalent housing had solid walls of high thermal mass with small apertures, and deeply recessed shaded balconies, often reflecting local arch forms in their profile. Environmentally and culturally, much of this work was excellent. The scale rose in the early fifties to the maximum walk-up of five stories, and above, and by then, particularly in Moscow, very high standards of spatial provision, construction and finish were creating a suitably high-quality environment for the main public thoroughfares. But as housing they were replicating the haute-bourgeois accomodation of pre-revolutionary years rather than tackling mass demand.

The most hypertrophied example of this tendency was the set of so-called High Buildings erected around central Moscow from 1948-52. These were the climax of Socialist Realist city planning, genuinely recreating the historic profile of a Russian town at Soviet scale. The tale of Stalin declaring from the Kremlin 'what we need is a new ring of churches around here' is certainly apocryphal, but conveys the three-dimensional concept (Figure 5.4). The 'profile of the Russian town' had been a central theme of planning histories and texts throughout the war-time and post-war period. In the absence of the Palace of Soviets, aborted in the war, these seven buildings, with clustered volumes stepped in form and capped with

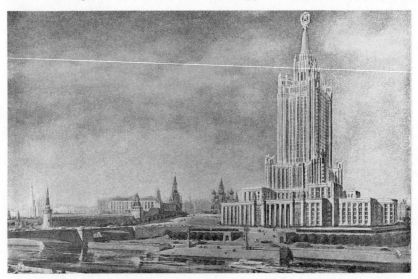

5.4 Dmitri Chechulin, High Building (Administrative) on Moscow River Embankment in Zaryade 1949 (not built)

towers were a reinterpretation and recombination of Russian church and tower forms, each uniquely profiled as the kind of orientational element conceived in the 1935 Plan. In function, they were variously apartment housing, ministerial headquarters and hotels, and as appropriate to the capital's next great prestige project, finishes were of the same high standard that characterised the Metro.

In 1949 the designs received the Stalin prizes for architecture. As Kornfeld, in his day a good Constructivist, wrote of them in 1952, these buildings 'were sharply distinguished from the western high buildings which are called skyscrapers... born of the ugly system of capitalist land-ownership, speculation and commercial competition'. 'The Soviet High Buildings are based on principles of socialist humanism' and they use 'the means of architecture and contemporary technology ... to make the life of the individual happier, and his city more beautiful'.[35] No wonder such people now cheerfully wrote like that. The last major official critical work on Socialist Realist architecture was simultaneously denouncing Ginzburg's thirty-year-old *Style and Epoch* and vilifying the architect himself (lately dead) by name. Of the whole movement this author, Tsapenko, said, 'The crushing of Constructivism signified the crushing of extreme aesthetic reaction, imported to us from the countries of moribund bourgeois culture, the crushing of a manifestation of anti-popular formalist aesthetics.' Amongst the other arts, the 'specific dual nature of architecture' lay in its obligation to satisfy 'the indispensible conditions of human survival, like housing' at same time as providing 'an instrument for the understanding of reality' through aesthetics.[36] The officially approved balance of these two factors, the aesthetic and the technical, was soon to be dramatically reversed.

Khrushchev took over from Stalin in 1953 as a man experienced in building: his senior Party post in Moscow in the thirties had involved him closely in construction of the Metro and realisation of the 1935 Plan. He was different in personal and political temperament. In December 1954, just over a year before he denounced Stalin himself, he denounced his architecture.

The occasion was an All-Union Conference on building problems. Khrushchev uncompromisingly attacked former *VOPrA* founder-member Mordvinov, now President of the Academy of Architecture, and with him the profession, for 'skating around the problems of building economics'. They are 'not interested in costs per square metre of living space', he said, but 'indulge themselves with unnecessary ornamentation of façades, and permit all manner of excesses.' The High Buildings had been a bad influence here, as architects who 'were mainly concerned with the creation of a silhouette' had 'caused excessive running costs through great heat losses', and provided very little usable floor-space for the vast quantitites

of structural materials employed. In a remarkable reversal of the official line he declared:

> The opposition to Constructivism should be conducted sensibly. It is not beauty we oppose, but excess... . We can no longer put up with the fact that many architects, while hiding behind phrases about "combating Constructivism" and in favour of "Socialist Realism" in architecture, are spending the nation's wealth recklessly... . This is not in the people's interest.

It was happening, he said, because architects were prima donnas, 'eager to create monuments to themselves, as Pushkin did'. The Academy which fostered this attitude must go. Beauty lay not in decoration but in 'fine proportions of the building as a whole and of the doors and windows, the skilfull placing of balconies, a proper use of the texture and colour of facing materials and the appropriate delineation of wall details and structure.' The direction of the future must be 'standard designs for housing, schools, hospitals, kindergartens and so on' with 'effective use of new materials ... and of pre-fabricated reinforced concrete components, large-panel and large-block construction systems.'[37]

A year later, in November 1955, the Second Congress of Soviet Architects was convened, following a Decree of 10 November 'On removing decorative excesses in architectural design and in building'. Shell-shocked, the Second Congress set about reversing the path down which they had travelled since the First.

Notes

1 For a useful (non-architectural) summary, see: C. Vaughan James, *Soviet Socialist Realism. Origins and Theory*, London, 1973, Chapter 1.

2 'X plenum pravleniya Soyuza arkhitektorov SSSR', speech by Yuri Yaralov, *Arkhitektura SSSR*, October 1980, p. 17.

3 M. S. Kagan (ed.), *Lektsii po istorii estetiki*, Leningrad, 1980, p. 96.

4 I. Matsa, 'Traditsiya i novatorstvo', *Arkhitektura SSSR*, 1, 1944.

5 A. V. Lunacharski , *O teatre i dramaturgii. Izbr. stat.*, 1, Moscow, 1958, p. 737.

6 I. Matsa, 'Demokratischeskie vsenarodnye osnovy sovetskoi arkhitektury', *Arkhitektura SSSR*, 3, 1943, pp. 3-7.1942

7 V. I. Lenin, 'Speech to the 3rd All-Russian Congress of the Komsomol', 2 October 1920, in Lenin, *Collected Works*, 31, Moscow, 1965, pp. 283-99.

8 A. V. Lunacharski , 'Ob otdele izobrazitel'nikh iskusstv', 1920, in Lunacharski , *Ob iskusstve*, 2, Moscow, 1982, pp. 79-83.

9 A. V. Lunacharski , 'Iskusstvo v Moskve', speech to 3rd Congress of the Comintern, July 1921, in Lunacharski , *Ob iskusstve*, 2, pp. 94-100.

10 I. B. Shub, 'Stroitel'stvo v gody vosstanovitel'nogo protsessa 1923/4-1926/7, *Planovoe khozyaistvo*, 10, 1926, pp. 43-56.

11 I. Fomin, 'Poyasnitel'nie zapiski k proektu paviliona SSSR v Parizhe' (Explantory notes to the project for the Soviet pavilion in Paris), archival documents published in V. Khazanova (ed.), *Iz istorii sovetskoi arkhitektury 1917-25. Dokumenty i materialy*, Moscow, 1963, pp. 146-53.

12 On the development of this method see C. Cooke, 'Form is a function x: the development

of the Constructivist architects' design method', *Architectural Design*, 5/6, 1983, pp. 34-49.

13 A. V. Lunacharski , 'Khudozhestvennoe tvorchestvo natsional'nostei SSSR', speech to GAKhN, October 1926, in G. A. Belaya (ed.), *Iz istorii sovetskoi esteticheskoi mysli 1917-32*, Moscow, 1980, pp. 85-7.

14 'Deklaratsiya *VOPrA*' (*VOPrA*'s declaration), August 1929, published in V. Khazanova (ed.), *Iz istorii sovetskoi arkhitektury 1926-32. Dokumenty i materialy*, Moscow, 1970, pp. 138-9.

15 For detail on this competition see A. Cunliffe, 'The competition for the Palace of Soviets in Moscow, 1931-1933', *Architectural Association Quarterly*, 11, 1979, pp. 36-48, and C. Cooke, *Architectural Drawings of the Russian Avant-Garde*, New York & London, 1990, pp. 37-42, 106-15.

16 S. M. Kirov, speech to First All-Union Congress of Soviets, 30 December 1922, in Kirov, *Izbrannye stat'i i rechi*, Moscow, 1957, pp. 150-52.

17 L. Kaganovich, 'O moskovskom gorodskom khozyaistve i o razvitii gorodskogo khozyaistva SSSR', *Pravda*, 4 July 1931, pp. 3-4.

18 M. V. Kruikov, (ed.), *Byuleten' upravleniya stroitel'stvom Dvortsa Sovetov pri prezidiume TsIK SSSR*, 2-3, Moscow, 1931.

19 N. P. Zapletin, 'Dvorets sovetov SSSR', *Sovetskaya arkhitektura*, 2-3, 1932, p. 10.

20 Kryukov, (ed.), *Biuleten*, 2-3, p. 1.

21 Zapletin, 'Dvorets', p. 10.

22 A. N. Tolstoi, 'Poiski monumental'nosti', *Izvestiya*, 27 February 1932.

23 Letters of March 1932, CIRPAC in Barcelona to Stalin, April 1932, CIAM Officers to Stalin, in CIAM Archives, ETH-Zurich.

24 On this competition see my 'Ivan Leonidov: vision and historicism', *Architectural Design*, 6, 1986, pp. 12-21, and *Architectural Drawings of the Russian Avant-Garde*, pp. 42-5, 116-26.

25 A. A. Zhdanov, 'Soviet Literature: the richest in ideas', in H. G. Scott. (ed.), *Soviet Writers Congress, 1934*, London, 1935 & 1977, pp. 15-24.

26 Maksim Gorky, 'Soviet Literature', in *ibid.*, pp. 27-69

27 Gorki, *ibid.*, p. 36

28 Gorki, *ibid.*, p. 44

29 Gorki, *ibid.*, p. 59

30 I. Vobly, 'Dvorets sovetov i arkhitekturnoe nasledstvo', *Brigada khudozhnikov*, 3, 1932.

31 V. N. Semenov, *Blagoustroistvo gorodov*, Moscow, 1912, p. 2.

32 Central Committee resolution on the June Plenum 1931 speech of Kaganovich, 'O moskovskom', quoted as frontispiece to official publication of Moscow 1935 plan, *General'nyi plan rekonstruktsii goroda Moskvy*, Moscow, 1936. Details of the Plan derive from that volume.

33 L. M. Kaganovich, Message to the First Congress of Soviet Architects, *Arkhitekturnaya gazeta*, 40, 16 June 1937.

34 A. V. Shchusev, *Proekt vosstanovleniya goroda Istry*, Moscow, 1946, p. 47.

35 Ya. A. Kornfeld, *Laureaty Stalinskikh premii v arkhitekture 1941-1950*, Moscow, 1953, pp. 107-08.

36 M. P. Tsapenko, *O realisticheskikh osnovakh sovetskoi arkhitektury*, Moscow, 1952, pp. 75, 29-30.

37 Nikita Khrushchev, Speech to conference on construction questions, 7 December 1954, *Pravda*, 9 December 1954.

Sarah Wilson

6 The Soviet Pavilion in Paris

WE WILL RESOLUTELY PURSUE THE POLITICS OF PEACE WITH ALL
OUR FORCE AND BY EVERY MEANS.
WE DO NOT DESIRE ONE JOT OF ANOTHER'S LAND BUT WE WILL
NOT CONCEDE ONE INCH OF OUR OWN.

WE ARE IN FAVOUR OF PEACE AND WILL DEFEND THE CAUSE OF
PEACE. BUT WE FEAR NO THREATS, AND WE ARE READY TO
RESPOND WITH BLOWS TO THE BLOWS OF THE WARMONGERS.

STALIN.

Inscriptions, Soviet Pavilion interior, 1937[1]

The Soviet Pavilion erected in Paris for the Exposition Internationale
(World Fair) in 1937 was the most important architectural commission of
the early Stalin period to be built outside the Soviet Union itself. In many
respects a small-scale successor to the ill-fated Palace of the Soviets
project in Moscow (see previous chapter), the Soviet Pavilion in Paris
offered a signal example of the Soviet *Gesamtkunstwerk* – a microcosm of
the relationship between the state and the work of art and a vivid
demonstration, in many of its features, of how 'popular' art could be used
as a vehicle of Soviet ideology and propaganda. Designed by Boris Iofan as
an accumulating mass of abstract volumes in the modern-classical manner,
the dynamic shape of the Pavilion projected images of utopian dynamism,
mass society, technical and agricultural progress, in short an entire world-
view deriving from the highly centralised and hierarchical state which
purported to organise a mass society along communist lines.[2] At the
summit of the Pavilion was Vera Mukhina's immense sculpture *Worker
and Collective Farm Girl* (Figure 6.1), symbolising the much hoped-for
alliance of industrial and agricultural enterprise which had been Party
policy since the beginning of the Five Year Plan in 1928 – indeed had
received its initial formulation by Lenin. The Pavilion's position on the
Exposition Internationale site was dramatic. Facing the pavilion of Nazi
Germany at the foot of the Trocadero Gardens, it constituted an unmistak-
able visual and ideological challenge to the German state.

The Soviet Pavilion also gave vivid evidence of the existence of the
'cult of personality' in the Soviet Union, at a time when the veracity of
Stalin's economic miracle and his cultural policies were being scrutinised
by European intellectuals. Moreover, Soviet art and propaganda confronted

both their Nazi counterparts and a whole spectrum of traditional and modernist options – ratified by their sponsoring states – in the context of the Exposition Internationale as a whole. Robert Delaunay's team of painters, who covered the Art and Railway Pavilions with blow-ups of his 'Orphic' circles and spirals, could be seen to parallel the *rabkors* or 'shock-brigade'

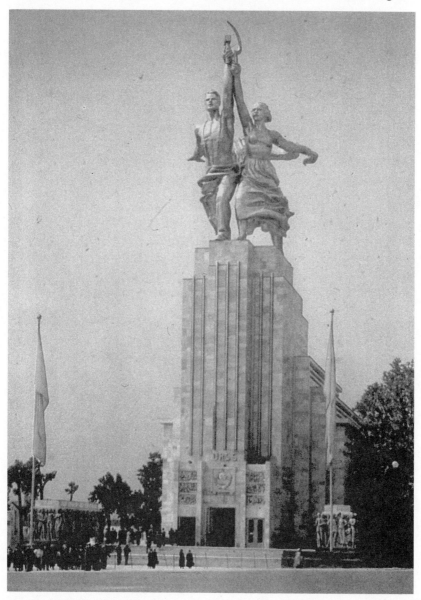

6.1 Boris Iofan, USSR Pavilion, Paris, 1937, with Vera Mukhina, *Worker and Collective Farm Girl*, 1937

107

painters who worked collectively to cover large areas for the murals in the Soviet Pavilion, but here all similarity ends. In this essay I shall focus upon a particular aspect of the architectural and ideological confrontation, namely the reception accorded to the Soviet Pavilion in Paris, and especially the commentary aroused by the interior decorations and the image of state communism that these decorations implied.

Debates had raged among supporters and detractors of the Soviet Union in France since at least 1930. In that year, Henri Barbusse, literary director of *L'Humanité* to 1929, director of the review *Monde,* from 1928, had published *Russie*, an energetic exposition of agricultural, industrial and cultural progress.[4] However, during the next few years it was the abuses and anomalies of the Stalinist system that were leaked and discussed in Europe. As early as December 1930, Aragon and Georges Sadoul in a tract addressed to intellectual revolutionaries had mentioned the trial of the *saboteurs* in Moscow. The Surrealists' fury at the refusal of the Western world to issue the exiled Trotski with a passport was proclaimed in the tract 'Planet without a visa', issued on 24 April 1934.[5]

Boris Souvarine, who had been a member of the managing committee of the French Communist Party in 1921, and had actually influenced Comintern policy during his stay in the Soviet Union from 1921-4, continued to defend Trotski on his return to Paris in his non-official *Bulletin Communiste.* The 'Souvarine group' which formed around his study group, the 'Democratic Communist Circle' and his review *La Critique Sociale*, founded in 1931, contained such disaffected Surrealists as Raymond Queneau, Michel Leiris, then Georges Bataille.[6] Souvarine provided a substantial counter-attack when in 1935 Charles Vildrac published *Russie Neuve* (The New Russia), and Henri Barbusse his more influential *Staline. Un monde nouveau à travers un homme* (Stalin: A new world through one man). Barbusse's ghost-written eulogy depicted Trotski as a troublesome deviationist.[7] Souvarine's own *Staline, Aperçu historique du bolchévisme* (Stalin: a historic vision of Bolshevism), was a meticulously documented, 500-page biography. Here, however, the cult of personality was described as 'the celebration of the most detested person in the Soviet Union'. He concluded that Stalin had created:

> ... a state of affairs in which any serious challenge must sooner or later lead to suicide such as that of Skyrpnik, or to assassination, such as that of Kirov, in one form or another. Between the different bureaucratic factions with their Stalins of every stature and their Molotovs of every calibre, among their clans and their cliques, the matter of life or death is constantly the question.[8]

By late August 1936, the construction of the Soviet Pavilion was well underway when news of the Soviet show trials reached Paris. On 3 September, André Breton gave a speech at the meeting at La Mutualité advertised as

'The Truth about the Moscow Trials', denouncing the trials and execution of Zinovev, Kamenev and their followers as 'abominable and inexpiable crimes'. He demanded a scrupulous investigation by the Vigilance Committee for Intellectuals. The position of the pro-Communist Association of Revolutionary Writers and Artists at the meeting, however, was to insist on the victims' betrayal of the state and their legitimate punishment.[9] In an atmosphere where each side portrayed the other as the perpetrators of lies and calumnies, perhaps the pragmatic reaction of the revolutionary Belgian artist Frans Masereel was not atypical: 'This plague of arrests and executions is a great nuisance, as you say, but that doesn't mean – often in spite of men and their actions – that the cause is not a good one; we still uphold it.'[10]

Two months after the trials, Trotski's own denunciation of the Soviet system appeared in French, causing a sensation in October 1936: *La Révolution Trahie* (The Revolution Betrayed), translated into French by Victor Serge, a former Soviet Communist Party official. Trotski described the transformation of the revolutionary impetus using metaphors from the French Revolution: 'The Soviet thermidor', 'Bonapartism', 'a crisis regime' etc. He was uncompromising about the rewriting of Soviet history under Stalin's terror: 'Facts are distorted, documents hidden, or on the contrary fabricated, reputations are forged or destroyed.' Literature he describes as organised within 'a sort of concentration camp for "belles-lettres" ... The life of Soviet art is a martyrology. After the directive article in *Pravda* against formalism an epidemic of repentance may be seen to have begun in the circles of writer, painters, theatre directors and even opera singers.'[11]

Despite the depth of investigation and the extensive bibliography in Souvarine's *Staline*, and despite both Souvarine and Serge's first-hand knowledge of the Soviet system (not to mention that of Trotski), their accounts were obviously regarded as partisan – in particular among the autodidact intellectuals of the Maison de la Culture, whose expenditure was directed towards bread, not books. The young communist painter, Boris Taslitzki, secretary of the *Journal des Peintres et Sculpteurs de la Maison de la Culture*, would never see the interior of the Soviet Pavilion: he could not afford the entrance fee.[12]

However the dramatic turn-around by André Gide, one of the most prominent intellectuals at the Maison de la Culture, could not be dismissed. His *Retour de l'U.R.S.S.* (Return from the USSR) was published by Gallimard in November 1936. Gide, an erstwhile apologist of the Soviet Union, was acutely discomfited, and all too aware of the furore he would create, as the silhouette of Boris Iofan's impressive pavilion rose up on the Trocadero site.[13] Gide's picturesque and engaging descriptions of the Soviet Union were interspersed with denunciations of the ignorance and uniformity of its culture, inequalities if not of class then of income, leading

109

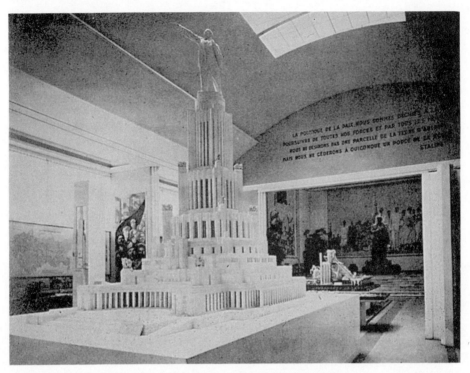

6.2 USSR Pavilion: Interior with Palace of the Soviets model, 1937

to the recreation of petit-bourgeois mentalities, a cult of personality embodied by the ubiquitous images and effigies of Stalin and its logical consequences: 'That Stalin is always right starts to mean in the end that Stalin is right about everything.' Great was the scandal and invective, numerous the written denunciations – by Romain Rolland and Paul Nizan among others.[14]

André Breton attended a meeting, on 26 January 1937 organised by the recently formed Trotskiist Workers' Internationalist Party to discuss the second series of sham trials in the Soviet Union. These Breton likened to 'medieval witch trials.'[15] In the same month the satirical journal, *Le Crapouillot* published a special number 'From Lenin to Stalin' by Victor Serge, which concluded: 'Where could one imagine that bureaucracy could maintain the regime of the strait-jacket indefinitely around a young people of 170 million souls which retains in its memory the heroic legend of the great years and its human condition to conquer?'[16] Serge's own *Destin d'une Révolution, U.R.S.S. 1917-1936* (Destiny of a Revolution), finished in Brusssels in January 1937, appeared shortly afterwards with Trotski's publisher, Bernard Grasset. Serge's sixth chapter, 'Directives for science, literature and education' was followed by a chapter devoted to 'The cult of the leader'. The excesses of the 'cult of personality' around Stalin were illustrated with various newspaper quotations – including the attribution to

Stalin of the creation of the world in a poem published in *Pravda* on 28 August 1936.[17]

Such was the context of debate when the Soviet Pavilion was officially inaugurated at the 1937 World Fair. Denunciations were dismissed as 'the systematic lies of the hate-press' by dazzled visitors such as one M. Phillipe Lamour, 'writer and journalist', whose comments were reproduced in the official exhibition commemorative volume: 'The Soviet Pavilion? An affirmation of power, a song of hope, a thrust towards the future.'

One of the most impressive of the pavilions, the USSR's competed with France and Germany architecturally, reflecting the trend towards giganticism and monumental classicism. Boris Iofan's scale models exhibited in Paris prior to construction had been challenging to the extent that Albert Speer modified his own designs for the Nazi pavilion opposite.[18] The architecture of the Soviet Pavilion ascended triumphantly in a metaphor of the progress and 'conquests' of socialism, providing a giant pedestal for Mukhina's ten-metre tall, flamboyant stainless-steel sculpture of a worker and peasant woman brandishing hammer and sickle respectively.[19] The idea of a very tall sculpture was the architect's, based on his design of a staggered pyramidal structure, topped with a huge statue of Lenin (recalling Bartholdi's *Statue of Liberty*) for the Palace of the Soviets of 1933.[20] A scale model of the latter was exhibited inside the pavilion (Figure 6.2), occupying the same symbolic space and function in the 1937 pavilion as Tatlin's *Monument to the Third International* had done in Melnikov's Pavilion in the Grand Palais at the Exposition des Arts Décoratifs in 1925. It was the USSR's first official reappearance in France since that time.[21] The original brief, dated 10 September 1935, made it plain that this was a project of great significance in terms of international prestige:

> The USSR pavilion must be considered as an exhibit in itself, expressing the expansion of socialist culture, of art, technology and the creations of the people, thanks to the socialist system. With its clear and joyful forms, the pavilion architecture must bear witness to the creativity of this system, which has promoted unprecedented development within mass culture and all man's creative capacities.[22]

The Soviet Pavilions at the Venice Biennales of 1928, 1932 and 1934 had attracted much attention in fascist Italy, where they were regarded as superior and evolving models of the continuum between art and politics.[23]

The 1937 pavilion itself and the Palace of the Soviets model were conceived as incontestable symbols of world power. Inside the pavilion, behind the Lenin statue on a wall under a barrel vault, Stalin's words of 'peace' (my epigraph) resonated with his insistence on the Soviet Union's right to its own territories – its *Lebensraum*. Despite the 'modernist' contradictions offered by Nikolai Suetin's pillars and free-standing elements, based on Malevich's *Architectonics* of the 1920s, the **111**

comparison afforded between Socialist Realist and National Socialist art was striking, emphasised, of course, by the pavilions' placement. In Albert Speer's edifice, models of the Nuremberg stadium and the Haus der Kunst in Munich paralleled that of the Palace of the Soviets; bronzes of naked athletes the Lenin and Stalin sculptures, academic realist paintings, contemporary, mythologised or 'medievalist' replaced the portraits of generals and crowds of peasants, but the state programme for the arts was just as visible.[24] It is no coincidence that talks marking the beginnings of the Nazi-Soviet rapprochement started on 27 May 1937.[25]

As the last full-bodied display of Soviet Socialist Realist art in Paris, the works in the USSR pavilion are of particular significance. To cite the memoirs of Gino Severini: 'I remember perfectly the inside of that pavilion, the two big pictures which decorated the vestibule of the main entrance and which were called "1917-1937" and many other pictures in the last section in which Stalin was always portrayed in the centre surrounded by generals or workmen – all of them, especially himself "terribly life-like".'[27] The realist painting schemes created in the spaces reserved for frescos in the Soviet Pavilion had been masterminded by the celebrated Soviet painter Aleksandr Deineka. The commemorative *Livre d'Or* of 1938 declared: 'Artistic panels decorate the rooms of the Pavilion and display the multiple aspects of the live of Soviet workers. These panels were painted by the masters of the older generation as well as the young painters trained since the Socialist October Revolution.'

The final room in the Pavilion was a huge hall which held an exhibition of Soviet painting, sculpture, theatre designs and craft. 'The paintings, selected from the great museum and exhibition collections characterise the essential divisions of Soviet art, and express its governing idea which consists of a realism reflecting all the aspects of Soviet life.' The exhibition hall was dominated by a very large statue of Lenin seated, by Merkurov, which lowered paternalistically above crowd of eager visitors – 15,000 of whom were to write 'appreciations' in the visitors' book. As opposed to the Lenin statue which, as it were, puts Rodin's *Thinker* into a modern jacket and trousers plus beard, and twists the body round as though Lenin were just about to speak, Merkurov's statue of Stalin in the final hall was upright, static, larger than life, but not gigantic (Figure 6.3). He was in uniform (modern dress was always to be a problem for realist sculptors), but with a floor-length great-coat draped across one shoulder and right hand clasped to his breast in a rhetorical gesture, Stalin assumed a Caesar-like appearance. The scale of the cheerful crowds discernible in the mural paintings behind him gave him the common touch – leader among men but a man from the people.[28] The *Livre d'Or* continued:

In this room the most outstanding Beaux-Arts masters are exhibited. The canvases of the painters Brodski and Sokolov and the works of the sculptors

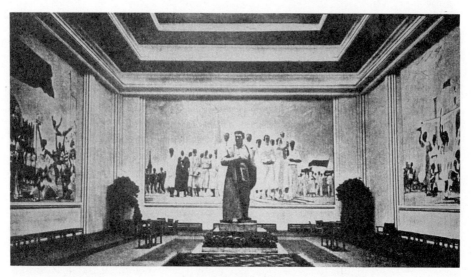

6.3 Sergei Merkurov, *Stalin*, USSR Pavilion installation view, 1937

> Andreev and Merkurov give a lively and moving impression of LENIN both as a leader and as a man. The image of STALIN is evoked in painting in Gerasimov's canvases and in sculpture by the works of Merkurov and Nikoladze.
>
> Numerous pictures stamped with a moving sincerity evoke the heroic epoch of the Civil War; others represent the heroic Soviet people, strong, courageous men, workers, peasants, Red Army soldiers, men of science, children.[29]

These were followed by 'drawings, etchings, engravings, watercolours treating subjects relating to Soviet construction and the new life.' Then came miniatures of revolutionary heroism painted by artisans from the village of Palekh and other villages, wood sculptures, precious stones cut by artists from the Urals, lace, damasks, carpets from Tajikistan and so on – the arts and crafts products similar to those displayed in the Exposition des Arts Décoratifs of 1925. On special tables, albums reproduced the most important works from the Hermitage, the Tretyakov Gallery, and the Museums of Western and Oriental Art. A more detailed picture of artistic life subsequent to the nationalisation of private collections, and enterprises such as the creation in 1936 of the Lenin Museum in Moscow, was given in the 1938 commemorative volume.[30]

The ubiquitous demonstration of the 'cult of personality' nonetheless dominated any historical or 'arts and crafts' exhibits. While the splendid *Livre d'Or* generally reproduced only 'high art' images or installation shots from the pavilions, it was the photographer Giséle Freund who pointed out the USSR's pioneering work in giant photomontage panels and the force of the photographic contribution in the Soviet Pavilion. The transitional role of photomontage for the development of Socialist Realist painting, where **113**

photographic documents were essential for the group portraiture of generals etc., was everywhere evident. The large portrait of Marx, Engels, Lenin and Stalin above the stand of Marxist Literature was the simplest and most didactic image in the Pavilion.

> One saw for the first time the use of monumental photography in Soviet Russia. It was used to impose the faces of the leaders upon the masses, hence for propagandistic purposes. Doubtless under the influence of cinema considerably enlarged photographs had already been used in the arena of advertising, but it's the Russians who first used them as a political tool. Their realist theories, a product of Marxism, fit perfectly with these images taken directly from life. No visitor was astonished to see photography given the honours in the Russian Pavilion; it's just what one expected. [31]

While the pavilion welcomed thousands of visitors throughout 1937, the dialectic of encomium versus 'exposure' continued. Dramatic photographic images of the 'USSR in Construction' were purveyed through the summer months in the magazine of that name, published in Russian, German, French and English by the state publishing house of Graphic Arts in Moscow. A special number (6, June 1937) on Sergo Ordzhonikidze, the People's Commissar of Heavy Industry, was illustrated with impressive photographs of the Kharkov tractor works. The designers, 'ES and EL Lissitsky' (*sic*), alternated tinted photomontages with loose colour plates of history paintings such as M. Avilov's *Comrade Stalin visits the First Cavalry Army in 1919*.[32] Yet that very month, on 11 June 1937, Stalin executed Tukhachevski, a marshal attached to the Ministry of Defence and in charge of the Red Army's armaments and strategy. In his wake, two more marshals were killed, then eleven commissars from Defence, thirteen of Stalin's fifteen army generals and no less than 35,000 officers.[33] The continual repaintings of military canvases necessitated the postponing of the twentieth anniversary 'Industry of Socialism' exhibition in Moscow by two years to 1939. *Le Crapouillot's* special 1937 number on 'Brainwashing' gleefully reproduced Aleksander Gerasimov's *Stalin at a Meeting with Commanders*, with the following caption: 'Exhibited in the USSR Pavilion, this painting, in the best tradition of the "Artistes français" Salons of the 1890s – represents the principal Russian military leaders. The game consists in calculating the exact number of generals who have been shot since the opening of the exhibition.'[34] Moreover, June 1937 saw the publication of André Gide's informed riposte to his detractors: *Retouches à mon retour de l'U.R.S.S.* (Retouching my return from the USSR). Here, he provided hard statistics on industrial deficiencies, illiteracy, surveillance, salaries, etc., this time citing his sources extensively. In general he used material that had been brought to him subsequent to the publication of his controversial memoirs, which corroborated the impressions and fears aroused by his 1936 visit. Anton Ciliga's *Au pays du Grand*

Mensonge (the English title was The Russian Enigma) would follow in 1938.[35]

As far as Russian avant garde art was concerned, it was left to the Surrealists to protest at the omission of Archipenko, Tatlin, Rodchenko, Malevich and Lisitski from the exhibition 'Origins and Development of International Independent Art' at the Jeu de Paume in August, while Sylvain Itkin's production in September of *Ubu in Chains*, with décor by Max Ernst and Breton's programme introduction, 'Outburst and Proliferation of Ubu', was yet another explicit comment on totalitarianism.[36]

Cahiers d'Art was the only luxury art magazine to engage in political criticism in this period. In October 1938, Matisse's son-in law, Georges Duthuit, wrote 'Union et Distance' (*Cahiers d'Art,* 1-4, 1939), attacking the inconsistencies of left-wing artistic positions – both Communist and Surrealist. He dismissed the Soviet Pavilion and its contents with contempt:

> It only remained for the official Bolsheviks in 1937 to bring us – with ecstatic looks – paintings which simple decency decrees should defy all comment. Their models and reproductions of public buildings, through the abuse of porphyry and brilliant metals, the paltry design and the vanity of their dimensions evoke the most monstrous fantasies of capitalist parvenus, dreaming in their original filth in some nightmare Buenos Aires or Monte Carlo.[37]

The coherence and, arguably, the splendour of the Soviet Pavilion stood against Duthuit's assertion, yet it had provoked both the unease and the distaste that he, as an anti-Communist onlooker, now attempted to articulate.

From a Russia described by the philosopher Petr Chaadaev in his *Philosophical Letter* (published 1836) as 'a blank sheet of paper' and whose 'rebirth' with the Revolution had in part engendered the *tabula rasa* aesthetic of the avant-garde, the Socialist Realist project with its emphases on pomp, tradition, nationalism and regional variation may be seen as a display of an 'invention of tradition' on a massive scale.[38] The 1937 Pavilion was a realisation in art and architecture of an immemorial *Reich* predicated on an unchanging future which could only consolidate previous achievements. The USSR would attempt to repeat the Paris statement at the 1939 New York World Fair, despite the international situation and increasing paranoia on the home front.[39]

Soviet official art, linked with the cult of personality, developed backwards, as it were, from photomontage to a nineteenth-century Beaux-Arts tradition, anticipating the restoration of the Academy of Arts of the USSR in Leningrad in 1947.[40] A continuity with the earlier indigenous works of the *Peredvizhniki* group of artists such as Repin was demonstrated only in its least pompous moments, and there was very little relationship to the generally literary directives of the 1930s to be found in texts by Marx, Engels, Lenin and Stalin.[41]

Art of the Soviets

In France, politically-speaking, the complete dichotomy now established over the Soviet question among the French left would structure debates for the next two decades and beyond. Soviet Socialist Realist directives which had a strong lobby in France at the beginning of the Cold War period, after 1947, collapsed with Stalin's death and the uneasy period of de-Stalinisation faced by the French Communist Party in 1956. The rest is history. From a post-modern perspective in a changing Europe and a post-utopian as well as 'post-Gorbachevian' perspective, much remains to be investigated.[42] Let us hope that the paintings and sculptures from 1937 and their progeny will escape the annihilation of successive waves of de-Stalinisation and de-Sovietisation. As testimonials, exalting or grim, to the Soviet project which has structured so much of our century, they are precious evidence.

Notes

1 The first quotation is visible in the photograph of the interior of the Soviet Pavilion published in *Paris 1937 Cinquentenaire,* Paris, 1987, p. 187; the second is quoted in: 'La Participation de L'U.R.S.S.', in the *Livre d'Or Officiel de l'Exposition Internationale des Arts et des techniques dans la vie Moderne,* Paris, 1938, p. 514 (a key document not mentioned in Paris, 1937…). The report in the *Livre d'Or* on the Soviet Pavilion pp. 491-505 ff. is complemented by the *Rapport Général,* Paris, 1938, vol. 10: 'Les sections Etrangères, Deuxième partie: L'U.R.S.S.' Translations throughout are by the author.

2 For a series of models in a more 'romantic' architectural idiom by Konstantin Melnikov, see S. Frederick Starr, *Melnikov, Solo Architecture in a Mass Society,* Princeton University Press, New Jersey, 19XX, pp. 201-3.

3 This article is modified from Chapter 2 of my doctoral thesis: *Art and the Politics of the Left in France, c.1935-1955,* University of London, 1991, entitled 'The Paris World Fair and its aftermath' in which the range of avant-garde and nationalistic styles and debates in 1937 are treated in depth.

4 *Monde* was the French organ of the International Union of Soviet writers. It conducted the Soviet *rabkors*-inspired proletarian literature debate from 1930. See also Henri Barbusse: *Russie,* Paris, 1930, especially 'La Drame de la Terre et du Blé' (Ch. III), La Littérature Prolétarienne' (Ch. X), 'Nouveaux films soviétiques (Ch. XIV).

5 See 'Aux Intellectuels Révolutionnaires' pp. 186-8 and 'La Planète sans Visa', p. 268-9 in José Pierre: *Tracts surréalistes et déclarations collectives 1922-1939,* Paris, 1982, plus his notes pp. 443-5 and 493-4. In fact, Aragon and Sadoul claimed that the trials demonstrated imperialist warmongering against the USSR (p. 186).

6 See Michel Surya: *Georges Bataille, La Mort и l'Oeuvre,* Paris, 1987: 'Le premier désaveuglé' and 'Le Cercle Communiste Démocratique', pp. 167-78.

7 See Frank Field: *Three French Writers and the Great War: Studies in the Rise of Communism and Fascism,* Cambridge, 1975, p. 73, claiming that Alfred Kurella was 'the badly-treated author of Barbusse's *Staline.*

8 Boris Souvarine: *Staline. Aperçu historique du Bolchévisme,* Paris, 1935, pp. 530-1 and 544. Re-edition with bibliographical notes etc., Paris, 1985.

9 See 'Appel aux hommes', and 'Déclaration lue par André Breton le 3 septembre 1936 au meeting: "la Verité sur le Procès de Moscou"' in José Pierre, *op. cit.,* pp 304-7, and

notes p. 509-13. Breton condemns Stalin as 'the principal enemy of the proletarian revolution'.

10 Quoted in Roger Avermaete, *Frans Masereel*, Antwerp and Paris, 1975, p. 59.

11 Trotski, *La Révolution Trahie* translated by Victor Serge, Paris, 1936, p. 209.

12 For 'proletarian' painting versus the beginnings of a pro-communist realism in France, see Wilson, *op.cit.*, Chapter 1: 'From the Abbaye de Créteil to the Maison de la Culture'. See also Etienne Forestier, 'Quelques Renseignements sur le syndicat des artistes en U.R.S.S.', in *Peintres et sculpteurs de la Maison de la Culture*, 6, June 1938, quoting an article by Kravchenko in *VOKS*. The apparently well-organised affairs of the 'United Association of Moscow Artists' are contrasted with the state of unemployment and uncertainty facing young French artists in 1938.

13 It was Gide who had opened the Writers' Congress for the Defence of Culture in June 1935, at a time when his position with regard to Moscow was as idealistic as many of his fellow writers. In October 1935 he had denounced what he called the stupidity and dishonesty of attacks against the Soviet Union. See Jean Schlumberger, 'Notes sur la politique' in the *Nouvelle Revue Française,* December 1934, p. 866. He quotes with scepticism Gide's praise of the USSR from the November issue (p. 749).

14 André Gide: *Retour de l'U.R.S.S.,* followed by *Retouches à mon Retour de l'U.R.S.S.,* Paris, 1936 and 1937. I quote from the 1978 edition, p. 61. Romain Rolland's attack appeared in *L'Humanité,* 18 January 1937.

15 See 'Discours d'André Breton à propos du Second Proces de Moscou' in *Tracts..., op. cit.* pp. 308-11, wrongly dated '16 janvier'.This is corrected to 26 janvier 1937 in the notes p. 513. The Parti Ouvrier Internationaliste (P.O.I.) was formed in June 1936. Seventeen members of the 'Centre antisoviétique trotskyiste', including Yuri Piatakov, Karl Radek and Grigori Solnikov, were executed or given long prison sentences. José Pierre, *op. cit.*, gives full details pp. 513-19.

16 *Le Crapouillot,* special issue 'De Lénine à Staline' by Victor Serge (written December 1936), published January 1937. Biographical details about Serge himself are given, followed by subsections: 'The Third International,' 'The NEP and the Opposition', Zinovev, 'From Lenin to Stalin', 'The assassination' (a blow-by-blow account of the trial and execution of the sixteen victims involved in the Zinovev-Kamenev trials, 19-25 August 1936), 'Two documents' reproducing Kamenev's confidential resumé to Zinovev 'We consider that Stalin's conduct jeopardises the whole revolution', and finally 'The Terror.' Quotation p. 67.

17 Victor Serge (born Victor Lvovich Kibaltchich in Brussels in 1890), had a history of anarchist activity and arrived in Russia in 1919. Here he became a member of the Soviet Communist Party, and a colleague of Zinovev on the executive committee of the Communist International. He was a fusilier, and a commissioner for the secret police archives. Banished from the Party and imprisoned in 1928, deported in 1933, he was finally exiled from the Soviet Union and deprived of Soviet nationality in 1936. See also Victor Serge: *Destin d'un Révolution, U.R.S.S., 1917-1936,* Ch. VII 'Le culte du chef', p. 153:

> O grand Staline, o chef des peuples,
> Toi qui fit naître l'homme,
> Toi qui fecondas la terre,
> Toi qui rajeunis les siècles
> Toi qui fait fleurir le printemps,
> Toi qui fais vibrer les cordes musicales
> Toi, splendeur de mon printemps, o Toi,
> Soleil reflété par des millions de coeurs...

18 Quoted by Philippe Lamour, *Livre d'Or*, p. 514. See also Albert Speer, *Au coeur du troisième Reich,* Paris, 1971, p. 117 and in *Paris, 1937, op. cit.*, p. 19.

19 Matthew Cullerne Bown, in *Art under Stalin,* Oxford, 1991, p. 82: 'It became the great symbol of Stalin's USSR, defined in the new constitution of December 1936 as "a state of workers and peasants." Despite its "progressive" image and material it was completely hand-made, laboriously fashioned in individual sections, each shaped on a carved wooden template.'

20 Like Hitler's sculptor, Arno Breker, Mukhina had been trained in Paris. She had frequented Bourdelle's studio at the Grande Chaumiére prior to 1914. See the description of the modifications she made to Iofan's ideas and the reference to her memoirs, *Literaturokritikeskoe nasledie,* Moscow, 1960, vol. 1, in Jean-Louis Cohen's description of the USSR pavilion in *Paris, 1937, op. cit.,* p. 186, including footnote 5.

21 See Jean-Louis Cohen's text, *Paris 1937, ibid,* pp. 183-9 for details of the architectural competition of 1936, the various proposals by Moisei Ginzburg, Karo Alabyan, Konstantin Melnikov, Vladimir Shchuko and Vladimir Gelfreikh and Alexei Shchusev, reproductions of the losers' designs, Iofan's project in perspective with a more stylised version of the sculpture which Mukhina modified, and views of the pavilion in maquette by day and night, from the air, and two interior views, plus a bibliography of Russian writings on the subject. The Palace of the Soviets project, interrupted by the war, was never built.

22 I translate from the French given in *Paris 1937, op. cit.,* p. 184.

23 See Igor Golomstocki, 'Encounter in Venice', in Chapter II, 'Between Modernism and Total Realism'. in his *Totalitarian Art in the Soviet Union, the Third Reich, Fascist Italy and the People's Republic of China,* London, 1990, pp. 51-5,

24 Ironically, Sophie Tauber-Arp's review *Plastique,* which was pursuing a policy of modernist revivalism in the increasingly reactionary climate of 1937-9, devoted pages to Malevich's *Architectonics* at this time. See Wilson, *op. cit.,* pp. 117-27 for a discussion of the German Pavilion in context of anti-fascist and French right-wing responses.

25 Date given in Golomstock, *op. cit.,* p. ix. Golomstock's notion of totalitarian culture and my own position is very different from Cullerne Bown, *op. cit.,* p. 138, who emphasises the national and traditional origins of Soviet Socialist Realism and sees National Socialist art in Germany as 'a short-lived aberration'.

26 The *Exposition Lénine* 1870-1924, held at the Grand Palais in May-June 1970, was the subsequent appearance of officially sponsored Soviet art in Paris.

27 Gino Severini, 'The Position of Art in Russia', in *The Artist and Society,* London, 1946, p. 25.

28 For the descriptions of the contents of the Pavilion see the *Livre d'Or op. cit.,* p. 503 ff., 'Les Arts'. The 30-metre-high, concrete version of Merkurov's *I.V.Stalin,* exhibited in Mechanisation Square at the All-Union Agricultural Exhibition in Moscow, 1939, is illustrated in Cullerne Bown, *op. cit.,* p. 83.

29 *Livre d'Or, ibid.*

30 See the *Livre d'Or,* p. 504: 'Museums are more frequented these days than at any time in their existence before the Revolution. This fact demonstrates the profound interest that the popular masses have for art. LENIN's dictum has come to pass in the U.S.S.R: "Art belongs to the people. Art must penetrate with its roots into the depths of the labouring masses. It must be within reach of the masses and loved by the masses." The exhibitions of contemporary Soviet art as well as the great masters of the Russian past such as Repin, Surikov or Kramskoi, are visited by hundreds of thousands of people: labourers, office-workers, soldiers and schoolboys. The exhibition buildings are not vast enough to receive all the visitors. Reproductions of artworks are diffused among the masses in enormous quantities and are used to decorate rooms lived in by workers and collective farmers. The Soviet regime has created a great number of museums and exhibitions, historical, revolutionary, regional, industrial, commemorative, agricultural,

artistic etc. The great new Lenin Museum created in 1936 in Moscow enjoys an extraordinary popularity.' See also the description of Soviet museums in Joseph Billiet, *La Culture artistique en U.R.S.S,* Paris, . 1945, part III, 'La mise en valeur du patrimoine artistique', p. 13 ff. with reference to the first 'Congrès pan-russe des musées' in 1930.

31 Gisèle Freund, 'La photographie à l'Exposition' in 'Paris 1937, New York 1939', *Arts et Métiers Graphiques,* special issue, 1938, p. 38.

32 See *U.S.S.R. in Construction,* 4, June 1937: 'Designed by ES and EL Lissitski, text by S. Tretiakov and V. Stavski, photographs chiefly by M. Alpert. Assisted by Z. Chebotayev.' The French version was distributed in France by Messageries Hachette, Service abonnements, 111 Rue Reaumur, Paris 2ᵉ.

33 This information is quoted in Philippe Rivoirard, 'Le Pacifisme et le Tour de la Paix', Paris 1937 *op. cit.,* p. 316.

34 *Le Crapouillot,* special issue no. 20, 1937, 'Le Bourrage de Crânes', edited by J. Galtier-Boissiére, p. 50. See also Cullerne Bown, *op. cit.,* p. 109 for the repainting story. This was repeated for the All-Union Agricultural Exhibition with its various regional pavilions, including a 'GULag' pavilion devoted to the constructive achievements of the prison camp administration! This was also postponed to 1939.

35 André Gide, *Retouches à mon retour à l'U.R.S.S.,* p. 135: 'I only managed to instruct myself after writing my book on the U.S.S.R. Citrine, Trotski, Mercier, Yvon, Serge, Legay, Rudolf and many others brought me documentation.' Gide quotes statistics with dated references to *Pravda, Pravda Vostoka* and *Izvestiya,* Lenin and Trotski themselves, Souvarine, Louis Fischer, Jean Pons, Victor Serge; Sir Walter Citrine, *I search for Truth in U.R.S.S.* (sic); M. Yvon's brochure, *Ce qu'est devenue la Révolution russe*; Lucien Laurat, 'Coup d'oeil sur l'economie russe' in *L'Homme Réel,* 38, February 1937, etc. Anton Ciliga's *Au Pays du Grand Mensonge,*1938 was translated into English as *The Russian Enigma* in 1940, ed. George Routledge. *Sibérie, terre d'exil et de l'industrialisation. Dix ans derrière le rideau de fer* was written in Paris in 1949, and published in 1950.

36 See 'Lettre ouverte à M. Camille Chautemps, Monsieur Jean Zay, Monsieur Georges Huisman' 7 August 1937 and 'Ubu enchainé' in José Pierre, *op. cit.,* pp. 311-2, 313 ff. and notes 519-21.

37 Georges Duthuit, 'Union et Distance', *Cahiers d'Art,* 1-4, 1939, p. 58.

38 See Frederick C. Coppleston, *Philosophy in Russia From Herzen to Lenin and Berdyaev,* Tunbridge Wells and Indiana, 1986, Chapter 2, 'Chaadaev: Russia and the West', p. 26 ff, and Eric Hobsbawm and Terence Ranger (eds), *The Invention of Tradition,* Cambridge, 1983, introduction. Hobsbawm distinguishes perennial 'custom' from ideologically created 'tradition', which incorporates a false notion of continuity with the past.

39 Iofan's Soviet Pavilion at the New York Worlds Fair of 1939 was 'a pedestrian attempt to repeat the Paris triumph' despite the impressive brigade paintings: *Well-known People of the Soviet country* and *Sports parade* (170 and 150 square metres respectively). See Cullerne Bown, *op. cit.,* pp. 82-3.

40 See Cullerne Bown, *op. cit.,* p. 173-4.

41 George Plekhanov's Marxist criticism of 1912 'L'Art et la vie sociale' had been promulgated in France in 1931. See *Littérature de la Révolution Mondiale,* 3, p. 107 fL and 4, p. 78 ff. A. A. Zhdanov had enunciated the concepts of 'Socialist Realism' and revolutionary Romanticism at the Soviet Writers Congress of 1934 . See *Soviet Writers Congress 1934,* London, 1977 reprint, p. 20-22. For France see *Sur la Littérature et l'Art: Karl Marx et Frédéric Engels, Sur la Littérature et l'Art: Staline; Lénine,* texts translated and presented by Jean Fréville, Paris, Editions Sociales et Internationales, 1936, two volumes. All stock of the Editions Sociales Internationales was destroyed after the Nazi-Soviet pact in 1939.

42 Boris Groys, *Staline, Oevre d'Art Totale,* Nîmes, 1990, orginally published as *Gesamt-kunstwerk Stalin*, Munich and Vienna, 1988, concludes with a comparison between Western 'post-modernism' and Russian 'post-Utopianism'. I use his categories.

7 Aleksandr Gerasimov

Aleksandr Mikhailovich Gerasimov was born on 12 August 1881 in Kozlov,[1] a medium-sized town in the Russian black-earth regions whose nearest big neighbour is Tambov. This was, and still is, Russia beyond the pale of European sophistication. The princess Olga, in Saki's *Reginald in Russia*, invites Reginald to stay on her estate, 'the other side of Tamboff, with some fifteen miles of agrarian disturbance between her and her nearest neighbour.' The urbane Reginald reasons that 'there is some privacy which should be sacred from intrusion.' In the course of his life as an artist, Gerasimov came to reciprocate fully Saki's disdain. He championed the cause of conservative, home-grown Russian realism against Western movements; Picasso (born in the same year), he anathematised as a 'formalist'. His career exemplifies two striking traits of Russian culture: the shrinking from foreign contact and the great resources of national pride and self-sufficiency, that were encouraged and exploited for political ends by Stalin. These were the conservative values of provincial Russia, absorbed by Gerasimov during his upbringing in Kozlov; they inspired him; and in the favourable conditions provided by Stalin's regime enabled him to become the most powerful figure in the Soviet art-world.

There was nothing in Gerasimov's background to suggest he might become an artist.[2] Kozlov had its own railway station, a developed agricultural trade, and a population of some 40,000 by 1897; but during Gerasimov's youth it was not home to a single artist, let alone an art-school. It had a theatre, but this provided less compelling entertainment than organised fist-fights, a town tradition in which Gerasimov claimed to have excelled. His parents were both born serfs and had little contact with, or interest in, high culture; his mother never went to the theatre in the course of her whole life. Gerasimov's father was a small trader in horses and cattle, and although Gerasimov attended school from the age of seven to fourteen, much of his youth was spent assisting his father. The business of buying and selling required the young Gerasimov to make long trips through the Russian steppe, for which he afterwards felt a powerful nostalgia. He learned the livestock trade inside out, right down to the method of slaughtering cattle.

Gerasimov seems to have had an affinity for art. By his own account, he showed an early talent for drawing, and really began to take the activity

seriously when, at the age of thirteen, he saw a trader in a shop make a drawing of a horse. He was struck by the man's ability to make a likeness. Soon afterwards he was delighted by a book of Gogol's stories, illustrated by Igor Khrabrov, the pseudonym of Igor Grabar. He began to draw regularly, especially portraits, and to make copies from reproductions. In 1900 the painter Sergei Krivolutski, a graduate of the St Petersburg Academy, opened a studio in Kozlov. Gerasimov, busy with his father, could not find the time to study with him, but did show him some drawings. It was Krivolutski who first advised Gerasimov to study art seriously. He hesitated, but when in 1903 his father finally retired to run a modest market-garden, Gerasimov, with no other firm prospects, set off for Moscow to try to gain a place at the Moscow College of Painting, Sculpture and Architecture (*MUZhVZ*).

When Gerasimov took the entrance exam to the *MUZhVZ* he was twenty-two and had received no art education. His background can be contrasted with that of, say, Robert Falk, a child of the Moscow intelligentsia, who began lessons with Konstantin Yuon at the age of sixteen and entered the *MUZhVZ* in 1905 at nineteen. Gerasimov nevertheless won a place, as one of two students selected from thirty-two applicants. His success he put down to his facility for portrait drawing, which outweighed his poor drawing from the cast. It seems possible that some allowance was also made for his lack of formal training.

Gerasimov felt that he made good, in the first few years, the technical deficiencies in his art education prior to the *MUZhVZ*. But it appears that a sense of social inferiority persistently set him apart from many of his fellow-students. He always felt keenly his particular status as a rough provincial in a milieu of sophisticates. He wrote late in life of his student years that 'Many people hated me, the more so because I did not have a particularly "refined" manner in conversation or argument.'[3] Maybe these words, published in 1954, were coloured by the class-conscious times in which they were written, but there is no doubt that even as a student Gerasimov began to display an antagonism to some of the urban intelligentsia, whom he scorned as 'aesthetes' because of their preference for avant-garde art. In 1909 he organised a protest against the domination of the jury for student shows by avant-gardists, and achieved the institution of a non-juried section. At about the same time he was threatened with expulsion for fighting with one of the 'aesthetes' in class.[4]

These student disputes about the language of art were, in embryo, those which affected the whole Soviet art-world in the 1910s, 1920s and 1930s. Even many of the combatants were the same: on the one hand Gerasimov and his student allies, arch-traditionalists such as Evgeni Katsman; on the other, those who believed in stylistic progress, such as Robert Falk, Nataliya Goncharova, Mikhail Larionov and David Burlyuk.

At the *MUZhVZ* Gerasimov's painting style was formed; it did not change significantly throughout his career. He favoured the full-bodied brushmark typical of the work of the Russian impressionists. The two leading members of this school, Kostantin Korovin and Abram Arkhipov, taught Gerasimov and he acknowledged their special influence. He also admired the work of Leonid Turzhanski, a student contemporary who painted scenes of life in the country with vigorous impasto. He visited Tretyakov's collection and admired Repin as a portraitist. To these indigenous influences may be added the example of the French impressionists, in particular Monet; and the Swede, Anders Zorn. Zorn who visited Russia in 1897 and whose work was to be seen in private collections and visiting exhibitions, made a deep impression with his virtuosity and mastery of *plein-air* effects. Gerasimov's painting is further distinguished by his aversion to the use of any form of thinner with his paint. He used paint in the consistency in which it came from the tube; if it was dryish and unwieldy he simply chose a brush with shorter, stiffer bristles with which to manipulate it. In some of Gerasimov's pictures, indeed, one is struck by how thick, inert paint has been pushed and dragged – against its will, as it were – over the canvas, when another artist might have coaxed the paint to behave by adding to it a liquid medium. He preferred to leave his surfaces unvarnished and matt.

In 1911, Gerasimov was given permission to paint a diploma work in preparation for graduation. Most unusually (if we bear in mind that he had studied for eight years), he refused. In various autobiographical sketches he always put this refusal down to a sense of not being fully prepared as an artist, and there seems no reason to doubt this. He asked Korovin if he might continue working in his class; Korovin agreed on the condition that Gerasimov remained officially enrolled at the *MUZhVZ*; and so he entered the architecture department and began to train as an architect, using all his spare time in Korovin's painting studio.

Gerasimov's last years as a student brought him a modest degree of professional success. His work began to find buyers at the annual student shows and was occasionally mentioned in the press. In 1913 a theatre was constructed in Kozlov to his design – his only executed architectural project, if one excludes the house he was to have built for himself in the 1930s. His paintings at this time fall into two broad categories: portraits, and scenes of life in and around Kozlov. Gerasimov was absorbed by the play of light and shade, often depicting a scene dappled in sunlight falling through foliage. In particular, he favoured a format in which a portrait was painted outdoors, the sitter placed next to a table on which was arranged a still-life of flowers, fruit and crockery on a decorative tablecloth, the whole scene a patchwork of sunlight and shade. He was indebted to French and Russian impressionism for this kind of motif, which he continued to use

throughout his career, even adopting it for portraits of Stalin. Also notable among the works of this period is a picture of pronounced horizontal format known by various names but usually as *Troika*, showing a horse-drawn troika being pulled at a gallop through the snow accompanied by two racing dogs. We have the point of view of a hypothetical passenger on the troika; we see the rumps of the galloping horses and the left arm of the driver, the rest of his figure cropped by the right edge of the canvas.

Troika was one of the works shown at student exhibitions in the 1910s which attracted a patron for Gerasimov in the writer, Vladimir Gilyarovski. Gilyarovski, like many Russian intellectuals, felt it his duty to draw closer to that mythical social unit, the people, and had worked as a barge-hauler on the Volga. His best books are picturesque accounts of traditional Russian life. Perhaps for Gilyarovski Gerasimov was a representative of the people, the son of serfs busily pulling himself up by his bootlaces. But he did not simply patronise Gerasimov; he shared his opinions on art, and in particular his distaste for the avant-garde. He once took the young painter to visit a literary and artistic circle in order to say to him, 'There, take a look at these decadent swine...'[5]

Gerasimov finally graduated in 1915, at the age of thirty-three, presenting (uniquely in the history of the *MUZhVZ*) diploma works in both the architecture department – a project for a mausoleum for the victims of the 1812 war – and the painting department – a large watercolour depicting a lecture by the historian, Vasili Klyuchevski, to students at the College. This choice of subject can be read, if not as a manifesto, then as further evidence of Gerasimov's attachment to the Russian past. He passed out as an artist, first class, and – the First World War in progress – soon received call-up papers. Gilyarovski arranged for him to work behind the lines as a *nestroevoi*, someone unfit for battle. He travelled around on supply trains and saw action only once, through binoculars. He did little painting during these war years, but perhaps showed some talent (if it may be so termed) for ingratiation as a portrait painter. When it became known that he was an artist, he was asked to paint an officer's portrait; soon after, he was commissioned to paint a general. It was from this general's mouth that Gerasimov first heard the news of the revolution of February 1917 and of the Tsar Nikolai's abdication.

He as still in the army when news came of the October Revolution. In the spring of 1918 he was finally demobbed and made his way back to Moscow. In the capital, according to his autobiography of 1963, he attended a meeting chaired by an avant-garde artist, which convinced him that he could not flourish under the avant-garde hegemony and caused him to return to Kozlov. This is believable: the ill-treatment of realists at this time by David Shterenberg, head of the art department of the People's Commissariat of Enlightenment, *NarKomPros*, is well-known; but it was a

detail omitted from Mikhail Sokolnikov's monograph on Gerasimov of 1954, and from earlier books and biographical sketches, which stated that Gerasimov returned from active service directly to Kozlov. In the Stalin period, Gerasimov's refusal to stand and fight the realist corner in Moscow in 1918 would have been considered a cardinal sin.

Gerasimov was in Kozlov from 1918 to 1925. The civil-war years were apparently precarious: Gerasimov claimed to have painted portraits of Marx and Engels and cast a bust of Marx only to have them destroyed and be himself forced into hiding when the White Army seized the town briefly in the summer of 1919. He did little easel-painting in these years; like many artists, his energies were directed into various forms of public art. He organised a society of Kozlov artists which produced posters, slogans, advertisements and helped to decorate the town on public holidays. At the end of 1919 he began work as a scenic artist in the town theatre (the one constructed to his own design in 1913), and this was the centre of his professional activity until 1925.

In 1925 Gerasimov moved back to Moscow. It is not quite clear what the pretext for this trip was; whether he went in his professional capacity as the scenic artist of the Kozlov operetta theatre, which was touring in Moscow; or whether he went to get permission from *NarKomPros* for a trip to Paris to see an exhibition of decorative arts, for which he had approval from the Tambov authorities. It seems possible that these opportunities, which both necessitated a journey to Moscow, coincided. Gerasimov was given to understand by *NarKomPros* that he had little chance of being allowed to travel to Paris. Gerasimov later blamed this refusal on the prejudice of avant-gardists in *NarKomPros* but it seems equally possible that he was simply the victim of the increasing repressiveness of Soviet society as a whole. Many artists had similar requests turned down; in 1928, for example, Aleksandr Drevin, a much more prominent and well-established figure than the Gerasimov who arrived from Kozlov, was refused permission for a similar trip. Be this as it may, Gerasimov, once in Moscow, did not return to Kozlov. No longer young – he was now forty-four – made the bold choice to start painting again in earnest and to build a career in the capital.

His first studio was a disused pavilion in the park which had been the venue for the 1923 Agricultural Exhibition (subsequently dubbed Gorki Park). Here he completed a large watercolour entitled *The Steppe in Flower*, and painted two versions of *In the Boat*, a striking image of bare-breasted peasant-women sunning themselves in a rowboat laden with fruit. The models for this work posed in a boat on the Moscow river. It is a typical Gerasimov painting in its robust handling, and in its delight in the play of sunlight and combination of figures and still-life; the group of half-naked peasant-women reveals Zorn's influence and prefigures a series of

works of the 1930s-40s, depicting a communal bath. After such a long lay-off – Gerasimov had not stretched himself as an easel-painter since graduation in 1915 – it was an impressive return to form.

Gerasimov re-established contact with some of his old cronies from *MUZhVZ*. Katsman, Gerasimov's ally in their student struggle against avant-gardism, was now a major figure in *AKhRR,* the Association of Artists of Revolutionary Russia. *AKhRR* was at the centre of a similar struggle now, attempting to assert a realistic style as the proper art of the new Soviet state. On the advice of Katsman and other *AKhRR* leaders, Gerasimov joined the Association. At the 8th *AKhRR* exhibition, which opened in 1926, Gerasimov made his début with *The Steppe in Flower*, a still-life and a portrait of Michurin, a celebrated botanist who also hailed from Kozlov. It was an inauspicious start, although Lunacharski, the People's Commissar for Enlightenment, commented on the 'joy in life' (*zhisneradostnost*) of Gerasimov's work.

It seems likely that Gerasimov felt his technique was rusty, because he attended the life-drawing classes run by *AKhRR* in its headquarters on Volkhonka Street. At one of these classes, in early 1927, he was invited by the sculptress, Mariya Denisova-Shchadenko, to accompany her on a visit to Kliment Voroshilov, recently installed as People's Commissar for Defence, whose portrait she was modelling . Gerasimov snatched a bit of plywood to work on and, in the course of the evening, asked Voroshilov for permission to paint a proper portrait. Voroshilov agreed, and Gerasimov executed a thoroughly conventional image of the great man seated in a mahogany armchair, which was exhibited at the 9th *AKhRR* exhibition in 1927.

In the course of their few sessions together, Gerasimov made a conquest of Voroshilov. The Red Army chief was genuinely interested in art; Gerasimov, by the account of everyone who knew him, was a man of formidable charm and wit despite his lack of social refinement – the absence of which probably stood in his favour with the communist leadership. The two men became friends. Gerasimov visited Voroshilov at his dacha, where the latter assembled a first-rate collection of nineteenth-century Russian realism (destroyed in a fire in 1952); and they also went hunting together. Voroshilov was one of Stalin's protégé's, chosen, like Molotov, Mikoyan and Kaganovich, to supplant the Bolshevik old guard loyal to Lenin and Trotski; his patronage was invaluable. Indeed, the friendship of these two men embodied much of the striving of *AKhRR* as a whole, many of whose artists devoted their best efforts to glorifying the Red Army. Gerasimov was quickly established as one of the charmed circle in *AKhRR* who, as Katsman confirmed in his memoirs, had permanent passes to the Kremlin.

Gerasimov was soon evicted from his pavilion in the park, and went to live and work for a year in the *AKhRR* headquarters. Towards the end of

1927 he moved into a big studio vacated by the sculptor, Sergei Konenkov, who had emigrated. It was a large space, which he shared with three other *AKhRR* painters, Mitrofan Beringov, Fedor Bogorodski and Georgi Ryazhski – the latter two both members of the secret police. Here he prepared a large portrait of Voroshilov on horseback for the 10th *AKhRR* show, which opened in February 1928 in the Central Telegraph Agency in Tverskaya Street. It was the most important exhibition of the second half of the 1920s. Prominent artists from groups other than the *AKhRR*, such as Deineka and Petrov-Vodkin, broke ranks to take part in it. It was visited by Stalin himself, who approved it and made the famous remark that his favourite picture was Repin's *The Zaporozhe Cossacks*. The show was devoted to the Red Army, which meant that Gerasimov's big equestrian portrait was, in effect, a thematic centrepiece. It was chosen for reproduction in a huge edition by *IzoGIZ,* the art-publishing house, and the royalty from this solved the financial problems Gerasimov had been experiencing up until this time.

In the space of three years since his return to Moscow, he had established himself as an important figure in the capital's art-world. He was a leading figure in *AKhRR*, which was by this time the dominant artists' group by size and influence; he had staked a claim as an artist with two large thematic pictures; and he had begun to hob-nob with the political leadership. Over the next five years Gerasimov continued to paint landscapes, still-lifes and private portraits, of which the best are probably the portrait of his wife, Lydia (1929) and a self-portrait of 1933 – a memorable image of a world-weary, middle-aged face (Figure 7.1). He created one powerful work showing the peasant life he had known as a boy, *The Slaughter* (1929). But he also demonstrated his readiness to assume the mantle of court painter. He painted two more large canvases featuring Voroshilov (in 1931 and 1933); three images of Lenin in support of the Lenin cult assiduously fostered by Stalin, including *Lenin on the Tribune* (1929) in a number of variations which considerably increased his official prestige (he also began, but never completed, a picture of the attempted assassination of Lenin in 1918); and in 1933, his first image of Stalin, a large canvas showing his speech at the 16th Party Congress.

He was not the only artist to take this path among the realist painters of the time, but he was among the most able of those who did. Other realists of comparable ability, with the signal exception of Isaak Brodski who died in 1939, chose not to devote their best energies to portraying the leadership. Thus Gerasimov, further bolstered by his friendship with Voroshilov and the leaders of *AKhRR,* began to emerge pre-eminent in this particular field.

Why he should have taken this path, which causes his name to be held in such opprobrium today, we can only guess. Ambition, greed, a lack of moral scruple no doubt played a part. He enjoyed spending money; Agnesa

Yakovleva, widow of the painter Vasili Yakovlev, remembers going shopping with Gerasimov for jewellery for his daughter with a suitcase-full of money.[7] His peasant upbringing was another factor; it had failed to supply him with high-falutin notions of the autonomy of art; art-for-art's-sake he considered a fraud. But it should also be remembered that Gerasimov, from the time he took the entrance exam to the *MUZhVZ*, considered himself a portraitist. What task nobler than to portray on a regular basis the twin geniuses of humanity, Lenin and Stalin?

He did not achieve, at this time, quite the pre-eminence within the art-world that was to be his in years to come. There still existed a plurality of opinion, exemplified at the end of the decade by the struggle between

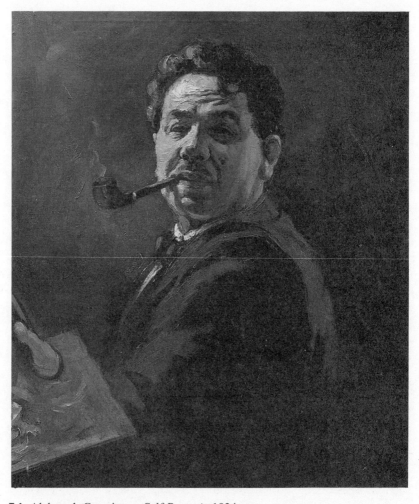

7.1 Aleksandr Gerasimov, *Self-Portrait*, 1934

AKhRR and the new avant-garde grouping *Oktyabr* (October). Gerasimov faced resistance from more than one quarter. In 1930 the Tretyakov Gallery hung *Lenin on the Tribune*, on loan from *IzoGIz*, above a staircase, as if it were a poster (which, in its uncomplicated enthusiasm, it resembles); moreover, the museum curatorial staff were reluctant to purchase it – indications of the continued resistance at this time to the more blatant examples of art as propaganda. This situation soon changed: the painting was bought and hung in a more dignified position, no doubt after pressure had been applied by the party. Gerasimov also came under fire from members of *RAPKh*, the Russian Association of Proletarian artists. *RAPKh* was formed in 1931 by a group of zealous young Party members who, in the frenetic atmosphere engendered by the collectivisation programme and Stalin's drive for new party members, tried to wrest the ideological high-ground away from other artists' groups. In their journal, *Art to the Masses*, they attacked Gerasimov (who was not at that time a Party member) as a fellow-traveller; they criticised his landscape *Black Earth*, depicting the bare countryside around Kozlov on a grey day, as an attempt 'to inspire terror before the all-powerful elements';[8] it was characterised as gloomy and therefore against the public interest. This sort of criticism is typical of its time, when the struggle for power between artists' groups was at its height; it went beyond the bounds of common sense into innuendo, casuistry and defamation. Nevertheless it was potent; Gerasimov felt compelled to reply, in a letter to *AkhRR*:[9] 'The blackness of the earth is a sign of its fertility: the clouds moving above it are a necessary condition of the future harvest; and the rooks are a sign that the soil is not exhausted and is full of living organisms.'[10]

The decree of April 1932 dissolving all literary and artistic organisations put an end to *AKhRR, RAPKh* and, according to the artist-survivors of that time, even (for a year or so) to the ferocious disputes which had bedevilled the art-world since the Revolution. The new organisation which guided all artists in the capital was the Moscow Organisation of the Union of Soviet Artists, *MOSSKh*. Gerasimov was one of the first intake of members and soon after received a place on the board.

In 1934 Gerasimov finally made his first trip abroad. It was a veritable Grand Tour. He spent four months visiting Berlin, Paris, Rome, Naples, Florence, Venice and Istanbul. If ten years earlier such trips had been hard to obtain, now they were a real privilege. Stalin had instituted a whole series of measures aimed at reducing contact with foreigners and foreign culture. Gerasimov's trip, like Deineka's to America in the company of the critic Osip Beskin in 1935, was a signal exception to the rule of cultural isolation, a carefully calculated perk for figures of exceptional importance to Stalin's regime. Gerasimov came home with a batch of watercolours, mostly of Paris.

In everything he wrote about this trip afterwards, beginning with articles in the journal *RabIs* in November 1934 and in the art magazine *Tvorchestvo* in January 1935, Gerasimov expressed his contempt for the Western contemporary art he saw and his admiration for the old masters in the Louvre and the Uffizi. He might well have written in good faith, but his trenchant opinions coincided precisely with the official propaganda surrounding the new Soviet style of Socialist Realism. Socialist Realism, announced in 1934 at the First Congress of the Writers' Union as the proper creative method for all Soviet artists, required artists to use traditional techniques based on the work of the old masters and nineteenth-century Russian realists and to eschew all kinds of modern innovation, or 'formalism'. These principles closely reflected Gerasimov's own instincts and received his wholehearted, combative support. Indeed, his patriotic inclination now hardened, under the influence of Stalin's chauvinist and isolationist cultural policy, into an iron xenophobic principle. Thus at a meeting of artists with Molotov in the Kremlin on 11 February 1937, he ventured the opinion that, for Soviet artists, there was 'nothing to go abroad for'.

Such a remark, calculated to deprive other artists of an opportunity for foreign travel, was all the more ungenerous because Gerasimov himself had returned from abroad fired by ambition. He wanted to create a work to equal the great masterpieces of past ages. The whole of 1935 he devoted to making portrait studies for a vast canvas, *The First Cavalry Army,* which he completed in 1936. One source of inspiration was Repin's well-known *Ceremonial Meeting of the State Council* (1901-3); others may have been some of Brodski's thickly-populated pictures of the 1920s. Gerasimov attempted to go one better than Brodski by eschewing photographic source-material and painting dozens of portrait studies from life. The result of so much effort was not a happy one. Gerasimov was no match for Repin, and the figures are wooden, although some of the preparatory studies are vigorous and expressive.

The First Cavalry Army was shown at Gerasimov's one-man exhibition of 1936; in the following two years many of the personnel portrayed in it were arrested as enemies of the people and imprisoned or executed, rendering the picture unsuitable for display during the rest of the Stalin period. Indeed, this most official of paintings had been transformed by events into a potentially subversive image. When it returned from Paris, where it had been on display in the Soviet Pavilion at the great international exhibition of 1937,[11] Gerasimov removed it from its stretcher and laid it face-down on his studio floor under the carpet, where it stayed for twenty years.[12] Gerasimov's other great group portrait of the 1930s, *The People's Commissariat for Heavy Industry*, also suffered because of the purges. It was commissioned in 1935 in preparation for the exhibition 'The Industry

of Socialism', planned for 1937 to mark twenty years of Soviet power. The arrests of members of the Commissariat forced Gerasimov to rework his painting time and again, until in the end he was forced to scrap his first version altogether.[13]

The year 1937, notorious in Soviet history because it marks the height of the purges, was also the year in which Gerasimov, in his fifty-sixth year, emerged in full feather as the figure we know today: standard-bearer of the Stalin cult and art-world boss. Before 1937 he had painted Stalin twice, in 1933 (his speech at the 16th Party Congress) and 1934 (a watercolour portrait). Now canvases devoted to Stalin began to gush from his studio: two portraits of Stalin and a small painting of him in his office (1937); *Stalin and Voroshilov in the Kremlin* (in at least three versions), *Stalin and Gorki Strolling on the Banks of the Moscow River* and a portrait of Stalin (1938); *Stalin and Mikoyan, Stalin and Gorki in Gorki* and two portraits of Stalin (1939); a portrait of Stalin (1940); *Stalin and Voroshilov on the Volga, Stalin at the Telegraph* (1941).

Two of these images became particularly well-known: a half-length portrait of Stalin on a podium at the 18th Party Congress, in which he faces the viewer squarely and stretches out his arm to him, which is known in a water colour version (1939) and an oil variant (1940); and *Stalin and Voroshilov in the Kremlin*, for which in 1941 Gerasimov was awarded one of the first Stalin Prizes to be offered in the visual arts, worth 100,000 roubles tax-free.

Stalin and Voroshilov in the Kremlin, in which Voroshilov (soon to be dismissed as head of the Red Army because of the Soviet failure in the war against Finland) embodies the security of the country and Stalin, his gaze penetrating the distance, its glorious future, suggests that Gerasimov believed the genre of the leader was compatible with artistic ambition. Gerasimov attempted to imbue it with something of the spirit of his past work: he depicts a certain state of the weather (albeit of allegorical significance) – storm past and blue sky breaking through the clouds. While carefully finished, the painting is executed with verve: the wet pathway is represented by broad strokes; the railings are brushed in laconically. The whole is a more ambitious painterly undertaking than another celebrated Stalin picture of the 1930s, Efanov's *An Unforgettable Meeting*, which is a model of academic efficiency but devoid of vigour in the handling. This side of Gerasimov's striving is strikingly apparent in *Stalin and Gorki in Gorki*, which attempts all the impressionist lyricism of his portraits of family and private people. But for all this, these works were not influential among artists as paintings: the work of Arkadi Plastov, for example, provoked much more of an enthusiastic response. Despite Gerasimov's efforts, the requirement of the leader-genre for a pedantic academic finish and dumb, uncontroversial composition had taken the edge off his work; a **131**

real talent was being made anodyne.

It seems likely that Gerasimov was aware of this danger and strove to counter it with pictures representing his private credo. In the late 1930s he began a series of studies and pictures on the subject of the Russian communal bath. This was a subject with precedent in Russian art, and in Soviet pictures of communal nakedness; the artist also had in mind paintings by Zorn of similar subjects. The *Banya* pictures exist in two oil versions and as a large water-colour. They are robustly painted, striking works, even if the colour has something of the schematised simplicity of a poster or theatre set. They are Gerasimov's last achievement of artistic importance. Voroshilov admired them on the grounds – not altogether plausible, to my mind – that they were free from eroticism.[14]

As Gerasimov devoted his artistic energies to the Stalin cult, so his star rose and grew brighter in art-world politics. He became a proselyte for the official line. Whereas in all the years before 1937 he had published a dozen articles, in the five years 1937-41 he published nearly thirty. These were mainly reviews of exhibitions and propaganda pieces with titles such as 'Under the Banner of Socialist Realism' (*Yunyi Khudozhnik* 3/1939) and 'The New Ascent of Realistic Art' (*Vechernyaya Moskva* 17.iii.41).

He also began to flex his muscles as a bureaucrat in the Artists' Union. In 1937 *MOSSKh* held its first general meeting and elected a new board. It was a stormy assembly held in dangerous times. Gerasimov was one of many public figures who were attacked by innuendo for supposed Bukharinite and Trotskiist connections; he was criticised for fraternising with high-ups and neglecting his obligations as a member of the *MOSSKh* board. He himself spoke with characteristic irony and, perhaps, a certain amount of disdain, admitting that he had not merely worked badly – he had not worked at all.[15] According to the verbatim record of this meeting, which lasted five days, Gerasimov, although included on the slate of candidates proposed by the Party for the new board, was at first not voted in by the rank-and-file. By a procedural move which the stenogram does not illuminate, he was proposed again and, apparently, accepted by the meeting. The board itself, again governed by the proposals of the union's Party section, made Gerasimov its chairman for two years, 1937-9. This was the period when *MOSSKh*, just like every other public body in the USSR, was ravaged by the arrests and executions of its members. For example, nearly all the former leadership of *RAPKh* responsible for criticising figures such as Gerasimov and Bogorodski at the start of the thirties, were liquidated, as well as many former avant-gardists. This was the responsibility, of course, of the secret police; it is impossible to say at the present time whether Gerasimov had any influence, for good or bad, in individual cases.

In 1939 Gerasimov was replaced as *MOSSKh* chairman by his

namesake, Sergei Gerasimov. He was made instead the head of a new organisation, the *Orgkomitet*, or organising committee, of the planned nationwide Artists' Union. The *Orgkomitet* outranked *MOSSKh* in executive power; it took responsibility for co-ordinating and controlling the work of artists across the whole of the USSR. Gerasimov was now established as the most powerful artist-bureaucrat in the land.

He began to accumulate awards. In 1936 he was made a Merited Art Worker and became the second Soviet artist, after Brodski, to receive an Order of Lenin. The most striking privilege he enjoyed was a new detached house, built to his own design in a small settlement in Sokol, which is now part of Moscow proper but in the 1930s was a leafy spot on its outskirts. More than half the ground floor comprises a cavernous studio. In it he placed a grand piano, because he liked to arrange soirées with performers from the Bolshoi Theatre. Here also he often slept on the floor, peasant-style, rather than use a bedroom. He collected old items of Russian armour and weaponry, some of them the former property of the nineteenth-century painter, Vereshchagin. According to his son-in-law, Gerasimov used to dress up on occasions as Taras Bulba, Gogol's warrior-hero who had occupied a unique place in his imagination since adolescence. On a plinth outside the house, in full view of the street, Gerasimov placed a plaster cast of Michelangelo's *Slave*. This was intended, perhaps ironically, as an image of his own capacity for work: he used to rise at five o'clock to paint because at ten he was already expected in the Kremlin for the start of the official day. Since Gerasimov's death the statue has been taken down, the victim of little boys throwing stones. To this day, the interior of the house preserves a gloomy aspect; even the studio is not a bright place. Some of those who knew him say that Gerasimov's home life was not entirely happy: his daughter, whom he doted on, was feeble-minded; his wife, who had cuckolded him while he was in the army, drank heavily. Legend has it that he used another studio, on Gorki Street, as a trysting place.

Soon after the Nazi invasion of 22 June 1941, Gerasimov was evacuated from Moscow along with other eminent art-world figures. He spent several months in Tbilisi and returned to Moscow in the summer of 1942. In that year he painted one of the key pictures of the Stalin cult, *A Hymn to October*. It depicts Stalin's speech in the Bolshoi Theatre on 6 November 1942, a rallying call and exhortation to troops departing to the front. On 21 March 1943 it was announced in the paper *Soviet Art* that he had been awarded a first-class Stalin prize, 100,000 roubles, for the picture. On 27 March 1943, *Soviet Art* revealed that Gerasimov had donated 50,000 roubles of his own money for tank-building – but that the sculptor, Matvei Manizer, also a prize-winner, had given 100,000 roubles to the General Command. Gerasimov now showed his mettle: on 3 April 1943, *Soviet Art* wrote that he had now presented the whole of his prize – 100,000 roubles – **133**

as well as the previously mentioned 50,000 roubles for tank-building. On 31 July 1943 Gerasimov became one of four artists to first receive the title, created by the Supreme Soviet some two weeks earlier, of People's Artist of the USSR.

The pressures of war forced Stalin to make all sorts of ideological compromises. He gave the Orthodox Church more freedom and appealed to Russian patriotism in an attempt to bolster morale. A similar shift in ideological emphasis took place in the art-world. Stalin prizes were awarded in 1943 to the artists Petr Konchalovski, Konstantin Yuon, Ivan Pavlov, Vasili Baksheev and Evgeni Lansere for their 'many years of outstanding service in the arts'. These were all artists of the older generation, masters who had chosen not to put their work too obviously at the service of the Communist Party; certainly, they did not paint the sort of propaganda works calculated under normal circumstances to win Stalin prizes. Konchalovski, in particular, had an enormous following among younger painters. In 1944 Gerasimov made his own contribution to this patriotic cause: a picture entitled *The Four Oldest Artists*, showing Baksheev, Vitold Byalynitski-Birulya, Pavlov and Vasili Meshkov seated in conversation around a table. This is the best of Gerasimov's several official group portraits. I write 'official' because the painting, while it was an expression of Gerasimov's own values, was above all a calculated piece of propaganda, emphasising Russian patriotism and traditional values in art. It received a Stalin prize in 1945.

After the great battle of Stalingrad the tide of war turned, and in 1943 the Red Army began its long advance on Berlin. A new period in Soviet history was opening up; the Soviet empire was to annex new provinces in Eastern Europe, to acquire nuclear weapons and, after the isolationism of the 1930s, was to confront the West in the Cold War. Gerasimov became a kind of international art-diplomat. He was despatched in November 1943 to Tehran to gather material for a big composition, *The Tehran Conference of the three Allied Powers*, completed in 1945. In the same year he painted a companion-picture, *The Moscow Meeting of the Foreign Ministers of the Three Great Powers*. At the end of 1945 he was sent to Romania to paint a general; in 1946 he visited Budapest with the architect, Boris Iofan, to search out a site for a Soviet war memorial; in 1947 he travelled to four-power Vienna for the opening of an exhibition of work by himself, Plastov, Deineka and Sergei Gerasimov. He then went on to Prague, where he met and talked with Czech artists, explaining his opposition to abstraction. Here, according to his autobiography of 1963, he gave what must be one of the most disarming reasons ever to explain the persistence of this phenomenon: 'I even think that one of the reasons why abstract art is so widespread is that a rich old lady seems like a beauty in comparison with the portrayal of a young woman in an avant-garde portrait, and this

reassures the well-to-do lady.[16] In 1948, at the World Congress of Intellectuals in Poland Gerasimov met Picasso his exact contemporary and a fellow-communist; in 1950, at the Peace Conference in Poland he met him again and shook his hand – an act so heinous that he had to justify it to a meeting of the Moscow Artists' Union in 1951.[17]

Alexander Werth was at the Intellectuals' Congress of 1948, and it is clear from his observations that Gerasimov even now had not shaken off the yokelish air which had caused him so much distress in his student days: 'Ehrenburg kept putting his arm around Picasso and telling him how he admired his great genius, and how bad, how very bad was that stuffed monster, the painter-laureate of the Stalin regime, Gerasimov. And he cracked jokes at Gerasimov, in Gerasimov's presence – jokes in French which Gerasimov did not understand.'[18]

It was while on a trip to Belgrade in 1947 that Gerasimov received a telegram informing him that he had been made president of the newly-created USSR Academy of Arts. This was probably not a surprise: the whole art-world knew that the choice was to be made between Gerasimov and Igor Grabar, an intellectual and artistic jack-of-all-trades – painter, author of a two-volume monograph on Repin, head of the state restoration studios. Katsman, for example, was called to a meeting with Voroshilov, who continued to take a close interest in art, and asked which of the two would make a better president, to which he replied with diplomatic finesse that to choose Grabar would be to choose the intelligentsia, to choose Gerasimov – the proletariat.[19]

The Academy was not a body like the artists' unions, where the election of board members involved a degree of democratic procedure. The Academy's membership was appointed by the Party; it was funded by, and answerable to, the Committee for Art Affairs. It was, in effect, the executive arm of the Party in the art-world.

The creation of the Academy coincided both with the start of the Cold War and with a period of unparalleled repressiveness in Soviet culture. After the war, Stalin encouraged an extreme Russian chauvinism; he looked on Russian culture as a rallying and unifying power – a means of bringing the Soviet Union's myriad national and ethnic groups, many of which had been disaffected by war-time experiences or by policies of annexation or exile, under firmer control. He justified this by referring to victory in the war as, above all, a Russian achievement. Anything foreign or, in the jargon of the time, 'cosmopolitan' (sometimes code for 'of Jewish origin') was anathematised. The principles of the new cultural campaign were set out in 1946-8 by the Leningrad party boss, Zhdanov, in a series of speeches on cultural matters and in a group of four notorious decrees issued by the Party Central Committee. In the art world it was Gerasimov, president of the Academy, who led the repressive crusade. **135**

His first shot was an article entitled 'More About Criticism' in *Soviet Art*, 12 July, 1946, in which he arraigned a number of critics, notably Anna Akhmatova's former lover, Nikolai Punin. This article inaugurated the post-war persecution of these critics, which led in 1948 to the dissolution (by decree of the *Orgkomitet*, of which Gerasimov was chairman) of the critics' section of the Moscow Artists' Union and expulsion of its leading lights, the Jewish critics Abram Efros and Osip Beskin, because of their 'cosmopolitan' views. The campaign culminated in Punin's arrest, incarceration and death in a concentration camp.

Over the next few years Gerasimov fired off salvoes of speeches and articles. In the five years 1947-51 over fifty of these appeared in print; they were considered important enough for a collection of them to be issued in 1952 under the title *For Socialist Realism*. Perhaps his most important pronouncements were the speeches he gave to sessions of the Academy of Arts. They include the opening papers at the first, second and third sessions of the Academy, held in 1947, 1948 and 1949. These speeches, with their references to Stalin as the final arbiter of artistic problems, their zealous promotion of Russian cultural traditions, their loud assertion of the world-wide supremacy of Socialist Realism and castigation of Western artistic decadence, matched the official pronouncements of *apparatchiki* in all the arts at this time. They were bombast, great expanses of depersonalised rhetoric whose physical equivalents in the visual arts are the huge ceremonial canvases of the Stalin cult.

This proselytising activity left its mark on Gerasimov's painting. It became less varied; he became less fertile. The list of his works for 1948–50 displays a concentration on official works to the almost total exclusion of the private projects, such as the *Banya* paintings and the portraits, still-lifes and landscapes which he had carried out in parallel with state commissions in the 1930s. In 1948, for example, he carried out the following:

Portrait of I. V. Stalin
I. V. Stalin by A. A. Zhdanov's Coffin
Portrait of V.. Molotov (two versions)
V. M. Molotov Speaking at the Meeting in the Bolshoi Theatre 6.xi. 47
Portrait of K. E. Voroshilov
I. V. Michurin in the garden (two versions)
Flowers

Eloquent works in the history of the Stalin cult followed in 1949: *There is a Metro!*, depicting Stalin's speech at the ceremonial opening of the Metro in 1935; in 1950, *The Great Oath*, portraying Stalin swearing fidelity to Lenin's ideals, executed by a brigade of young artists under Gerasimov's direction; and in 1951, *Artists Visiting I.V. Stalin*, which shows Gerasimov

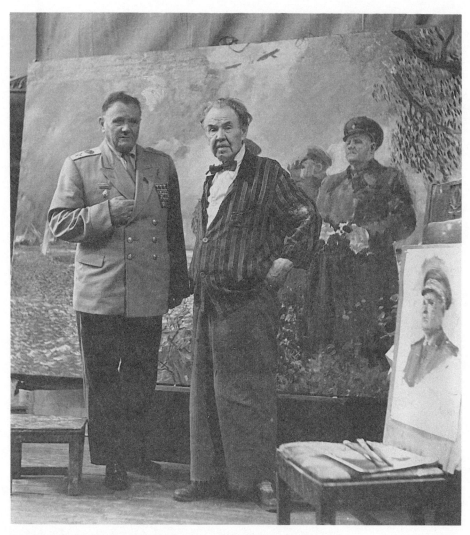

7.2 Aleksandr Gerasimov in his studio with a general, 1950s

himself, Katsman and Brodski taking tea with Stalin in the garden.[20] But by this time the tide was turning in the Soviet art-world. Although it is conventional to date the beginning of the thaw to 1956, after Khrushchev's speech denouncing Stalin, there was a groundswell of revolt against the rigid strictures of the Zhdanov decrees and against Gerasimov himself from the beginning of the 1950s. One of Gerasimov's most implacable enemies was Vladimir Kostin, an artist-turned-critic, supporter of Plastov, Deineka and other artists who had suffered from the *zhdanovshchina* and was expelled from the Moscow union in 1948. He was soon reinstated, but without the right to publish. On 23 October 1951, at an election meeting of

the Moscow union, he mounted a swinging attack on Gerasimov for his excessive self-esteem and for the idleness and lack of direction displayed by the *Orgkomitet*, of which he was chairman.[21]

Perhaps Gerasimov, who was seventy in 1951, was beginning to feel his age. After Kostin's criticism he responded only by pleading for a greater sense of comradeship in the art-world. According to his son-in-law, he began now to dread the responsibilities laid upon him; he used to compare making a speech to the ascent of Golgotha because of the hostility with which, he knew, it would be greeted. From 1951 he perceptibly tried to alter his ground. *Artists Visiting I.V. Stalin*, painted in that year, marks the end of his seventeen-year devotion to the Stalin-genre. At about the same time he began a huge decorative canvas, showing an oriental feast complete with dancing girls and exotic costume. It was an attempt to reassert himself as an artist, rather than a functionary. But it came too late; his powers as a painter were failing him and on his death the large canvas, encrusted with bright colours, remained unfinished.

The last decade of Gerasimov's life cannot have been a happy one (figure 7.2). On 22 November 1954 an article appeared in *Pravda* expressly criticising him and the other great artist of the Stalin cult, Dmitri Nalbandyan, for the 'decorative emptiness and false enthusiasm' of their big pictures. In 1956, after Khrushchev had denounced Stalin at a closed session of the Central Committee and a policy had been put into effect of destroying some of the paintings and sculptures devoted to Stalin, Gerasimov had an interview with Khrushchev. He declared that he and other artists had created works in accordance with their consciences; to deny and destroy their art now was to deny a whole period of Soviet history. Khruhchev said that Gerasimov did not understand. Gerasimov left, banging the door behind him. That evening he was visited by Matvei Manizer, the sculptor, and Petr Sysoev, the critic, who suggested he resign as president of the Academy on health grounds. Gerasimov refused. The next day they returned, and Gerasimov agreed to step down. That night he sat up, drank a whole bottle of vodka and had a heart attack. He never recovered his health.[22]

After his dismissal, Gerasimov struggled on with his painting. Towards the end of his life his health did not allow him to walk back and forth, so he viewed big pictures through the wrong end of a pair of binoculars to get a view of the whole and jabbed at them with a long-handled brush. No important works emerged. His time had gone; he had put too much of his faith in the false prophet, Stalin.

Notes

1 Renamed Michurinsk in the Soviet period.
2 The account of Gerasimov's childhood and youth is largely drawn from his autobiographical *Zhizn Khudozhnika*, Moscow, 1963, with some help from Sokolnikov, M.P., *A.M. Gerasimov*, Moscow, 1954.
3 Sokolnikov, *op. cit.*, p. 70.
4 Legend has it that his opponent was Robert Falk.
5 A.M. Gerasimov, *op. cit.*, pp. 87–8.
6 Denisova-Shchadenko 1894–1944) met Lenin in Geneva in 1916; it seems possible she was broadly acquainted with the Bolshevik top brass.
7 Personal communication, 1991.
8 Sokolnikov, *op. cit.*, p. 129.
9 In 1928 *AKhRR* was renamed *AKhR*, the Association of Artists of the Revolution.
10 Sokolnikov, *op. cit.*, p. 129.
11 See Sarah Wilson's essay in this volume for details of this picture's reception in Paris.
12 Personal communication from Gerasimov's son-in-law, Vladilen Shabelnikov.
13 *Ibid.*
14 *Ibid.*
15 *TsGALI* 962/6/203 p. 46.
16 A. M. Gerasimov, *op. cit.*, p. 175.
17 *TsGALI* 2943/1/605 p. 47.
18 A. Werth, *Musical Uproar in Moscow*, London, 1949.
19 Personal communication from the late Vladimir Kostin, who had this anecdote from Katsman.
20 This meeting has been described by Brodski in his *Moi Tvorcheskii Put*, Leningrad-Moscow, 1940, pp. 103–4.
21 *TsGali* 2943/1/603 pp. 49–58.
22 The story of Gerasimov's meeting with Khrushchev and the subsequent visits of Manizer and Sysoev was told me by Gerasimov's son-in-law, Vladilen Shabelnikov.

8 Painting in the non-Russian republics

Until the recent declarations of independence by its constituent republics, the USSR comprised more than 20 million square kilometres, of which just under a quarter were in Europe, the rest in Asia. It was a land-mass larger than South America and of massive ethnic variety. The art of the Soviet Union, encompassing the contributions of myriad nationalities and ethnic groups, presents a unique example of a sustained attempt, mounted by the Communist Party, to weld a single coherent culture out of extreme diversity.

The dimensions of the Soviet Union coincided more or less with those of the Russian empire as it had existed before 1917. The Russian city of Moscow was the country's cultural centre. Russian artistic traditions were encouraged and imposed in the non-Russian republics. But the relationship of the non-Russian cultures to the mainstream of Soviet art was always vexed and hedged about with double-talk. The politicians and ideologues preached a degree of cultural autonomy; but the practical policies of the Stalin era increasingly contradicted this idea, and by about 1950 the idea of a melding (*sliyanie*) of cultures was being promoted by art critics. This signified, in practice, the complete subjugation of national traditions to Russian ones. Despite the onslaught from Moscow, national identity survived in the art of non-Russian republics, often in the form of works that, by rendering unto Stalin his ideological due, achieved a striking synthesis of the prescriptive and the personal, the dour and the decorative, the Russian and the home-grown.

The USSR came into being in December 1922 on the basis of the unification of four so-called union republics: Russia (the largest), the Ukraine, Belorussia and the Transcaucasian republic, comprising present-day Azerbaijan, Armenia and Georgia. The coming-together of these lands in 1922, officially described as voluntary, was actually as a result of the exertions of the Red Army, which put down the independence movements which had flourished across the country during the Soviet Civil War of 1918-21. Kiev, for example, had ten successive regimes before the Bolsheviks seized final power and created the Ukrainian Soviet Socialist Republic.

During the 1920s and 1930s the structure of the Union was progressively refined to create a more wieldy administrative structure. In 1924, two new republics, Uzbekistan and Turkmenia, were formed in Turkestan, hitherto deemed part of Russia. In 1929, Tadzhikistan was

fashioned out of part of Uzbekistan. In 1936, another part of the Russian republic was abstracted and resurrected as the republics of Kazakhstan and Kirgizia; and the Transcaucasian Federation was dissolved and the republics of Azerbaijan, Armenia and Georgia created. National feeling was being exploited here; a modicum of self-determination, of specious nationhood, was being offered as a sop for the sake of a greater goal, the stability of the empire.

During the same period, the Soviet Union grew as more and more of the territory of the old Russian empire, given up willy-nilly during the Civil War, was won back. The Basmachi revolt in Turkestan, aided by the Russian turncoat, Enver Pasha, was finally extinguished in the late 1920s. The Molotov-Ribbentrop pact allowed the Western Ukraine and Western Belorussia to be annexed, with Hitler's complicity, in November 1939. In 1940, some Finnish territory was swallowed up; and the deal with the Nazis allowed Stalin to engorge Bessarabia (taken from Romania), which formed the basis of the new republic of Moldavia; as well as Latvia, Lithuania and Estonia. This completed the re-conquest of lands that had once formed part of the Russian empire. Moscow's annexation of this territory was of course never admitted by the Soviets to be a continuation of Russian imperialism; it was officially described, until recent times, as the outcome of spontaneous popular decisions, and advertised as such in art.

This history suggests that, however monolithic the USSR may have seemed from without, the possibility of nationalist uprisings and dissent posed a real threat to its unity. Whatever the official propaganda, politicians in Moscow understood this. No less than political repression and military force, they used cultural policies to bind the country together. Stalin himself recognised early on that the question of the artistic culture of the non-Russian republics was indissolubly linked to that of their political ties to Moscow; therefore he gave this question particular attention. In May 1925, about a year after the death of Lenin, Stalin gave a speech entitled 'On the Political Tasks of the University of the Peoples of the East' at which he talked of a 'proletarian culture, socialist in its content' which would 'adopt various forms and means of expression with different peoples'.[1] Proletarian culture, he went on to say, did not replace national culture, but gave it content. In 1930, at the 16th Party Congress, called at the height of the programmes of industrialisation and collectivisation, he returned to this subject. During his main speech he warned of two 'deviations': Great Russian Chauvinism, on the one hand, and nationalism on the other. He quoted Lenin to emphasise the point that, although the abolition of cultural differences was a socialist ideal, these differences would be with them for a long time and would persist even after the world-wide triumph of socialism. He brushed down and refined his formula of 1925: 'What is culture during the dictatorship of the proletariat? It is a

culture socialist in content and national in form, having the aim of educating the masses in the spirit of socialism and internationalism.'[2] During his summing up at the end of the Congress he returned to the question again, taking this time the specific example of verbal language. Languages, he said, could not merge and become one until socialism had triumphed not only in the Soviet Union, but around the world. To illustrate what he meant he used an example which suggests that the lost portions of the Russian empire, to be regained only nine or ten years later, were on his mind even then:

> There is a Ukraine in the USSR. But there is also a foreign Ukraine. There is a Belorussia in the USSR. But there is also a foreign Belorussia. Do you think that the question of the Ukrainian and Belorussian languages can be solved without taking into account these particular circumstances?

This passage suggests why, in the 1920s and 1930s, the policy of creating new republics was adopted by the political leadership. It not only offered the best chance of political stability and efficient government in a state that was still, for all its bluster, economically and politically fragile; it was also a policy that would seem to legitimise the eventual seizure of new territory by allowing it to be described as an act of reunification. In the face of these considerations, there could be no place in the 1930s for Great Russian Chauvinism; although nationalism, too, was still a danger.

Stalin's pronouncements of 1925 and 1930, and in particular his talk of culture 'socialist in content and national in form', seemed to countenance

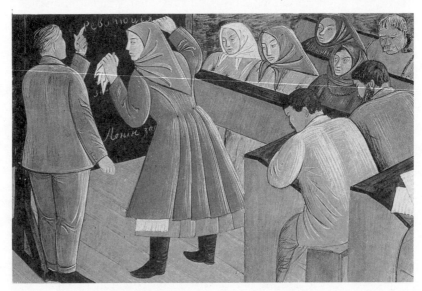

8.1 Vasili Sedlyar (School of Boichuk), *In the School for Liquidating Illiteracy*, 1925

stylistic variety in the art of the various Soviet republics, as long as these styles could be characterised as springing from national traditions. This induced a degree of sophistry in art discourse, as critics and artists used the national traditions argument to justify work in a whole variety of styles, the inspiration for which, in some cases, was surely European modernism as much as indigenous traditions. This sophistry was the only possible line of defence for those who opposed the vicious attacks on 'formalism' being mounted by the evangelists of realism in Moscow, especially after the pubication in 1933 of Osip Beskin's book, *Formalism in Painting*, and the proclamation in 1934 of Socialist Realism as the official state art.

In the Ukraine, the most influential painter in the 1920s and early 1930s was Mikhail Boichuk. He led a school of muralists working in a style derived, so his supporters emphasised, from the example of the Italian primitives and from old Ukrainian religious and folk painting (Figure 8.1). But Boichuk was a sophisticated man who had studied in Cracow, Munich and Vienna and worked in Paris from 1908 to 1911 before returning to the Ukraine. He was known abroad, and received a visit from the Mexican muralist and friend of Picasso, Diego Rivera, in the mid-1920s. He was fully aware of international trends, including the adaptation of various forms of naive and primitive art by the avant-garde; and his work might well be described as an offshoot of the international avant-garde movement. He and his group carried out several big mural compositions in the Ukrainian capital, Kiev. Boichuk himself was a professor at the Kiev Art Institute, 1924-36.

The influence of European modernism may also be detected in the work of the Armenian, Martiros Saryan, who travelled widely abroad and lived in Paris from 1926 to 1928 before returning to live in the Armenian capital of Erevan. He passed through a symbolist phase in the early 1900s before settling on a colourful language derived from Fauvism, but which his many Soviet supporters in the 1920s and 1930s grandly dubbed 'the realism of the East'. Like Boichuk in the Ukraine, Saryan had a considerable following among the young artists of his republic. His colourful *Bridge-Building in Erevan* makes it clear that the stylistic freedoms enjoyed by non-Russian artists well into the 1930s did not imply a rejection of the socialist content required by Stalin's guiding dictum.

Saturated colour, typical of Saryan's work, was one trait which Soviet critics learnt to expect from painters living in the hot Asian and Transcaucasian republics. Another was a certain simplification or schematisation of form. Again, the proscription against foreign influence meant that this could not be explained in terms of the modernist movement; it had to be presented as something indigenous, springing from national and folk art traditions. Much of the writing published in the 1930s about **143**

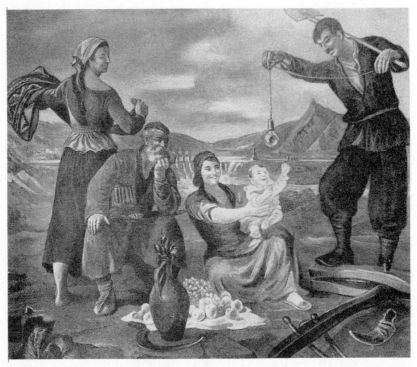

8.2 Irakli Toidze, *Ilych's Lightbulb*, 1927

the work of Aleksandr Volkov, who lived in Tashkent, the capital of Uzbekistan, is an example of such rationalisation. During his studies in St Petersburg and Kiev in the years 1908-16 Volkov had come into contact with avant-garde art; his work of the 1920s and 1930s is clearly influenced by Cubism, perhaps via Russian Futurism. Yet in 1935 he discussed his work as follows:

> The painting of the East is built chiefly on the primitive and on a painterly, decorative beginning. This is the basis of my work. Elaborating works of primitive flatness, I have introduced a whole system of triangles and other geometric forms and arrived at the depiction of man based on the triangle, that being the simplest of forms.[4]

In other words, for reasons of political expediency, he described a style unmistakeably influenced by Cubism and Russian Cubo-Futurism as springing exclusively from the native traditions of Soviet Asia. This was the kind of gloss needed to ensure the survival of a style nothing like the realism being encouraged in Moscow.

Realism also had its adherents in the non-Russian republics. From the mid-1920s onwards, when filial groups of the Moscow realists' organisation, *AKhRR* (The Association of Artists of Revolutionary Russia),

began to be formed all over the USSR, they were an increasingly well-organised and well-supported alternative to artists such as Boichuk, Saryan, Volkov and their followers.

The European republics – the Ukraine, Belorussia – had their own schools of traditional painters, among whom the Ukrainian, Fedor Krichevski, was outstanding. To describe his figurative works of the 1920s, highly stylised and reminiscent of Japanese art, as realism would be stretching a point; but in the 1930s he joined the movement to a realistic style and in *Victors over Wrangel* (1934) produced one of the most convincing Socialist Realist paintings of the decade.

Georgia and Armenia, republics with a cultural history bound up with Christianity, also had schools of European-style figurative painters, although these were not particularly strong in the 1920s. The Georgian, Irakli Toidze, produced one of the most engaging propaganda paintings of the 1920s, *Ilych's Lightbulb* (Figure 8.2). It shows peasants marvelling at one of the fruits of the electrification of the Soviet Union initiated by Lenin, who advanced the famous slogan 'Communism equals Soviet power plus electrification of the whole country.' In the background is the Zemo-Avchaly hydro-electric power station (*ZAGES*), opened in Georgia in 1927.

In the 1930s a conspicuous school of Socialist Realists emerged in Georgia. Its members devoted great energies to glorifying their fellow-countryman, Stalin. The source-book for their efforts was Lavrenti Beria's hagiographical booklet, 'A History of the Bolshevik Parties of Trans-Caucasia' (1935). A big exhibition of Georgian art was held in Moscow in 1937 and received with great enthusiasm by the Moscow art establishment, and this established a number of Georgian painters as prime movers of the Stalin cult in art. Another painter, Dmitri Nalbandyan, who was born in Georgia of Armenian parents and studied at the Tiflis Academy until 1929, moved to Moscow in 1931 and there pursued the most notorious of all careers devoted to the 'genre of the leader', as he himself liked to put it. In Georgia there was also a Beria-cult of some proportions, the leading exponent of which was Ivan Vepkhvadze.

Unlike the Ukraine, Belorussia, Georgia and Armenia, the Muslim republics had no tradition of Western-style figurative art. This meant that, before the war, the doctrine of Socialist Realism found scant support indeed in some places. In Kazakhstan, which was only linked to Moscow by train in 1930, a self-taught artist, Ebilkhan Kasteev, was an isolated figure struggling alone to adapt his naive folk style, reminiscent of Chinese art, to the demands of Socialist Realism. He produced an oeuvre which never quite loses its naivety but convinces by sheer dint of its intensity, to which a number of rooms are devoted in the State Art Museum in Alma-Ata.

The dazzling light and exotic culture of Uzbekistan – and its remoteness from Moscow ideologues – induced a number of Russian painters to move

there in the 1920s and 1930s. The foundations of a realist school were laid here by Pavel Benkov, a Russian graduate of the St. Petersburg Academy. He and his wife settled in Samarcand in 1930, where they were soon joined by Benkov's former pupil, Zinaida Kovalekskaya. In Samarcand Benkov opened an Uzbek art school.

Kirgizia produced one of the most celebrated painters of the Stalin period, Semyon Chuikov. Born in Kirgizia, educated at the Moscow *VKhuTeIn*, he became the first chairman of the Kirgiz Artists' Union in the 1930s. In Chuikov's work, realism is leavened by a measured simplification of form and intensification of colour; features not pronounced enough to alienate hard-line critics in Moscow but sufficient to make Chuikov an important figure in what might be called the liberal wing of the art establishment of Stalin's time. *On the Frontier*, shown at the 1938 exhibition commemorating the Red Army's twentieth anniversary, was his first big official success. Its subject – a Kirgiz border guard and mounted peasant together responding to an incursion into Soviet territory (presumably from China, with which Kirgizia shares a border) – is a typical example of the 'defence theme' which played such an important role in art and literature in the late 1930s; a time when international tensions were running high and the possibility of unprovoked attack was being impressed on the Soviet public.

Although decisions and initiatives originating in Moscow played an increasingly important role in the lives of artists in the non-Russian republics during the 1930s, the Soviet Union was such a vast country that many regions retained a degree of cultural autonomy. Not until after the war were the grandiose All-Union exhibitions introduced – annual displays of art from all over the country which served to encourage and confirm the ideal of a single, pan-Soviet culture. In the pre-war period, the city to provide the most flourishing alternative to Moscow and Leningrad was, if not Kiev, then Tiflis (in 1936 renamed Tbilisi), the capital of Georgia. Tbilisi was home not only to native artists but also to young Armenians and Azeris who studied at its Academy of Fine Arts.

A number of painters working in Tbilisi not only managed to conserve precious freedoms of style but also rejected the socialist content officially required in the work of all artists. Two important figures were Lado Gudiashvili and David Kakabadze, both of whom spent the first half of the 1920s in Paris. Gudiashvili painted erotic images of women, drawing on the style of old Iranian art. Kakabadze, on his return from Paris, boldly continued to make nearly abstract paintings. But the outstanding figure, one of the greatest of Soviet painters, was Aleksandr Bazhbeuk-Melikyan who, although born of Armenian parents, lived all his life in Tbilisi.[5] His invariable subject was the female figure. Many of his paintings are of nudes; others depict exotically dressed women in the role of juggler,

8.3 Aleksandr Bazhbeuk-Melikyan, *A Wandering Circus*, 1939

acrobat or magician. In the 1920s he painted carefully-finished canvases under the influence of the Swiss symbolist, Boecklin. In the 1930s his handling of paint became more luscious as he responded to the work of Rembrandt and Monticelli. His mature paintings bear a resemblance to Gudiashvili's in so far as both artists liked to depict voluptuous women; but Bazhbeuk-Melikyan's work is more vital in execution, more intense in its dramas, sexier. His turbulent paint-surfaces flout the official stylistic norms of the 1930s and '40s; his subject matter is devoid of any spirit of social purposefulness. Most strikingly of all, Bazhbeuk-Melikyan completely disregarded the official, puritanical attitude to sex. His oeuvre, along with that of the Leningrad artist, Pavel Filonov, represent the outstanding example of a trenchant personal statement in the art of the Stalin period (Figure 8.3).

From the mid-1930s onwards waves of arrests swept away the intelligentsia of the non-Russian republics as Stalin attempted to destroy what he perceived to be a widespread nationalist threat. Writers suffered much more in this respect than painters, but the latter were also among the victims. The most notorious case was that of the Ukrainian, Mikhail Boichuk, whose mural paintings drawing on folk art sources were now deemed nationalistic. Boichuk and several of his colleagues were arrested; **147**

Boichuk was executed; and all the Boichukists' murals were destroyed.

Stalin's chosen antidote to nationalism in the field of culture was an increased emphasis on Russian traditions. This policy only became really evident in the art world after the 1941-5 war; but before the war there were unmistakable signs of it in other, related areas. An important signifier was the official attitude to the question of language. In 1928, as a means of simplifying and homogenising the *mélange* of alphabets used by the non-Russian peoples, a whole list of republics and regions were required by decree to adopt a Latinised alphabet; the areas affected included Azerbaijan, Georgia, Kirgizia, Uzbekistan, Kazakhstan, Dagestan and Turkmenia. In a series of decisions in the late 1930s, this decree was effectively revoked and the Russian alphabet introduced instead. A decree issued jointly by the Central Committee and the Council of People's Commissars on 13 April 1938, On the Obligatory Teaching of the Russian Language in the Schools of the National Republics and Regions, suggested that a decision had indeed been taken to impose Russian as a *lingua franca* on the whole of the USSR.

The invasion of the Nazis in June 1941 caused great upheavals in the art world.[6] Belorussia and the Ukraine were overrun and many local artists died or were badly wounded in the fighting. As Nazi troops advanced on Moscow and surrounded Leningrad, normal artistic activity came to a halt for some time in Russia, too. Many Russian artists were evacuated to Uzbekistan. The staff and students of the art institutes of Moscow, Leningrad and the Ukrainian city of Kharkov were relocated in the ancient city of Samarcand, where students were billeted in the beautiful old Muslim seminary, the Regestan. The first crop of painting students from the Moscow Institute of Visual Art, opened in 1935, completed their diploma works and graduated in Samarcand in 1942. Other Moscow artists lived for a while in the Uzbek capital, Tashkent, where some of them carried out large thematic pictures on war subjects. These artists and students began returning to Russia in 1942 as the tide of battle turned. Their stay left little permanent mark on the artistic life of the country.[7]

The new emphasis on the supreme importance of Russian cultural traditions was on the agenda in the art world from the moment when, at a banquet in the Kremlin in May 1945, Stalin toasted the Russian people as the nation which had contributed most to victory in the war – a scene recorded in a giant painting entitled *To the Great Russian People* by the Ukrainian, Mikhail Khmelko, which was awarded a Stalin prize in 1947; but it really only became evident as a fully-fledged policy in the art world a couple of years later.

This was, of course, the period of the so-called *zhdanovshchina* – the Party's most determined attempt, led by Andrei Zhdanov, to gain control of the country's cultural life. But from the point of view of the non-Russian

republics perhaps the most important single event of these years was not any of the decrees on culture issued between 1946 and 1948 but the creation in 1947 of the USSR Academy of Arts. The Academy was designed by the Party to promote its policies in the visual arts with greater effectiveness than the semi-democratic artists' unions had done; it was staffed by hand-picked realist artists, nearly all of them Russians. In his inaugural speech the president of the Academy, Aleksandr Gerasimov, touched on many themes; but he made clear the new official line on the nationalities question. He talked of 'The development and flowering of the multi-national art of the peoples of the USSR, led by the Russian art of the Soviet epoch...'[8] and urged artists in all the republics to study above all 'the great realist heritage of Russian art'.[9]

This new Russianism conflicted with the policies of the 1920s and 1930s; in particular with the dictum 'socialist in content, national in form', derived from Stalin's own utterances, and with Stalin's explicit warning against Great Russian Chauvinism in culture. This apparent inconsistency could not be overlooked, and it was tackled at some length by the critic Boris Veimarn, in a speech entitled 'On the Tasks of the Soviet Visual Art of the National Republics' given to the Academy of Arts in 1949. Veimarn made repeated reference to the formula of 'socialist in content, national in form', but now gave it a new gloss. He said that in the duality of form and content, content was 'decisive' (*opredelyayushchee*). He talked of the 'correct understanding of national form in art as a realistic reflection of socialist reality'.[10] Socialist content, he maintained, educated the masses 'in the spirit of internationalism', implying the need for a common artistic language across the whole USSR. He tried to discredit the idea that artists in the non-Russian republics should be allowed a certain amount of decorative freedom. Drawing a clear distinction between the decorative elements of everyday life and decorativeness as a stylistic device in art, he said:

> In some republics of Transaucasia and Central Asia there is a widely-held idea that the national particularity of the Soviet art of the Eastern peoples consists in decorativism... . But decorativism as a method is formalist and has nothing in common with the tasks of Soviet art. Decorativism does not allow Soviet actuality to be correctly represented in art.[11]

Towards the end of his speech, he summed up succinctly: 'In the light of comrade Zhdanov's directives about the classical heritage, the great importance which the traditions of Russian realism have for the development of the visual art of all Soviet peoples, without exception, is especially clear.'[12]

In the course of his speech, Veimarn was at great pains to separate out the wheat from the chaff. He reserved special opprobrium for Gudiashvili, who had participated in the great show of the little post-war thaw, the 1946

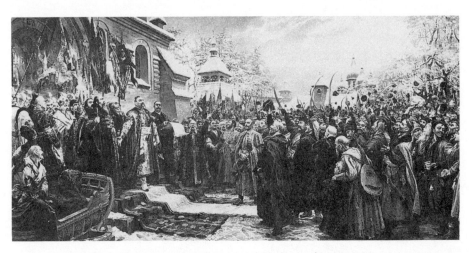

8.4 Mikhail Khmelko, *Eternal Unity (Eternally with Moscow, Eternally with the Russian People)*, 1951-4

All-Union Exhibition in Moscow, and whom he now termed a 'recidivist of formalism'. He criticised artists from most of the republics, including the newly-acquired Baltic states. The substance of these criticisms included not only the complaint of decorativism, equivalent to formalism, but also of excessive reliance on historic national styles ('stylisation'); and, as far as content was concerned, of 'mysticism' – implying religious content – and 'idealisation' of historic figures, meaning the failure to portray them from a Marxist standpoint.

The outstanding example of an artist who managed to tread the fine line between acknowledging colourful national life and the vice of decorativism, in the form of saturated colour and broad brushwork, was Semyon Chuikov. His picture of a proud Kirgizian schoolgirl making her way across the steppe to school, entitled *A Daughter of Soviet Kirgizia* (Plate II) (executed in three or four versions between 1948 and 1950), was one of a series of paintings extolling life in the little Asian republic that was awarded a Stalin prize in 1949. The viewer would have understood it as a panegyric to the benefits and opportunities brought to a small unsophisticated country by the Soviet educational system.

Chuikov was an influential artist in the post-war period; his example suggested to painters a way of retaining a modicum of freedom in colour and brushwork at a time when a high academic-finish and sombre tonality were at a premium in Moscow. But critics such as Veimarn preferred an altogether dourer brand of painting, in which ideological content was apportioned clear pride of place above form. Thus in his speech to the Academy of Arts he made particular mention of Khmelko's *To the Great*

Russian People which, as he put it, 'expresses the best feelings of the people of the Soviet Ukraine'.[13]

Khmelko, a Ukrainian, was a distinctive figure; the most relentlessly efficient of all those who attempted vast portentous canvases in the post-war years. He won two Stalin prizes; but even he could run into trouble: his painting of Bogdan Khmelnitski (Figure 8.4), the Ukrainian leader who signed a treaty of friendship with Russia (one of many paintings commissioned at this time to extol historic links between Russia and the other republics), was refused a Stalin prize because Stalin himself saw, in the burgeoning mass of figures in national costume, the expression of an excess of national feeling.[14]

In order to disseminate the principles of the Russian academic tradition more effectively, Stalin's art administrators set up a so-called Studio of Nationalities at the Repin Institute in Leningrad in the late 1940s. Here talented young painters from those republics in which 'cadres' of realists were weak were sent for extra, intensive study. A similar facility was established in Moscow around 1950. However, it was not assumed (nor was it practical) that student artists from all the republics would move to Moscow or Leningrad for their education. A strong realist training was given in Kiev at this time; and several young Kiev artists won Stalin prizes in the 1940s and early 1950s. Realism was also taught to a standard sufficient for the Moscow ideologues in the Baltic republics, where a number of Russian painters went to study, and at the Tbilisi Academy, which attracted students from neighbouring Armenia.

By about 1950 the strictures requiring painters all over the Soviet Union to adhere to the principles of Russian realism had resulted in the establishment of a homogeneous painting style over the whole country. From Kiev and Minsk to Transcaucasia, from Central Asia to the Baltic republics, works were produced that were indistinguishable in style from those of painters from Moscow and Leningrad. The formula of 'socialist in content, national in form' had had all real meaning drained from it by the analyses of post-war critics such as Veimarn. The party had succeeded in imposing a unified artistic culture – a standard painting style, a fixed repertoire of subjects, a single art history – on nearly all painters and certainly on the work shown at all significant exhibitions across the whole vast expanse of the USSR.

This state of affairs did represent a triumph of sorts for those many artists, critics and politicians – not all of them Russian – who had striven to achieve it. But this unified artistic culture began to decay almost as soon as it was brought about. We can say that it was achieved by about 1950 or thereabouts and lasted for three years or so, until Stalin's death. At the 1954 All-Union Exhibition, for example, 'formalists' such as Gudiashvili were readmitted as exhibitors. The cultural thaw that followed led to

151

developments in the art of the non-Russian republics similar to those which took place in Moscow. The heavy dough of prosaic realism was leavened by a return among painters to national and folk traditions and by a fresh look at foreign art. In the Ukraine, Tatyana Yablonskaya, twice a Stalin prize winner, adopted a colourful, simplified style under the influence of Ukrainian folk art. In Moldavia, Mikhail Greku painted his important triptych, *The Story of One Life*, inspired by the design of a hand-made carpet. In the Baltic states artists rediscovered a tradition of *belle peinture* indebted to French art. The 'decorativism' denounced in the late 1940s broke out again all over the place, exemplified in the work of the Azeri painter, Togrul Narimanbekov.

Today the realist tradition which the party fought so hard to impose in the Stalin era has, in diplomatic jargon, 'gone native': that is, been modified so thoroughly by many schools of artists, particularly those in Central Asia and Transcaucasia, as to be almost unrecognisable. During the period of *perestroika*, young artists in all the republics either adapted – or simply jettisoned – their art-school training, which was still based on the Russian academic model, in the search for an original style. An art of a new kind has appeared in many places, one coloured by national aspirations, a new outlook beyond the boundaries of the USSR, and a spirit of experiment and irreverence, rather than the treacherous old dogma of 'socialist in content, national in form'.

Notes

This chapter is a slightly abridged version of the author's 'How is the Empire? Painting in the non-Russian republics', which appeared in the exhibition catalogue *Soviet Socialist Realist Painting, 1930s–1960s*, Museum of Modern Art, Oxford, 1992.

1 I. V. Stalin, *Sochineniya*, 7, Moscow, 1947, p. 138.

2 I. V. Stalin, *Sochineniya*, 12, Moscow, 1953, p. 367.

3 I. V. Stalin, *Sochineniya*, 13, Moscow, 1951, p. 7.

4 Cullerne Bown, *Art under Stalin*, p. 56.

5 Until the Khrushchev thaw Bazhbeuk-Melikyan used the Russified form of his surname, Bazhbeuk-Melikov, in an attempt to avoid discrimination (presumably from Georgians).

6 See Cullerne Bown, *Art under Stalin*, pp. 141-63 for an account of Soviet art during the war.

7 Grigori Ulko, a Russian artist living in Samarcand, related to me the following anecdote: The Russian artists who lived in Samarcand during the war – many of them famous names – each presented a work to the local artists' union as a token of thanks. The head of the Samarcand union in the post-war years, unwilling to take responsibility for all these paintings and drawings, which bore a high nominal value and required looking after, organised a commission to write them off. This done, he made a bonfire of the lot.

8 P. M. Sysoev *et al.*, *Akademiya Khudozhestv SSSR, Pervaya i Vtoraya Sessii*, Moscow, 1949, p. 17.

9 *Ibid.*

10 M. G. Manizer (ed.), *Akademiya Khudozhestv SSSR, Tretya Sessiya*, Moscow, 1949, p. 110.

11 *Ibid.*, p. 115.
12 *Ibid.*, p. 129.
13 *Ibid.*, p. 122.
14 Mikhail Khmelko told me about Stalin's objection to his painting when I visited him in Kiev in 1990.

Aleksandr Kamenski

9 Art in the twilight of totalitarianism

The bloody years of the Second World War have a special place in Soviet art history. At this time, aesthetic debates were suspended to make way for the use of art as propaganda. The works of 1941–5 are of interest mainly as documents of their time. There are a few exceptions to this: the portraits, landscapes and historical compositions of masters such as Pavel Korin, Sarra Lebedeva, Petr Konchalovski, Vera Mukhina, Robert Falk and Vladimir Favorski. These artists were engaged on a spiritual quest, quite distinct from the programme asserted by politicians. Their work was the seed-corn from which the best art of succeeding decades grew; but this was only after the hiatus of the post-war years, from 1946 to 1954, when the Party tried to take complete control of art.

As the war drew to a close, the Soviet intelligentsia was filled with hope. Its members believed that the people would draw new moral strength from the victory over Fascism, and that this would lead to the restoration of some of the cultural freedoms suppressed during the 1930s. At first this hope seemed justified. In 1944, as Soviet troops advanced on Berlin, new works by Shostakovich and Prokofiev were performed; poets such as Pasternak and Akhmatova read previously unpublished works; and at exhibitions some of the forgotten Russian artistic heritage, from icon painting to master-pieces of the Silver Age (1890s–1910s), began to be put on show. People believed that a turning-point in spiritual and cultural life had arrived.

But this turned out to be an illusion. The totalitarian system which had been established over more than thirty years had merely hidden its teeth during the war; after the victory over the Nazis the beast let rip once more. It may seem surprising that in a poverty-stricken, ruined and starving country so much attention was paid to cultural questions, but this attentiveness was a fact. Between 1946 and 1948 the Party issued one unforgettable decree after another concerning music, the theatre, cinema and literature. In 1949 it initiated the struggle against 'cosmopolitanism', smacking of anti-Semitism. These decrees, and the speeches and press commentaries which accompanied them, had an especially reactionary nature and were phrased in crude military terms. This aggressive anti-intellectual campaign is often termed the *zhdanovshchina*, after Andrei Zhdanov, secretary of the Central Committee of the Party and Stalin's closest confidant on ideological questions, who directed it.

This period shone with falsity. Soviet artists were required to produce

'optimistic' works, 'rich in enthusiasm and heroics', 'singing the praises of blossoming socialist construction'.[1] Such bragging contrasted strikingly with everyday reality in a country on the threshold of starvation and despair, but none the less it was expected from artists. Everything linked to 'bourgeois society' was subjected to attack, as well as anything touching on human values or novel views on beauty or the origins of spirituality, whether in a foreign or domestic context. Any criticism of Soviet society, even the most harmless, was met with spiteful rage. In Zhdanov's decree 'On the Journals *Zvezda* and *Leningrad*' he spat on the traditions of early twentieth century Russian literature, especially the work of Akhmatova, and anathematised the brilliant anti-philistine satire of Mikhail Zosh-chenko as 'rotten and corrupting'.[2]

Fine art escaped decrees, but the declarations made about it were clear enough. At a congress of Soviet musicians in January 1948, Zhdanov said:

> Not so long ago the Academy of Arts was set up... As you know, at one time there were strong bourgeois influences in painting which appeared everywhere under a leftist banner and tagged themselves with names such as Futurism. Cubism and Modernism: they overthrew rotten academicism and voted for novelty. This novelty manifested itself in insane depictions of girls with one head and forty legs... How did it all end? With the complete collapse of this 'new movement'. The Party reasserted the significance of the classical heritage of Repin, Bryullov, Vereshchagin, Vaznetsov and Surikov.[3]

The idea was plain. Any kind of novelty in art was unequivocally rejected and classicism offered as a staple diet. Imitation, both of memorable Russian masters of the nineteenth century and of pseudo-academic genres, was encouraged.

But it would be wrong to imagine that artists in the 1940s and 1950s worked only on imitation and light entertainment. The truth is something more than this. Soviet post-war art created a world of myth according to a fixed plan. The approved works of art of this period gave a picture of life which was invented by the Party and had nothing in common with reality. Artists were required to 'depict Soviet reality in ... works glorifying the greatness of our time.'[4] The required world-view was, to say the least, one-sided, but it was adopted by nearly all artists. Here is a sample list of the titles of paintings shown at the All-Union art exhibitions of 1948–52: *Congratulations to the Heroine, The Cotton-Growers' Award Ceremony, A Toast to the Hero of Socialist Labour, The Decree about Awards, Awarding the Lenin Prize to the Kirov Factory, The Glorious Days of the Sormovo Shipbuilders, At the Triumphant Conference, Industrial Successes, Abundance of the Collective Farm* and so on *ad infinitum*. The authors of these pictures (often of huge dimensions) were depicting a fictitious land 'flowing with milk and honey' in the most banal and bombastic manner.

The works of this time had their own special aesthetic quality, **155**

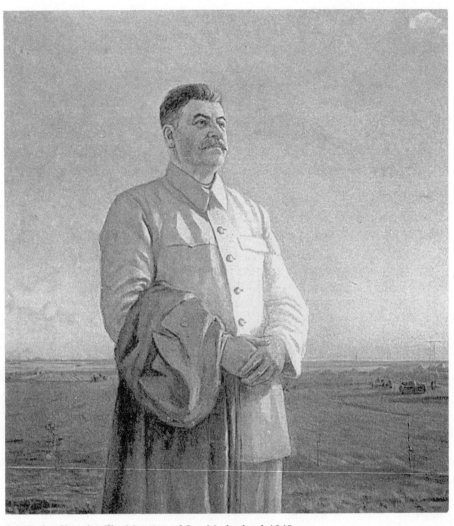

9.1 Fedor Shurpin, *The Morning of Our Motherland*, 1948

Paradoxically, the greater the ingratiating falsity displayed by an artist, the more trustworthy his work was deemed. This is why one decree urged the strictest attention to small details (in view of the insincerity of the whole). All types of non-naturalistic convention in the depiction of form and space were rejected as varieties of 'formalism'.

The compositional standards were set by the posters of the time. The standard format was: in the foreground a large figure or group of figures rousing the viewer to some kind of activity desired by the Party; in the background a panorama of new ploughs or a construction site or smoking factory chimneys. One famous example of this is Shurpin's *The Morning of Our Motherland* (Figure 9.1). In the background is a generalised view of collective-farm fields, in the foreground a figure of Stalin which reminds us more of a sculpture than a living portrait. What is drawn here is essentially symbolic; artistic problems of skill, quality and originality were of secondary importance.

In post-war Socialist Realism there was no room for independent thought. The artist's own opinions might as well have been extinct, for he became the blind executor of tasks sent down from on high. He was required, in his paintings, to contribute to and elaborate a complete mythology, one that pervaded history as well as everyday life. At the centre of this mythical world was the leader – Lenin or Stalin – whose word was law. The leader was habitually represented among the attentive – nay, awestruck – masses. Among many paintings of this kind one celebrated example was *Lenin at the Third Congress of the KomSoMol*, painted by a team of artists led by Boris Ioganson, one of the Party's art-world stalwarts.

Essential to the myth was the spirit of unfailing optimism. Real life was agonisingly difficult, but Stalin still demanded from his subjects an unwavering faith in a bright future. Soviet artists were required to depict 'the forces of Soviet power moving towards a new unseen dawn of well-being and culture'.[5] Collectively they portrayed this dawn, which never could materialise. The stage-sets of the myth were factories, power-plants and collective farms; the props were new machines or piles of produce; the leading players were politicians, bureaucrats or the stakhanovites – super-workers. The individual was situated in the collective, and the collective subordinated to the decisions of the Party: a hierarchy of power clearly adumbrated in Aleksei Vasilev's *They Are Writing about Us in 'Pravda'.* which shows a Moldavian peasant woman reading form the Party newspaper, *Pravda*, to a group of her fellow-workers on a collective farm (Plate III).

Pictures of day-to-day life were not allowed to bear witness to individual thoughts or problems; they had to reflect 'typical' examples of socialism in practice. Aleksandr Laktionov was a classic illustrator in the puffed-up **157**

genre of everyday life: true on the outside, lies within like cheap chocolates. His *Moving to a New Flat* is a typical example, in which a whole family gives its blessing to the system. A representative of the working classes, say a factory or hospital worker or a cleaner, identified by her simple headscarf, is moving to a splendid new flat. Standing beside unpacked suitcases and piles of books (denoting the family's thirst for knowledge), a young pioneer holds a picture of Stalin reverently in his hands. Clearly question Number One, on moving in, is: where shall we hang the image of our beloved leader?

Landscape art was also affected by this ardent programming. In his article 'What Kind of Landscapes Do We Need', Vasili Yakovlev, one of Stalin's court painters, wrote: 'A landscape is a picture, skilfully drawn, enlivened with things of interest today, depicting all the new things that contemporary society offers. A landscape full of movement, life and the work of the Soviet people – such a landscape will be both lively and life-affirming.'[5] This kind of 'aesthetics' simply destroyed the landscape's lyrical nature, its testimony and originality. But even natural motifs could be used to promote the desired life-affirming psychology. Landscapes of a purely poetical nature were not given space at exhibitions, but the painstaking panoramas of Vasili Meshkov, Aleksandr Gritsai, Yakov Romas and others were deemed sufficiently 'monumental' and the sentimental views of Lidiya Brodskaya and other salon-type artists were promoted as heart-rending romances.

There were two strands to official portrait painting under the *zhdanovshchina*. One was the laudatory (*aplodismentnyi*) approach, rooted in Stalin's cult of personality. Here Stalin, Lenin or sometimes a lesser light was depicted on a rostrum above a crowd, or else surrounded by a group of attentive citizens. He utters words of wisdom; his listeners are either hanging on his every word or have already broken into rapturous applause (Figure 9.2). The second type might be termed accessorial. Here the sitter was portrayed together with some elements of his trade: a scientist with a test-tube, a miner with a pick, a farmer on a background of burgeoning cornfields, a general laden with medals. These socialist heroes each had, of course, their own individual faces, but they were linked by a shared air of conviction and determination.

How was this myth of a happy, heroic life imposed on the work of those artists who played a leading role in the exhibitions of 1946–54? It goes without saying that every piece of art criticism was geared towards supporting the myth; any articles that deviated, however minutely, from the official line did not see the light of day (it should be realised that even Impressionism now ranked as a deadly enemy of Socialist Realism). And in March 1947 an Academy of Arts of the USSR was set up, which from the beginning had the goal of annihilating 'sedition' in art. The Academy

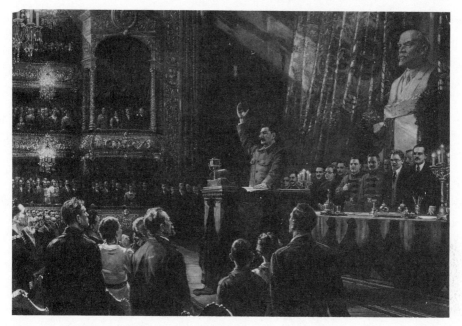

9.2 Aleksandr Gerasimov, *The Great Oath*, 1950

controlled the leading art schools and expelled any teacher or pupil who wandered off the officially defined path.

All this led to the serious deterioration of art and its replacement by lifeless, deceiving clichés in the types of pictures described above. But although the development of art was hampered, there was a glimmering of rebellion at official exhibitions. A kind of artistic resistance movement emerged after the war, which managed to preserve real art and the spiritual values to which it had to answer.

The leaders of this resistance were masters of the older generation who preserved the principles they had respected in the 1910s and 1920s. Indeed, a few of these artists experienced a flowering in their work at the very height of the *zhdanovshchina*. Robert Falk is an example. During the 1940s and 1950s he pursued his theory of 'pictorial continuity', according to which everything in a picture is interconnected, a complex web of harmonious forces. Falk produced at this time a series of 'philosophical' landscapes, nearly all painted in the environs of Moscow, in delicate silvery tones. They reflect the secret, living speech of a sensitive, pure soul. To these landscapes must be added the portraits and self-portraits of these years, which are most subtle psychological images, pursuing harmony with a tragic voice. Falk's works do not, of course, have any link at all with the mythological world of official Soviet art.

159

Other artists of the older generation should also be mentioned. Vladimir Favorski, a wise master of engraving and drawing; the sculptor Aleksandr Matveev, creator of tragic images; Sarra Lebedeva, also a sculptor, who made compelling portraits; Petr Konchalovski, sincere in his spontaneous, energetic brushmarks; Martiros Saryan, a master of lyrical landscape; Pavel Kuznetsov, an incomparable colourist; Aleksandr Tyshler, the creator of an entire magical world. These are some of the artists whose work shone out like bright beacons in the grey stagnant waters of convention and talentless rubbish. Their efforts meant that young people had before them living examples of professional artists who had stood firm and defended the spiritual values so grievously battered by Stalinism.

These young people, after the death of Stalin, started to learn not only from the older generation, but also from the whole heritage of Russian art, from icon painting to Suprematism and Constructivism, that had been suppressed. Discovering these works brought great changes in the outlook of young artists. Zhdanovism they rejected as an idiotic dream and the mythology of Stalinism began to lose its potency. But, in 1992, this too is already history with a dramatic evolution of its own.

Notes

1 A. Zhdanov, *Sovetskaya Literatura – samaya ideinaya, samaya peredovaya literatura v mire,* Moscow 1953, p. 8; and A. Zhdanov, *Doklad o zhurnalakh 'Zvezda' i 'Leningrad',* Moscow, 1946, p. 37 ff.

2 These were two Leningrad journals. *Zvezda* was placed under the control of the Central Committee, and *Leningrad* was ordered to cease publication.

3 *Soveshchanie deyatelei sovetskoi muziki v TsK VKP (b),* Moscow 1948, p. 141.

4 *Pravda,* 7 November 1951.

5 A. Zhdanov, *Doklad o zhurnalakh,* p. 38.

6 V. Yakovlev, 'Kakoi nam nuzhen peizazh? Zametki khudozhnika', *Iskusstvo,* 5, 1949, p. 28.

Susan Reid

10 The 'art of memory': retrospectivism in Soviet painting of the Brezhnev era

We must take the entire culture that capitalism left behind and build socialism
with it. We must take all its science, technology, knowledge and art. Without
these we shall be unable to build communist society. V.I. Lenin, 1919.[1]

More and more, my days flow over into memory. And life turns into something
strange, a duality: there is one life that is reality and a second that is illusion,
memory-made, and they exist side by side, like a double image on a broken-
down television set. Yuri Trifonov, 1980.[2]

Memory is the basis of conscience and morality, memory is the basis of culture
… To preserve memory, to cherish memory is our moral duty before ourselves
and before our descendents. D. S. Likhachev, 1985.[3]

Concern for the preservation of historical monuments and other cultural values
is the duty and obligation of citizens of the USSR.
 Article 68, USSR Constitution, 1977.[4]

An obsession with memory characterises Soviet painting of the 1970s and
early 1980s. I use the term 'memory' or 'retrospectivism' here to unite a
range of thematic concerns and stylistic practices. These include the re-
thinking of Russian and Soviet history; a new use of the history of art as a
manual of authoritative styles to be adapted or as a dictionary of citations;
and – given less attention here – the theme of autobiographical remin-
iscence.[5] The better works which may be placed into the category of
'retrospective' or 'memory' painting are united by an attempt to establish
an active relation or 'dialogue' between the present and the past. They open
up the past – of which ideologues gave only a doctrinal view – for re-
inspection, and to gain a perspective on the present. The term 'memory'
provides a bridge to similar concerns in Soviet literature and film of the
period, to Trifonov, Aitmatov, Tarkovski and Mikhalkov, to name but a few.[6]

Retrospection serves a variety of functions in Soviet painting of the
1970s: legitimising or criticising the regime, nostalgic, self-aggrandising
or psychotherapeutic, universalising or nationalistic. Soviet critics write
much about the need to reconnect with the past.[7] The Proustian quest to re-
establish the genealogy of past and present is perhaps the central venture of
the more significant art of the Brezhnev era.

Khrushchev's revelations about Stalin had shaken confidence that the Soviet Union was set on the right path to attain the radiant future, while hopes of rapid economic progress and greater liberalism were conclusively dashed by the 1968 invasion of Czechoslovakia. The cultural intelligentsia's concern with re-connecting with the past, which began to be noticeable at this time, may be seen as an expression of this loss of hope in the future, and of a corresponding need to find a sense of direction and of integrity. One response was a conservative nostalgia for a mythologised past and a regard for the past as an absolute authority, irretrievably remote from the present. The opposite approach was a critical examination of the origins of the present, a re-investigation of the path already trodden, and an interrogation of memory with an ethical commitment to the complexities of truth. In the face of public silence about much of the past, a commitment to preserve memory – and, with it, conscience, and a sense of personal responsibility for history – was a moral position taken by some of the intelligentsia.[8]

After the reckless destruction of architectural monuments which took place under Stalin and continued throughout the sixties, historic preservation came on the agenda. In 1968, and again in 1979, special issues of the design journal *Dekorativnoe iskusstvo* were dedicated to the question of architectural conservation.[9] In 1976 a law was passed which made respect for historic monuments the moral duty of every citizen,[10] and this was confirmed in the new Constitution of 1977, where the preservation of the heritage of the past was connected with the moral and ethical education of the Soviet people.[11] D. S. Likhachev was active throughout the decade in promoting respect and love for relics of the past, and connected this closely with morality and patriotism.[12]

This discussion will concentrate on references to history and the history of art in 'permitted' painting, that is, in the work of artists of the liberal or 'left' wing of the Artists' Union, the most radical of whom steered a narrow course on the margins of official acceptance.[13] In order to keep this study within manageable proportions, the focus – with some exceptions – is on Moscow. To begin to discuss the importance of history and memory in the non-Russian republics would open up the boundless issue of nationalism.[14] A book could be written on the importance of memory for each ethnic group. Among artists of the RSFSR a nationalist tendency may also be discerned, which sees its mission as the preservation of Russian traditions, and which has much in common with the conservative wing of village prose. Here, however, I shall concentrate on what might be called the 'universalising' tendency, which rejects the notion that there is any single valid tradition, and which attempts to connect with a European cultural past.

From the Revolution up to the time of Khrushchev, Soviet official
162 culture had its eyes set steadfastly on the radiant future, being required to

depict 'reality in its revolutionary development', and to 'catch a glimpse of our tomorrow'.[15] Socialist Realism was represented as the consummation of a realist tradition that was exemplified in pre-revolutionary art by the *peredvizhniki*. In practice, the art-historical sources of Stalinist Socialist Realism were more diverse than this would imply. Nevertheless, the normative definition of correct style for true Socialist Realism restricted the scope to explore and openly acknowledge alternative art-historical models. Dogma was particularly uncompromising in the immediate post-war years, the 'Zhdanov era'. As a Soviet critic, Anna Yagodovskaya, writes in the journal *Iskusstvo* in 1971:

> Approximately up to the mid-fifties the most fruitful and almost the only tradition acknowledged to be worthy of contemporary respect was the art of the second half of the 19th century, and in the first place the tradition of '*peredvizhnichestvo*'... . (acknowledged) as the highest of possible forms of realism. Such a treatment of the question not only excluded whole cultural epochs from the artist's field of vision, for example the Russian middle ages, the searches of Russian masters of the beginning of the 20th century, but also in a certain way distorted the view of the best achievements of the Renaissance and the art of the 17th and 18th centuries, inhibited a deep understanding of the work even of such painters as A. Ivanov, Fedotov, Ge, Surikov, Vrubel', and finally made them take a guarded attitude to certain stylistic tendencies even in the Soviet artistic heritage – to the works of Deineka, Konchalovski, Korin, P. Kuznetsov and others.[16]

The question of the creative relation to the heritage, Yagodovskaya goes on to say, arose particularly acutely at the end of the fifties – that is, during Khrushchev's 'thaw'.

However, it was not until after the thaw that a broad range of art-historical models began to be perceived as a relevant for young artists. The immediate priority, when it became possible during the late-fifties to early sixties, was to relearn the lessons of Russian modernism and pick up the threads of its 'broken tradition'. This meant, above all, mastering the formal means of painting. The Manezh affair at the end of 1962, when Khrushchev attacked the pernicious influence of modernism, signalled the end of the thaw in the arts. [17] Overtly modernist experiments in painting went underground. But the academic impressionist style identified with Socialist Realism in the Stalin era had already lost its monopoly. Young artists whose ambitions lay within the established structures, but who were unwilling to paint in the manner associated with the Stalinist Academy, began to look further afield and gradually other forms of 'realist' art attained respectability.

The re-exploration of art history played an important part in the process of diversification of artistic style which took place from the thaw onwards, as artists were able to draw on the authority of the classics to practice a **163**

variety of realisms.[18] In the 1970s the history of art also provided a language of symbols and allegories to which artists referred in order to introduce increased complexity and multivalency into their work – or at least to create the impression of intellectual depth. Although the view that there was a single valid realist tradition for Soviet art continued to be upheld by conservative critics throughout the Brezhnev era and up to the present day, it was challenged by an increasing number of artists and liberal critics.

Khrushchev's secret speech of 1956, in which he revealed some of the truth about the Stalinist past, set in motion a recovery from amnesia. Under Stalin, access to information about the past was restricted and history reduced to expurgated episodes tailored to fit the needs of the present. On the individual level, too, the connection with the past was ruptured. Personal and family memories had to be suppressed during the Stalinist terror, when few families escaped without some member being purged. Family albums and other relics of one's origins were hidden or destroyed.[19] Children grew up without knowing their family past or genealogy. This is the significance of a number of paintings of the Brezhnev era – especially in the early eighties – which represent a montage of family photographs and documents, such as V. Tyulenev's *Family Album. From the History of Prokushevo* (1984). Genealogy is also the subject of Illarion Golitsyn's paintings where aristocratic family portraits – shadows of forgotten ancestors – hover murkily over contemporary gatherings.[20] The severance of the present from the past affected other areas of inquiry, too. Freudian psychoanalysis, with its emphasis on the connection between the individual's early history and his or her later psychology was outlawed, as was the science of genetics, especially from 1948, because it challenged the views of the omnipotent Lysenko on the relationship between environmental influence and heredity.[21]

Khrushchev's revelations about Stalin's crimes threatened the legitimacy of the Party leadership, and after Khrushchev was ousted in 1964 the Stalin question was swept under the carpet. In the Brezhnev era, historical and political revelations could not be made openly. Nevertheless, fear of repression had decreased and art and literature continued the work of reconnecting with the past – of reasserting history as a process that lives on through its connections with human consciousness and culture and which is open to investigation and multiple interpretations. (It burst into the open with *glasnost*, an important aspect of which has been the investigation into the 'blank spots' of Soviet history.)

Around 1962-3 a change can be remarked in the work of the more adventurous of those artists who did not go underground, such as Pavel Nikonov and Nikolai Andronov, two of the founders of the official art of the thaw, the 'severe style'. In the later fifties and early sixties they and others had reworked accepted Socialist Realist subjects to show more of

the severity of real life. Stylistically, a key work of the severe style such as Andronov's *Raftsmen* of 1960-61 replaces the accepted muddiness of colour with a 'Cézannist' clarity, derived from Konchalovski and other members of the Knave of Diamonds (the pre-revolutionary artists' society influenced by the work of Cézanne). The composition is sparse, without non-essential details, and the baroque diagonal which characterised much Socialist Realist painting of the late forties has been rejected in favour of confrontation with the viewer. Influenced by the work of Deineka and other members of *OSt* in the twenties, the severe style emphasised simplified expressive outline. Painters of this generation began to be interested in Russian medieval icon and church fresco painting. Many went on pilgrimages to Ferapont monastery in the Russian North to study the well-preserved frescos of Dionysius. This interest is evident in *Geologists* (1962) by Pavel Nikonov (Figure 10.1), along with the influence of Aleksandr Drevin. In this painting a sense of doubt emerges, which had been less apparent in the earlier assertive and confident works of the severe style. Weary and demoralised, the geologists are pictured pausing on their journey through the wilderness, and appear uncertain how to go on.[22]

A pioneer both of a new study of icon painting and of the rediscovery of the International Gothic, early Italian and Northern Renaissance, was

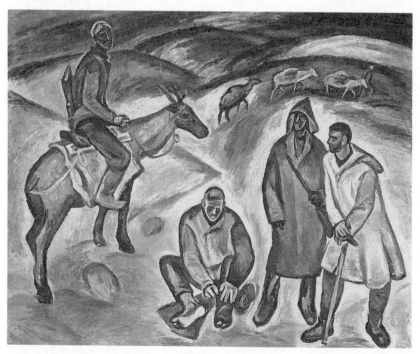

10.1 Pavel Nikonov, *Geologists*, 1962

Dmitri Zhilinski.[23] His painting of 1964, *Family*, selectively combines the technique of icon painters with aspects of the Italian and Northern Renaissance. He abandons aerial perspective, painting the background figures with as much intensity and sharpness of focus as those in the foreground, and in place of a steady progression from front to back the middle ground is elided. He departs from conventional attempts to represent the way reflected light and shade modifies colour – the greyish impressionism at that time accepted as realistic – and instead uses clear, unmodulated local colour. In short, despite its clearly readable figuration, his painting did not pass muster according to the definition of realism still dominant at the time.

Zhilinski continued to make reference to the art of the past throughout the sixties and seventies. But he was not alone in his generation in turning towards a distant, and usually Pre-Raphaelite, past for an ideal of beauty and harmony. A number of artists in the second half of the sixties referred to Gothic, Renaissance and Russo-Byzantine art, hoping to illuminate the present day by their reflected grace and spirituality, qualities which had been absent from the severe style. Contemporary critical literature explains this tendency as a search for 'universal human values' and for a sense of belonging to the transhistorical Great Time.[24] The will to confer on contemporary genre scenes a symbolic dimension which transcends the everyday was particularly evident in the popularity of 'eternal themes', such as that of a solemn meal, or mother and child. Critics attributed a broadly humanist significance to paintings which use patently Christian iconography. The example of Kuzma Petrov-Vodkin (1878-1939), newly restored to respectability, may have encouraged artists to believe that a synthesis of the Russo-Byzantine tradition with the Italian Trecento and Quattrocento could be a relevant for contemporary Soviet art. There was an exhibition of Petrov-Vodkin's work in 1965.

The influence of Petrov-Vodkin is clearly felt in the work of the Belorussian painter, Mikhail Savitski. In addition to borrowing Petrov-Vodkin's faceted surfaces and spherical perspective, Savitski makes similar use of Christian iconography. His *Partisan Madonna*, like Petrov-Vodkin's *Petrograd Madonna*, transforms a simple Belorussian peasant woman, tanned from work in the fields, into a symbol of a people's sacrifice, courage and hope for renewal.

Savitski was not alone among painters from the European republics of the USSR in referring to Christian art of the past. Nikolai Kormashov, a Russian painter living in Estonia, paints Soviet women collective-farm workers, in August 1970, with their heads haloed by pale headscarves, clustered together in the graceful curving poses of icons. One critic writes in the mid-1970s that Kormashov's 'use of certain elements of icon painting ... reminds one anew of the continuity of human values, revealed in the re-echoing of the times (*pereklichka vremen*). It is a kind of call to

traditionally established associations and social symbols, which ... constitute the live wealth of humanistic consciousness.'[25] In this way the critic secularises or humanises the religious resonance.

Rita Valnere, a Latvian, travelled to Italy in 1970, from which time she began to imitate the colour of Italian fresco painting, adopted the classical technique of glazes, and turned to 'universal human themes' such as motherhood. According to one commentator in 1974, Valnere's encounter with Renaissance art in Rome, Florence, Assisi and Venice, with the work of Michelangelo, Giotto and Veronese, made her realise that 'socialist art is the heir to the centuries-long commandments of humanism in the artistic development of humanity'.[26]

In Soviet criticial literature, the practice of artists from the mid-sixties onwards of making stylistic and iconographic references to art history, and in particular their predilection for Renaissance sources, is linked with the concept of 'socialist humanism'. The editor of the major art journal *Iskusstvo*, Vladislav Zimenko, in his book *The Humanism of Art* (published in English in 1976) situates Soviet art at the culmination of a long 'humanist' tradition in world art and especially in the Renaissance, and comes close to instating Deineka as the modern Michelangelo.[27] In the introduction, Zimenko summarises the main thrust of his narrative: 'that the historical novelty of Soviet art consists in the fact that it continues and carries forward, on a fundamentally new social and methodological basis, the great tradition of humanism inherited from the finest representatives of mankind's artistic culture'.[28] Zimenko makes an explicit link between the concept of socialist humanism and Lenin's conviction that socialist culture should continue the best achievements of the past of humanity.[29]

Official ideology of the 1970s emphasised the realisation in the historical stage of 'developed socialism' – which, according to official rhetoric, Soviet society had now entered[30] – of the Marxist ideal of the fully-rounded, harmoniously developed individual: a kind of modern-day Renaissance man.[31] Intentionally or not, the fashion for appropriation from art history affirmed this rhetoric, by showing contemporary Soviet people basking in the reflected glory of the classics. Second- or third-rate painting in the seventies looked to a fairly limited range of art history, mainly that which expressed a sense of order and harmony. In some cases it seems likely that the immediate models were not original Renaissance art (or reproductions thereof), but vicarious interpretations in recent Soviet art. When Zhilinski began to imitate Renaissance painting in the sixties this represented a departure from the normative model for Socialist Realism. Zhilinski taught many of the most talented and original painters of the generation of the 1970s, some of whom used the past to critical effect. But his work also spawned numerous lesser epigones who sought to impart an air of philosophical profundity to their banal work by invoking the

167

authority of the Renaissance. They turned out endless simpering paintings of static groups of exaggeratedly graceful young people, often enraptured before the treasures of World Culture in a museum, and self-aggrandising self-portraits in the guise of Renaissance artist-philosophers.[32] The superficial and idealised representation of the Soviet seventies as a golden age of harmony and culture – a new Renaissance – became the academicism of stagnation. It was repeated *ad nauseam* at exhibitions of young artists into the 1980s.

A notably grandiose representation of the accumulated achievements of the human mind over the ages is *Homo Sapiens* of 1980 by the Uzbek painter, Dzhavlon Umarbekov. The central axis of this humanist hymn is defined by Botticelli's Venus, radiating out from which are emblems representing the wonders of science, superimposed over the figures of Leonardo, Einstein, Avicenna, Navoi, Dante and Tsiolkovski.[33]

Critical opinion was divided over the issue of 'retrospectivism'. Liberal critics, while condemning the more derivative archaising, in general supported the new eclecticism. The fact that references to the classics of art history in effect propagandise the optimistic image of contemporary Soviet society which the regime wished to promote does not appear to have disturbed such critics. The ideals claimed by official rhetoric, such as the fully rounded development of each individual and the increased respect for cultural, intellectual values, were ones with which they could identify. Above all, for leading liberals such as Aleksandr Kamenski and Aleksandr Morozov, the new eclecticism was a step in the right direction towards diversifying the definition of Socialist Realism.[34] Morozov argued repeatedly in essays from the mid-seventies, that, from its very inception, Socialist Realism consisted of diverse tendencies, although with time one alone had become dominant.[35] Calling on the authority of Lenin's statements concerning the continuity of socialist culture from the best of the past, he proposed a 'compensation theory' of Soviet art: in the seventies artists were continuing a process which began in the thirties, of assimilating

> those values which were relatively little developed in our national plastic heritage. After all, Russia did not know antiquity, and her 'middle ages' lasted right up to the end of the 17th century; and now in the twentieth century, when bourgeois consciousness submits humanism to the most sceptical reevaluation, the New Russia not only declares its respect for the humanist classics, but also demonstrates its creative viability.[36]

This synchretic openness is, Morozov argued (along with D. S. Likhachev[37]), consonant with the best traditions of Russian culture.

Not everyone agreed, however, that the Leninist principle of continuity with the past gave licence for omnivorousness. The new eclecticism had its opponents in the art world among more conservative and nationalist artists and critics.[38] They rejected it as threatening the integrity of Russian and

Soviet art, which they regarded as coterminous with a national tradition leading from the *peredvizhniki*, through *AKhRR*, to the academic impressionism of the thirties and forties and subsequently reaching its perfection in the photographic naturalism of the last years of Stalin's life.[39] The issue of eclecticism became the battleground between reformist and neo-Stalinist tendencies – between liberals who regarded it as a step towards breaking down and relativising the imposed interpretation of Socialist Realism, and dogmatists who upheld the continued validity of a unified normative correct style.

Conservative critics were worried not only by the disintegration of the Russian national tradition, but also by the ease with which some artists moved between different adopted styles to the extent that no single one was identifiable as their own authorial and authoritative voice.[40] In an article published in 1987, E. Kalinin sums up the objections against the eclecticism or 'neo-traditionalism' of the seventies.

> With good grounds critics found that it was not a creative, personal 'appropriation' of style, as, for example, was the inclusion of 'phrases' from the language of ancient Russian painting in the grand style of Petrov-Vodkin... In this artistic tendency, as one of its researchers expressed it aptly, 'the choice of style is equal to the choice of a creative persona (*litso*)'. In this way the most important experience of world painting is called in question, which consists in the idea that an artist cannot be outside his own language, genuinely individual and contemporary to his epoch.[41]

Critics, both favourable and disapproving, noted a greater distance and playfulness in the artist's relationship to style in the 1970s.[42] This observation was partly to do with changes in the art, partly the result of changes in critical perception and a shift of authority from Wölfflin to Panofsky.[43] Athough it was towards the end of the seventies that a new conceptual role for style became more evident, as early as 1971 Yagodovskaya had remarked with reference to the use of historical styles that 'Any retrospection is a kind of mask. It is put on in order to be understood. However, a mask either fuses with the face, becomes a personal one, or it must be removed.'[44] In 1980 Anatoli Kantor wrote of the new tendency of the seventies towards what he calls the 'conceptual picture': 'In "conceptual pictures" style is not by any means reborn as the most immediate expression of the individuality of the artist or of the epoch which gave birth to him. The style of the picture, chosen by the artist precisely for this painting (in the next work it might be different), serves as a directing symbol, guiding the attention of the viewer...'[45] Debates in the art journals in the mid-1970s to early-1980s made clear how problematic the concept of 'style' had become.[46] One such debate, in *Dekorativnoe iskusstvo*, focused on the fashion for historical reference in design, referred to as the 'retrostyle'. The term 'post-modern' was also used, though no

attempt was made precisely to define its connotations in the Soviet context. But if post-modern is taken as a chronological term to refer to that which superseded modernism, its use has some justification, since many contributors identified the new eclecticism or retrostyle as an attempt to diversify and humanise the design of the environment in a reaction against the monotony of functionalism which had dominated since the beginning of the sixties.[47] Some rejected the term 'style' altogether, as tending to mean 'unified style', a normative concept which such critics considered incompatible with the complexities of the late twentieth century.[48]

The publication of Bakhtin in the late sixties and seventies made available the concept of 'carnival' to describe the playful and temporary appropriation of stylistic masks and direct citations from the classics.[49] Some critics represent the tendencies of the later seventies in Bakhtinian terms as a 'carnivalisation' of Soviet art.[50] Although no explicit political conclusions could be drawn from this in published art criticism in the repressive atmosphere of 'stagnation', between the lines the association with Bakhtin implies the anti-authoritarian nature of this venture. The idea is attractive, but aside from the achievement of diversification of what passed for Socialist Realism, few works of the seventies deserve to have such an independent, dialogising (to use Bakhtin's term) role attributed to them. Rather, as I have attempted to show above, stylisation after Renaissance and other historical periods became a fashion, which confirmed the official self-image of the Brezhnev era.[51] Although it was opposed by conservatives – the ideologues of culture were no more monolithic than was the Party itself – a broader, but far from open-ended pedigree had by now been established for contemporary Soviet art, one which included those periods and artists that had been excommunicated in the most ruthlessly monologising periods of Stalin's rule.[52]

Nevertheless, while their opposition should not be overstated, it may be said that a number of artists within the establishment resisted the ideological function of art, retreating into a world of private significance and moral values. In the 1970s art history served them as a source of identifiable styles and citations which could be intertwined to create a density of potential interpretation. While remaining within the bounds of the now more liberal definition of realism, their work did not facilitate a single, clear, unambiguous reading which is a prerequisite for propaganda. Critics note the increasing complexity, 'subtextualisation', intellectualism, theatricality and paradoxical nature of the work of the more independent artists of the decade.[53] Whereas, at the beginning of the 1970s, Yago-dovskaya had spoken of the use of historical styles as identifiable masks or codes by which to be better understood, by 1984 Aleksandr Yakimovich compares the polystylism of the seventies to a mask which does not reveal but conceals the artist's presence.[54] In the best works of the Brezhnev era

there is a surplus of meaning which resists containment by official ideology. Olga Bulgakova and Aleksandr Sitnikov, for example, refer to Egyptian art and to the *commedia dell'arte*, in addition to icon painting and the Renaissance, in their conventionalised, hieratic images of the mid-1970s to early 1980s. Their art-historical references point up the difference between art and ideals of goodness and beauty, on the one hand, and life on the other.[55]

In addition to the term 'carnival' and theories of the novel, Bakhtin's writings provided the concept of transpersonal cultural memory conveyed through time by such constants as genre – a kind of genetics of culture.[56] The concomitant realisation that art and literature are by nature historical, which became a commonplace in seventies criticism, challenges the notion that they 'reflect reality', and focuses attention on the diversity of modes of representation as so many historically determined conventions.[57] Thus the recycling of historical styles draws attention to the 'artificiality of art'. D. S. Likhachev introduced the terms 'ecology of culture'[58] and the 'literariness of literature' to refer to the 'various forms of reflections in literature of preceding literature, without an understanding of which a full understanding of literature is impossible.'[59] Intertextuality in poetry was much discussed in the literary journals.[60] Many Soviet art critics noted the 'dual vision' of the young artists of the 1970s,[61] the tendency for 'cultural experiences to become just as much a source for their creativity as real life collisions and impressions,' and to filter life through the prism of art.[62] This narcissistic playing out of Larionov's assertion at the beginning of the century that 'an other's art can be just such a theme for painting as can actuality itself,'[63] worried some critics. They objected that art history was coming between young artists and the study of contemporary reality.

As the seventies moved on, the repertoire of styles available for recycling and periods of art from which to cite expanded and diversified, so that the early Renaissance lost its predominance. It was not only the styles and iconography of 'high' art of the past that were recycled. Some commentators distinguished two main tendencies in the art of the seventies: the 'neo-classicist', and the 'primitivist'.[64] The look of 'timeless' folk and naïve art had already been a popular mask since the late sixties. One of the major practitioners of this 'primitivist' tendency was Nataliya Nesterova, whose work refers in manner and subject matter to Niko Pirosmanashvili, the Georgian 'Rousseau'. In addition, by the late seventies mechanical modes of representation such as photography and film were also sometimes imitated, with attention to the anomalies of these media.

Among the artists of the seventies generation who appropriated art historical styles are Igor Orlov and Vadim Dementev. Igor Orlov abandoned the restrained 'new objectivity' that had characterised his still lives of the late sixties, and turned to painterly bucolics with a pantheistic

sense of the vitality of nature. Reminiscences of classical landscape in the compositional devices and a heavily-glazed, old-master look lend his Russian landscapes a strange remoteness and the fragile presence of dreams. One painting, where a figure playing the flute sits on a distant hill in the twilight, is appropriately titled *Reminiscence of Poussin* (1984).

The paintings of Vadim Dementev might be seen as a visual demonstration of the theory of genre memory. His landscapes recall Ruisdael, the Barbizon school and the Russian landscape painters Shishkin, Savrasov and Levitan. Unlike some of his contemporaries, in Dementev's case the resonance of his landscapes with his precursors in the genre is not a temporary playful assumption of a persona. Rather, he has assimilated the tradition at the level of technique, having taught himself from their example the academic scale of tonal gradations, how to mix colours and use glazes, and having internalised their compositional principles to the extent that his selection and framing of views of the countryside around Moscow is predetermined by the accumulated example of his art historical models.[65]

In the late seventies the use of a montage structure became popular. Sometimes a montage of images was used to represent the workings of memory as a synthesis of distinct times and spaces. A number of artists began to combine references to incompatible sources in a stylistic montage which often sets up an opposition between the old world of 'humanist' cultural values and the contemporary technological world. This became particularly fashionable in the Baltic Republics and Central Asia – often supported by some knowledge of verist surrealism and American hyperrealism – as well as in Moscow. In Nikolai Belyanov's *Reflection* (1981) a procession of characters, fragments from old art, floats across a bluish photorealist scene of modern industrial construction.[66] Vermeer is a popular guest in many works around 1980, as is reflected in the titles of two paintings by M. Borisov, *But maybe one of them is Vermeer?* (1982) and *One morning Vermeer came to me* (1980).[67] By suggesting that the artist has live communion with the dead master who is his inspiration, these paintings illustrate the concept of the 'dialogue with the past' which was a commonplace of liberal Soviet criticism. Rein Tammik, an Estonian, also refers to Vermeer in *The Studio* of 1982, where bathed in Vermeeresque light, the figure of the artist from the Dutch painter's *The Artist's Studio* (Allegory of History) is transposed to a modern studio among contemporary Soviet journals, seated at the easel about to paint an atomic explosion.

The ghost of Rembrandt also makes an appearance. The Kazakh painter, Erbolat Tulepbaev, places himself with his wife opposite Rembrandt and Saskia in *Youth (*1982), a painting whose steep perspective transparency and dream-like ambience refer to Salvador Dali. There are many paintings around the beginning of the eighties which appropriate freely from well-known historical works in this way, borrowing recognisable fragments –

usually human protagonists – as well as some stylistic references.

There is an important point of contact between Soviet painting of the later seventies and early eighties with Western post-modernism. This is the conscious conceptual use of existing images as ready-made visual units,[68] which makes problematic the notion of authorial self-manifestation. It is more helpful, however, to attempt to understand these phenomena in relation to the Soviet context. In everyday life skill in dissembling and double-voicing were essential strategies for social survival and advancement. In this situation, the existence of a sincere self which might be fully present in art or any other public form was questionable. This was fertile ground for the embrace of Bakhtinian concepts. The 'masquerade of styles' in 'permitted' painting of the age of stagnation parallels the phenomenon of the *personazhnyi avtor*, the use of an assumed persona, style and voice, which is an essential element of non-conformist culture in Moscow in the seventies and eighties.[69]

One 'permitted artist' who has command over a number of different stylistic masks is Tatyana Nazarenko. Nazarenko is in many ways the characteristic Moscow artist of the 1970s. A student of Dmitri Zhilinski, she graduated from the Surikov Institute in 1967, that is, at the time when historical references began to proliferate in Moscow painting. Much of Nazarenko's work is about history, memory or the continuation of the past in the present. Her work of the early seventies tries on a number of different historical styles. At that time, by her own account, she looked to the old masters for practical lessons in how to draw and paint well, since she felt that her education had not given her adequate mastery of her craft.[70] However, her choice of art-historical model was determined according to its aptness for the subject depicted. Her portraits of the early seventies are in the style of Holbein, van Eyck or Ghirlandaio; a village festival scene, *Seeing out Winter* of 1973, refers to Bruegel; works painted in Central Asia recall Pavel Kuznetsov's characteristic evocations of life in the steppe. In her mildly satirical genre paintings, a naïve style is coloured with shades of *Neue Sachlichkeit*. Later in the seventies she sometimes makes direct citations. These may be in the form of a picture or reproduction on the wall of a room. In her *Self-Portrait. Flowers* of 1979, the bride and groom from van Eyck's *Arnolfini Wedding,* slightly altered, hover in an unexplained space above the artist.

In the late seventies and early eighties, Nazarenko made frequent use of a montage of different spaces and times, which often merge by fading into transparency where they abut. A number of paintings use this approach to imply the process of reminiscence, the summoning of the past into the present by the medium of a central protagonist whose consciousness unifies the inchoate fragments of the remembered past. In the triptych *Life* (1983), for example, the profile of an old woman is repeated in each panel **173**

in varying degrees of clarity or 'presence', superimposed alternately over old photographs and faces conjured up out of the past, or against the background of a scene from contemporary life. The shifting focus and intertwining of memories with the present day imply that the former may potentially take on a greater reality or 'presence' than the latter. In *Moscow Evening* (1978) the backdrop is provided by a view of contemporary Moscow which is both a topographically accurate record and a metaphor for the continued existence of the past in the present (Figure 10.2). The city is an architectural palimpsest, where new buildings mix with old, the material record of human activity and habitiation over time. Slightly abstracted from this scene and from one another, four young people dressed in the style of the 1970s sit around a still-life of old books, photographs and portraits which float in the foreground. Among these young people a woman in eighteenth century dress emerges semi-transparent, as if to manifest the possibility of making the past present.[71]

While art-historical references and themes of reminiscence are common in the seventies, paintings about historical events themselves were rare,

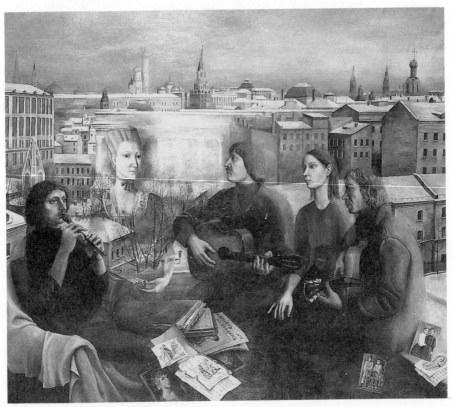

10.2 Tatyana Nazarenko, *Moscow Evening*, 1978

although historical novels and plays were popular.[72] Nazarenko is unusual within her generation of 'permitted'- as opposed to hard line – painters in that she returned, in four major paintings, to the traditional academic genre of history painting. As the picturing of significant human action, history painting had always occupied first place in the academic hierarchy, and as such it had ususally played a role in creating and perpetuating mythologies legitimising the regime. It glorified the deeds of the present by reference to parallels in classical myth or in a deified past, and through stylistic echoes of classic art, the pose of the heroes proclaiming an ancient Greek or Roman genealogy. True to the nature of the genre, Nazarenko chooses for the subject of her history paintings episodes which, in Soviet mythology, were used to establish the origins, pedigree and legitimacy of the Bolshevik Revolution, on which depended, in turn, the legitimacy of each successive regime. But her paintings open up the ambiguities in the interpretations of these episodes and their relation to the present.

Nazarenko painted *The Execution of the People's Will Activists*[73] between 1969 and 1972, after graduating from the Surikov, as the recipient of a scholarship to work in the Academy studios. The imposing surroundings and traditions of the Academy of Arts made her feel she had to live up to them by producing a significant painting in the grand manner.[74] Having followed the established practice for history painting of researching the subject and making many preliminary studies, she produced a large dignified work which is dually historicist, referring to the past in both style and theme .

The members of the revolutionary organisation, the People's Will, condemned to death for assassinating Tsar Aleksandr II in 1881, are monumentalised and isolated by their elevated position on the scaffold, silhouetted against the empty blue sky. The volumetric treatment of the foreground contrasts with the flatter, more linear and comparatively weightless figures of the revolutionaries. The repetitive poses of the bulky grey police – their neckless heads made squatter still by the flat caps – and the rotund rumps of their solid white horses turned towards us in the centre, contribute to a sense of their dull earthbound nature, incapable of flights of idealism. They form the base of a cone, creating a very stable composition, gripped rigidly in place by the one-point perspective. The low central viewpoint, stable geometry, sense of volume, the clear blue sky, all reveal Nazarenko's interest in Italian fresco painting of the Quattrocento, which taught her how to achieve her desired effect of unnatural stillness and theatricality. The self-contained geometry of the composition distances the scene from the viewer. This represents a deliberate rejection of the principles of composition in which the artist had been trained, which were to use the effects of light and shade and of cropping inherited from the late nineteenth century to give the impression of immediacy and throw the **175**

viewer right into the action of the picture.[75] Nazarenko avoids such an effect, so that the viewer is not absorbed in the specific detail of a particular historical moment, but stands outside it, free to relate it to other such moments through time. For this reason, too, the painting is cleansed of extraneous detail. The artist wishes to elevate the condemned revolutionaries to universal significance and make a general statement about the relations betweeen those who actively oppose tyranny and the grey forces which keep tyranny in place; between those few courageous individuals who speak out and the silent masses on whose behalf they protest.

The choice of moment to depict, the execution, arouses associations with the *peredvizhnik* history painter, Surikov, whose *Morning of the Execution of the Streltsy* was first shown in 1881, on the very day the People's Will assassinated the Tsar.[76] But in its frontality, geometric division into an upper and lower register, and its sparse clarity, Nazarenko's composition is closer to Aleksandr Deineka's painting of revolutionary history *The Defence of Petrograd* (1927) (Figure 3.4), than to Surikov.

The People's Will are represented in Soviet hagiography as precursors of the Bolsheviks. While giving them their due for recognising the necessity of political struggle against autocracy, the official attitude towards them was always selective and ambivalent, partly because the Bolshevik's had historically rejected and distanced themselves from this group's tactics.[77] It is, after all, a dangerous thing for any regime to hold up regicides as exemplars.[78] Nazarenko's painting, begun in 1969, was as much about the present as it was about history. The faces of the condemned revolutionaries are portraits of Pavel Litvinov and other young people who in 1968 demonstrated on Red Square against the invasion of Czechoslovakia.[79] Even the flat caps worn by the police – a historical detail researched by the artist – uproot the scene from the late nineteenth century into the present day, since there is little to distinguish the uniform of the Tsarist police from that of Soviet militia.[80]

In 1978 Nazarenko's produced another major history painting, *The Decembrists. Rebellion of the Chernigov Regiment*. The painting concerns the suppression of the rebellion against the Tsar in January 1826 of the Southern Society of Decembrists, who were well-educated young officers, liberal aristocrats inspired by the Enlightenment and the French Revolution. Again, the official Soviet attitude to the Decembrists is ambivalent.[81]

Nazarenko based the figures of the rebels on the style of early nineteenth century provincial Russian portraits. They float in an indefinite space and several episodes are combined simultaneously, as if in the space of memory. A disembodied face of a woman hovers on the right, a quotation from a portrait by Kiprenski. In the foreground is a *trompe l'oeil* still life of weapons and documents. Although painted in a style which recalls the period of the events depicted or even earlier – the eighteenth century – the

papers are aged and curling at the edges which implies that they are seen at the present time of the artist and viewer. Among the papers are poems by Pushkin and Ryleev, contemporary with the events, but also a reconstruction written by the historian Natan Eidelman in the late twentieth century. The painting is a montage of different times and spaces. It departs not only from the traditional unities of time and place, but also from stylistic unity. The stylistic and temporal polyphony of the Decembrists is read by one Soviet critic, Krichevskaya, as allowing multiple readings: 'In the painting several distinct styles are united, as if embodying various sources of memory about the past, whereby they all exist independently, in parallel, in different dimensions. This is an affirmation of a multiplicity of views on a historical event, a polyphonic attempt to understand it.'[82] She adds that the montage of visually disjunctive parts, figures and planes leaves a large creative role to the viewer, along with the right to a subjective 'reading' of the painting.

Inspired by her acquaintance with the historian Natan Eidelman, Nazarenko set out not so much to produce a painting of history itself, as to present a version of history which makes clear that it is seen from the present.[83] As Krichevskaya writes, Nazarenko's painting, 'demonstrates the process of entering into the historical past'.[84] The purpose of the still life which frames the 'vision' of the Decembrists is to set up a dual time frame – a 'dialogue between present and past', as Soviet critics like to call it. Like Eidelman, Nazarenko presents here an excess of documentary evidence over and above that which would be necessary to prove a particular interpretation of the events. At the same time, she invokes the ambience of the period. Eidelman's importance as a historian is both in writing in a popular, readable way, breathing life into history, and also in the undogmatic breadth of the picture he presents. He reconstructs events such that the outcome does not seem teleologically fixed, but leaves room for the reader to imagine 'what might have happened if…'. In a recent appreciation of Eidelman, N. N. Pokrovski writes that, whereas dogmatic history straightens out the real historical process, choosing only a single 'revolutionary' line from the polyglossia of social life, Eidelman is always polyphonic.[85] He rejects received certainties about Russian and Soviet history, returning to primary sources and sometimes revealing facts which contradict expedient official accounts. Eidelman exposes the process by which he has reached his conclusions, while leaving room for readers to judge for themselves, by quoting passages at more length than necessary and juxtaposing contradictory witnesses. He thereby, according to Pokrovski, draws

the reader into the process of scientific criticism of the source, demonstrating the limits of the possibility of bringing the truth to light. In the most responsible moments of this reconstruction of events the voice of Eidelman is almost

inaudible behind the magnificantly arranged solo and choral parts of contemporary witnesses. As a result the historical proof turns out to be complex, put together from parts of various authority, and sometimes it is also relative.[86]

Like Eidelman, Nazarenko reveals the process of reconstruction of history. The richness of the intertwined visual resources provides an excess of connections outside the painting, so that each viewer finds something new and brings his or her associations to the interpretation. As Krichevskaya writes of Nazarenko's work in general,

> The introduction into the structure of the painting even of individual motifs of art of the past immediately includes it in a number of historical and esthetic parallels, which are called on to push apart the boundaries of the local situation, and give it a supplementary breadth of generalisation. Among these parallels, the author's idea is overgrown by a multiplicity of subjective visual associations. The multiple significance of the semantic saturation of the painting is as if programmed from the start.[87]

Its polyphonic structure rejects the dogmatic role expected of all Soviet painting but, above all, of such a prestigious and significant genre as history painting.

Nazarenko's last important history painting in the Brezhnev era, *Pugachev* of 1980 (Figure 10.3), like *The Decembrists*, concerns a challenge to the Tsarist autocracy. The folk hero Emelyan Pugachev was a Don Cossack who proclaimed himself Tsar Peter II and led a mass rebellion of the peasantry against Catherine II in 1773 . Here again a representation of historical events is combined with a still-life of realia and documents, painted illusionistically and in close-up. But whereas these were placed in the foreground of the *Decembrists*, here a wooden divide separates the two into distinct spaces, exterior and interior, agents and witnesses, then and now. On the left, Pugachev, under arrest, is escorted in a cage to his trial and execution. But the iron cage dissolves into the sky above and the red, flame-like figure of Pugachev seems in fact freer – despite his cage – than the barely individualised soldiers below in their standardised poses, who unquestioningly fulfil their orders. The convoy is led by the national hero, Generalissimo Suvorov. Textbook histories usually elided the fact that it was Suvorov who was sent to arrest the revolutionary Pugachev. Nazarenko's painting, based on documentary research, does not attempt to gloss over the contradiction that here is one national hero arresting the other.[88]

Pugachev makes stylistic reference to imperial and military traditions. The mounted figure of Suvorov leading his forces echoes the tradition of mounted portraits of Peter the Great, such as Johann Tannhauer's *Peter I at the Battle of Poltava* (1710s). The clearest reference, however, is to Mikhail Lomonosov's mid-eighteenth century mosaic in the Peter and Paul Fortress, St Petersburg, which also represents the Battle of Poltava.[89] This

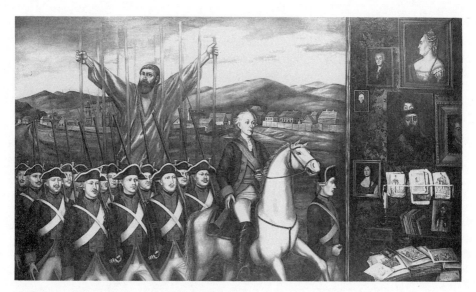

10.3 Tatyana Nazarenko, *Pugachev*, 1981

pedigree for Nazarenko's painting is revealed in her treatment of the composition, the pattern of the lances, and the stilted, repetitive poses of the soldiers. But Nazarenko imitates Lomonosov's glorification of Russian Imperial expansionism in a context which is ignominious, where the might of the armed forces is turned against a peasant revolutionary who had already been captured and handed over to the authorities by his own former supporters. The unflattering implications of the representation of the military were perceived by the censors when Nazarenko's *Pugachev* was hung at an exhibition in 1980, the time of the beginning of the war with Afghanistan. Nazarenko was asked to remove the work. 'With a painting like that,' the censors asked her,' how are we going to inspire our young soldiers with the sense of military duty?'[90]

References to a number of other art-historical sources co-exist in *Pugachev*. The faces of Pugachev and Suvorov are based on contemporary portraits (although one Soviet commentator sees a likeness to Vysotski in the face of Pugachev).[91] The transparency of the landscape seen through the rythmic pattern of cage bars and bayonets is reminiscent of Velasquez's *Surrender of Breda* (1634-35) – a rather more dignified meeting of two great historic personalities. Meanwhile, the simplified rhythmic painting of the soldiers is reminiscent of the primitive *lubok* (wood-cut) as well as Lomonsov's mosaic. In contrast with the smooth doll-like treatment, Pugachev himself is painted with sweeping expressive brushstroke. With his arms reaching upward and out, his pose recalls simultaneously Christ crucified and Christ transfigured. The pose and paint application also draw

179

on associations with Goya's *Third of May, 1808*, of 1814.

The section on the right includes copies of eighteenth-century portraits, an icon and an old candlestick, contemporary drawings of different types of execution, aged papers and leather-bound books. It could either be a museum display or the desk of a contemporary member of the Russian intelligentsia, such as Nazarenko herself, investigating the history of the Pugachev rebellion. Except for the fact that the books and papers are already yellowed and friable, it might also represent Pushkin's desk at the time when he wrote his account of Pugachev. A continuity of the traditions of the Russian intelligentsia is implicit. The light is dim and yellowish, giving the effect that this section of Nazarenko's painting is covered in ageing varnish like the eighteenth century portraits of Catherine II and Pugachev – superimposed, mask-like, over a portrait of the empress – it represents. As in the *Decembrists*, the precise illusionism of the depiction gives the objects an immediacy which suggests that they represent the present tense of the artist and viewer, while simultaneously refering to the eighteenth-century *trompe l'oeil* tradition. Thus, within the 'museum display' itself there is a complex sense of time, of continuity between the present and the past, through the efforts of the intelligentsia to preserve and investigate the traces and witnesses of historical events. The documents and realia on the right, combined with a whole baggage of cultural associations, are the raw material from which the artist has constructed her 'vision' of the historical event on the left.

No single style here can be identified as Nazarenko's own, authoritative voice. Instead multiple voices intertwine, borrowed from the art of the past and from the present. The juxtapostition of realia and documents on the right with a non-canonical vision of a historical event on the left, deprives the latter of the status of being 'history itself', and reveals it as 'history' reconstructed or imagined in the present. This duality inhibits belief in a single authoritative version, while indicating the means by which the past still lives and is available to us for inspection. History is presented here as a dialogue between now and then, something which is actively constructed not only by the artist using prototypes of the art of the past, but also by the viewer situated in the present.[92] Such a reading of the significance of Nazarenko's history paintings was available to Soviet critics. Nazarenko's presentation of history as a path from the present – history not closed and finite, but open to the present day – challenges those monologising forces which base their authority on a controlled version of history and myths of origin. Nazarenko's paintings of the Decembrists and Pugachev not only represent historical attempts to oppose tyranny: the manner in which they represent them is itself programmatically anti-dogmatic.

Notes

1 V. I. Lenin, 'The Achievements and Difficulties of the Soviet Government', *Collected Works* 29, Mar-Aug. 1919, Moscow ,1965, p. 70.
2 Interior monologue of Pavel Evgrafovich Letunov in Yuri Trifonov, *Starik*, Moscow 1980, trans. J. Edwards and M. Schneider, *The Old Man*, New York ,1986, p. 16.
3 D. S. Likhachev, *Pisma o dobrom i prekrasnom*, Moscow, 1985, p. 164.
4 Article 68, USSR Constitution, 1977. *Great Soviet Encyclopedia*, 31, Moscow 1979, English translation, New York 1982.
5 The broad cultural significance of the 'sense of history' or 'idea of memory' is discussed by Irina Karasik, 'K probleme istorizma khudozhestvennogo soznaniia 1970-kh godov,' *Sovetskoe iskusstvoznanie* 81/2.
6 Dual temporal perspective in Mikhalkov's film is discussed by E. Stishova, 'Piat' vecherov i vsia zhizn', *Iskusstvo kino*, 10, 1979. There are countless essays on the *svyaz vremen* and memory in prose and poetry, especially in *Voprosy literatury* around 1980. On the moral importance of preserving memory as represented in the prose of Trifonov, see Nataliya Ivanova, *Proza Yuriya Trifonova* (Moscow, 1984), especially the chapter 'Zabvenie ili pamiat' on *Dom na naberezhne* and *Starik*.
7 The term *svyaz vremen*, the connection of times, is used to refer to this nexus of concerns relating to history, memory and cultural memory.
8 Exemplified by the prose of Yuri Trifonov.
9 *DI,* 1968, 7; *DI,* 7, 1979.
10 The law 'Ob okhrane i ispolzovani pamyatnikov istorii i kultury,' was passed 29 October 1976 and came into effect on 1 March 1977, according to L. Steshenko, 'Okhrana pamyatnikov istorii i kultury v SSSR', *DI,* 7, 1979, 7, p. 2. The law is also cited and discussed by Ivan Belokon, 'Pamiat i kultura', *Moskva*, 7, 1979, p. 166.
11 See epigraph.
12 For example, D. S. Likhachev, 'Ekologiya kultury', *Moskva*, 7, 1979; and, recently published in English, as *Reflections on Russia*, trans. Christina Sever, Boulder, Colorado, 1991.
13 The term 'permitted art' (*razreshennoe iskusstvo*) was coined by V. Levashov and E. Degot, 'Razreshennoe iskusstvo', *Iskusstvo*, 1, 1990, pp. 58-61, to refer to the 'intermediate zone between the two main spaces – official and non-official culture' (p. 58). The term 'permitted' indicates its status as art which was allowed to be exhibited as a temporary concession – a suspension of the official rules, rather than their complete removal. Otherwise known as the 'left wing' of the Artists' Union (*Levyi Moskh* in Moscow), this intermediate layer includes T. Nazarenko, I. Starzhenetskaya, N. Nesterova, O. Bulgakova, A. Sitnikov and others.
14 The retrieval of national history and culture is central to the upsurge of national consciousness awakening from the enforced amnesia or 'mankurtisation' imposed by a longstanding, Russifying integration policy. Chingiz Aitmatov narrates the 'legend of Mankurt' in *I dolshe veka zhitsya den*. Tatyana Nazarenko discussed the significance of this legend as an allegory for the Soviet experience of amnesia in an interview in April 1990. 'Mankurtization' is discussed by Thomas Venclova, 'Ethnic Identity and the Nationality Issue in Contemporary Soviet Literature,' in Katerina Clark (ed.), *Rethinking the Past and the Current Thaw*, special issue of *Studies in Comparative Communism*, XXI, 1988, pp. 3-4.
15 Andrei Zhdanov, Speech at the First All-Union Congress of Soviet Writers, 1934, in John Bowlt (ed.) *Russian Art of the Avantgarde. Theory and Criticism*, London 1988: pp. 292-4.
16 Anna Yagodovskaya, 'Esteticheskaya pamyat i zhivaya sila sovremennost',' *Iskusstvo*, 4, 1971, p. 6.
17 There are many accounts of the Manezh Affair, which has entered the mythology of

Soviet art as the origin of the artistic underground. A concise account may be found in Igor Golomstock, 'Unofficial Art in the Soviet Union', in Golomstock and Glezer, *Soviet Art in Exile*, New York, 1977, pp. 87-8. For an alternative version, see Nina Moleva, *Manezh God*, Moscow, 1989.

18 A new, broader definition of Socialist Realism was aired. Editorial introduction, 'Obsuzhdaem problemy sotsialisticheskogo realisma', *Voprosy literatury*, 5, 1972, p. 29. The opposition to attempts to liberalise is mentioned in an account by one of the 'liberal' critics, Aleksandr Morozov, *Aspekty istorii sovetskogo izobrazitelnogo iskusstva 1960-1980-kh godov*. Moscow, 1988, p. 14.

19 These reasons for the obsession with recovering a connection with the past were given by Nazarenko in an interview, Moscow, April 1990.

20 On the continuing presence of the past in the work of Golitsyn see I. Gerchyuk, 'Zhivopisets Illarion Golitsyn', *Sovetskaya zhivopis' '76/'77*, Moscow, 1979, pp. 163-9.

21 Film critic Tatyana Elmanovich regards the fate of Soviet genetics as symptomatic of the *svyaz vremen* under Stalin. Interview, Tallinn, 1989.

22 The significance of this painting as a watershed, representing a new complex concept of man, is discussed by A. I. Morozov, 'Traditsii nravstvennosti', *Tvorchestvo*, 4, 1979, p. 9, 18. Aleksandr Kamenskii agrees on its importance, but regards it as a culmination of the qualites typical of the severe style rather than a shift away from it: see his 'Itogi i kanuny', *Sovetskaya zhivopis' 6* (1984), Moscow, 1985, pp. 48-9

23 Zhilinski's use of art history is discussed by P. Pavlov, 'Aspekty masterstva,' *Sovetskaya zhivopis' 9*, Moscow, 1987, pp. 185-200; A Yakimovich, 'Pokolenie 70-kh godov pered litsom khudozhestvennogo naslediya', *Sovetskaya zhivopis' '78*, Moscow, 1980, p. 109; I. Egorov, 'D. Zhilinski', *Sovetskaia zhivopis' '74*, Moscow, 1976, pp. 79-82.

24 For example, Yakimovich, 'Pokolenie 70-kh'.

25 B. Bernshtein, 'N. Kormashov', *Sovetskaya zhivopis' '74*, Moscow, 1976, pp. 226-9.

26 R. Latse, 'Rita Valnere – master kartiny', *Sovetskoe stankovoe iskusstvo*, Moscow, 1974, p. 134.

27 Vladislav Zimenko, *The Humanism of Art*, Moscow, 1976, p. 135: 'Michelangelo's athletic figures on the ceiling of the Sistine Chapel, the powerful biblical characters of Ivanov ... Surely much in Deineka's mature works comes from this pure spring. In his own characteristic way, he affirms our life as an embodiment of the great experience of all mankind.'

28 Zimenko, *op. cit.,* p. 11 (emphasised in original).

29 In opposition to *proletkult* theoreticians' insistence that the new leading class, the proletariat, need have nothing to do with anything produced under bourgeois dominance in the past, Lenin had argued on many occasions that the new prolatarian culture should be the development of the best models, traditions and results of existing cultures (see epigraph). Also Lenin, *Poln. Sobr. Soch.* T. 41, Moscow, 1970, p. 462.

30 On 'developed socialism', a concept which entered official ideology in 1971, see Terry L. Thompson, *Ideology and Policy*, Boulder, Colorado, 1989; James P. Scanlan, *Marxism in the USSR: A Critical Survey of Current Soviet Thought*, Ithaca, 1985; Donald R. Kelley, *The Politics of Developed Socialism*, New York, 1986; Alfred B. Evans, Jr., 'Developed Socialism in Soviet Ideology', *Soviet Studies*, 24, July 1977, pp. 409-28.

31 L. I. Brezhnev, 'O kommunisticheskom vospitanii trudyashchikhsiya', Moscow, 1975. V. Zimenko compares the situation for the arts under developed socialism to that of classical antiquity and the Renaissance: 'developed socialist society appears also in a new aesthetic quality. It is essentially the first society after the experiments of the antique polis and Renaissance communes, where the regular, planned development of an integral system of culture has become possible in practice... Art begins more and more actively to exercise a harmonious influence on man, many-sidedly forming his personality.' V. Zimenko, 'Struktura izobrazitelnogo iskusstva v razvitom sotsialisticheskom obshchestve', *Iskusstvo* 1971, 9, p. 2. The association between 'developed socialism', the

formation of a new type of individual, and humanism is made in an Editorial, *Voprosy literatury*, 6, 1975, p. 98. See also V. Kisunko, 'Nerastorzhimaya svyaz', *Khudozhnik*, 11, 1976, who directly links the concepts of developed socialism, humanism, and the assimilation by Socialist Realism of all the best of world culture of the past, especially p. 63. A. Yakimovich, 'Pokolenie 70-kh' uses the concept of humanism to discuss the unity of esthetic and ethical ideals and the importance for both of continuity with the past: p. 123. An important discussion of the concept of developed socialism in relation to the intensification of the process of assimilating the culture of the past is A. I. Morozov, 'Preemstvennost v razvitii sovremennogo sovetskogo iskusstva', *Sovetskoe iskusstvoznanie 19*, Moscow, 1985, especially pp. 6, 10.

32 The critic Georgii Golenkii comments disparagingly on this tendency to excessive niceness, ecstasy and harmony, in 'Iskrennii interes k zhizni', *Khudozhnik*, 12, 1976, p. 5.
33 Discussed by Aleksandr Kamenskii, *Romanticheskii montazh*, Moscow 1989, p. 328
34 A. I. Morozov, 'Preemstvennost v razvitii', p. 8 and note 11. 'Diversity'is one of the key terms in art criticism of the 1960s and 1970s. Multiplicity within Socialist Realism is a leitmotiv of much of Morozov's work. See also V. S. Manin, 'O nekotorykh tipologicheskikh svoistv sovetskogo iskusstva kontsa 50-kh – nachala 70-kh godov', *Sovetskoe iskusstvoznanie '79/2*, Moscow, 1980, p. 5. Morozov links diversity and developed socialism in 'Sovremmenye voprosy i opyt istorii', *Sovetskoe iskusstvoznanie '81/2*, Moscow, 1982, p. 48.
35 A. I. Morozov, 'V avangarde kultury veka,' *Khudozhnik*, 11, 1977; 'Sovremennye voprosy i opyt istorii'; 'Preemstvennost' v razvitii'; also his *Avtoreferat,* Moscow, 1988.
36 Morozov, 'V avangarde', p. 27; 'Sovremennye voprosy', p. 49; 'O dvukh aspektakh v izuchenii sovetskogo iskusstva', *Iskusstvo*, 1, 1974.
37 D. S. Likhachev, 'Zametki o russkom,' *Novyi mir*, 3, 1980, p. 28; M. Alpatov, 'Vysokaya missiia russkogo iskusstva', *Kommunist*, 8, 1982, p. 5, also discusses the relation between Russian culture and the foreign styles it assimilated in the past, and cites Belinskii on this matter.
38 Morozov, *Avtoreferat*, p.14, discusses the necessity of struggling against forces which, in the atmosphere of stagnation, tried to make only one line of the artistic heritage 'legal'.
39 See the debate in *Tvorchestvo* in the mid-1970s, intiated by M. Makarov, 'V poiskakh tselostnosti,' *Tvorchestvo*, 8, 1976. Morozov, *Avtoreferat*, p. 18. discusses the official view of Soviet aesthetic theory in the 1930s-1950s which, he says, in many ways determine artistic policy right up to *perestroika*.
40 See the debate on '*tselostnost*'' in *Tvorchestvo,* 1976-1978.
41 E. Kalinin, 'Zhivopisnaya metafora segodnya,' *Sovetskaya zhivopis 9,* Moscow, 1987, p. 182.
42 M. N. Yablonaskaya, 'Tvorchestvo molodykh khudozhnikov na novom etape', *Sovetskoe iskusstvoznanie '77/1*, Moscow, 1978, p. 11. Yablonskaya contrasts the free relation to appropriated traditions in the seventies to the way artists in the sixties tended to submerge their own individuality in the models they emulated.
43 Olga Arturovna Yushkova, personal communication, April 1990.
44 Yagodovskaya, 'Esteticheskaya pamyat', p. 14.
45 A. M. Kantor, '1970-e gody kak etap istorii iskusstva', *Sovetskoe iskusstvoznanie '79/2*, Moscow, 1980, p. 50.
46 See the debate on '*tselostnost*' in *Tvorchestvo* 1976-78. Also the debate on the 'retrostyle' in *Dekorativnoe iskusstvo SSSR* 1981-83, initiated by Nikita Voronov, 'Stil' detskikh grez', *DI*, 1, 1981. The latter debate raised questions about the concept of stylistic unity and centred largely on the rejection of the unity of the functionalist style dominant since the late sixties, implicit in the return to organic ornament and historical stylisation.
47 Yuri Gerchiuk, 'Gipnozy stiliya', *DI* 5, 1982; Lyubov' Belikova, 'Blesk i nishcheta retrostilya', 10, 1982. The scholar of Constructivism, Selim Khan-Magomedov, is in

favour of the unity of the functionalist style of the 1920s, revived in the 1960s – see his 'Stilevoe edinstvo ili eklektika?' *DI*, 4, 1981.

48 Gerchiuk, 'Gipnozy stilya,' 1982, p. 26.

49 M. Bakhtin, 'Problemy poetiki Dostoevskogo', was published in Moscow in 1963; his 'Formy vremeni i khronotopa v romane,' was partially published in *Voprosy literatury, 3,* 1974; 'Rable i Gogol' in *Kontekst 1972,* Moscow, 1973. For a full chronolgy of Bakhtin's publications, see Tzvetan Todorov, *Mikhail Bakhtin. The Dialogical Principle,* Minneapolis, 1984. Concepts derived from Bakhtin tended to be used in a superficial way in art criticism; 'carnival' is a case in point.

50 One of the most consistent arguments in this vein is A. Yakimovich, 'Cherty perekhodnosti. K kharakteristike tvorcheskogo soznaniya 70-kh – nachala 80-kh godov', *Sovetskaya zhivopis 6*, Moscow 1984.

51 The extent to which historicism in seventies painting was conformist is very hard to determine. In principle, Renaissance and classical sources were acceptable for Socialist Realism. In practice, any painting which departed too far from *peredvizhnik*-derived naturalism was not acceptable to hard-liners according to the criteria of 'lifelikeness', and too close an imitation of early Renaissance would be considered unnatural. Nevertheless, the fact that by the mid-'70s Renaissance echoes had become a fashion implies that there was no longer any struggle involved in adopting this manner. As I indicate, however, there are aspects of the historicist trend which are inherently reformist because they problematise the question of style which had been taken for granted in Stalinist Socialist Realism in which it had to be as transparent or 'silent' as possible. It is debatable how much power the Stalinist old-guard still held within the art establishment in the age of stagnation. Much of the art discussed and reproduced in the Soviet journals departs from the Stalinist model of realism, and much of the published criticism is written by moderate or 'liberal' critics (most of whom were not, however, sufficiently liberal to pay atttention to 'underground' art). The best way to understand the situation is to think of it as a constant struggle between neo-Stalinist and moderate or reformist wings. The stagnation of the Brezhnev years was a result of the counterbalancing of these pressures. The two poles – liberal and conservative – are not fixed but relative positions and their content changed with time. The polarity also disguises a much greater diversity and nuancing of positions along a sliding scale.

52 V. Zimenko, *The Humanism of Art*, represents the new ̦orthodoxy, which would nevertheless have been resisted by those to the right of him. Zimenko probably represents a centrist, compromise position within the establishment, as the editor of *Iskusstvo*, the joint organ of the USSR Ministry of Culture, the Academy of Arts of the USSR (bastion of hard-liners) and the relatively liberal Union of Artists of the USSR. Zimenko's account of Soviet art omits the dominant style which had become synonymous with Socialist Realism, replacing it by individuals such as Deineka, Saryan, Plastov, Petrov-Vodkin, who had been accused of Formalism during the cultural clampdown of the late forties.

53 For example, Yakimovich, 'Cherty perekhodnosti'.

54 Yagodovskaya, 'Esteticheskaya pamiat', p.6.

55 On Bulgakova and Sitnikov's relation to art history, see their interview by A. Degtiar, 'Obretennoe vremia', *Tvorchestvo*, 1, 1980.

56 See the discussion of genre in *Tvorchestvo* 1979-80. Also on aesthetic memory: Yagodovskaya, 'Esteticheskaya pamyat'; L. Krichevskaya, 'Kartiny Tatyany Nazarenko', *Khudozhnik,* 6, 1982, p. 25; V. Kisunko, 'Nerastorzhimaya svyaz', p. 64: 'The art of the past – is precisely the collective memory, the repository of the collective memory of humanity.' For a discussion of the Bakhtinian idea of genre as the representative of memory in the process of literary development, see I. Kartasik, 'K probleme istorizma', p. 27. See also V. Leniashin, 'Zhanrovaya sistema kak problema iskusstvoznaniya', *Khudozhnik*, 10, 1977. On cultural memory, see V. Kubilius, 'Poeziia

i Kul'tura', *VL,* 6, 1979.

57 I. Akimova, 'Vystavka pyati,' *Tvorchestvo,* 8, 1975. Akimova notes (p. 16) that Nazarenko's use of citiations places her depicted scenes on the border between the real and the conventional (*uslovnoe*).

58 For example , D. S. Likhachev, 'Ekologiya kultury', *Moskva,* 7, 1979.

59 Likhachev defines the 'literariness of literature' in his 'Akhmatova i Gogol' in *Traditsiya v istorii kultury,* Moscow 1979, p. 226, n. 7.

60 On intertexutality: V. Kubilius, 'Poeziiia i kultura'; A. Kushner, 'Zametki na poliakh', *Voprosy literatury,* 1, 1980, especially section 'Pereklichka', pp. 212 ff.; I. Podgaetskaya, 'Istorizm liriki'; Likhachev, 'Akhmatova i Gogol' and the following essay in the same volume: I. P. Smirnov, 'Poeticheskie assotsiativnye sviazy "Poemy bez Geroiia"'.

61 A. Degtiar', 'Obretennoe vremya,' 1980, p. 20.

62 I. Karasik, 'K probleme istorizma', p. 37. Karasik summarises the discussions on the use of 'cultural motifs' and the 'artfulness of art', p. 36 ff. Nazarenko refers to the tendency to perceive life through art of the past in 'O svoem pokolenii', *Tvorchestvo,* 1, 1977, p. 23.

63 M. Larionov, cited by G. Pospelov, 'M. F. Larionov', *Sovetskoe iskusstvoznanie '79/2,* Moscow 1980, p. 248. Also cited by Karasik, 'K probleme istorizma', 1982, p. 37. An interesting deliberation on whether art can be the self-reflection of art is V. Kubilius, 'Poeziya i kultura'.

64 A. Degtyar, 'Molodye mastera i masterstvo', *Tvorchestvo,* 1, 1977.

65 Vadim Dementev, interview, Moscow 1990.

66 Belyanov's painting is discussed by Morozov, 'Molodost' strany – 1982', *Sovetskaya zhivopis 6,* Moscow 1984, p. 33; and by A. Kamenskii, *Romanticheskii montazh,* Moscow 1989, p. 327.

67 See Kamenskii, *ibid.*, p. 326. He concludes that Borisov's message is that 'humanity lives not only by the present day; that all the wealth of culture, created over many centuries, surrounds us and in the final count determines the 'spiritual-genetic code' of contemporary people.'

68 Karasik summarises the new quality of the use of art history in the (later) seventies: 'Contemporary "retrospectivism" has not so much an instrumental as a conceptual (*kontseptsionnyi*) character. Cultural-historical associations are included in the very structure of the artistic image, are not simply the means of expression of an idea, but are the essence of this thought... Perhaps one should speak of the self-cognition of art through art itself. If, at the beginning of the 20th century, art analysed its own language, its form-creating means and potential, then today, perhaps, what is going on is the comprehension of the idea of art, of its constant motifs, "iconography", its repertoire of subject and theme, pictorial systems. If we are to talk about means, then it is not primary elements and content-neutral structures, but stylistic structures, compositional blocks, stable plastic motifs...' Irina Karasik, 'K probleme istorizma', pp. 35-6.

69 For example, the work of Ilya Kabakov and Dmitrii Prigov.

70 Interview with Nazarenko, Moscow, April 1990.

71 The interest in parapsychology, seances etc., fashionable among the Moscow intelligentsia, is illustrated by Trifonov in his *Drugaya zhizn* (trans. Michael Glenny, *Another Life,* London, 1983), and is another manifestation of the desire to connect with the past.

72 See the discussion between authors of historical novels in Boldyrev, 'Minuvshee menia obem let zhivo... (Yu. Davydov, Ya. Kross, B. Okudzhava, O. Chiladze ob istoricheskom romane)' *Voprosy litertury,* 8, 1980, pp. 124-54.

73 The People's Will was the subject of a number of novels and plays around this time, including Yuri Trifonov's *Neterpenie* (Moscow: 1972). Questioned about her interest in history in a recent interview, Nazarenko says that, 'In the period of working on the first of

my history paintings, *The People's Will*, interest in history hung in the air. In those years the Sovremennik theatre put on the trilogy *Narodovotsy. Dekabristy. Bolsheviki*: later Trifonov's *Neterpenie* was published.' Interview by Irina Akimova, 'Beskompromissnost', *Tvorchestvo*, 10, 1989, p. 5.

74 Interview with Nazarenko, Moscow, April 1990.

75 *Ibid.*

76 Alan Bird, *A History of Russian Painting*, Oxford, 1987, p. 149.

77 The entry on the People's Will in *The Great Soviet Encyclopedia*, 17 (3rd edn, Moscow, 1974; New York :1978), ends: 'The activity of the People's Will became one of the most important elements of the revolutionary situation of 1879-80. The eventual failure of the People's Will was inevitable, however, owing to the untenability of the program's premises, the erroneous tactic of secret political conspiracy, and the predominance of terrorist means of struggle over other means' (p. 618).

78 Nazarenko speaks of how the People's Will slogan *ubei tirana* ('Kill the tyrant!') was feared by Stalin. Interview, April 1990.

79 Nazarenko was close to the parents of Litvinov. The central *Narodovolets* on the scaffold, Zhelyabov, has Litvinov's face. The others are also based on the protestors against the invasion of Czechoslovakia, except Sophia Perovskaya, because Nazarenko did not see a photograph of Nataliya Gorbanevskaya, the only woman demonstrator. Nazarenko, interview, April 1990. (On the demonstration in Red Square against the invasion of Czechoslovakia, see Gorbanevskaya, *Red Square at Noon*, Harmondsworth, 1973.)

80 Nazarenko originally thought of high, plumed headgear for the police, but rejected it because it looked too operatic. She wanted flat caps both for their formal and expressive effect and for their closeness to familiar contemporary uniforms. Research revealed that the day of the execution happened to be the day of transition to summer uniform, including precisely those flat caps. Nazarenko, interview, April 1990.

81 The Decembrists are grudgingly acknowledged among the revolutionary forbears of the Bolsheviks: 'However, indecision and a narrow *dvorianstvo* (gentry) outlook, characteristic of all the Decembrists, caused the failure of this first organised armed uprising against the autocracy.' 'Northern Society of Decembrists', *Great Soviet Encyclopedia*, 23, 3rd edn, Moscow 1976; New York and London, 1979, p. 178

82 L. Krichevskaya, 'Kartiny Tatyany Nazarenko', p.23.

83 The importance of Eidelman was first suggested to me by Konstantin Akinsha and later confirmed by Nazarenko in a personal interview, April 1990. In a recent published interview with I. Akimova, Nazarenko speaks of the importance to her of Yuri Davydov and Eidelman: 'I learned from them precision and an unprejudiced view of the historical process, boldness, and independence of judgement.' 'Beskompromissnost', p. 5.

84 Krichevskaya, 'Kartiny', p. 23.

85 N. N. Pokrovski, 'Problemy istorii Rossii v rabotakh N. Ya. Eidelmana', *Voprosy istorii*, 8, 1990 p. 162

86 *Ibid.*, p. 165.

87 Krichevskaya, 'Kartiny', p. 20.

88 Nazarenko tells how she discovered this detail when researching the painting; interview, April 1990. She also discusses her depiction of Suvorov and Pugachev – perceived as irreverent at the time – in the interview with I. Akimova, 'Beskompromissnost', p. 5. In fact the *Great Soviet Encyclopedia* – which can surely be taken as a standard source – states quite plainly in the entry for Suvorov (though it is not repeated under Pugachev's) that 'In August 1774, on orders of the Empress Catherine II, Suvorov was dispatched with troops to crush the Peasant War led by E. I. Pugachev. However, the rebels were routed before the arrival of Suvorov, who had only to escort the captive Pugachev to Simbirsk.' 25, (Moscow, 1976; New York 1980) p. 256.

89 I am indebted to Maria Carlson for first drawing my attention to this important source for

Nazarenko's painting. Personal communication, October 1990.

90 Interview, April 1990. A slightly different version, but the same in essentials, is given in 'Beskompromissnost', p. 5.

91 A. Morozov, *Tatyana Nazarenko*, trans. by John Crowfoot, Leningrad, 1988, p. 24: It seems more likely that Morozov has in mind Vysotski in the role of Pugachev in the 1967 Taganka production of Esenin's *Pugachev* which was curtailed. Vysotskii died in 1980, the year of Nazarenko's painting.

92 However, the fragility of the means of access to history is also implied. Without the effort and spark of imagination to inspire them the documents and other relics of the past remain dead and unable to provide any connection with the past. Compare Trifonov, *Drugaya zhizn*, trans. *Another Life,* p. 103.

Aleksandr Sidorov

11 Ilya Glazunov: a career in art

Among contemporary Soviet artists you will find no one who has so consistently excited public opinion as Ilya Sergeevich Glazunov (b. 1930). For more than four decades his work and his private life have been surrounded by scandal, rumour and conjecture. Virtually every step in his life and work have attracted the attention of friend and foe alike, among both the general public and the narrower circle of specialists. Judgements on Glazunov, the man and the artist, are completely polarised, ranging from the rapturous to the defamatory.

The enormous fame of Glazunov's art is difficult to explain using aesthetic and artistic criteria alone. Its notorious 'national flavour' is but one aspect of his leading position among artists of debatable talents. But what is particularly interesting is the fact that Glazunov is perhaps the best example of a glittering career which was 'unofficial'. By 'unofficial' we mean the attainment of popularity by deviating from the traditional, official pathways to success.

You can compare the career-structure of a Socialist Realist 'classic' such as Aleksandr Gerasimov to a path whose every stage unfolds in strict observance to a set of conventional rules: first, a diploma with distinction, followed by authorship of works 'necessary for the people', then participation in a large ideological exhibition, a 'parade of achievements', a prestigious prize, more awards and honorary titles, a series of one-man shows plus a workshop and monographs, and so on up to 'People's Artist of the USSR' and membership of the Academy of Arts.

Ilya Glazunov had it the other way round. His teachers at the institute took no special notice of him, nor he of them. He either did not take part or was not allowed to participate in official exhibitions. He did not refuse awards, but was given them because his work simply had to be recognised rather than because it was approved; his success was recognised partly against their will. He was consistently ignored at the elections for the Academy of Arts of the USSR. In 1990, when the artist had reached the age of sixty, he commented that 'as usual, the Soviet government didn't pay any attention to me at all'.[1]

Glazunov embodies an artistic career-type which runs parallel to the norm, but develops in an alternative way. Appealing to a general audience, it poses difficult questions about 'ordinary taste' which were not answered by the directors of official culture. Prominent among these was the

question of national consciousness and how it might be revived. This consciousness, after all, had been defiled and insulted by the destruction of 'Russian' monuments after 1917[2] and particularly of those expressive of the humanistic elements in Christian culture, with its rich traditions. Another demand which Glazunov's art was able to meet was the public trend towards a wider and less officious subject-matter after the mid-1950s, what Saltykov-Shchedrin had called 'the aesthetics of the street... those gems of bad taste'.[3] It probably has to be admitted that Glazunov was more sensitive to the public's demands than the government commissions and departments. He seemed able to sense accurately which themes, feelings and experiences would excite this broad public.

Equally importantly he was able to do without official support and recognition precisely because he had a feeling for the less traditional ways of popularising his work. Of course, in official Soviet culture it was impossible to tread the path of a Van Gogh or a Modligliani, personifying unworldliness and elemental creativity followed by neglect and a pauper's death. On the contrary, our hero did not leave his reputation to be determined by his descendants or the flow of time, but saw to it that it was moulded by individuals and groups who had helped him materially and morally and who had already assisted in advancing his career. One such individual was remarkable for the persistence with which he queued to see his favourite artist's show. Another may have found Glazunov the telephone number of some well-placed official. A third may have commissioned a portrait of his daughter or his wife. All of these made up a new kind of supporter for a new kind of 'unofficial' art.

There is little doubt that Glazunov capitalised on the crisis of Stalinist culture, the moment at which its values began to decay and when a totalitarian culture changed towards becoming a demagogic one, a culture characterised by a certain pluralism of values, particularly among high-brow ideologues and 'builders of culture' who were devoted to the principles and ideals of Socialist Realism. At this period, in the 1960s and 1970s, the populace could now read 'banned' literature, watch pornographic films and tell political jokes for the first time. In Stalin's time official art served 'the people' and its leader. Taste was dictated by government norms which excluded the private commercial commission and hence the chance to exist outside the official cultural system. By the time Glazunov appeared, this position was changing. Private tastes, however vulgar, began to be satisfied: not officially sanctioned, but not prohibited either. Simultaneously there appeared the need to decorate everyday life, not merely with such things as carpets and cut-glass but with images in which you could see the face of your successful family or indeed your own face: in other words, the portrait.

Glazunov was among the first to recognise the possibilities opened up **189**

by the new atmosphere after Stalin's death, which centred upon cultural links with other socialist and even capitalist countries. From the beginning, he played the part of official representative of Soviet art. At an art competition as part of the Fourth International Student Congress in Prague in 1956, his picture *Julius Futchik* won first prize. It is an interesting fact that his first exhibition in Moscow in 1957 was organised by precisely those members of the *KomSoMol* (Young Communist League) who had taken a leading part in the Congress.

What Glazunov initially catered to a limited demand. Eventually his commissions would come from important officials in well-financed institutions: famous cultural figures, Party figures, diplomatic personnel and others like them. Many of these became not only the heroes of his portraits but his protectors and saviours in difficult situations, which Glazunov tended to survive through his extrovert character and by means of the mythical halo which by then hung over his life. But he did more than simply open up a market of new, officially sanctioned patrons. His gathering reputation was like a gold-mine which gradually broadened and strengthened. People dashed after this Soviet klondyke, including many who had criticised him earlier.

It is not known exactly why the monograph of Glazunov by the Italian communist critic Paolo Ricci was published when it was.[4] It was followed by a visit to Italy, where he completed dozens of portraits, including those of Gina Lollobrigida and Eduardo de Filippo. A chain reaction of orders followed. The Danish Prime Minister Otto Drag invited the artist to paint his wife's portrait. A personal exhibition opened in Copenhagen in 1966. One business trip led to another: Poland, Italy, East and West Germany, France, India, Spain, Finland, Vietnam, Sweden, Nicaragua, Cuba, England, and many more. International organisations such as UNESCO commissioned large works, in this case Glazunov's picture *The Contribution of the Peoples of the USSR to World Culture and Civilisation.*

It is certainly possible to develop a jaundiced and somewhat cynical view of Glazunov's spectacular career. As a rule, the army of those who call themselves his apologists have no connection with art at all. There are the writers S. Mikhalkov and V. Solukhin, for example, or chief editor of *Ogonek*, V. Korotych, or the chief editor of *Yunost*, A. Dementev. One would also have to count those whose portraits he painted, such as the singer Elena Obrastsova, the actor Innokenti Smoktunovski, the writer Valentin Rasputin and no less a figure than Leonid Brezhnev; not to mention Julietta Mazina, Luchino Visconti, Federico Fellini, Indira Ghandi and Salvador Allende, as well as Finnish President Urxo Kenanen, the French actress Maria Kazares and Kurt Waldheim and his wife.

Published assessments of Glazunov's work often endow him with the qualities of a saint. The following is a representative example:

With its drama and sense the planning this picture [*Great Russia, One Hundred Centuries*, 1988] could be compared to a symphony….The great classics [including Glazunov] are those who generate ideas in harmony with their time, and which outlive the routine production of past artists – ideas of which the artist himself was not necessarily aware, but which he was able to articulate by the force of his genius…. The ancient voice of man's consciousness: who are we, where have we come from and why are we here today? These kinds of universal questions resound in Glazunov's work.

The artist himself, of course, was always more modest: 'I have given my life to what we call *perestroika,*' he once said.

So far as professional criticism was concerned, Aleksandr Kamenski's article, published in 1964, was first devoted to the then 34-year old Glazunov. Entitled 'The Sphinx Without Enigma', it pointed out that 'the sensational success and popularity of Glazunov in the eyes of the general public are the result of a number of aesthetic "secrets" which he has uncovered'.[7] In explicating the idea of the 'sphinx' in Glazunov, Kamenski first of all pointed to 'the vain pursuit of sensation and effect, which includes all kinds of prejudices'. He accused Glalzunov of 'profiting from backward, infantile artistic tastes, from association with 'big' names, from playing with grandiose themes and thoughts'; of relying upon merely external effects ('effect by first glance'), and of

using a range of hackneyed visual devices, accompanied by unprincipled borrowing from other artists of the past: something from Surikov, something else from Nesterov, another thing from Borisov-Musatov, yet another from Kustodiev, another from a famous Soviet illustrator, and so on. By imitating a gamut of different traditions, the play of imitation turned into something akin to creaming off the best.

He attempted to 'assault the viewer with theatrical tricks: mounting a little icon onto a helmet, or decorating a fur hat and kaftan with a superimposed embroidered pattern' (Figure 11.1).

Indeed Kamenski left no stone unturned in uncovering the fake foundations of Glazunov's art, while nevertheless trying to acknowledge his 'kind instincts and generous aspirations'. The critic states hopefully that 'Glazunov is still young, and the riches of his creative development are open before him'. Everything depends upon

whether he can conquer the temptations of early success and cultivate artistic taste (so far entirely lacking), a sense of seriousness as well as civic and artistic principles – qualities which are intolerable to deception, money-grabbing or affectation. Only then can the better sides of his talent flourish, when he will perhaps attract critics and viewers alike, not by pretence but by frankness and creative honesty.

With the benefit of hindsight, it probably has to be admitted that Glazunov developed exactly those aspects of art for which he was criticised.

191

11.1 Ilya Glazunov, *A Russian Beauty*, 1968

Following Kamenski, there was a twenty year gap until critics began to look at Glazunov's reputation once more on the occasion of the 1986 exhibition of his work in the Manezh in Moscow. Most of these were probably ineffective: they had the effect of adding fuel to the flame. This was partly because any debunking attempts by critics were smothered, in **192** effect, by the flood of pro-Glazunov propaganda in large-circulation

journals such as *Yunost*, *Ogonek*, and *Sovetskii soyuz*, as well as the efforts of the record company Melodiya, by postcards, slides and television broadcasts. But it was also partly because the critics tended not to extend Kamenski's earlier arguments. Glazunov was able to say 'Ever since 1956, when my first exhibition took place, I hear the same reproaches – nothing new. If you take the press as a whole – I mean the malevolent part – it's all based on the same article.'[6] A further reason may be that in 'the malevolent press' Glazunov was depicted as a sickly anomaly who had broken the rules of good form, and not as one who revealed something disturbing about the existing culture.

Since 1987, however, there have been attempts to see Glazunov in terms of previous history and culture, in terms such as 'popular', 'mass' and 'kitsch'. Now-forgotten opportunists of the later nineteenth century, artists like Kotarbinski, Svedomski and others, were described in terms which brought this genre into clearer view. One article described them as having coped 'very quickly' with northern European symbolism, with its inventory of 'decapitated heads, rivers of blood, young girls symbolising sin, cheap mysticism and other methods of shocking the viewer – the kind of art that later fuelled the national German style of heartless heroes, sickly-sweet maidens and false patriotism'.[9] There is little doubt that this critical turn was itself the product of the *glasnost* era. Here, public consciousness was aroused from its long sleep and many kinds of 'bourgeois' phenomena were discovered in the 'socialism' of the moment, ranging from drug addicts and prostitutes and extending to organised racketeering, state corruption – and Soviet 'mass' culture. 'Mass culture' became a subject for inspection not only in art but in literature, cinema and music, as demonstrated by the two 'Round Table' forums that were published in *Iskusstvo* in 1988. Indeed there is an intimate connection between Glazunov's popularity and the devices of street art that have appeared in the last few years. We see the same huge eyes staring out from countless five-rouble portraits which are sold on street corners. The main difference is the price: a modest one for the amateur, thousands for Glazunov's saints and heroes of the motherland.

Finally, it is worth looking at Glazunov's techniques as a strategist. He has succeeded in consolidating his reputation abroad as an important representative of the Russian Christian tradition, parading its emotions on the faces of Russian maidens, terrifying tsars, bloody feuds and evil deeds, in manner of heroes created by Dostoevski, or Blok. The majority of his stereotypes were symbols of Russian culture, the Russian 'spirit', a national style which Glazunov selectively lifts from icon painting, theatrical opera sets, from Eisenstein's films, but mostly from the type of *à la Russe* style that can be found in Russian restaurants in Paris or in the dance-band clothes of the hard-currency Beriozhka shops. This folksy style is seen for **193**

example in Glazunov's *Misteriya XX veka* (*20th Century Mystery*) of 1978, his *Vechnaya Rus* (*Eternal Russia*) of 1988 (Figure 11.2), or his *Velikii Eksperiment* (*The Great Experiment*) of 1990, which formed part of a programmed attempt on his part to reach the lucrative Western market, by then reaching out in the direction of Soviet artists generally.[8]

Achieving a modicum of popularity in the West undoubtedly enabled Glazunov to play a larger and more risky game with the authorities at home. The year of *20th Century Mystery*, 1978, was the height of the stagnation period, and yet showed Stalin in a sea of blood, surrounded by the assassination of Nicholas II, Mussolini, Solzhenitsyn, Stolypin and Golda Meyer. The artist claimed in one his recent interviews that he 'suffered repression and threats of unpleasant consequences, and there was even talk of throwing me out of the country…. if it hadn't been for the wide popularity of *Mystery* and the fact that it was printed widely in the West, there is no knowing how it would have ended'.[9] The paradox here is that his popularity in the West – combined with claims about threats of repression – contributed to his becoming more wealthy and notorious than the Socialist Realist masters of yore. There is little doubt that he played the 'Western' card with finesse. He personally helped with the supervision of reproductions of his works, recordings of his views, charity exhibitions, glitzy social evenings, even badges reading 'I Love Glazunov'.

At the same time, the artist kept carefully within the values and criteria of official art at home. He depicted politically acceptable subjects: Vietnam, Chile, Nicaragua, Cuba; the glorious achievements of 'socialism' such as Baikalo-Amurskii Magistral (acronymically *BAM*, the railway development in Siberia) or Tyumen, the town specially created for

11.2 Ilya Glazunov, *Eternal Russia*, 1988

industrial workers; contemporary heroes, patriotic themes, the history of the Revolution, and so on. Thus Glazunov produced pictures which beat official government artists at their own game. He played in different registers and worked in a diversity of genres, creating a broad picture of 'reality' that the public would immediately understand.

Glazunov had his own workshop in the Surikov Institute and in the All-Russian Academy of Painting, Sculpture and Architecture; he had a purely nominal director's post in the Museum of Decorative Arts of the Peoples of the USSR; he was accorded a tribute by the Bolshoi Theatre (unprecedented even for Peoples' Artists); his exhibitions both at home and abroad were apparently spontaneous, and took precedence over those of competitors. In short, the 'Glazunov phenomenon' was infectious. Glazunov became, perhaps despite himself, an inspiration for 'liberals' and lovers of 'unofficial' culture. He straddled the boundary between government and unofficial art. He successfully represented many of the religious and philosophical values without which a genuine development of national spirituality is perhaps impossible. That he could do all this with a style that was partly traditional, partly popular and partly original, in the face of seventy years of Soviet power in which aesthetic and artistic criteria were largely repressed, is a fact. In the end we may have to admit that it is also some kind of achievement.

Notes

1 *Sovetskaya kultura*, 14 July 1990, p. 9.
2 See the chapter in this volume on Lenin's Plan for Monumental Propaganda, pp. 16-32.
3 Mikhail Saltykov-Shchedrin, Russia's leading nineteenth-century satirist.
4 Paolo Picci, early 60s.
5 *Tvorchestvo*, 1964, no 10.
6 *Moskovskii Komsomolets*, 8 July 1988.
7 *Dekorativnoe Iskusstvo SSSR*, 2, 1987, pp 19-20.
8 See, for example, *Ilya Glazunov* (exhibition catalogue), Barbican Centre, London, 1987.
9 *Sovetskaya kultura*, 14 July 1990, p. 9.

Aleksandr Borofski

12 Non-conformist art in Leningrad

It is a characteristic paradox that Leningrad, which for more than sixty years bore Lenin's name (but was recently renamed St Petersburg), was always something of an irritant to the Soviet regime. There is hardly another city in the USSR where intellectual life was so consistently attacked as here. Whole generations of Leningrad intellectuals and artists were washed away by waves of terror under the Soviet regime. The most reactionary campaign in the history of Soviet art, initiated by Zhdanov in 1946 and lasting, in effect, for ten years, originated in Leningrad. Here, hidden from foreign embassies and journalists, Party leaders and cultural officials acted with unprecedented insolence and impunity: Leningrad artists were deprived of any possibility of expressing disagreement with the authorities. Even in more liberal or 'vegetarian' times (to use Anna Akhmatova's phrase), the atmosphere was often one of unspoken terror. This suffering was exacerbated by the devastating effects of the Second World War and the siege of the city from 1941-3. The memory and the prospect of suffering have provided the grim background to the lives of non-conformist artists in this northern city from the 1950s to the present day.[1]

The unique artistic culture of Leningrad reached its apogee in the early years of the twentieth century. In the 1930s, touched by provincialism and a sense of self-sufficiency, it started to decline; indeed, one could argue that Stalin's cultural policies caused it to be brutally interrupted. Not only was the experimental art centre *GInKhuK* closed in 1927, but Malevich (its director) was arrested, albeit briefly. Pavel Filonov was constantly persecuted in the 1930s, and his school, the Masters of Analytical Art (*MAI*) was crushed. The brilliant children's book illustrator Vladimir Lebedev was hounded at the same time; and in the second half of the 1930s the Leningrad Academy of Fine Arts, once an important centre for non-traditional art education, was transformed into a conservative establishment from which its independently-minded professors were banned. Other victims of the NKVD-GPU would take too long to list. They include Malevich's associate Vera Ermolaeva, the brilliant painters Petr Sokolov and Bronislav Malakhivski, and the art historian and critic Nikolai Punin, who later died in a prison-camp in 1953.

In the mid-1950s, when Soviet artists began to assert new ideas that conflicted with 'official' ideological standards, Leningrad suffered a particularly hard ordeal. But perhaps it was precisely because of the

uncompromising nature of Communist Party policy in the city that the unique character of Leningrad culture, suppressed since the 1930s, began to reassert itself in the 1950s. Indeed, it was the artists of the older generation, those who had lived through both the 'Golden Age' of the Russian avant-garde and the years of terror that followed, who now assumed a special significance in Leningrad. These artists – Vladimir Sterligov, Tatyana Glebova, Pavel Kondriatev, members of the Ender family, Osmerkin's pupil Osip Sinklin, Nikolai Akimov – had no social illusions. One can scarcely imagine them openly challenging the authorities, like the young Moscow artists at the time of the Manezh affair in 1962. They did not speak out and declare their non-conformism; they did not appeal to journalists; but they perceived themselves as artistic 'outsiders'. Perhaps their long and turbulent lives had convinced them of the worthlessness of 'collectivism'; certainly they did not form a unified and coherent 'underground' as in other circumstances they might. None the less, the authorities felt the force of their 'inner protest' and spared no effort in trying to isolate them from younger artists. Their impact upon the work of Leningrad non-conformist art can hardly be overestimated.

Nikolai Akimov's name in particular is associated with the revival of interest in the heritage of the 1920s (and not only avant-garde art) that took place among young artists and critics in the mid-1950s. Akimov taught Oleg Tselkov, Mikhail Kulakov and Igor Tyulpanov and encouraged a taste for plastic experiment for its own sake, conceived and realised without reference to the tenets of official realism.

Similar ideas were explored by a group of Sterligov's pupils, including Aleksei Koshin, Elena Aleksandrova, Sergei Spitsin and Georgi Zubkov, who returned to styles related to the modernist masters of Western Europe.

These were the explorations of young artists, inspired by the example of older figures who did not participate directly in their programme. Another group which broke with the stereotype of 'official' painting in the 1950s initiated a school which eventually embraced both the older and the younger generations in its ranks. This group was expelled from art school for 'leftist' bias. It included Richard Vasmi, Vladimir Shagin, Solomon Shwarts and, most important of all, Aleksandr Arefiev, a truly original figure who is now almost a legend. They evolved an 'engaged' social art that would expose the dull, squalid and little-seen aspects of everyday Soviet life. All of them, as artists, had their own plastic goals as well as a shared attitude to society, but for a time in the mid-1950s they were united in a powerful movement that inspired a 'severe style' in Leningrad, analogous to that which appeared in Moscow in the same decade.

The situation changed in the second half of the 1960s, and in the 1970s. Opposition to official norms in art became more forthright. Many artists came to think of themselves as having an 'alternative' mission in culture. **197**

Here we can speak of a whole range of figures whose work ranged from the abstract figuration of Gleb Bogomolov (Figure 12.1) to the classicising manner of Vladimir Ovchinnikov, from the conceptualism of Evgeny Rukhin to the playful though far from simple manner of Vladlen Gavrilchik. A new type of painter-activist appeared, a *kulturträger*, perhaps, organiser of informal shows and activities, who personified a certain type of artistic dissidence (Rukhin, who died a tragic death in 1976, and also Mikhail Shemyakin, were outstanding representatives of this type). Artistic actions were seen as inevitably 'political'; non-conformist artists cultivated the self-image of 'the persecuted artist'; and a reflex of grouping together to resist pressure from 'outside' became standard: a true and cohesive underground came into being in Leningrad.

The mid-1970s saw the peak of the official struggle against non-conformism both in Moscow and Leningrad. After the break-up of the 'bulldozer show' in Moscow in late 1974 there appeared, in Leningrad, 'official' exhibitions of 'non-official' artists at both the Gaza Club and the Nevksi Club – small clubs in the workers' districts of the city of the kind that had originated in the 1920s for workers' leisure and 'culture', had lapsed into a totally ideological function in the 1930s, and had been transformed in the 1950s and 1960s into leisure centres, housing cinemas, libraries and amateur societies. This rising 'alternative' culture in Leningrad took on the name of 'Gaza-Nevski'.

Today, as I see it, a leading position in Leningrad culture is still occupied by this first generation of non-conformists, although relatively

12.1 Gleb Bogomolov, *Megalandscape*, 1978

few still survive. Leading figures include the expressionist painter Vladimir Shagin; the explorer of colour relations Igor Ivanov, the abstractionist (I call him this in spite of occasional surreal figurative images) Gleb Bogomolov, who exploited the kind of texture that was called 'noise of the surface' in the 1920s; and the explorer of surface-texture in the representation of the world, Anatoli Belkin.

Vladimir Ovchinnikov deserves to be specially mentioned. He is that rarest of contemporary artists, a narrator and story-teller. He took part in the notorious 1974 show at the Gaza Club. Unlike many of his contemporaries, however, Ovchinnikov never felt the need to show his familiarity with 'free' Western art by using its devices for political ends. Neither did he indulge in the ironic parodying of visual stereotypes in the manner of the Moscow Sots-Art group. Ovchinnikov's world is hard to speak about in the terms of art criticism. It is a simple world. He appears to be on familiar terms with ancient mythological characters and Biblical subjects (Plate IV). But his favourite characters are ordinary women in small provincial markets, homeless drunkards asleep on benches, pensioners playing chess in the park, gypsies at railway stations. These characters generally get on well: angels may feel at ease in the company of invalids and railside vendors; and centaurs, finding themselves in a Russian village, behave quite naturally. The viewer is effortlessly absorbed by the narrative potential of Ovchinnikov's scenes, many of which have rich historical and sociological references. Will his mythical characters start to feel the weight of human worries on their shoulders? How will they behave when locked into a routine earth-bound existence? And what of Ovchinnikov's ordinary men and women? Will they maintain their introversion and self-absorption in the face of their fantastic new companions?

Equally important is Vadim Voinov. He makes what he terms 'functional collages'. In his work anything from garbage to a super-modern commodity can figure. Voinov's intention is not to estrange us from these objects, as some Western artists do, but to establish connections and put the viewer in contact with the world of times past, its passions, tragedies and emotions. In Voinov's work, an object usually performs an allegorical or metaphorical function. His collage *Zoo à la Zoshchenko*[2] (Figure 12.2) is typical: it is made up of a group photo of the 1940s showing holiday-makers in pyjamas, a magazine illustration depicting a giraffe, and a postcard with a lion in a wire cage. Zoshchenko is the popular children's writer (and satirist) of the 1920s. In Voinov's hands the metaphor at the heart of Zoshchenko's story[3] is materialised and every object given a metaphoric reading. The result is a symbol of the epoch which is both appallingly 'realistic' and at the same time highly artificial.

The polysemic character of Voinov's work is fully revealed in another work entitled *The Leningrad Case*, which is reliant on the platitudinous **199**

12.2 Vadim Voinov, *Zoo à la Zoshchenko*, assemblage, 1988

idea that policy-making is akin to chess. The historical moment to which the work refers may be divined from the photographs of two of Stalin's most notorious henchmen, Beria and Dekanozov, as well as from a newspaper page covered in black stripes (these stripes were the standard way of obliterating the names of political leaders who had fallen into disfavour and been 'erased'). With these signs Voinov shows that he is referring to the notorious case after the war when Stalin eliminated practically all the Leningrad leaders who had directed the defence of the city against the Nazis in 1941-4. But the emotional implications of the work are due also to compositional and plastic metaphors. Voinov emphasises the Suprematist concept of the triangle and the quadrilateral: figures which, according to Malevich, accumulated maximum form-building energy and existed beyond space and time. Appearing as they did in Russian art at a time full of bloody events, in Voinov's work they now assume a deeper significance, not restricted merely to 'experiment' in art. They function as signs of the radical social 'experiment' of Sovietism which mercilessly

crushed the life and hopes of the individual. It will be clear that despite the superficial similarities between Voinov's work and that of some Western artists, their moralising and narrative character is entirely in character with the Russian tradition.

The group known as *Mitki* (named after Dmitry (Mitya) Shagin) occupies an intermediate position between the older generation and the younger artists. The *Mitki* group was formed in the early 1980s, although they feel strong organic affinities with older artists, particularly with Arefiev's group. In this sense the *Mitki* are traditionalists. The group's activities are diverse: they are not just artists, but writers, actors, authors and performers. They are 'life artists' absorbed in their own modes of language, life and mythology.

The critical question is whether the *Mitki* have any aesthetic significance, and whether the relationship between their 'art' and their 'lives' is genuine, or merely declared. Some believe that the *Mitki* are primarily 'artists of life', and that whether some of them actually paint paintings is their own affair. If that were wholly true, then writing about the *Mitki* would be inappropriate. But I believe that there is an important relationship between their lives and their art. In the beginning this was expressed in a series of ironic prints in which the group intervened in all the dramatic 'incidents' of European culture: stood between Pushkin and his murderer, cut off their ears to give to Van Gogh, talked Mayakovski out of his suicide. Since then, the *Mitki* have in effect made a certain kind of life experience into art. Leading an 'underground' life, they became well positioned to portray communal flats and boiler houses, courtyards and coridors, beer kiosks and queues – in other words, everyday Leningrad life. What they cannot be called is 'realistic': this life was perceived in an estranged way, from an aesthetic viewpoint in which mass culture, police thrillers and city folklore all played a part, as well as historical examples such as Mikhail Larionov's primitivism and the laughter culture of the *Oberyuty*, the group of absurdist experimental writers with whom Malevich was associated in the later 1920s.

The *Mitki*'s influence has been diverse. Olga Florenskaya, for example, makes textile collages using Mitkian material such as scraps, rag and bric-a-brac, along with improvisational techniques. For some reason she is drawn to naval themes, simply told, but not without historical and literary allusion. The *Mitki* attempt to evoke life in the same way, as if described by a sailor in a bar.

There were marked similarities between several groups founded in the early 1980s, in particular a kind of domineering creative attitude and a brutal and shocking expressiveness. The impact of their work was akin to rock music. The outstanding formation here was The New group, which initially included Timur Novikov, Oleg Kotelnikov and Afrika (Sergei

Bugaev). Their painting was conceived, really, as part of Leningrad rock culture, with its own rituals and rules; 'The New' worked closely with Sergei Kiriokhin's *Pop-Mekhanika*, the famous Leningrad rock group.

But from the mid-1980s art in Leningrad began to change. Leaders of The New, for instance, began to show a clear desire for aesthetic codes that were both individual and affirmative. Each individual within the group needed to estabish certain cultural landmarks and continuities. For them, Basquiat was the most popular Western figure, whereas Warhol and Rausch-enberg took on the status of 'familiar idols'. Where once the accent was on group protest and demonstrations (such as painting derelict houses scheduled for demolition), today the most far-sighted of The New identify themselves with particular prototypes and traditions, a focus that has bought about a clear shift towards painting and concepts of individual style.

Timur Novikov appears to be the most succesful. He has developed a distinct artistic personality despite his tendency to reproduce his own work, or to dissolve it in the impersonal mass-production material supplied by his students. He uses stencils to make a witty and subtle play of visual stereotypes. The resulting forms, simple and clean-cut, emphasise the inspiration Novikov still finds in the work of the earlier Soviet avant-garde. His stencils represent a certain psychgological reality. *The Cruiser Aurora*, for example – no mere symbol, but a stereotype of Soviet mentality – appears as a simple litle boat which could be drawn by a child. Here is a movement from stereotype to archetype, from a mythologised structure to an initial 'natural' quality, that can yield a rare sense of freshness, an engaging immediacy of perception that sets Novikov apart from the more ruminative Sots-Art practitioners of Moscow and New York.

At one time moment, Afrika was also drawn to the experience of the early Soviet avant-garde. During the past two or three years, however, he has joined with the younger generation of Moscow conceptualists, especially the 'Medical Hermeneutics' group, to develop his own version of an art highly sensitive to processes on what one might call 'pre-plastic' levels of consciousness.

From the context of The New, meanwhile, a number of trends have originated, and not only of the conceptualist type. Bella Matveeva and Denis Yegelski are striving to revive the hedonistic, sensuous tradition of the Russian 'Silver Age' within the context of contemporary life. Matveeva proposes a feminist interpretation of woman's sexuality that would be familiar to an audience in the West. The so-called 'Necro-Realists' also originated within The New. Now quite independent, they include Evgeni Yufit, Igor Bezrukov, Sergei Serp, Valeri Morozov (Figure 12.3), Andrey Mertvy and Vladimir Kustov. The Necro-Realists' activity is markedly synthetic; it is they who initiated 'parallel cinema' in Leningrad, doing the job of director, camera-man and actor. Their shows,

which are really performances, include dance and concrete music. Initially their work had much in common with Sots-Art. Their films manipulated the stereotypes of a specific Soviet mentality, particularly the 'optimistic' Soviet cinema of the 1930s, the 'social dream factory'. But the Necro-Realists go further today. The group's favourite subject-matter – corpses, scenes of violence, pathological studies of anatomy – is meant to articulate attitudes to death, which they regard as the most significant parameter of social consciousness today. The result is a unique opportunity to study the life of Soviet society as viewed through the contradiction between clichés of an idealised norm ('death for the Party' and 'death for the future' and other sacrificial ideas of the Soviet period) and reality.

This same contradiction has already produced much black humour, much of it from the 1970s. Here is an anonymous example: 'Yesterday I asked the electrician Petrov, "Why is this wire twisted round your neck?" He said nothing in reply, and only kept swinging his boots, in silence.' Stories like these were massively popular with the public; somehow their black humour was a reaction to the absurdity of everyday life under a decaying regime.

I cannot claim, of course, that the Necro-Realists were inspired by this particular example, but there is no doubt that these young painters have

12.3 Valeri Morozov (Necro-Realist group), *Very Cold*, 1988

been able to grope for the 'pain points' in contemporary attitudes towards death and life that were dominant at a given moment. However paradoxical, by emphasising 'the dead thing' in so many ways, the Necro-Realists have been able to break through to the 'the living thing', and thus to overcome the indifference to existential issues that appears to characterise the post-modernist framework.

And what of the immediate future? Following the failed *coup d'état* of August 1991, the demolition of the Communist Party and the ideological evacuation of the KGB, it comes as an odd realisation that these events have so far had a surprisingly small effect on art.[4] The older generation of non-conformists appear to be reacting somewhat painfully to this state of affairs. Perhaps because resistance to the authorities had become second-nature to them, they can hardly imagine artistic life without it. Younger artists, on the other hand, are showing signs of becoming less interested in politics than in the demands of the art market. We may even be faced with the prospect of the imminent disappearance of non-conformist art – of social romanticism, Bohemian life, and of the underground mentality that had almost become an ethnographic feature of Leningrad/St Petersburg art. At the same time, this process may signify that late or post-Soviet culture may naturally and organically integrate itself into world art.

Notes

1 The term 'non-conformist art' has been chosen as the lesser of various evils. Terms such as 'underground' or 'unofficial' art have chronological limitations, the former, for instance, being mainly applied to the period from the late 1950s to the early 1980s: but it then lost its meaning as the authorities lost the habit of controlling artistic life with the help of the intelligence services. Furthermore, 'underground art' has always been imbued in the Russian tradition with important political implications, as being 'supressed' or 'concealed'. 'Unoffical' too connotes an opposition to 'official' art, a distinction which has become complicated of late. The term 'non-conformist' suggests the artist's independence of Soviet ideology and of its administrative structures, but does not imply suppression or control in the same sense. Although all these terms are often used as synonyms, I use 'non-conformist art' here as perhaps the most neutral and all-embracing term, reserving the others for particular chronological periods.

2 Zoshchenko was an outstanding Russian satirist, severely persecuted by the Stalin regime in the late 1940s.

3 A character in a children's humorous story remarks that he would prefer to stay in a zoo cage than in the wild. The statement was used politically against Zoshchenko, who was held up to shame as a fault-finder and a slanderer.

4 This was written in November 1991 (Eds).

Aleksandr Yakimovich

13 Independent culture: a Soviet phenomenon

In what I propose to call 'independent' art in the former Soviet Union today, there is a very striking absence of traditional moral and aesthetic certitudes. It is this extraordinary vanishing act, and its consequences, that I want to examine in this chapter.

But first, we need to remember the background against which 'independent' culture arose: that of the communist state and its ideological convictions. We do not need to rehearse the lineaments (or the lineage) of this apparatus, of the norms and illusions which it sought to impose. The fact is that Soviet artists after the period of Brezhnev began in increasing numbers to associate *all* static and stable constructions of mind with the ideology which they were attempting to escape.

Classic Soviet 'conceptualism' of the 1970s and 1980s, for example, leaned heavily upon the principle of impossibility: a far cry from outright political opposition or explicit protest. In these years – the period of Mikhail Suslov's dominance of the Communist Party Ideology Department from 1968 to 1985 – the very idea of a non-naturalistic, non-figurative art was from an 'official' point of view virtually unthinkable. In these years conceptualists such as Ilya Kabakov and Erik Bulatov repeatedly experimented with 'impossible' combinations of things, actions and meanings. Kabakov, for instance, made large blank canvases carrying momumental but actually hollow phrases and sentences: anonymous platitudes and banalities that were constantly being enunciated – about weather, domesticity, health or children – that in a new context became deeply ambivalent. Kabakov made us feel a kind of insanity within common-sense. Things which should be contrary are not so. Kant's 'practical reason' was suddenly in abeyance.

Erik Bulatov, likewise, painted reassuring and 'realistic' landscapes but placed over them different signs, inscriptions and objects which stood in vivid contrast to 'nature'. The words 'sky' and 'sea' obliterate a sunny seascape (Figure 13.1). Or in another case, an idyllic picnic scene has the word 'Danger' running across it, in red. Is there danger in the plants, or the soil? Or is the seemingly peaceful conversation of people resting on the grass laden with foreboding? The nature of the contrast is of course unverifiable. And yet in another sense we are being given a straightforward lesson on what we cannot do – namely differentiate the dangerous from the

205

13.1 Erik Bulatov, *Sky Sea*, 1984

friendly, the good from the bad.

In fact much (or even most) 'independent' art of the period proposes the devaluation of contrasts and the intermingling of all notions and ideas. Take the pictorial and photographic chimeras of Vitaly Komar and Aleksandr Melamid (who have lived in the USA since the mid-1970s). These artists are in several ways remarkably tender towards the dehuman-ised reality created under the Imperial Soviet regime: they combine pity, tenderness and disgust, a complex assortment of attitudes which are then re-addressed to what they identify as a mad, brutal, terrifying but also dear motherland, the Soviet state. They painted Stalin among antique columns and draperies, accompanied by a semi-naked muse, presumably working together on the new 'revelation' of the programme of Socialist Realism (Figure 13.2). Elsewhere, they designed an 'advertisement' for Cola-Cola

13.2 Vitaly Komar and Aleksandr Melamid, *The Origins of Socialist Realism,* 1982-83

quoting (apparently) Vladimir Lenin, in the manner of official Soviet posters. Or they painted a portrait of Ronald Reagan as a centaur: both a representational portrait and a Hollywood cowboy memory made up into an impossible whole.

The work of the Neo-Constructivists Vyacheslav Koleichuk and Francisco Infante is also devoted to the goal of realising 'unthinkable' things. Confronted with a composition by Infante, one is tempted to say that it is impossible, but it exists nevertheless. He places mirrors, geometrical forms and artificial lights into land- and sea-scapes, confronting the viewer with enormous paradoxes of understanding.[1] Are these constructions massive or weightless? Do they fly in space or repose? Are they mystical visions or do they manifest the triumph of science and technology? That there are no evident answers is part of the artist's purpose.

These examples of complex impossibility are not restricted to conceptualist art. The 'conservative avant-garde' of Nataliya Nesterova, Tatyana Nazarenko, Olga Bulgakova, Lazar Gadaev, Andrei Volkov and others persistently re-worked themes of the double body, the mannequin, the clockwork figure.[2] They visualised a strange world indeed. Nesterova painted numerous 'promenade' pictures of picnics and holiday-makers on the sea shore, which on the surface look as though they belong to the tradition of Bellini and Matisse of happy harmony with nature, serenity and peace. But one notices immediately that something is missing – or perhaps added. The figures, faces, buildings and landscapes are so clumsily painted, so preposterous, that feelings of ambivalence are inevitable. Heaviness and roughness overwhelm the viewer, who tries to reconcile the attributes of a happy myth with a barbarous drama of brushstrokes and forms.

Somehow, here, the old image of a 'Golden Age' collides with an different idea, namely Brueghel's vision of a paradise of fools and idlers. We are tempted therefore with the suggestion that nothing separates the age-old dream of harmony from a kind of sarcastic incredulity or paradox. And it seems to be part of a more general pattern in which man's ability to recognise and understand events is on the point of failing. Living human beings cannot be distinguished clearly from imaginary beings, robots or werewolves. Freudian feelings of the 'uncanny' (*das Unheimliche*) constantly pervade Nesterova's works.

Or look at the paradox of 'living death' or 'dead life' which appears in the so-called coffins of Vadim Sidur, which enable us to contemplate not only the ambivalence of the living and the dead, but that of eternity and transience. His works often bear an intentional similarity to victimised or decaying human bodies; but this analogy is as often denied as it is emphasised.

To enquire deeper into these works one should look at the 'coffins' themselves: they are metallic containers of various sizes and forms filled

with ready-made industrial tools and instruments. These 'technical

cadavers' plainly deny the idea of decay by their patently incorruptible substances (iron, bronze, aluminium), and in this sense seem eternal, at least by human standards. And yet what are they really about? What kind of meaningful duplicity emerges from this art?

Or take the traditional figurative sculptures of Lazar Gadaev. His figures are cast in bronze and comply with the principles of firmness, stability and monumentality. Yet at the same time the norms of traditional sculpture are subtly rejected. The treatment of forms and surfaces itself reproduces the appearance of Causacian children's toys made of bread or dough: perhaps childhood reminiscences of the artist, who was born in the Caucasus. Specific deformations, swollenness and sometimes an impression of being gnawed or eaten resolutely refute the idea of stability in Gadaev's works. The viewer remains puzzled. Is this durability or transience? Solidity or mutability? Pairs of opposites make up an impossible whole.

These examples demonstrate that 'independent' art as a whole traded repeatedly in the mixing and intermingling of ideas: significant and insignificant; intelligent and silly; beautiful and ugly; normal and pathological. The human psyche takes on the character of a kaleidoscope. Mental configurations become fugitive and accidental. Stable structures wane. There is no certainty about right and wrong, possible and impossible, true and false. After all, a kaleidoscope is scarcely an instrument to provide the world with a firm structure. All values and the orientation towards 'reality' becomes both questionable and questioned.

The Neo-'realists' around Nataliya Nesterova and her formation flirted with these paradoxes, although in fact the maximising of duplicity and paradox was not their main intention. For this, one has to look at the younger generation of Sots-artists, those who came to attention around 1980. Andrei Filippov, for example, evolved a Third Rome legend in many of his canvases at the time. The idea goes back to the Medieval Russian claim to possess the only true religion: Moscow was called the 'Third Rome' because it was third in importance only to Rome and Constantinople (Constantinople was called the Second Rome by some Byzantine writers). Filippov is really interested not in political propaganda or ideological unmasking, but in a rejection of ideology as a whole. Paintings of the series included strange and morose rituals alongside frightening visions and violent scenes. These are things the Third Rome lives with, the artist seems to suggest.

One of the paintings represents what seems to be a political murderer – archetypally a 'bad' figure'. And yet Filippov's historical theatre, with its frightful masks and repulsive beings, gives us no feeling of anything being good or bad. All creatures are morally equal. No one knows who is a hero or who a villain. We ought to understand that history is beyond our **209**

understanding, this art seems to propose. We use signs but cannot prove any connection between the signifier and the signified (as post-modernists in the West say). Human beings operate with simulacra; they vainly think that they can disclose the meaning of events, processes and facts; whereas in this inverted cosmos 'good' means the same as 'bad', and 'true' and 'false' can substitute for each other.

One could go so far as to say that constructing myths in order to refute ideological fixities was the primary pursuit of many of the younger conceptualists between 1980 and 1990. Konstantin Zvezdochetov depicted episodes from the life of an imaginary country called *Perdo* – the word was chosen because of its indecent allusions in the Russian: *perdet* means 'to fart'. Zvezdochetov invented an entire range of 'philosophical', 'historical' and 'sociological' meanings for his paintings, making extensive use of a volcabulary of 'Perdians', 'Perdianness' and 'Perdisation', to the extreme embarrassment of an unprepared Russian public. It turned out that the life of the Perdians revolved around its most venerated object: a water-melon. People were represented as dying for it, suffering for it, knowing nothing better than it. The Perdian 'cult of the water-melon' was then interpreted variously as a symbol of femininity, as an allusion to Communism (its red inside), and so on. The artist cast himself in the role of a 'Perdian' art critic, operating with a local version of psychoanalysis and political science.

Later conceptualism, of the period 1985 to 1990, became positively hostile to ideology. Attempting to paralyse the reasonable, the Pertsy group exhibited, among other things, a sculpture in the form of a baby with Hitler's face, wrapped up in linen and painted with mathematical formulae (Figure 13.3). This was an almost exemplary aggression: everyone knows that the child image is important to Christianity, and that early communism developed an imagery of the 'baby Lenin'. And yet this figure carried a face generally considered to be satanic. Its magic signs and letters invoked sorcery or the Egyptian death cult. Thus art brought about a transformation of extremes: Absolute Good and Absolute Evil were interchanged; borderlines evaporated.

There is a simple explanation why this collapse of values took place. Elsewhere this might have appeared to be a revolt against 'reason' and 'humanism'. And yet in Russia this could not be so, since 'reason' and 'humanism' had for so many decades functioned as the prescriptions of an ideology called 'historical materialism', and the dismantling of ideology led inexorably, in the short term at least, to the dismantling of structures and oppositions. The tacit argument was that the official communist cult of 'reason' was the strongest proof that could be provided that 'reason' is synonymous with 'non-reason'; the same went for terms like 'truth', 'humanism' and 'morality'.

210 In the field of literature it is perhaps not surprising that the same

phenomenon occured. Vladimir Nabokov's *Invitation to a Beheading* (written in the USA in 1938 and subsequently reworked) depicts 'lost souls' living in a puzzling and puzzled society. The story concerns the sanatorium existence of a man condemned to death: he is different, that is his only crime. Yet his death sentence is pronounced in a 'humane' manner. His executioner becomes his 'friend' before cutting off his head. Love collapses into annihilation, help into violence, solace into pain. The Communist Party which itself collapsed these antagonisms was mercilessly parodied in Nabokov's tale.

This 'union of opposites' as a symptom of the blurred mind grew into a major preoccupation of independent Russian and Soviet literature between about 1960 and 1990. Writers such as Fridrick Gorenshtein, Yuri Mamleev, Aleksandr Zinovev, Chingiz Aitmatov, Fazil Iskander, Vladimir Voinovich – and others – reproduced in several ways the paradoxes and psychological anaesthesia induced by more or less permanent communist thought. A few examples will have to suffice. Gorenshtein (now living in Berlin) depicts in the genre of traditional Russian 'realism' the everyday life of the home, the streets, the shops and the hospitals, while behind the peaceful façade of

13.3 The Pertsy Group, *Baby Hitler*, late 1980s

events there lurks a deeper violence akin to civil war. People living under prohibitions and humiliations wage a battle for survival against each other. Elderly women struggling for food in a store turn out to be Amazons or revolutionary communist heroines. Peasants arriving in Moscow from their poverty-stricken countryside resemble a partisan fighting unit manoeuvering against city defenders who try to shield minimally available goods. When they arrive exhausted in the hospitals because of hypertonia or heart attack, the reader can see that the medical services resemble a field hospital, and the patients wounded soldiers.

In Mamleev, likewise, we encounter a world that has all but collapsed. Miracles and magic phenomena enter the prosaic world of events, while demonic guests from the nether world take part in everyday life. The banal becomes the irrational, the normal the pathological, madness and perversity appear everywhere; apparantly gentle and respectable people say and do what is characteristic of outcasts and boors. All norms, codes, values and judgements embrace each other in a field of universal promiscuity. Even a saint or a prophet within such a *danse macabre* become an incarnation of the devil himself.

Other writers could be cited: Zinovev, for example, with his Anti-Utopia in the vein of Zamyatin and Orwell. Aitmatov constructs figures of dehumanised humanity, who cannot be villains because they have already lost the distinction between good and bad, reasonable and insane (for example in the novel *Railway Station Hit by Blizzards*). Even the characters in Valentin Rasputin's novels – Rasputin was chosen by Gorbachev to play a role in the Presidential Council – destroy things, lives and nature in an irrational way; and this is a neo-conservative who has become a mouthpiece of traditional values and Russian patriotism. Fazil Iskander's *Rabbits and Boa-Constrictors* is an investigation of relations between victims and their executioners – that theme once more – written in a meditative and ironically pedantic manner which reveals how victims need their torturers and vice-versa. Who then is innocent and who is guilty? Vladimir Voinovich's *Adventures of the Soldier Ivan Chonkin*, finally, is a whole carnival of up-side downs and back-to-fronts. An anti-communist makes a successful career in the Soviet secret services: the hero Ivan, an accident-prone blunderer, turns out to be more lucky (and intelligent) than the rest of the world. Criminals are heroes and heroes criminals. Voinovich is a virtuoso of eccentric turns and absurdities which evoke the traditions of Russian folklore in a contemporary, satirising mould.

Of course these artists and writers adopt many different methods and different styles.[3] But they negotiate a common 'reality', one characterised by lost choice, erased demarcation lines and interchangeable concepts. This is the world of the good bad and the bad good, of the true false and the false true, the world where the certainties of ideology have been displaced

by one in which no one knows how to behave. Perhaps in one important sense the ideological claim to know 'good' and 'bad' better than the rest of the world was undermined *by* this independent art and literature – conceivably because artists and writers had particular scores to settle. In another sense the plight of this art and literature is unique.

An extraordinary philosophical parallelism between the 'West' of Europe and the so-called 'East' can be illustrated in the following way. Independent art in the Soviet Union may be said to reproduce a specific state of mind, one of confusion, dismemberment and numbness, in which opposites easily collide. The writings of Jean-François Lyotard, Jean Baudrillard and Frederic Jameson deploy paradoxically similar concepts to paint a picture of civilisation in the 'West': in which the mind suddenly notices that there is no 'real' border between sense and nonsense, between knowledge and insanity, between falsity and truth.

Western thinking – to dwell on this for a moment – seems hypnotised by the 'crisis' of humanism, the 'end' of rationalism and morality. The famous 'death of the self' thesis and the consequent difficulties of asserting what is 'really true' about the human animal – this doctrine has acquired a central position in the Western humanities. The decay of 'human' values in post-industrialist society is characterised with some drama in Baudrillard's essay 'The Ecstasy of Communication'.[4] Jameson, too, compared the post-modernist mind-set with that of the schizophrenic. One English critic recently spoke of the 'collapse of the immune system' in Western culture. His argument was that the protective mechanisms against chaos, dissociation and insanity are no longer effective.[5] The rational world inherited from the Enlightenment is said to have disappeared: old and new, tradition and innovation, sense and nonsense, the real and the fictional, these demarcations are now said to have become erased. 'Good' and 'bad' are certainly beleaguered categories within recent French and American cultural theory. The Kantian categories have gone; man can no longer regard himself as an inhabitant of a 'normal' existential environment, let alone as master of his world.

In Western Europe the roots of this feeling have long been visible in art. The work of Joseph Beuys, Anselm Kiefer and Christian Boltansky gave credence to the notion of a labyrinth of meanings in which 'the real' always retreated in the face of attempts to grasp it securely.[6] The bibliography of post-modernism is already too large to summarise, yet one point emerges relatively clearly: this 'crisis' of humanism is indistinguishable from the abundance and the openness of the developed first world, its ceaseless flow of information and images powered by technology. A conclusion sometimes hinted at is that 'values' are simply not needed in a society premissed upon rampant consumption and rapid information-flow. Post-modernism offers the proposition that chasing the distinction between **213**

'beautiful' and 'ugly' or between 'meaningful' and 'nonsense' is a futile pretension that savours of anthropocentrism and the spirit of the Enlightenment.

It is paradoxical for us that the developed world seems to have attracted its most pitiless verdicts not from the communist bloc but from its own internal critics. *Homo Sovieticus* remains puzzled. He always supposed it was he who was prone to distress and disintegration. He cannot easily explain to himself how Foucault or Barthes could regard human nature as 'perishable'; nor how Baudrillard could relish the loss of human critieria. For Russians, traditionally, an idea must not only be thought out, it must be lived and it must be suffered. The Soviet critic sees Western theory more as a symptom; as a sign of 'comfort depression', perhaps, since he knows all too well that the 'death of the self' is really caused by psychiatric jails, concentration camps and repression in everyday life.[7]

Independent writers such as Benedikt Erofeev, Evgeni Popov and Ludmilla Petrushevska describe the everyday life of people in the USSR as still a sort of gulag existence – as a sort of concentration camp that covers one sixth of the globe. This is why the Russian intellectual today must remain hesitant about the new Western anthropology. It seems to him to amount to another tragi-comic inversion, for while he and his colleagues are fighting strenuously for liberalisation, for openness, for information and the market, Western thinkers are mercilessly discrediting these same goals.

The task today for independent culture in Russia is an immensely difficult one. Becoming free of communist slogans, though not easy, has already been achieved. So has becoming free of ideas of Utopia. And yet independent thinking on culture must still be careful to distance itself from putting forward 'positive' programmes or 'constructive' proposals for regeneration.

The point can be made though Alexander Herzen, a 'dissident' of the nineteenth century, who said in response to demands for 'constructive' ideas, 'We are not the medicine, we are the pain'. Several thinkers in contemporary Russia keep loyal to Herzen's idea. The kind of outlook connected to the intellectual lineage of Dostoevski and Gogol has been developed by Mikhail Epshtein. The shelterlessness and alienation of humans in a surreal geographical and historical landscape – an updated version of Heidegger's concept of *verworfenheit* – is what he writes about so sensitively. The psycho-sociology of Vladimir Kormer and Leon Rzhevski is exclusively devoted to the problems of *Homo Sovieticus*: Kormer on the inner conflicts and contradictions of the Soviet psyche, and Rzhevski on the 'underdeveloped personality' of Soviet man, his apparently eternal juvenilism and his stunted maturity under the impact of totalitarian rule.[8]

Particularly important in this context is the existential ethics of the painter and writer Maksim Kantor. Kantor is one of those truly independent thinkers who are worried by the fact that *both* historical trajectories – the Soviet model based on dictatorship and the Western model based on the market – produce similar types of conformist, survivalist personalities with seriously reduced capacities to make distinctions between good and bad. Thus the independent thinker in Russia today describes the anthropological catastrophe as one in which the mind no longer knows the difference between fiction and reality (Epshtein), between resonsibility and irresponsibility (Rzhevski), between value and its decay (Kantor).

Is there any deduction which can be made from this, *vis-à-vis* the direction of future work? One begins perhaps from the unsettling parallelism between the anthropological crisis of the West and the collapse of antinomies in the East. Post-modernism and post-structuralism in the West coincide in a curious way with conclusions arrived at by independent art and philosophy in the Soviet state. In art, the now classical conceptualism of Komar and Melamid or the Moscow-based neo-conceptualism of German Vinogradov and the Medical Hermeneutics group are only part of a vast panorama that duplicates ideas of confusion, alienation and the reversibility of meanings. The paintings of Nazarenko and Nesterova, the canvases of Kalinin, Ganikovski and Naumova; the philosophy of Maksim Kantor; the sculptures of Baranov and Gadaev; all of these exemplify the problems generated by a sense of fictional reality, by protestations of pain, danger and evil, by a dramatic loss of reality. No motto would fit them better than *coincidentia oppositorum*. This art poses the largest problem of its time: that of a civilisation that is lost and can no longer discern oppositions, and yet one that must construct oppositions in order to understand the world. In this sense the tasks of both East and West may be said to converge.

And yet ultimately one senses that the Western intellectual arsenal will not yet fit the Soviet situation. Post-modernism is (was?) after all devoted to problems of man and society under the aegis of limitless consumption, abundance, free choice, openness, permissiveness, virtually instantaneous communication and a range of factors totally absent in the former Soviet Union today. That is why post-modernist analogies are ultimately misleading; the philosophy, sociology and psychology of Western Europe and America cannot serve us directly. The independent mind, of course, cannot be against freedom; but it can and must be against illusions connected with attaining freedom. We have to find our own way.

Art of the Soviets

Notes

1 For some illustrations of Infante's work of this period see Matthew Cullerne Bown, *Contemporary Russian Art*, Oxford, 1988, plate 3 (p. 15) and plate 92 (p. 103).

2 See Susan Reid's chapter in this volume, pp. 161-87 above and the accompanying works by Nesterova, Nazarenko and Bulgakova.

3 The argument here could be extended into Soviet film of the period 1960 to 1990, one aspect of which links it firmly with 'independent culture'. Andrei Tarkovski's *Ivan's Childhood* (1964) tells a story about a boy who lost his family in the Second World War, and who ends up helping soldiers in the front line in their operations against the Germans. Who could really guess who he was, this courageous and pitiless small warrior – hero or monster? Later, Tarkovski divined the problems of the 'humanly inhumane': his art was a meditation on good and bad in conditions of erased borderlines. He died in mid-career in 1983, after making *Sacrifice* and *Nostalgia*. His characters are often travellers through life, pilgrims in search of lost values who encounter only that which frustrates and dissatisfies. The vision of the totalitarian state in Tengiz Abuladze's *Repentance* is similar to that of Zinovev in literature or Mamardashvili in philosophy; it proposes a 'system' which is dominated by duplicity and mixed oppositions. Grand proclamations about 'justice' and 'order' becomes a delusive or vague slogan. Great men, pillars of society, are in fact criminals. The younger film-maker Aleksandr Sokurov is perhaps the most radical in portraying this universe of lost differences. In a 1990 interview he declared that he wants to film Soviet life 'as it is'. In *A Lonely Voice of Man, Mournful Senselessness* and *The Eclipse* he tries to get an audience to recognise their real lives on screen, though in the presence of the deception and death. A normal family in a normal house suffers catastrophe (in *Mournful Senselessness*). Loyalty becomes as deceptive as love; truths come to be false; in the final episode people die one after another on a raft lost at sea, a visual metaphor for their isolation and loss of direction.

4 J.Baudrillard, 'The Ecstasy of Communication', in H. Foster (ed.), *The Anti-Aesthetic: Essays in Post-Modern Culture*, Washington, 1983, pp. 126-34.

5 N. Wakefield, *Post-Modernism: The Twilight of the Real*, London, 1990, p 17.

6 See for example M. Kubaczek, 'Winking, Scepticism, Passion', in *Moskau – Wien – New York: Eine Austellung der Wiener Festwoche* (exhibition catalogue), Vienna, 1989.

7 I think it was around 1980 that the American thinker Ihab Hassan said that life in the prosperous West was like existence in a comfortable concentration camp.

8 Kormer, in *Voprosy filosofii*, 6, 1987, and Rzhevski, in *Syntaxis*, 17, 1987.

Notes on contributors

ALEKSANDR BOROFSKI studied art history at the Ilya Repin Institute of Painting, Sculpture and Architecture in Leningrad, and wrote a doctoral thesis on Russian theatre posters 1870–1970 at Moscow University. He lectured at the Mukhina Institute of Applied Arts in Leningrad, and has written many articles and catalogues about modern and contemporary Soviet art. He has curated several exhibitions at the Russian Museum in Leningrad, where he is Head of the Department of Contemporary Art.

TOBY CLARK has taught art history at Winchester School of Art, Coventry Polytechnic and West Surrey College of Art and Design. He is currently preparing a doctoral thesis on the historiography of Russian Constructivism at Sussex University.

CATHERINE COOKE trained as an architect at Cambridge and is now Lecturer in Design in the Technology Faculty at the Open University. Her publications include *Russian Avant-Garde: Art and Architecture* (editor, 1983), *Vienna, Dream and Reality* (editor with Hans Hollein, 1987), *Deconstruction* (editor with Andrew Benjamin, 1989), *Architectural Drawings of the Russian Avant-Garde* (1990), *Street Art of the Revolution* (editor with Vladimir Tolstoy and Irina Bibikova, 1990) and *Soviet Architectural Competitions, 1920s-1930s* (with Igor Kazus, 1992).

MATTHEW CULLERNE BOWN studied at Camberwell School of Art, the Slade School of Art, the Stroganov College, Moscow and at Moscow State University. He is the author of *Contemporary Russian Art* (1988) and *Art Under Stalin* (1991), and organised the exhibition *Soviet Socialist Realist Painting, 1930s–1960s* at the Museum of Modern Art, Oxford, in 1992.

WOLFGANG HOLZ studied at the School of European Studies at the University of Sussex, at Moscow State University, and recently completed an MA in Political Science at the University of Konstanz. He now works for the *Swäbische Zeitung*.

ALEKSANDR KAMENSKI (1922-92) was a Moscow art critic who suffered persecution under Stalin. He supported the painting movement that emerged in the Khrushchev 'thaw', for which in 1969 he coined the term 'severe style'. His most recent book of essays, *Romanticheskii montazh*, was published in Moscow in 1989.

CHRISTINA LODDER is a Reader in Art History at the University of St Andrews. Her publications include *Russian Constructivism* (1983), the Catalogue Raisonné of Naum Gabo's sculptures and constructions (in *Naum Gabo: Sixty Years of Constructivism*, 1985), and numerous articles on Constructivism and the Russian avant-garde. She is currently working on a full-scale study of Naum Gabo.

SUSAN REID is a doctoral candidate in the History of Art at the University of Pennsylvania, researching permitted painting and criticism under Khrushchev

and Brezhnev. She is a lecturer at Sheffield City Polytechnic and curator of the exhibition *Heat and Conduct: New Art from Tblisi*, Mappin Art Gallery, Sheffield and Arnolfini gallery, Bristol, 1992.

ALEKSANDR SIDOROV is an art historian who has written about contemporary and twentieth-century Soviet and Russian art. His books *Petr Vilyams* and *Yurii Pimenov* were published in Moscow in 1980 and 1985 respectively. He is currently employed at the Russian Academy of Arts in Moscow.

BRANDON TAYLOR is Reader in the History of art at Winchester School of Art, and is author of many articles on contemporary and modern art, a number of exhibition catalogues on contemporary artists and art, and the books *Modernism, Post-Modernism, Realism* (1987), *The Nazification of Art: Art, Design, Architecture, Music and Film in the Third Reich* (edited and introduced with Wilfried van der Will, 1990), and *Art and Literature under the Bolsheviks: Cultural Policy and Practice in the Soviet Union 1917–1932* (2 vols, 1991, 1992).

SARAH WILSON is a lecturer in twentieth century art history at the Courtauld Institute of Art, London. She worked on the exhibitions 'Paris-Paris. Creations en France 1937–1957' at the Centre Georges Pompidou (Paris, 1981) and 'Aftermath: France 1945–1954' at the Barbican Art Gallery (London, 1982), and has been involved in mounting major exhibition of the work of Dufy, Leger and the Surrealists. She has published on Picabia, Hans Richter and Max Ernst, and her monograph on Matisse appeared in 1992.

ALEKSANDR YAKIMOVICH has a doctorate from Moscow University and has worked at the Institute of Art Research, Moscow and at the Pushkin Museum of Fine Arts. His publications in Russian include *Chardin and the French Enlightenment* (1980), *Diego Velazquez* (1988), *Young Artists in the USSR* (1988), and *The Universe of Lost Differences: Problems of Culture in Late and Post Soviet Civilisation* (1992). He has also published in journals outside Russia such as *Parkett, Siski, Art Position, Cimal* and *Der Tagespiegel*. Since 1988 he has been a free-lance lecturer and writer on cultural matters.

Index

Figures in italics refer to captions.

DATE DUE